THE FREDERIC REMINGTON BOOK

BOOKS BY HAROLD McCRACKEN, Litt. D.

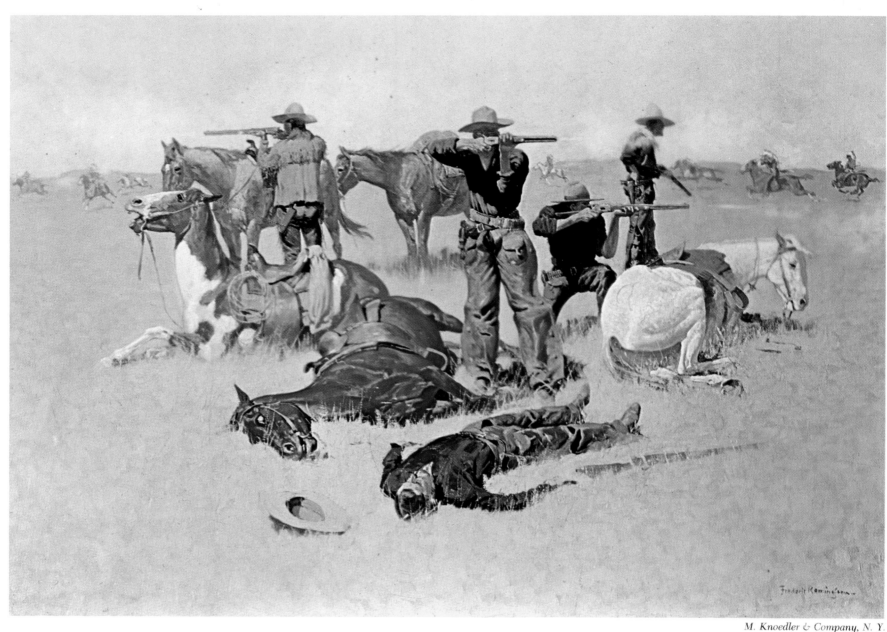

1. THE INTRUDERS

The Frederic Remington Book

A PICTORIAL HISTORY OF THE WEST

Harold McCracken

GARDEN CITY, N.Y.

Doubleday & Company, Inc.

1966

ACKNOWLEDGMENTS

The photographs of original paintings, drawings, and bronzes reproduced in this book have been collected over a period of more than thirty years. A number of dealers, museums, and individuals have been most helpful by supplying me photographs and color transparencies of the works they have handled. Among these are M. Knoedler & Co., Inc., Newhouse Galleries, Kennedy Galleries, James Graham & Sons, and J. N. Bartfield, all of New York City; also the Thomas Gilcrease Museum, of Tulsa, Oklahoma; the Amon Carter Museum, of Fort Worth, Texas; the Rockwell Gallery of Western Art, of Corning, New York; and the Whitney Gallery of Western Art, of Cody, Wyoming. The color transparencies and photographs were mostly made by Jack Richard, of Cody, Wyoming, and Donald Brenwasser, of New York City.

HAROLD McCRACKEN

Cody, Wyoming

TO ANGIE
Without whose constant assistance
this book would never have been written.

Library of Congress Catalog Card Number 66-20937

Contents

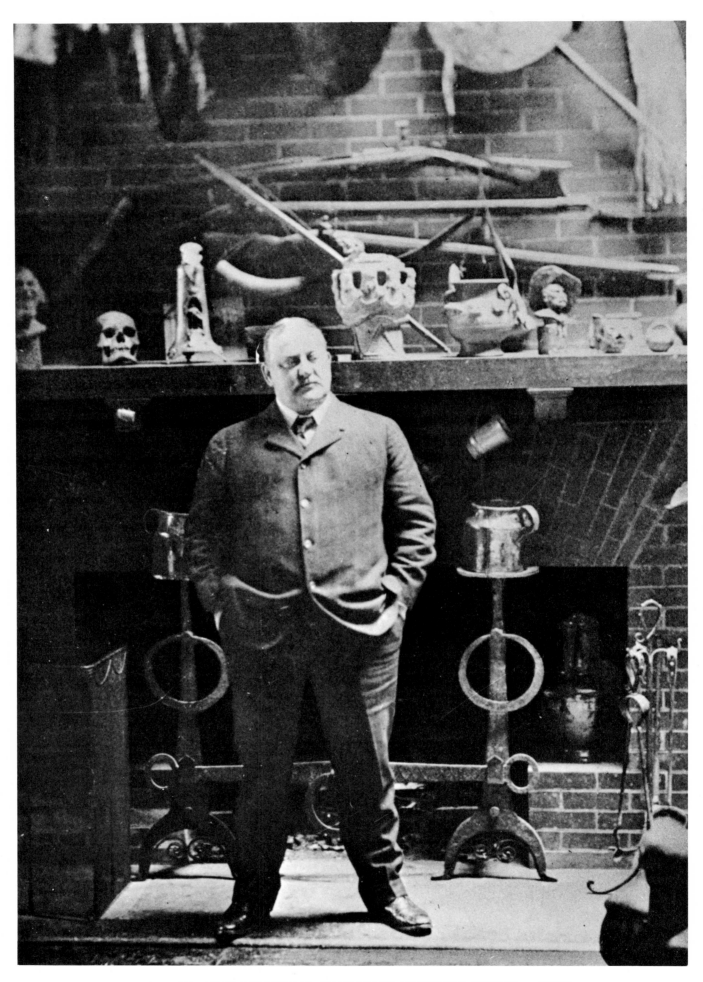

2. FREDERIC REMINGTON IN HIS NEW ROCHELLE STUDIO — 1905

The official correspondent.

CHAPTER I

Frederic Remington— Pictorial Historian

FROM the days when the earliest Spanish explorers rode the first horses northward from Mexico, through the days of the immigrant covered wagons, until the last defiant Indian war whoop was permanently silenced, the sprawling land stretching westward from the Mississippi River has provided the backdrop for one of the most dramatic, colorful and prolonged episodes in the history of the human race. Its three and a half centuries of wilderness strife involved the adventurous sons of Spain, France, England, and most of the other European countries, as well as the ambitious growing pains of the fledgling United States. Diversified and heterogeneous as it was, it is all a part of our historical heritage.

No historical glossary is so rich with connotations of rugged individualism and virile courage. On such clear-cut and purely indigenous prototypes as the Spanish conquistador, the French *coureur du bois,* and the American frontier scout, mountain man, fur trader, squaw man, cowboy, wagon boss, and all the others. Mix it all together and we call it the "Old West."

As the story slips further into the limbo of the past, it becomes increasingly important that we should have and preserve as faithful a comprehension as possible of that whole historical heritage.

Probably more has been written about it than any other epoch in history; and yet much will always remain clouded and indistinct, limited to the impersonal records of dates and events. There is much of importance of which we have no records at all. The whole story has been badly misinterpreted by fiction writers and movie makers.

In our search for a clear and faithful conception of the Old West and those who made it a part of our history, there is no more comprehensive or more satisfying source than the assembled pictorial record that was made by Frederic Remington. His whole life as a documentary artist was dedicated to the singular thesis of being the pictorial historian of our Old West. His horizon was broad both historically and geographically. Most of what he recorded was from firsthand intimate association, at a time when the Western frontier was in its most exciting full bloom. What was added from retrospect was done from careful research and from the benefit of a feeling born in the places and among the people where recollections were still fresh. Remington's artistic credo was truthful realism and the "little people" who are always the human grist for the mill of history, rather than the organized campaigns, spectacular events, and big names that are the meat of most historians.

Theodore Roosevelt, when President of the United States, in a letter to the editor

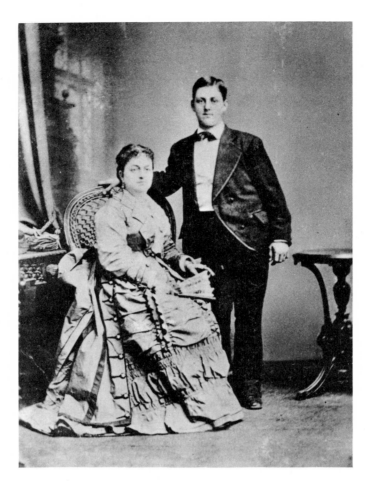

4. FRED AND HIS MOTHER

of *Pearson's Magazine* under the date of July 17, 1907, gave his evaluation of Frederic
Remington's work: "He has portrayed a most characteristic and yet vanishing type of
American life. The soldier, the cowboy and rancher, the Indian, the horses and the cattle of
the Plains, will live in his pictures and his bronzes, I verily believe, for all time." Theodore
Roosevelt knew the West from personal experience, long research, and the writing of many
volumes that had made him a recognized authority on the subject.

As early as 1895 the historical importance of Remington's work was recognized.
In *Harper's Weekly* of July 20, 1907, Julian Ralph made the following significant statement:
"The little army of rough riders of the Plains . . . the half-breeds, the dare-devil scouts, the
be-feathered red man, and all the rest of the Remingtoniana must be collected some day to
feast the eye, as Parkman and Roosevelt and Wister satisfy the mind." Although a long time
has since passed, it is the purpose of this book to bring together an assemblage of Frederic
Remington's pictures that best represent this documentarian's pictorial record of our Old West.

Frederic Remington was well qualified for his chosen career. His ability as an artist was
a natural and exceptional one. From early childhood, pictures of soldiers fighting Indians and
cowboys riding with stampeding cattle decorated the margins of his schoolbooks. His mother
had an ambitious desire for her only child to become a tycoon of industry. His father, who
was more intellectual than robust, had a quiet desire for the boy to follow in his own foot-
steps as a successful newspaper publisher. There was, however, an inherited spark of excite-

ment and adventure in his blood, from colonial ancestors who had fought in the French and Indian War, the Revolutionary War, and the War of 1812.

Frederic Sackrider Remington was born on October 1, 1861, in the small college town of Canton, in upstate New York, not far from the St. Lawrence River and the Canadian border. It may have been October 4, as given in the newspaper obituaries at the time of his death and subsequently copied. However, during the long period of intensive research by the present writer, using the records of the Remington Art Memorial and the family estate, the accepted birthday was October 1. It was also on the anniversary of this same day that he was married in the year 1884. According to Frederic Remington's sister-in-law, Miss Emma L. Caten, who lived with the Remingtons a considerable part of their married life and was buried alongside her sister and Fred, it was on the anniversaries of October 1 that they celebrated his birthdays.

Fred's father, Seth Pierre Remington, was a deeply dedicated patriot, as his forefathers had been. When the Civil War began, he neglected his newspaper to recruit a company for the mounted regiment that became the famous fighting Eleventh New York Cavalry. When his first-born was but two months old Seth Remington sold his Canton paper and left for the war with the regiment he had helped to organize. Clara Remington took their infant son to live in the big house of her own parents, the Henry L. Sackriders, a prominent Canton family. For four years they waited for the father's return, while he rode thru much fighting in the campaigns in Tennessee and Mississippi. At the end of the Civil War, Seth Remington came home as a lieutenant-colonel with a distinguished military record, and he repurchased his newspaper.

It was only natural that sturdy, red-faced, and sand-haired Frederic should grow up in a saddle and learn his riding lessons on the best mount to be found in the county, under the tutelage of his hard-riding veteran cavalry father. Fred developed a fine ability in handling horses and never lost his deep interest in them. When most lads his age were pedaling tricycles along the sidewalk, he was galloping across the countryside on his own horse. Large and strong for his age, young Fred excelled in every form of boyhood sports. He also had a liking for getting into fist fights and a strong distaste for the confinement of school classrooms.

There were several influences that served as straws in the wind of fate for the restless young Remington. One was the surge of popular interest in the West which followed the Civil War. The California gold rush had sparked this, and, with the war over, stories began coming back about new gold fields, wild Indians attacking immigrant wagon trains and herds of cattle moving northward from Texas. The best newspapers were following the trend of growing popular interest, and Seth Remington's was no exception. The subject was a frequent topic of conversation in his home, and these stories fired yound Fred's interest and imagination.

When Fred was eleven the family moved to the nearby and larger town of Ogdensberg, on the St. Lawrence River. He was sent to a private school, although in the fall of 1876 he was transferred to a military academy. He was overly high-

5. "MISSIE"

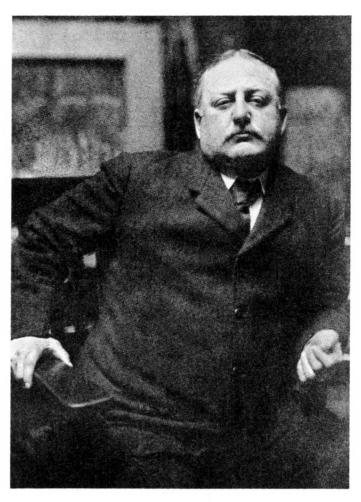

6. REMINGTON IN HIS PRIME

spirited, independent, and sometimes rebellious, and even the rigid discipline of the military academy had but little effect upon him. Drawing and sketching were from early childhood his main interest.

In the fall of 1878, when just approaching his seventeenth birthday, he was sent to Yale, enrolling in the newly established art school. But the stuffy studio classrooms and restriction to drawing pictures of plaster casts of ancient works of statuary were too far removed from his favorite portrayals of dashing horses carrying frontier troopers into action. The brief toleration only planted a long-lasting distaste for academic art. Remington did much better at football. He made the varsity team and also became Yale's heavyweight boxing champion.

In 1880 Seth Remington died, leaving his son a modest inheritance. Fred quit Yale, to his mother's great disappointment. For a time he held a clerical job on the staff of the Governor of New York, but this bored him and he quit. He still worked at his art, although there were those who said he could never amount to anything. Then, during the summer of that same fateful year of 1880 an otherwise insignificant incident happened. Quite by accident he met Eva Adele Caten, who had come up from Gloversville to spend a few days. She was prim and pretty and vivacious. Fred Remington was notorious among his friends for never having been serious about the opposite sex, but this time it was all very different.

He immediately and completely fell in love. From the first moment he began an intensive courtship. Possibly it was the first night after they met that he drew the sketch of Eva which is reproduced on page 11.

When Eva returned to Gloversville, Fred followed—to ask her father for her hand in marriage. Mr. Lawton Caten was a practical gentleman of successful business experience and had the future welfare of his attractive daughter very much in mind. He gave tolerant consideration to the future prospects of this aspiring son-in-law. Then Mr. Caten gave the sad news that he would not consent to the marriage.

Fred Remington went back to Ogdensberg with some very unpleasant thoughts haunting him. Becoming an artist, as a means of supporting a pretty and fashionable wife like Eva Caten, now seemed unattainable. He decided to abandon the whole idea. He would go West—not to become an artist, but with the avowed determination of making a quick fortune. An impetuous, reckless youth of nineteen, bitter and disappointed in his first love affair, he lost no time in breaking all home ties and hurrying away to the wild West—if only to come back and flaunt a fortune in the face of Mr. Lawton Caten.

Remington went to Montana. Probably because of the rich new gold fields being reported there, the beginning of a promising activity in the cattle industry, and the reputa-

7. MEN OF THE OLD WEST

tion of being one of the toughest parts of the West. He bought a fine Western saddle horse and took off into the hinterlands like a wild bird just learned to use its wings. This was what he had really wanted to do for a long time and he loved every bit of it: the frontier saloons with their smell of sweaty men, who held high respect for a man who could use his fists and never hesitated when the occasion was presented; the rough trails through the rough country with the big sky overhead; and one didn't have to be introduced to find a friend. Becoming a part of frontier life where it was the rawest and most characteristic of the Old West quickly became more important than finding the fortune which had brought him there.

How he got back on the path toward his ultimate career came about in another incident, which is best told by Remington himself (*Collier's,* May 18, 1905):

"Evening overtook me one night in Montanna and by good luck I made the campfire of an old wagon freighter who shared his coffee and bacon with me. I was nineteen years of age and he was a very old man . . . During his long life he had followed the receeding frontiers . . . 'And now' he said, 'there is no more West. In a few years the railroad will come along the Yellowstone . . .'

"He had his point of view and he made a new one for me . . . I saw men all ready swarming into the land. I knew the derby hat, the smoking chimneys, the cord-binders, and the thirty-day notes were upon us in a restless surge. I knew the wild riders and the vacant land were about to vanish forever . . . and the more I considered the subject, the bigger the forever loomed. Without knowing exactly how to do it, I began to try to record some facts around me, and the more I looked the more the panorama unfolded." Thus it was that Frederic Remington found the inspiration for the future, to which he devoted the rest of his life.

He could have stayed in the towns where there were comfortable hotels and a semblance

8. RED MAN'S MEAT

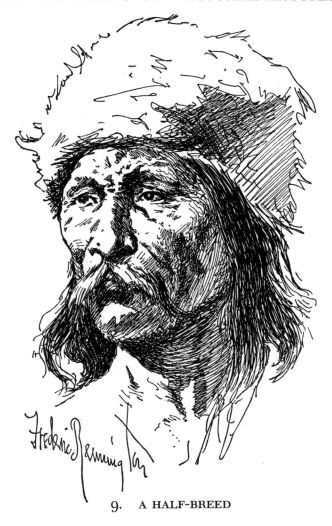

9. A HALF-BREED

of social pleasantries to enjoy. Instead, he rode the back country, where he could drink with the earthy characters in the little cow-town saloons and remote mining camps. He had brought no sketch book and there were none to be obtained, but the purpose was served by store wrapping paper and writing pads, carried in his saddle bag.

For five years Frederic Remington roamed the West, mostly on horseback. He wandered from the cattle roundup camps of northern Montana to the gold seekers' camps in the desert haunts of the Apaches in the far Southwest, and deep into old Mexico. He followed the Oregon Trail and the Santa Fe Trail, and most of the principal cattle trails. He shared the campfires of followers of Sitting Bull and Geronimo, and little columns of U. S. cavalry out to round up or kill renegade Indians who had murdered and raped immigrant wagon trains or tiny white settlements. He became the friend of such frontier personalities as "Buffalo Bill" Cody and General Nelson A. Miles. No student could have applied himself with more desire or determination to a chosen thesis; and all the while, by the hard but sure practice of trial and error, he was teaching himself to draw and paint the things he saw.

Remington began quite early to send pictures back East to the magazines, with the hope of having something accepted for publication. The first of these to succeed was reproduced in *Harper's Weekly* of February 25, 1882. It carried the title *Cow-boys of Arizona—Roused by a Scout,* with the half-disappointing credit line "Drawn by W. A. Rogers from a sketch by Frederic Remington." The sketch was undoubtedly crude, although

it had impressed the editor sufficiently to have it redrawn by a staff artist and used as a full page in the magazine. It marked the beginning of an illustrious career.

Remington kept plodding at his self-guided struggle to make realistic pictures of what he saw and to fill his mind with all he could learn about the frontier. His inheritance was diminishing, and he had an overly liberal disposition to buy drinks for those he happened to meet in every cow-town saloon he visited. He had also become an ardent collector of fine examples of Indian paraphernalia of all kinds, cowboy gear, old guns, and other things that represented the frontier West. He sent these back to Ogdensberg, for the day when his dream studio would be a reality and he could use them to make his paintings realistic and accurate.

By 1884 he had seen more of the frontier West than most men in a long lifetime, and he had begun to sell an occasional picture. A store in Kansas City became interested and made a few sales. The hundreds of sketches and more or less finished pictures had become too bulky to carry about in the manner he traveled, so he bought a little ranch near Peabody, Kansas. There he improvised a studio and settled down to serious painting. There he also played host to the friends he made among the cowboys around the Kansas City stockyards, where he spent a lot of his time. But this did not last. Selling the ranch, he moved into a small house in a residential section in the outskirts of Kansas City.

Remington had made a couple of brief trips back to see his mother in Ogdensberg. Whether or not these trips included visits to Gloversville, or just what contact there had been with the petite little lady who had been responsible for his self-imposed exile in the West, is not known. However, it is evident that Eva Caten had by no means been forgotten; and it is equally evident that the lingering romance was not a one-sided affair. For it was about this time that the announcement of their marriage was set for Fred's twenty-third birthday, October 1, 1884.

He had learned that pictures of frontiersmen, troopers, cowboys, and Indians were a discouraging means to making a living, even for a vagabond on horseback; and he fully realized that having a bride in the house would require considerably more than pictures to look at. To provide what seemed to be a reliable income, he invested most of what remained of his inheritance in a one-third interest in one of Kansas City's most popular cowboy and stockman's saloons. The business was a good one, but the partners were not. The liquor emporium moved into new and better quarters. Then Remington suddenly learned that he had been double-dealt out of his interest in the prospering saloon. Just how this was brought about is not known, although the situation proved to be an irrecoverable personal tragedy. In spite of the staggering setback, he managed to gather enough courage to return to Gloversville for the appointed ceremony in the bride's home.

Their return to Kansas City was hardly a favorable beginning. "Missie," as he called her, was a brave and devoted young wife. But Kansas City in those days was a far cry from the Victorian comforts of her father's house in Gloversville. It was all very rough, and frightening, and lonely. Frederic worked desperately, but his painting brought in very little money. He continued to send pictures back East. How many no one will ever know. The results, however, are a matter of record. A single illustration made *Harper's Weekly* of March 28, 1885. *"Ejecting an Oklahoma Boomer"* was used on the cover of the magazine, carrying the credit line "Drawn by T. deThulstrup from a sketch by Frederic Remington."

This is the way we look
yours
Fred—

10. "THIS IS THE WAY WE LOOK. FRED."

In spite of it all, Fred and Eva were very happy. She completely sympathized with his determined dedication to the goal he had set. Financially their situation went from bad to worse. His mother came to Kansas City and demanded that he give up his crazy ideas and return with her to go into some business in which a respectable living could be made. He refused and Eva stuck by him.

The more desperate their plight became, the harder he worked. But when their first anniversary was still many weeks away, the inevitable closed in upon them. With the laughter and good wishes of their wedding day still fresh in their memories, Eva was put on the train, alone, to face the difficult ordeal of returning to her father's house. But she promised to wait, again.

Remington disposed of everything that was disposable. He bought a new saddle horse and set out to ride to Arizona, where there was a new gold strike. Maybe he could still find that illusive fortune. Joining two prospectors, he made a brief try in the Pinal Range, but he decided that he didn't like searching for gold in desert mountains. Then once again he turned to the role of a wandering vagabond artist on horseback. Riding northward across Arizona, New Mexico, northern Texas, and up into Indian territory, he made more sketches as he traveled. At the end of the summer he returned to Kansas City.

He had decided to go to New York and make a strenuous and possibly final attempt to break through the seemingly impregnable wall to artistic success. According to his own story, Frederic Remington arrived in New York City with a total of three dollars. He also had what was undoubtedly the largest assortment of drawings, sketches, and paintings of the frontier West, plus the most comprehensive and intimate knowledge of the subject, that any young artist ever took to the market.

The ever-faithful Eva came down from Gloversville to join him and they went to live with some friends in Brooklyn. He borrowed a little money from an uncle and started out to peddle his pictures, with uncompromising determination.

The story of Frederic Remington's rapid rise to success is one of the classics in the history of artists. Within four months he made the cover of *Harper's Weekly* with a full page and full credit to himself. That was on January 9, 1886. Before the end of the year his pictures were spread through ten issues of that popular national publication, and there was the beginning of a long and profuse series in *Outing Magazine*. In 1887 he had one of his paintings hung in the annual exhibition of the American Water Color Society and another in the annual exhibition of the National Academy. The following year another of his paintings won both the Hallgarten and the Clark prizes of the annual exhibition of the National Academy, and he also had 187 of his pictures in four of the best magazines of the day. From this time on he was rewarded with a success that continued to gather momentum and proportions.

Having won the highest awards attainable in American art circles, within less than four years since coming to New York, lifted Remington into substantial success. In March 1890 they purchased a large gabled mansion in fashionable New Rochelle. There he and Missie were to spend nineteen happy and prosperous years. Fred's spacious dream studio was a veritable museum of Indian, cowboy, and frontier materials, and Missie was a gracious hostess of the mansion, for social parties and the entertainment of noted guests.

In 1895 Remington made his first attempt at sculpture, which resulted in the famous *Bronco Buster*. He also became almost as successful as a writer of fact and fiction as he was an artist. His novel *John Ermine of the Yellowstone* was produced as a play on Broadway. But factual pictures of the Old West were always the main purpose of his life and in this he became eminently successful, both artistically and financially.

Unfortunately, death made an untimely visit to Frederic Remington. A sudden attack of appendicitis and an emergency operation resulted in an abrupt ending of his career, on December 26, 1909, shortly after his forty-eighth birthday. He was just attaining his ultimate goal, of combining fine art with the pictorial documentation of the Old West.

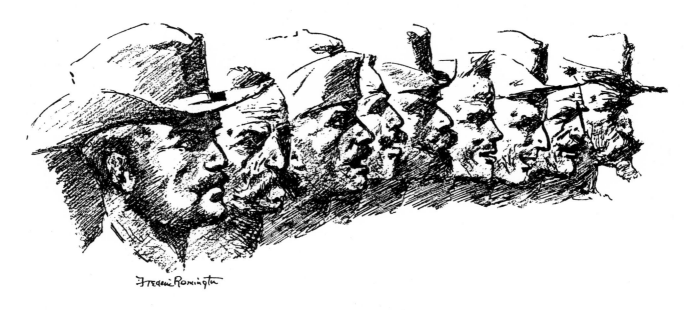

11. SOME FRONTIER TROOPERS

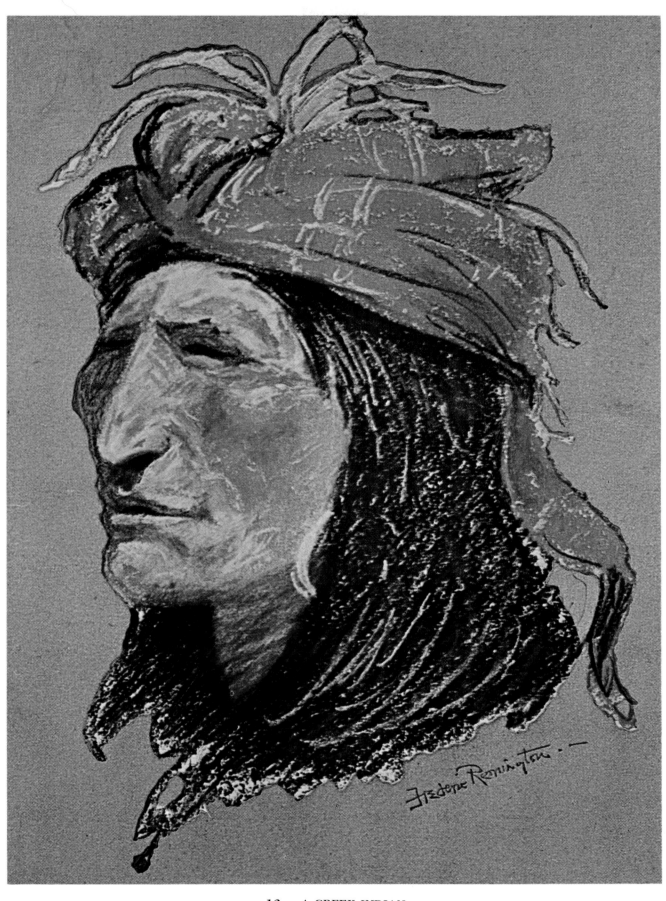

12. A CREEK INDIAN

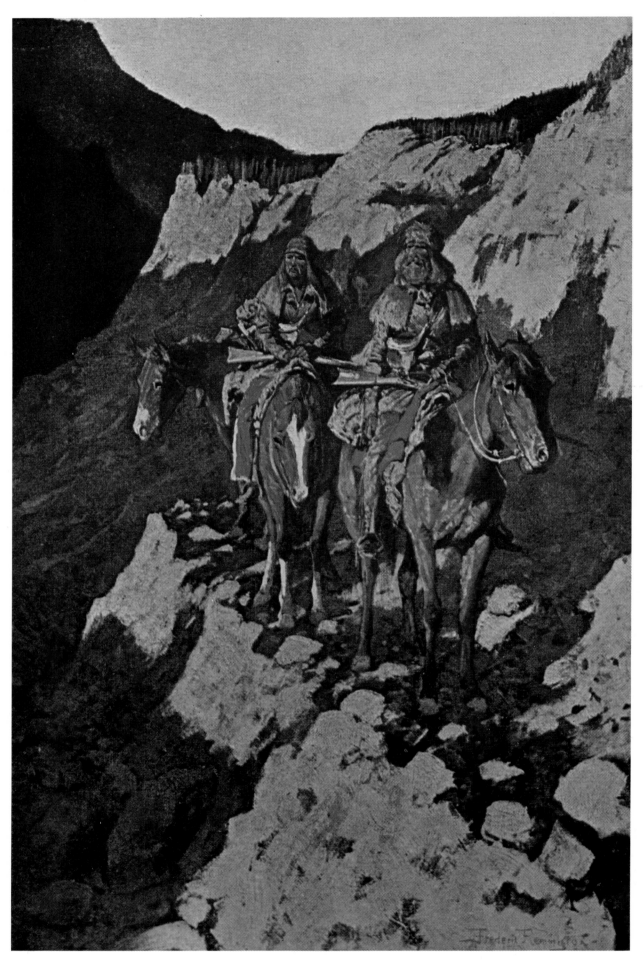

13. THE UNKNOWN EXPLORERS

CHAPTER II

Explorers of the West

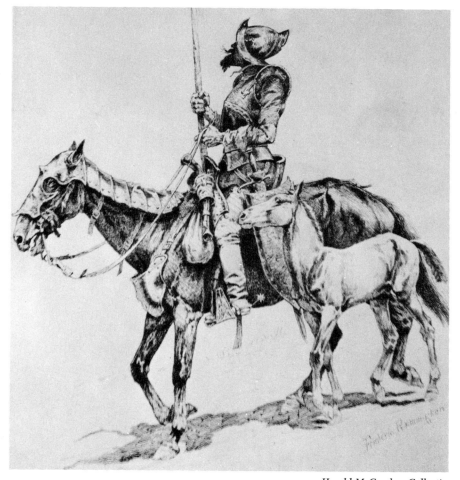

Harold McCracken Collection

14. FIRST OF HIS RACE

THE earliest of our European ancestors to explore the American West were the Spanish *conquistadors*—a century before the *Mayflower* landed the Pilgrims at Plymouth. It was also the Spanish who brought the first horses, cattle, and cowboys across the Atlantic to the New World in their big galleons. The early Spanish expeditions that pushed northward from Mexico into the vast unknown were manned by adventurers, garbed in medieval armor, who rode the first horses ever seen on the Great Plains. Some of these animals were lost and others were captured by the Indians, who promptly adopted them for their own uses. Frederic Remington was one of the first to recognize the tremendous advantage which the introduction of the horse became to the life and culture of the Plains Indians.

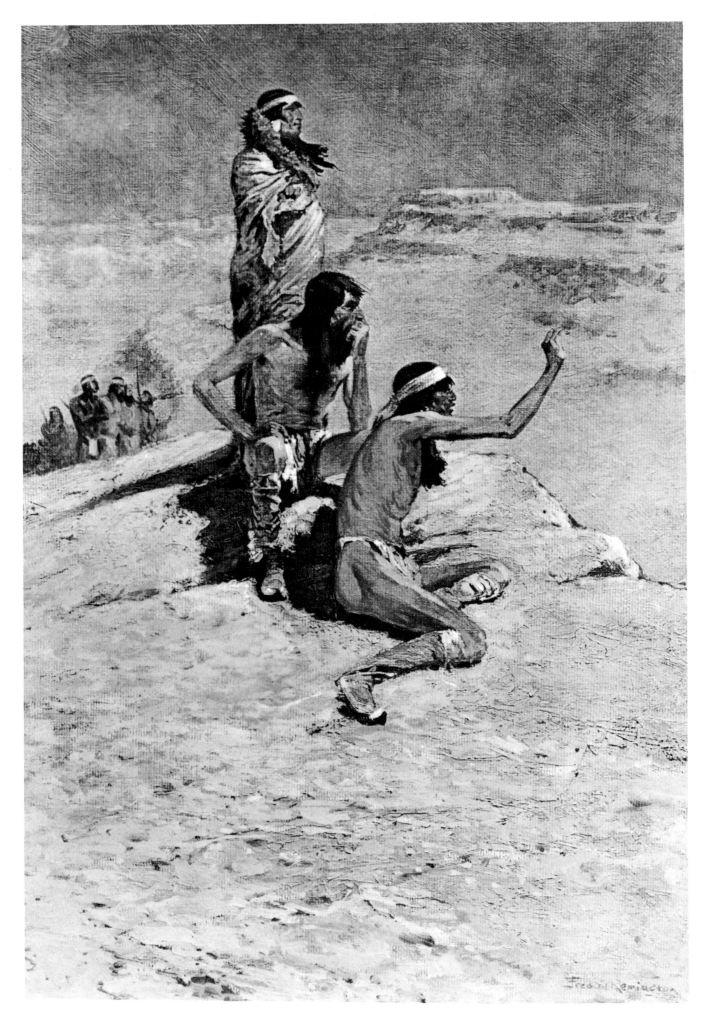

15. CABEZA DE VACA

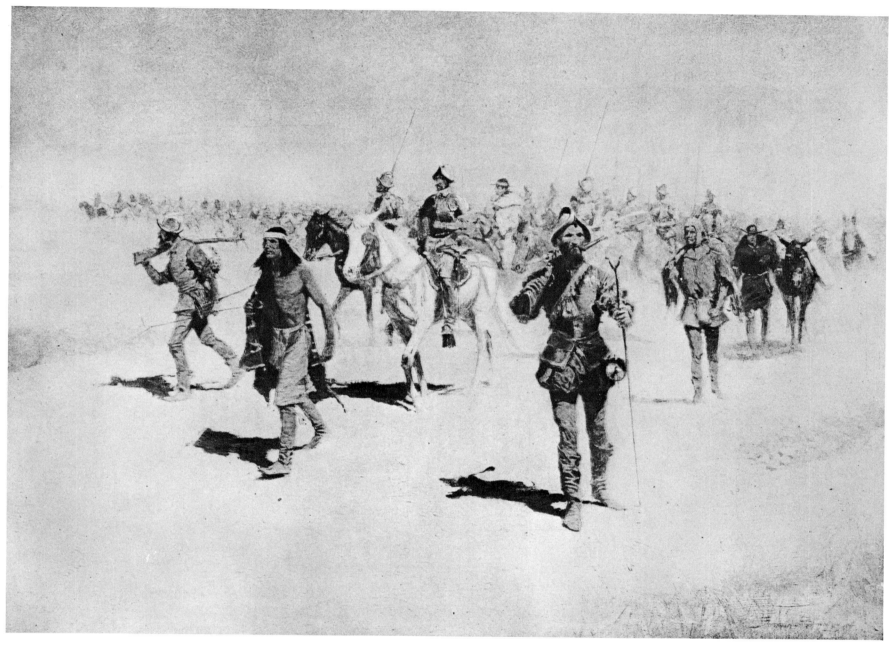

16. THE EXPEDITION OF FRANCISCO CORONADO

Cabeza de Vaca and three companions were the first Europeans to see the Great Plains, herds of buffalo, and Indians of our Southwest. Survivors of a shipwreck near the mouth of the Mississippi River, they spent eight torturous years walking westward across the continent, reaching Mexico City on July 24, 1536.

In contrast, four years later the expedition of Francisco Coronado moved northward from Mexico. The leader, arrayed in gilded armor and plumed helmet, rode proudly on a fine horse at the head of a thousand armored horsemen, carrying two-handed swords and followed by a thousand servants leading spare horses and driving loaded pack animals. They explored and conquered as they went, as far northward as present Colorado and Kansas.

These two expeditions mark the beginning of our history of the Old West.

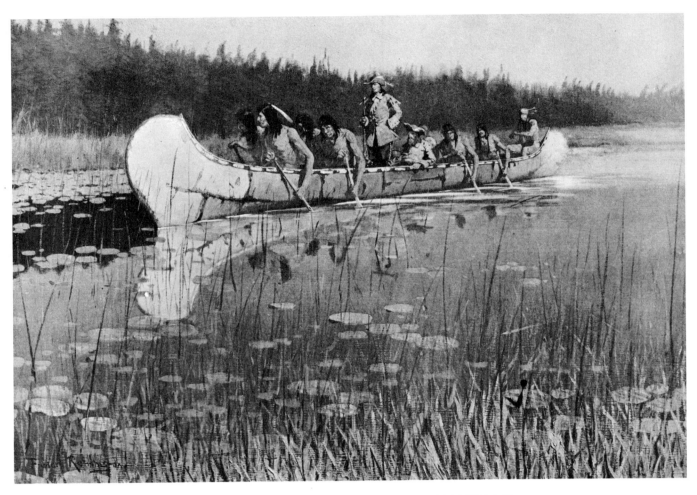

17. PIERRE RADISSON AND MEDARD GROSEILLIER

IT WAS the French who first caught the golden vision of the fur trade in the interior of
North America. In the castles and courts of France and elsewhere in Europe there was a
great demand for fine furs, although to the American Indians the soft pelts of the beaver
and fox were little more than common materials for clothing, generally discarded in favor of
the flesh for food. Spurred by the extraordinary profits from this trade, and the expanding
of empire to protect this source of riches, the adventurous French began pushing westward
from their colonial foothold along the St. Lawrence, and it was they who became the first
European explorers and fur traders in the northern wilderness.

Pierre Radisson and Médard Grosilliers were the first Frenchmen of note to penetrate
the American West. They spent the winter of 1658–59 trading on Lake Michigan and in the
spring went on to the upper Mississippi River. Then they pushed on westward to penetrate
well into the unknown region of the upper Missouri. Thus the French expansion and the fur
trade in the West began.

As Frederic Remington was born and raised in the St. Lawrence country, he had from
early childhood been exposed to the lore of the rough and romantic pioneer French-Canadians,
who were his neighbors and in some instances close family relations. It is only natural that
he should have a more than ordinary interest in delineating this phase of the early develop-
ment of the West.

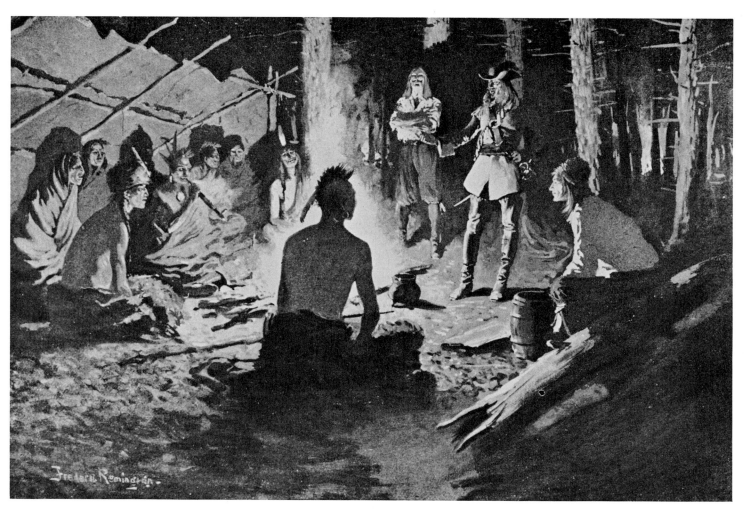

18. AT THE IROQUOIS COUNCIL FIRE

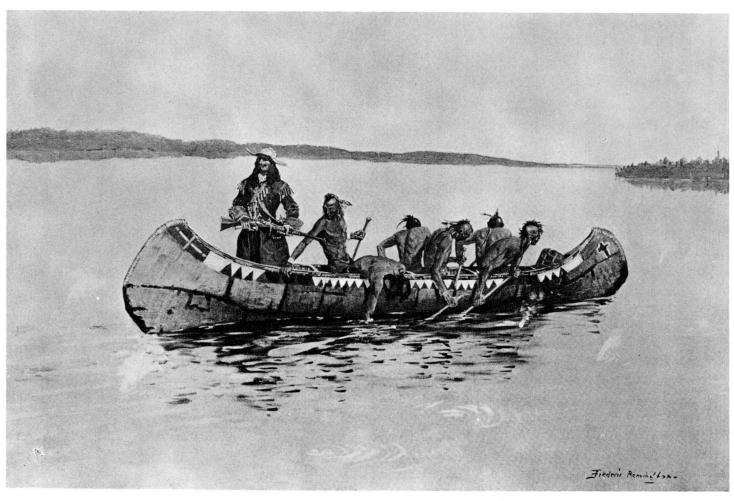

19. THIS WAS A FATAL EMBARKATION

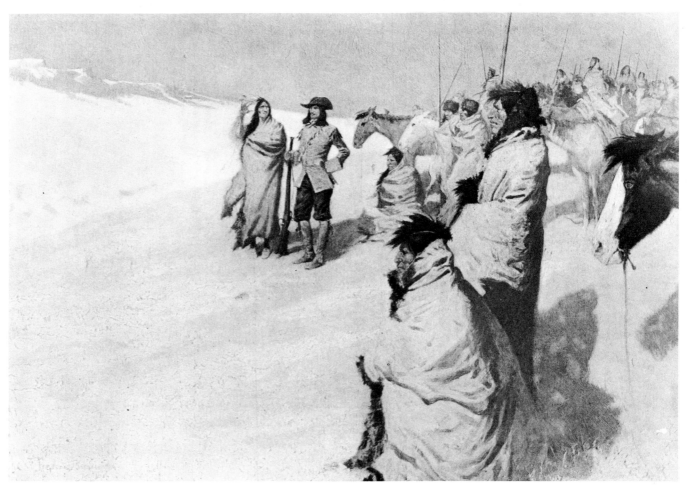

20. SIEUR DE LA VÉRENDRYE

S IEUR DE LA VÉRENDRYE was a colorful fur trader and soldier of fortune. In the spring of
 1731 he set out from the settlement on the St. Lawrence where Montreal stands today,
on a bold and ambitious undertaking. The French had explored and taken control of the
Mississippi valley and were looking ever westward to the conquest of the vast region that
lay beyond the farthest outposts of which they had any knowledge. La Vérendrye determined
to spearhead that program. He had with him his three young sons and fifty capable adven-
turers. His objectives were threefold: he would undertake to find a way to the "Western
Sea," the geographical myth which had plagued the minds of civilized men of the period
and which was believed to be a narrow strait separating America from the riches of Asia;
he would enjoy the personal glory and favor of his Bourbon King Louis XV by spreading the
French Empire across the whole breadth of North America; and he would establish a chain
of forts and fur trading posts as far as the land extended and of which he would become the
personal ruler.

La Vérendrye explored the American West over a wider area than anyone before him,
and established trading relations with the Indians that extended within sight of the Rocky
Mountains. But he lost his youngest son early in the venture, failed to find a way to the Western
Sea, and came to an unhappy end as a ruined man.

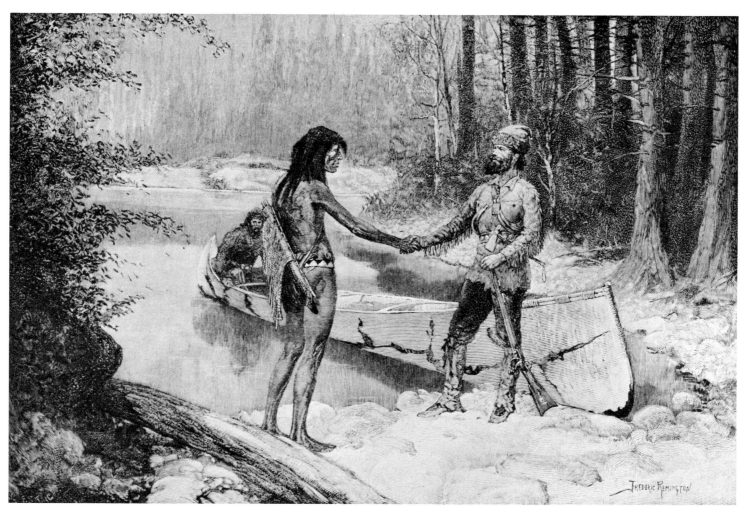

21. THE COUREUR DU BOIS AND THE SAVAGE

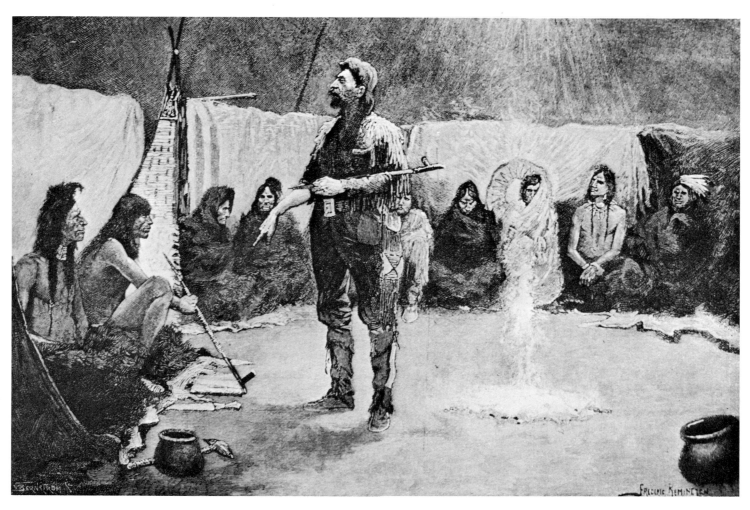

22. A FUR TRADER IN THE COUNCIL LODGE

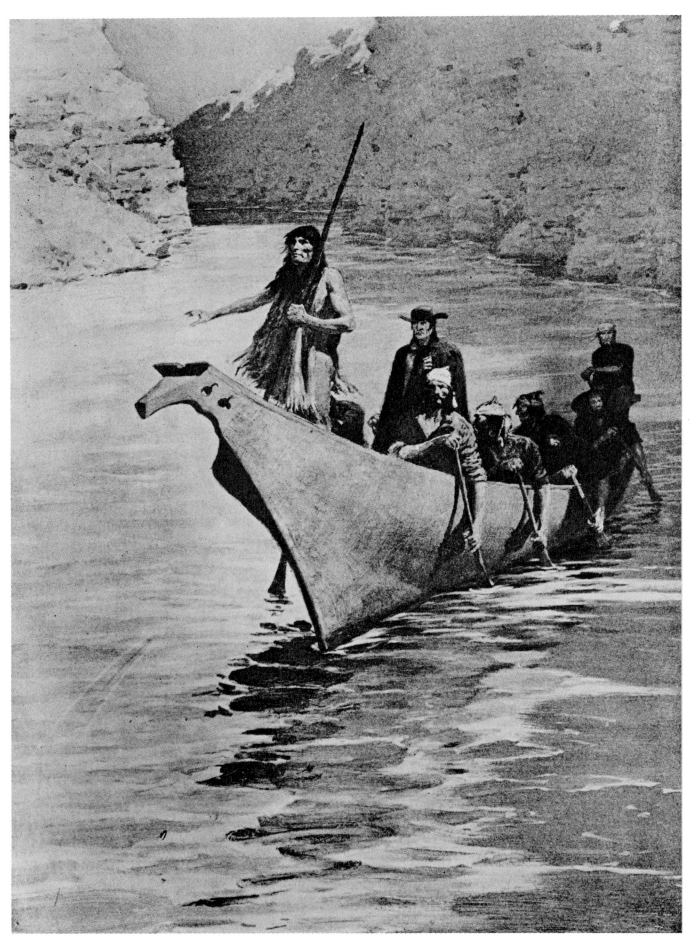

23. ALEXANDER MACKENZIE

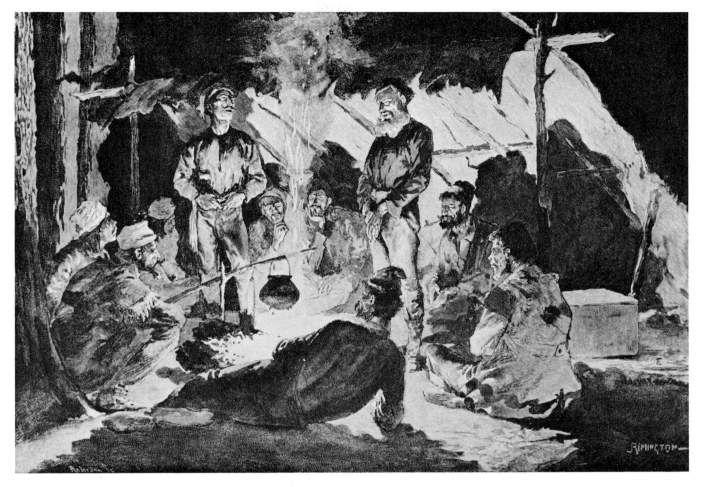

24. VOYAGERS IN CAMP FOR THE NIGHT

THE British made a challenge for an important role in the fur trade in 1670. It was then that King Charles II granted a chapter to the "Company of Adventurers of England Trading in Hudson's Bay." Thus began the Hudson's Bay Company, which eventually dominated the trade. Shortly after establishing a beachhead on the shore of Hudson's Bay, however, the French met the challenge with a march through the wilderness to wipe out their rivals; and thus began a bitter and bloody struggle that continued through a century and a half, even after New France was politically ceded to Great Britain in 1763.

The riches from the fur trade brought into competition several powerful rival organizations, both French and English, all fighting bitterly for broad and local monopoly. There was no need for exploration beyond the established trading posts. Among the few who did push on into the unknown was the pugnacious Scotsman Alexander Mackenzie, who made two important contributions to the exploration of the West. He ruled Fort Chippewyan, the remotest outpost of the Northwest Fur Company, on the subarctic shore of Lake Athabaska. In 1789 Mackenzie made his first historic journey to discovery, to the source of a new river and traveled down its entire length to the Arctic Ocean. Today that great river bears his name. Then in 1792–93 Mackenzie became the first white man in history to cross the northern Rocky Mountains and establish the fact that the fabled Western Sea was the Pacific Ocean.

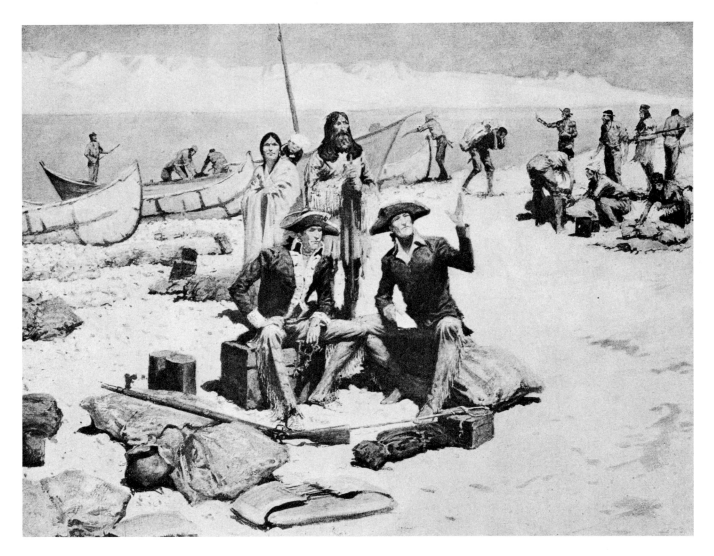

25. LEWIS AND CLARK

THE Lewis and Clark Expedition, of 1804–06, and the Zebulon Pike Expedition, of 1807, were the first parties sent out by the United States to explore the West. These followed the Louisiana Purchase of 1803, when our government was anxious to find out more about the vast area of little known territory we had purchased from France, as well as what lay beyond. The British were pushing down from Western Canada, the Spanish were well established in the Southwest and California, and the West was still the Great Unknown except to the few adventurous fur traders who wanted it kept that way. The Lewis and Clark Expedition marked the beginning of a systematic exploration and conquest of the whole West by the United States; and what was written about that journey up the Missouri and across the Rockies to the Pacific excited the popular imagination for the western movement to extend the boundaries of our nation across the continent.

Zebulon Pike closely followed Lewis and Clark. He was sent to explore our new boundary with Mexico and report on the strength of the Spanish. After discovering the Colorado mountain peak that bears his name, he traveled southward to Santa Fe, where he was captured and held prisoner for a considerable time, but he brought back the desired information.

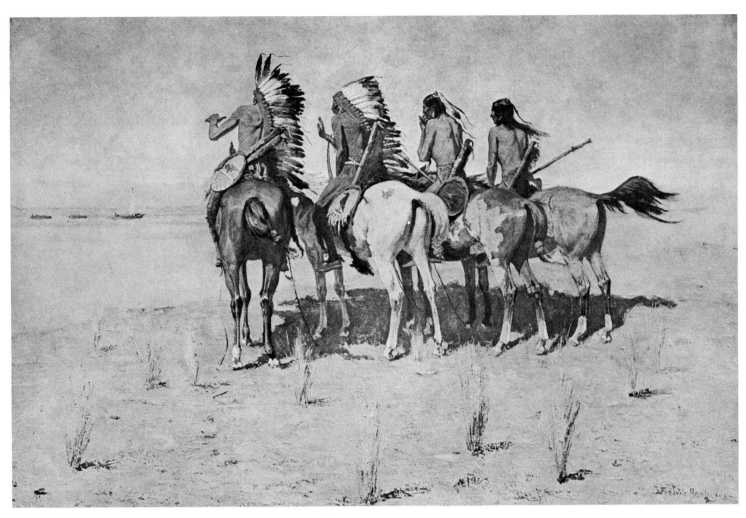

26. THE PIONEERS

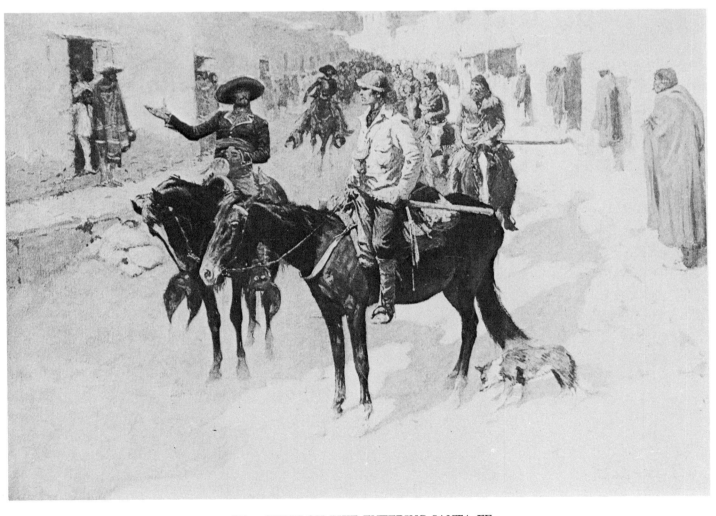

27. ZEBULON PIKE ENTERING SANTA FE

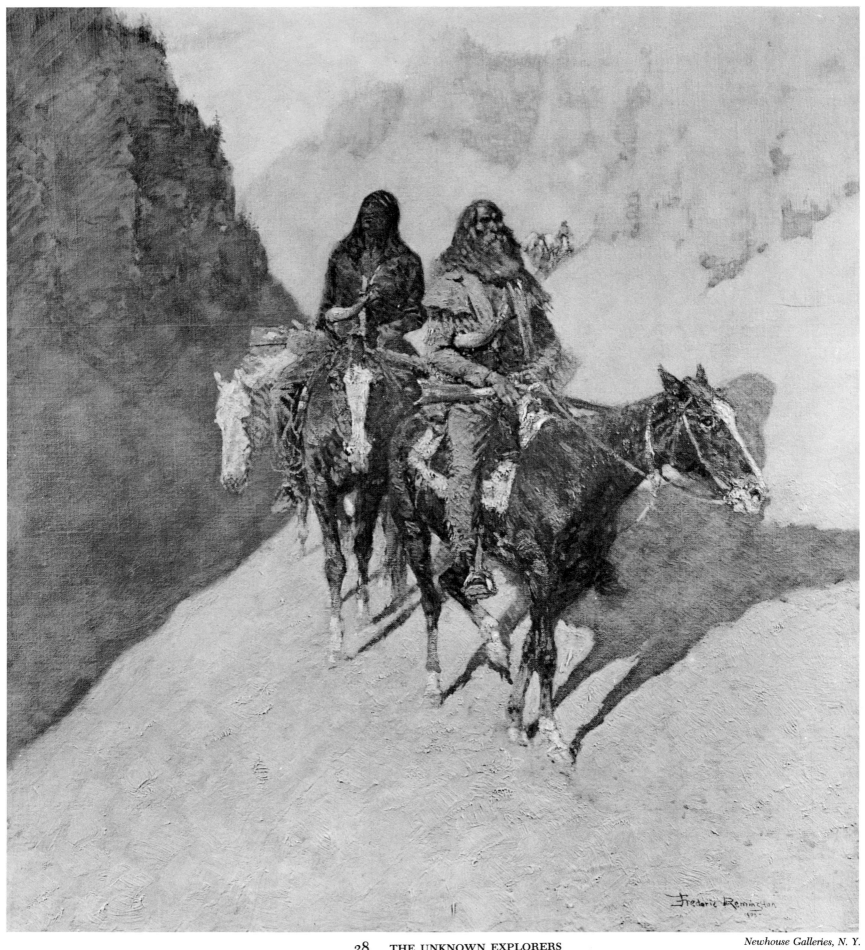

28. THE UNKNOWN EXPLORERS *Newhouse Galleries, N. Y.*

29. "I TOOK YE FER AN INJUN."

FREDERIC REMINGTON made a series of paintings portraying the important early Spanish, French, British, and United States explorers of the West. There were ten of these and they appeared as color reproductions in *Collier's Weekly* from October 1905 to August 1906. The series was known as "The Great Explorers" and the subjects were: De Vaca (page 22 of this book), De Soto, Coronado (page 23), Radisson (page 24), La Salle, La Vérendrye (page 26), Mackenzie (page 28), Lewis and Clark (page 30), Zebulon Pike (page 31), and Jedediah Smith (page 34). To these the artist appropriately added one titled *The Unknown Explorers* (color plate page 20; also see page 32).

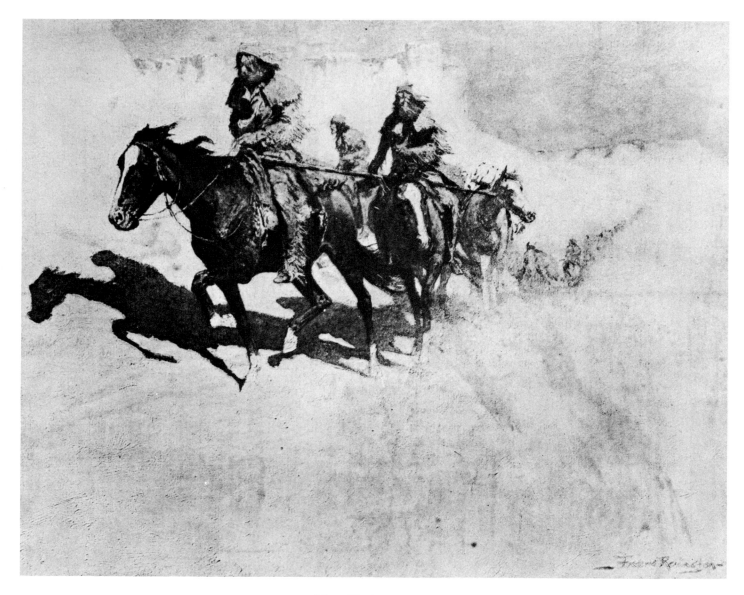

30. JEDEDIAH SMITH

31. AN OLD TIME MOUNTAIN MAN

32. JIM BRIDGER

On a back page in Remington's personal diary for the year 1908 are listed twenty-seven of his important paintings, with the startling heading "Paintings which I burned up." Included in this list is the notation: "The whole explorer series except La Vérendrye"; and another line reads: "The Unknown Explorers—Redone 1908." The last-mentioned painting is shown as a color plate on page 20 of this book and the redone version is shown on page 32. Fortunately, nearly all of these paintings were reproduced and thus preserved for posterity before the artist destroyed them. They were all fine works of art which today would be highly desirable to any private or museum collection.

It is difficult to understand the motivation of such destruction, although other fine artists are known to have done the same thing. A probable explanation is that the most dedicated artists are continually striving to improve their work and have a feeling that what has been done in the past is inferior. Frederic Remington harbored this feeling to an extraordinary degree. The above incident is not the only time that Remington destroyed pictures he had previously made. At another time, according to a close relative: "On one cold winter afternoon, Fred walked around the studio carefully selecting an armload of his pictures that had been there for quite some time, then carried them outside and one by one stamped a foot through them, and burned them up on the snow."

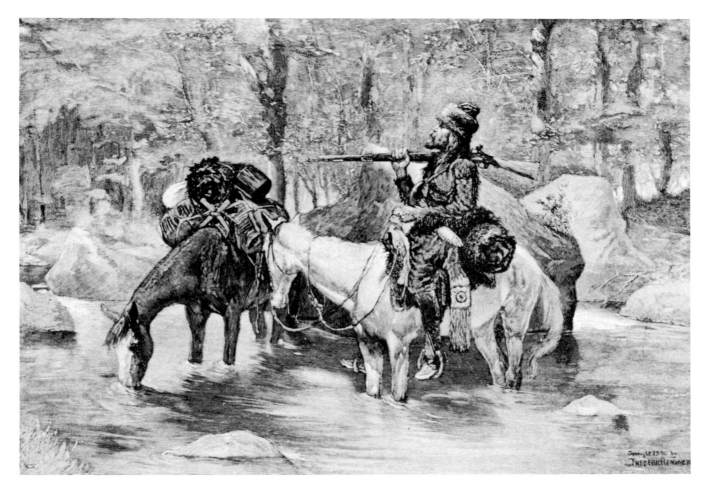

33. A WHITE TRAPPER

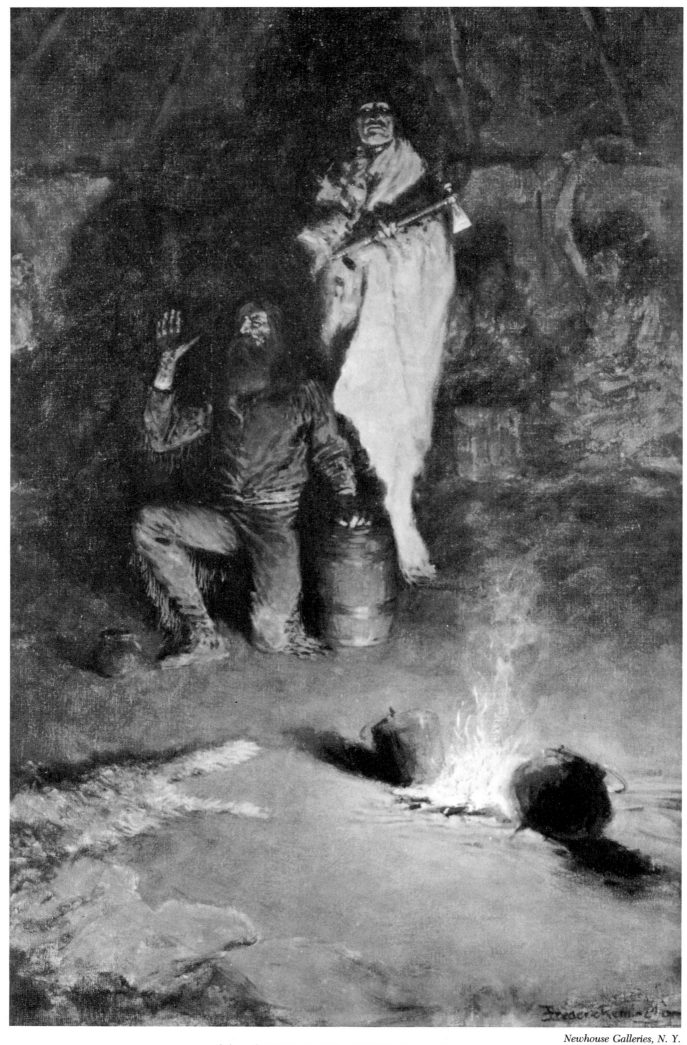

Newhouse Galleries, N. Y.

34. GUARD OF THE WHISKEY TRADER

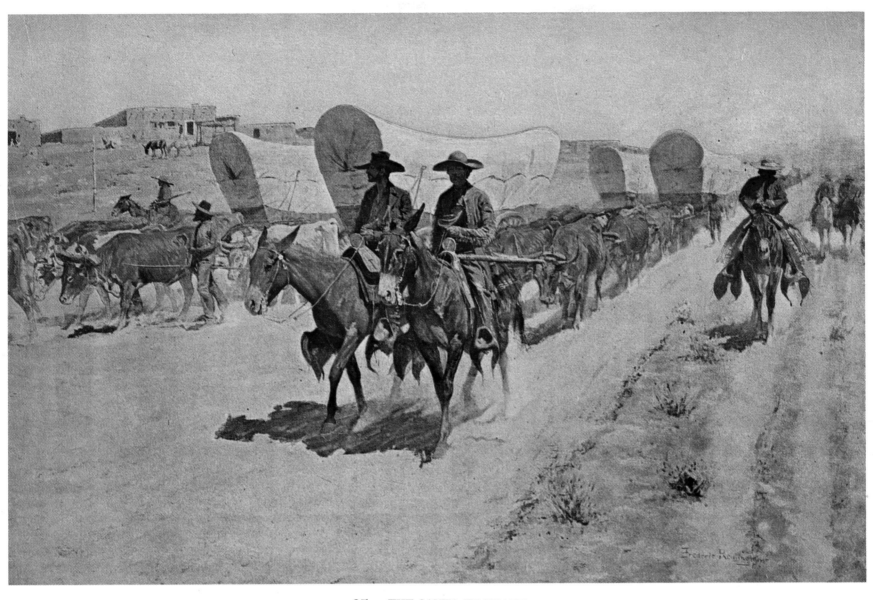

35. THE SANTA FE TRADE

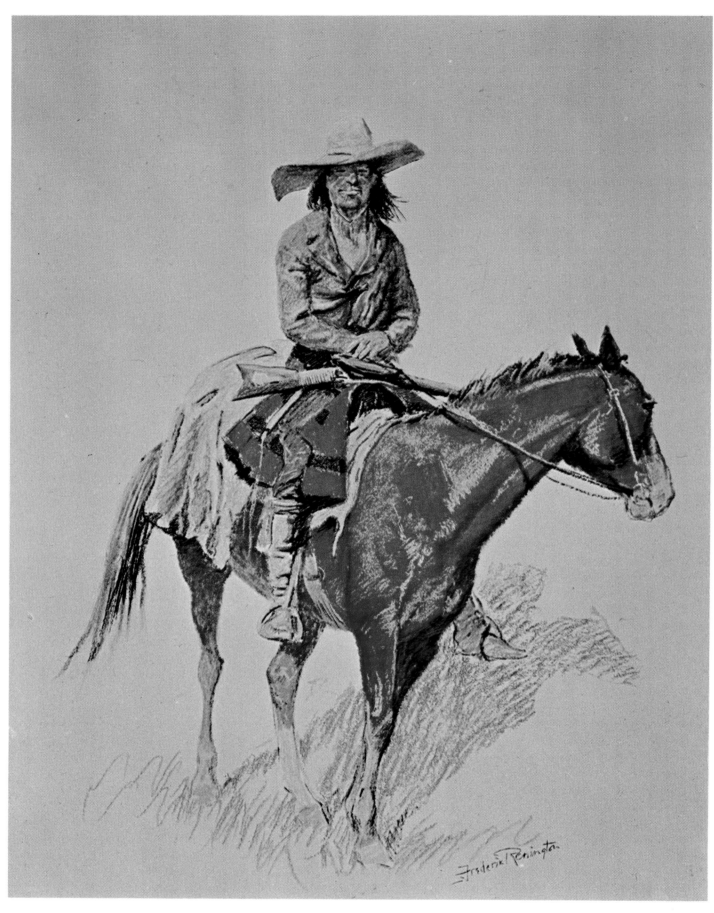

36. OLD RAMON

CHAPTER III

The Trail Finders

Those who followed the early explorers faced the same difficulties of hardship and survival. The dangers were many and the demands for stamina and courage were great. These men were to Frederic Remington "men with the bark on" and he portrayed them in historical realism. To the eminent art critic Royal Cortissoz his pictures were characterized as "hard as nails." They are storytelling vignettes of the Old West, simple, but clearly told, each as comprehensible as a thousand words.

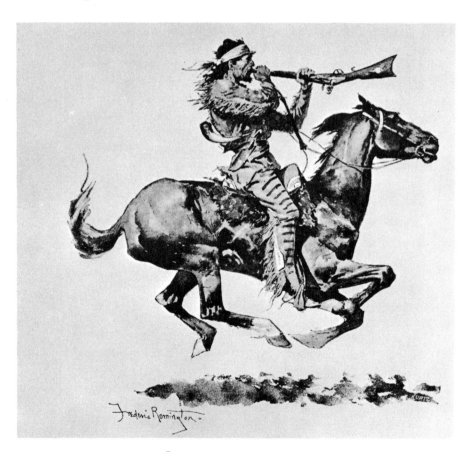

38. A BUFFALO HUNTER

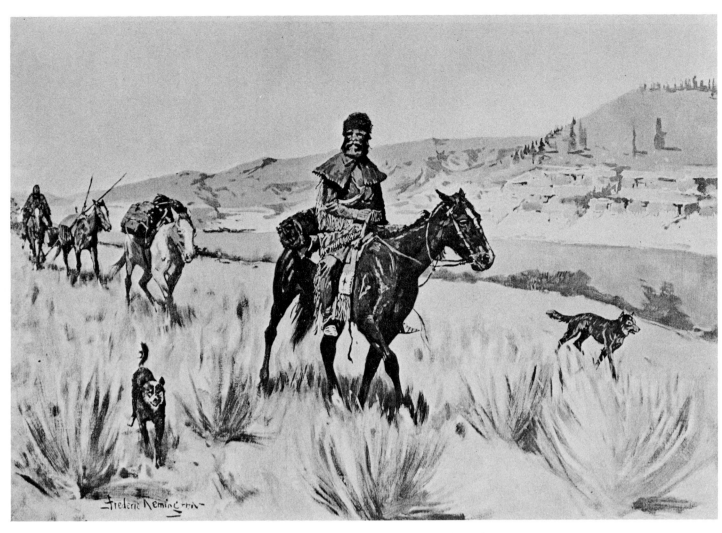

39. HUNTING A BEAVER STREAM — 1840

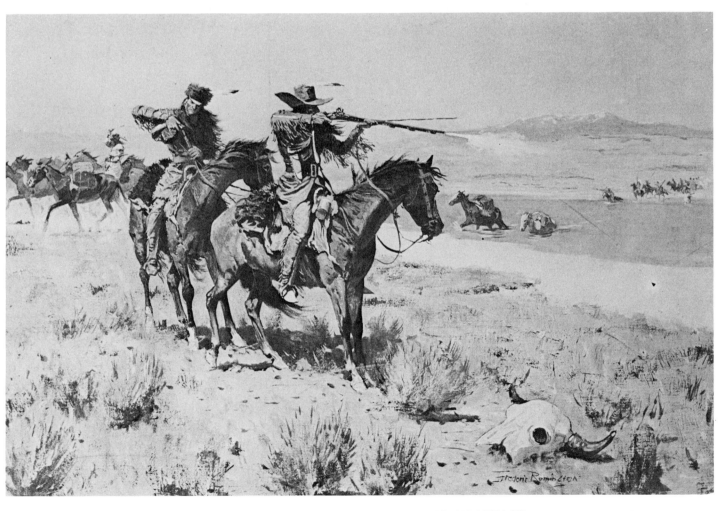

40. THE PACK HORSE MEN REPELLING AN ATTACK

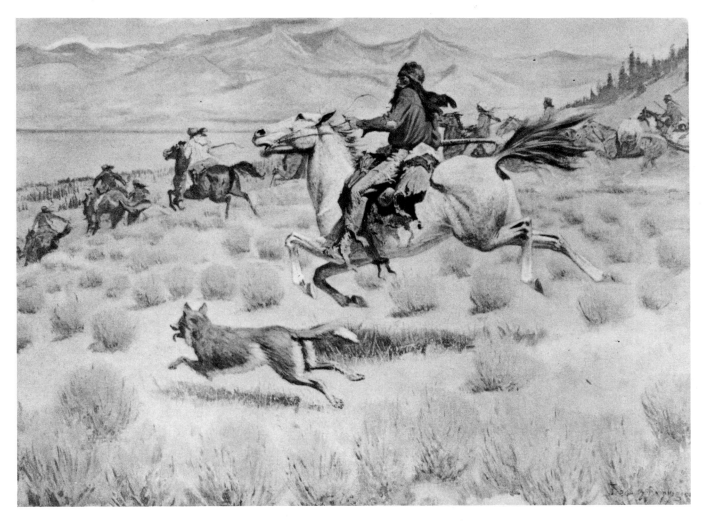

41. GATHERING OF THE TRAPPERS

L IFE for the frontier white trapper was rough and hazardous. They traveled in groups for defense and to locate places where beaver were abundant. The groups would divide in twos or singly to do the winter trapping. The beaver were not difficult to catch and often the harvest was a rich one. But it was usually in Indian country, where these white men were considered trespassers by the tribesmen, who sought out the solitary men to kill them in their lonely pursuit. The best trapping regions were along the mountain streams and lakes of the high northern Rockies. Nowhere were the rigors of life and existence more demanding. Dangerous trails, deep snows, blizzards, subzero weather, and the constant threat of hostile Indians. Those who survived were the most colorful of all the prototypes of the Old West—who came to be known as the "mountain men."

When the long winter was ended, the trappers would gather and ride down to a trading post or to some appointed pleasant valley for a rendezvous with itinerant traders who would come to bargain for their furs. The traders would bring supplies as well as money. There was always plenty of cheap whiskey, which was a staple medium of exchange for both white men and Indians. There were also cards for gambling and attractive Indian girls to add to the wilderness festivities.

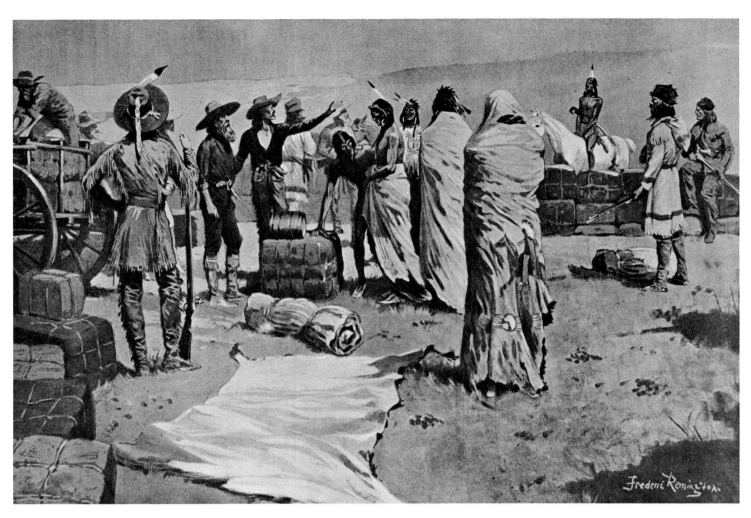

42. TRADING ON THE TRAIL

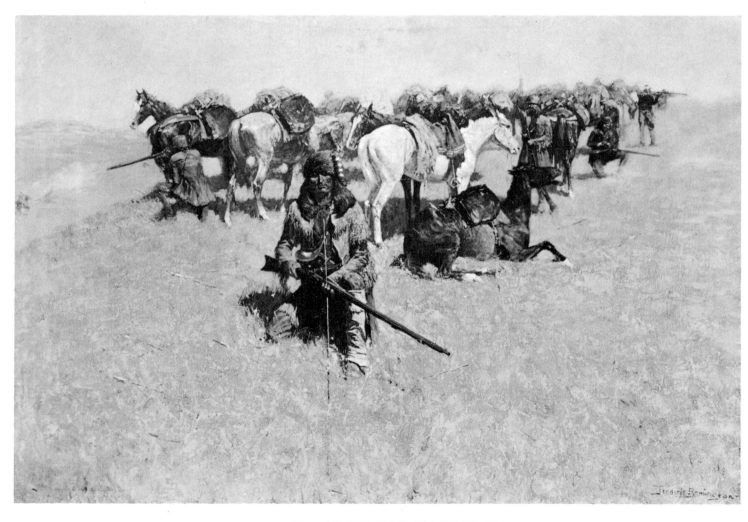

43. AN OLD TIME PLAINS FIGHT

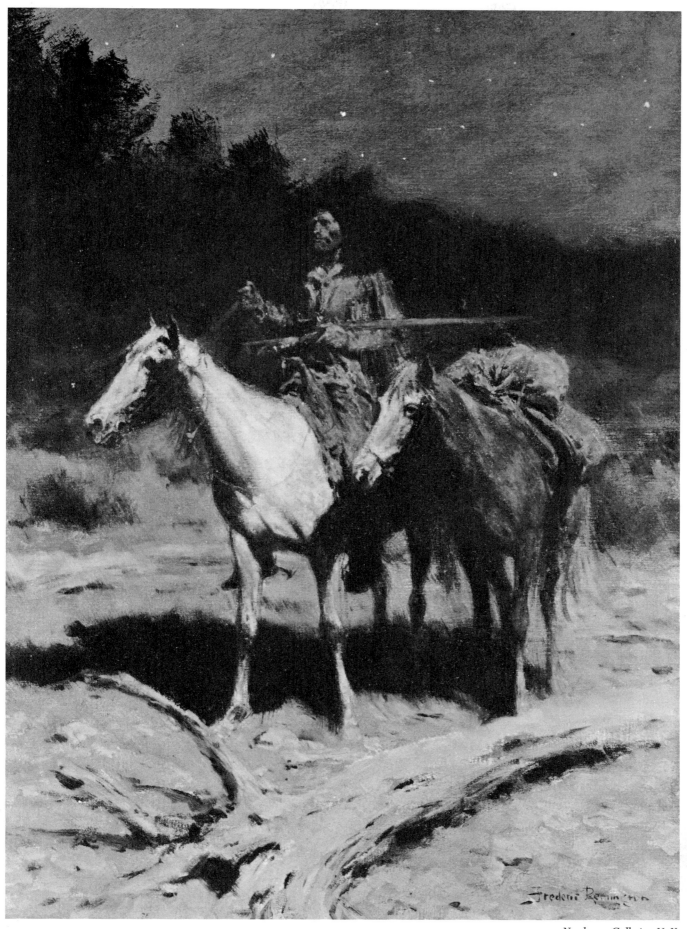

44. DANGEROUS COUNTRY

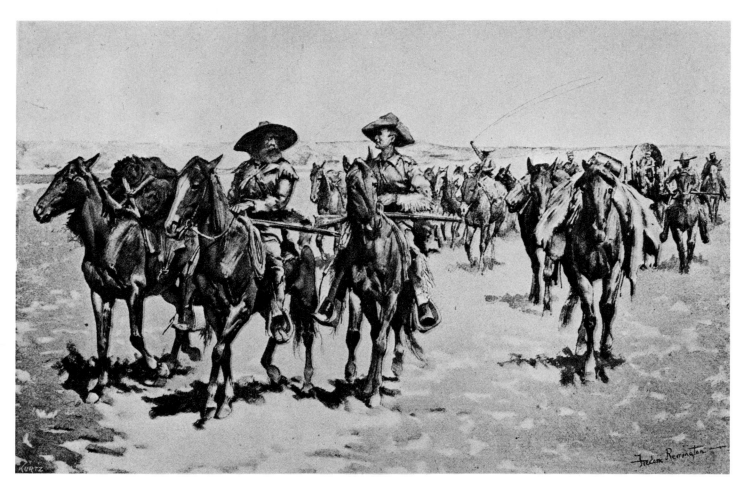

45. ON THE OREGON TRAIL

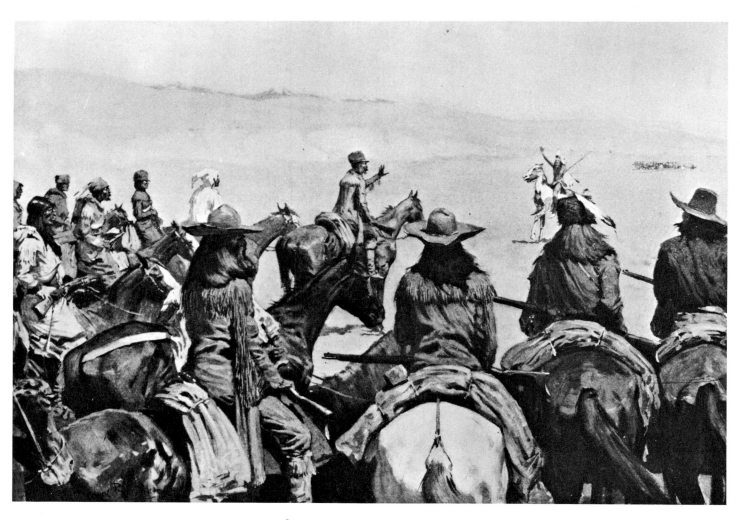

46. ONE CHIEF CAME FORWARD

As the fur companies multiplied and expanded, the influx of adventurous pioneers increased. Wagon trains began moving westward over the Santa Fe Trail and the Oregon Trail. Fortified supply stations were built and these added blacksmith and wagon-repair shops, general stores, and other necessary facilities for the pioneer travelers who became the vanguard of the western movement.

The Indians began looking upon the white intruders with increasing disfavor. Many of the nomadic tribesmen led a dual life. Desirous of acquiring the things the white man had to trade, the red men came peacefully to the big trading posts or the caravans that were too well armed to challenge, but they lost no opportunity to attack, kill, and loot where the situation was in their favor.

The Spanish had penetrated deep into the West from their empire in Mexico, and then retired to a languid conquistadorial siesta in the sunny Southwest; and the French had sold out their New World conquest and drifted down the Mississippi River to enjoy the fruits of their fur trade loot in the delta riviera; but the young and ambitious United States went into the West with a solid determination to make it a part of their new nation, with growing settlements, industries, and homes, instead of a wilderness.

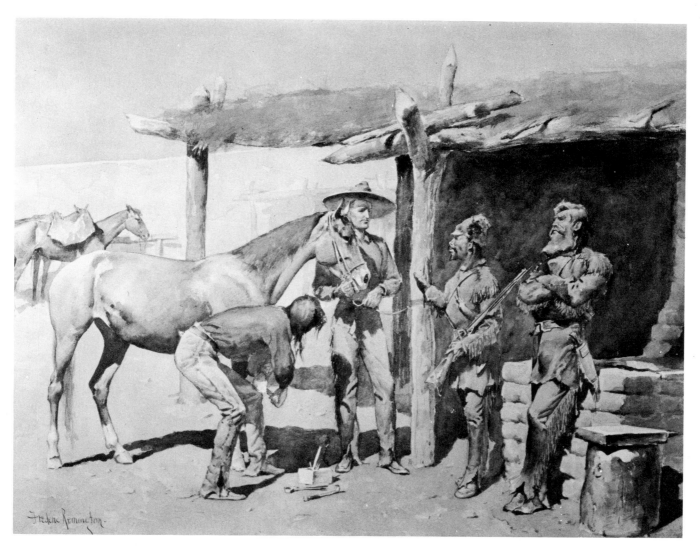

47. HORSE SHOEING AT FORT LARAMIE

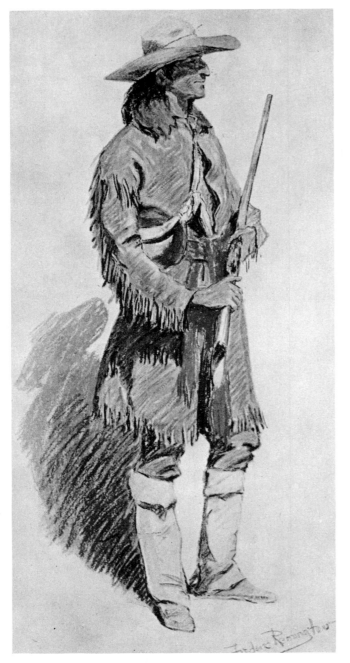

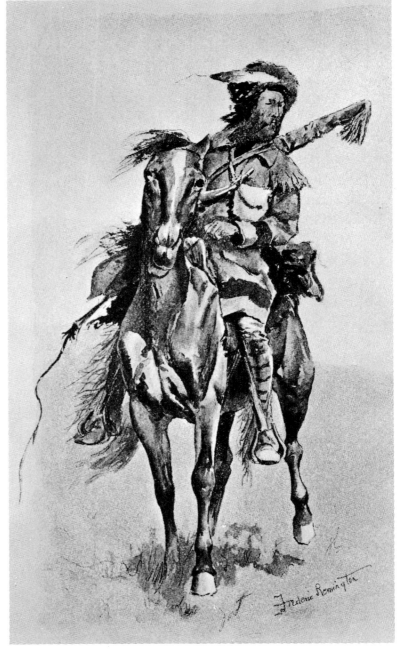

48. THE WILDERNESS HUNTER 49. SEEN AT LARAMIE

THE frontier West became a land of classic adventure, which got deeply into the blood of those who responded to its challenges. It did not take long to separate the men from the boys, although a lot of youths hardly dry behind the ears suddenly blossomed into robust manhood. Those who did not qualify or chose not to stay lost little time in joining the first wagon train bound back to the more prosaic life in the quieter East.

Some of the bolder of the *avante-garde* accomplished deeds that fully entitle them to honored places in the pages of history, yet they remain relatively unknown and unsung. Jedediah Smith, who in 1826 became the first white man to find a way through the mid-

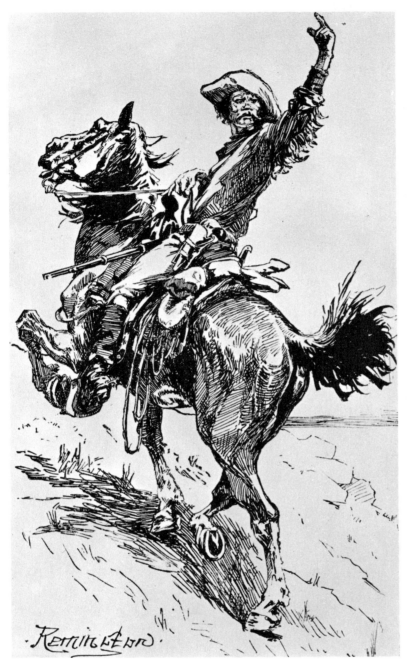

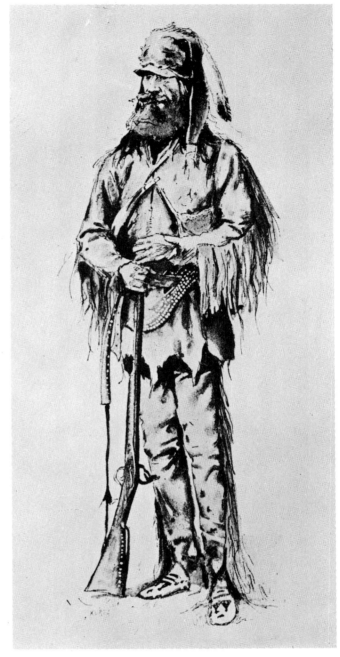

50. OPENER OF THE TRAIL 51. RUGGED AND ROUGH

continent Rockies and Sierras to the Pacific, and was the trail finder into regions that made Kit Carson, John Frémont, and others forever famous, is only dimly remembered. Men like Bill Williams, Uncle John Smith, Jim Beckworth, and many other little known heroes of indomitable courage and endurance contributed much to the exploration, conquest, and development of the West, and for the establishment of our nation as it is today. It should be remembered that before 1840 practically every feature of our Western geography and its routes of travel that we use today were known to these men, before the government-sponsored explorers and others who came later rediscovered so many of those places.

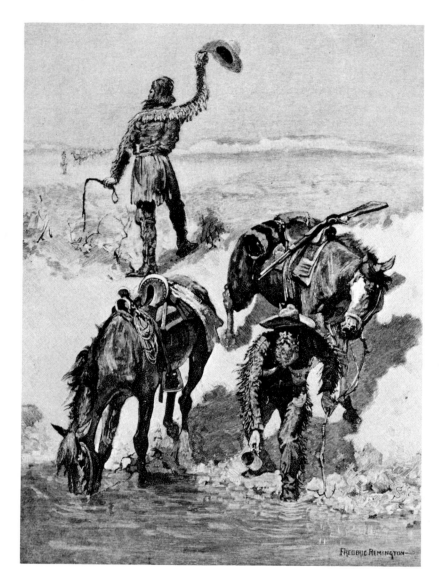

52. WATER!

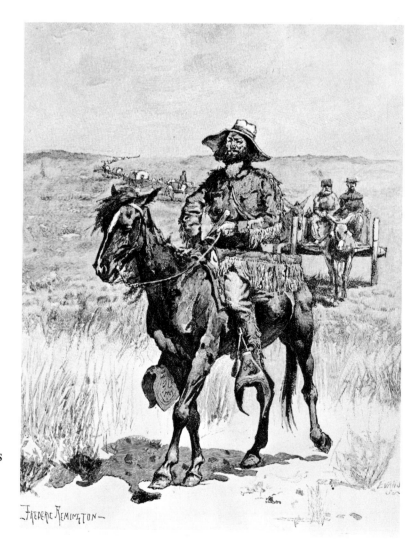

53. ON THE WAY TO NEW HOMES

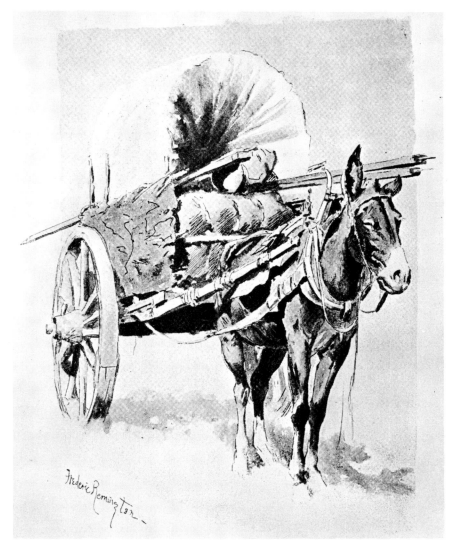

54. AN EMIGRANT'S MULE CART

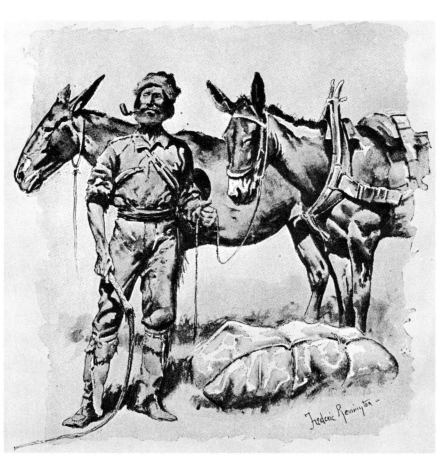

55. A BUFFALO HUNTER

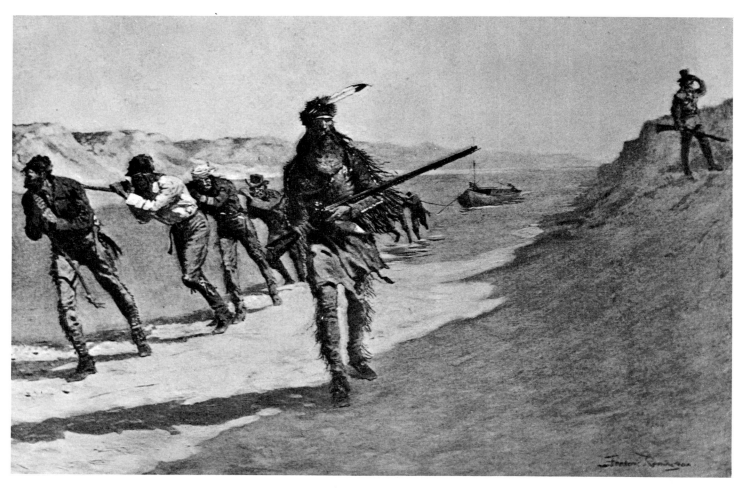

56. THE UP-RIVER MEN

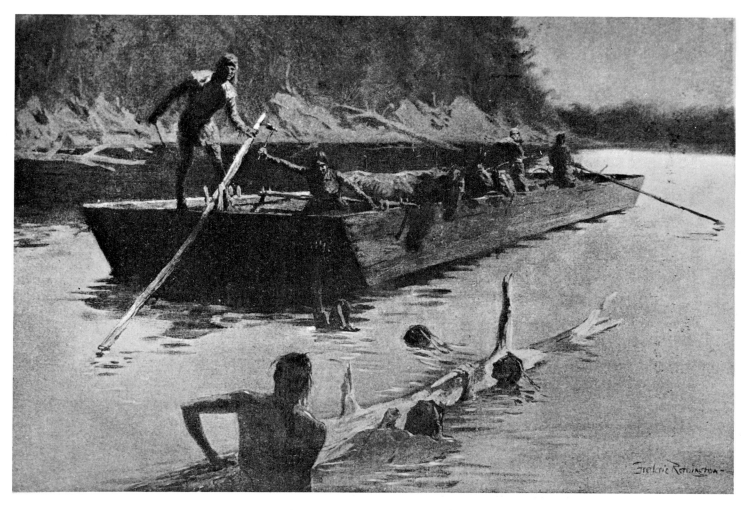

57. THE DOWN-RIVER MEN

THE rivers that for centuries had known only the footprints and occasional skin canoes of the Stone Age inhabitants of the broad land now became the scene of strange white intruders pulling heavily loaded wooden boats upstream, and others riding down with their boats loaded with bales of furs. The old Indian trails became the roadways for packhorse men and wagon men, bringing newcomers to the trading posts previously visited only by Indians and the trappers who came in for the spring rendezvous. Many of the newcomers were from Kentucky and Missouri and had grown up knowing the meaning of living on the frontier. There were also recalcitrant French half-breeds from up and down the Mississippi, wiry Scotsmen, and the trickling of European immigrants, some just learning to speak English.

They were largely a reckless lot. Many had only a vague idea why they were there, where they were going, or what they would do when they got there. Little could they realize the heroic drama in which they were playing a part, as the vanguard of a strange, scattered and disorganized little army, without leader or organization, beginning the conquest of an empire the size of half a dozen European kingdoms—the likes of which will probably never be seen on the earth again.

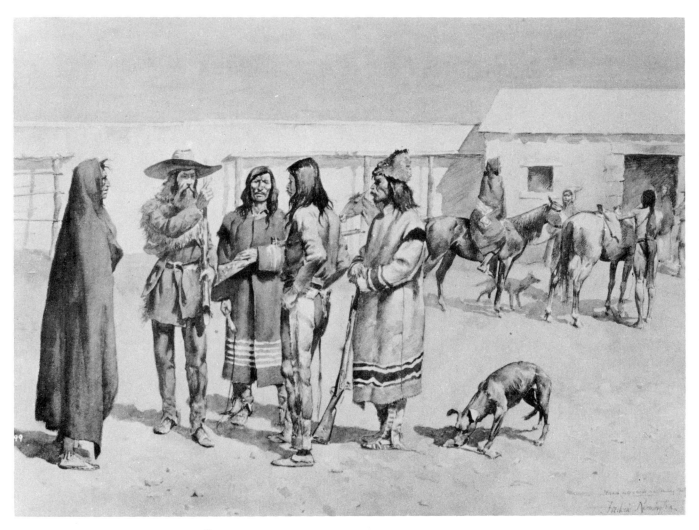

58. FRENCH HALF-BREEDS IN A TRADING POST

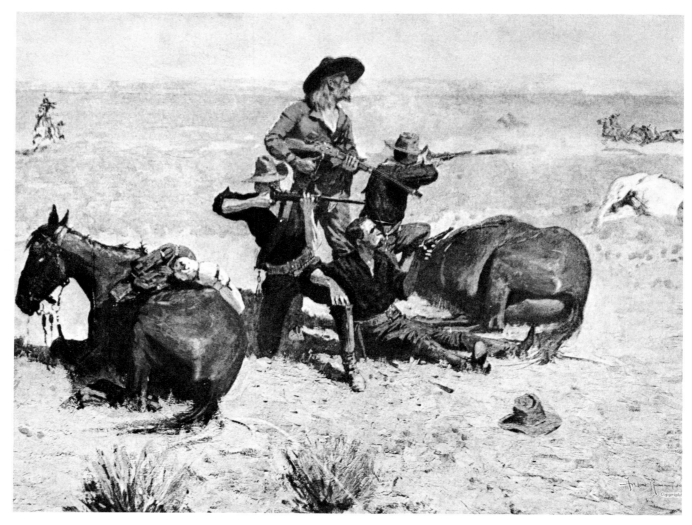

59. CAUGHT IN THE CIRCLE

ONE of the most critical perils for the frontiersman was for a small party to be caught in the open by a band of well-mounted hostiles. The Indians first objective was to down the horses. Then like wolves circling a crippled buffalo, the attackers would dart in and strike, or with infinite patience keep their victims harassed throughout the time necessary to sink helplessly from wounds, thirst, or hunger.

Frederic Remington was familiar with incidents of the kind, which were not uncommon during the early days on the Plains. Skeletons and participating Indians sometimes indicated the tragic stories, which Remington put into several of his pictures. The one on the opposite page, *The Last Lull in the Fight*, was recounted by an old Comanche warrior. The picture was reproduced in *Harper's Weekly* of March 30, 1889, and the accompanying text relates: "The scene is the arid plains of the Southwest . . . and as a typical struggle to the death against hostile Indians, may stand for many an unrecorded experience in the far West . . . The man pierced with an arrow seems the most fortunate of the four, as he lies dead . . . He has all ready gone where the others must follow him. Their bones will bleach on the sand-hillock, and other travelers will wonder what their story was."

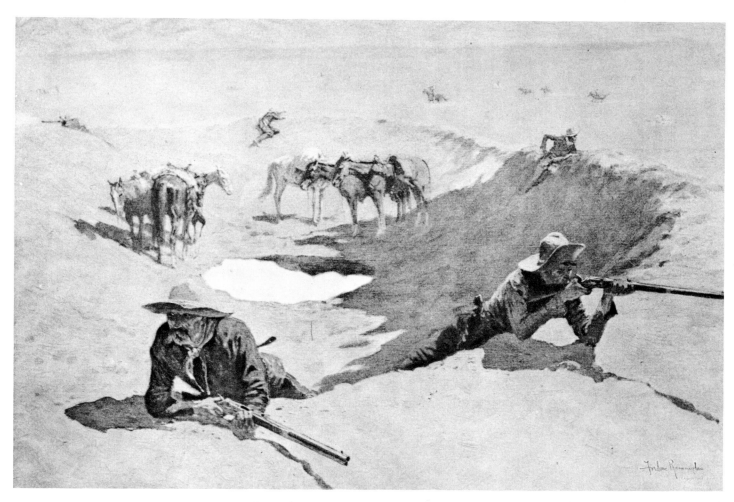

60. FIGHT FOR THE WATER HOLE

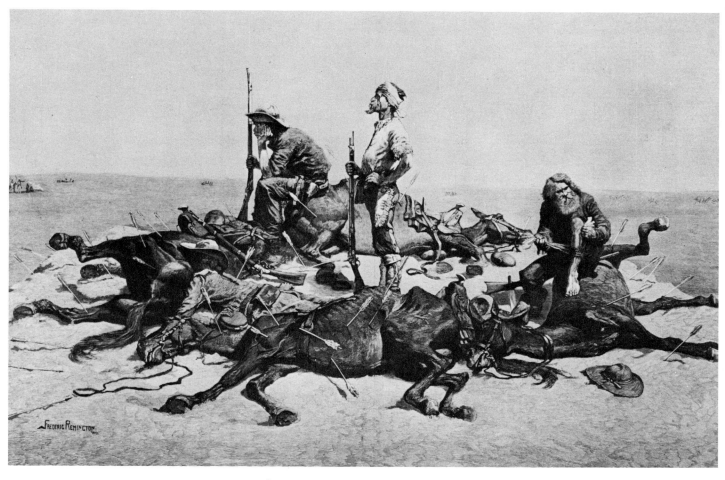

61. LAST LULL IN THE FIGHT

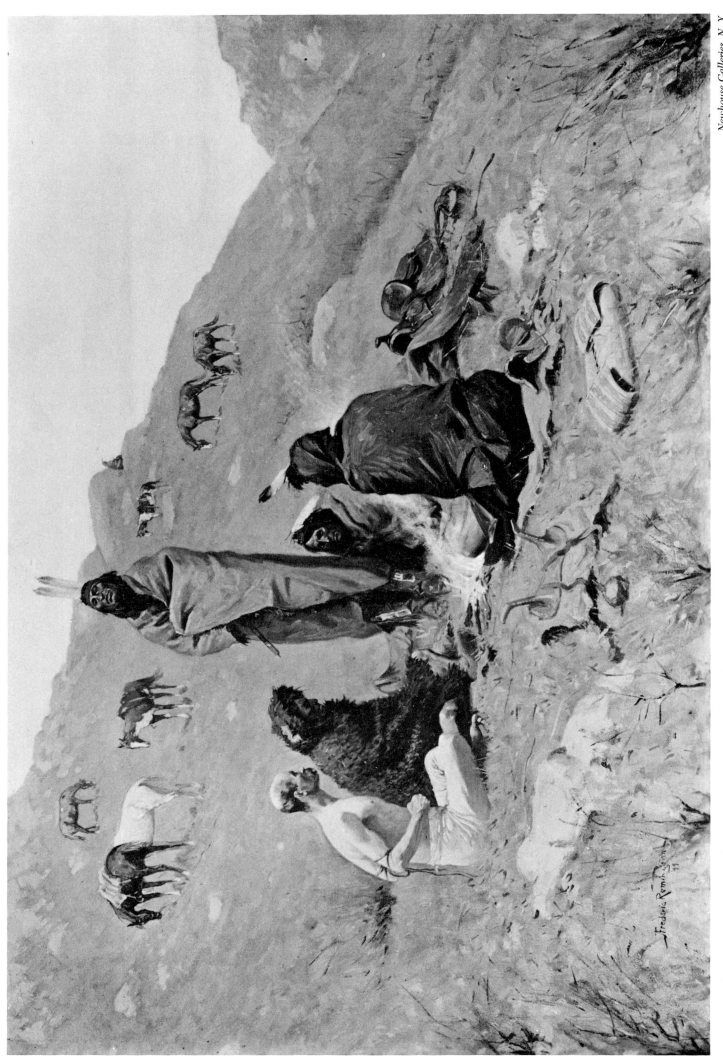

62. CAPTURED

63. THE DEAD MEN

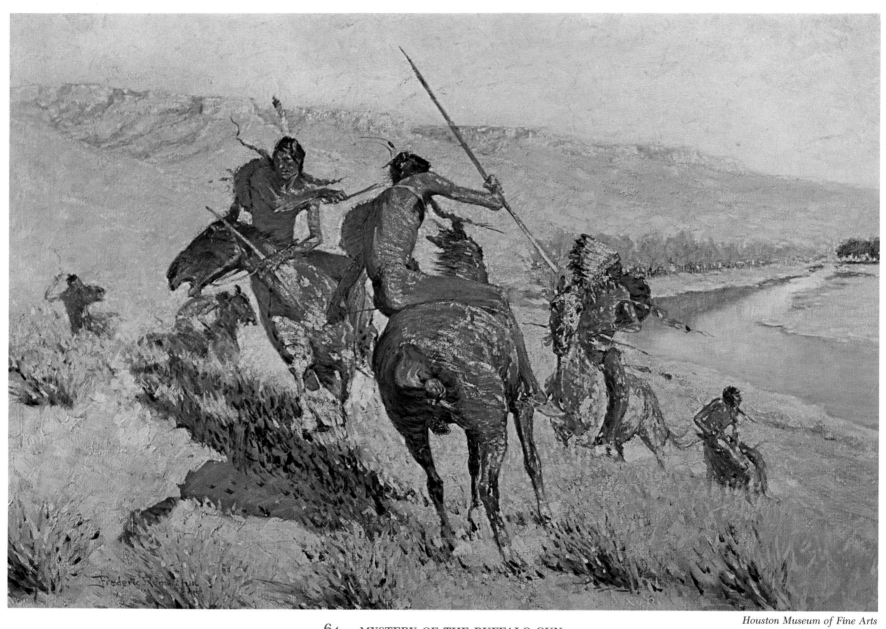

64. MYSTERY OF THE BUFFALO GUN

CHAPTER IV

Pioneers on the Plains

THE beaver trappers were unwelcome trespassers in Indian tribal territory, but when the white men began slaughtering the buffalo, it became a more serious matter. For longer than any medicine man knew, the Indians had depended upon the buffalo for food and other necessities of life. The wholesale destruction of the buffalo, more than anything else, incited the red men to warfare against the white intruders.

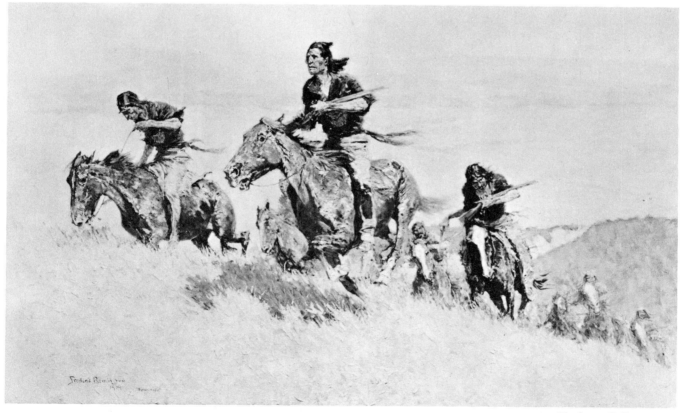

Newhouse Galleries, N. Y.

66. BUFFALO HUNTERS—BIG HORN BASIN

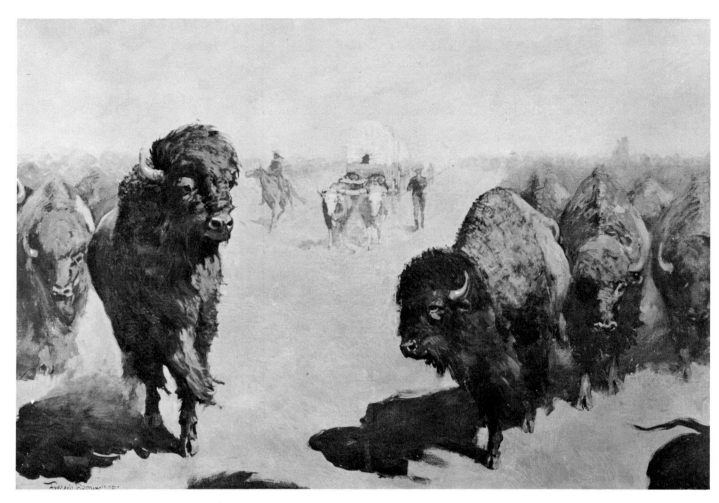

67. A LANE THROUGH THE BUFFALO HERD

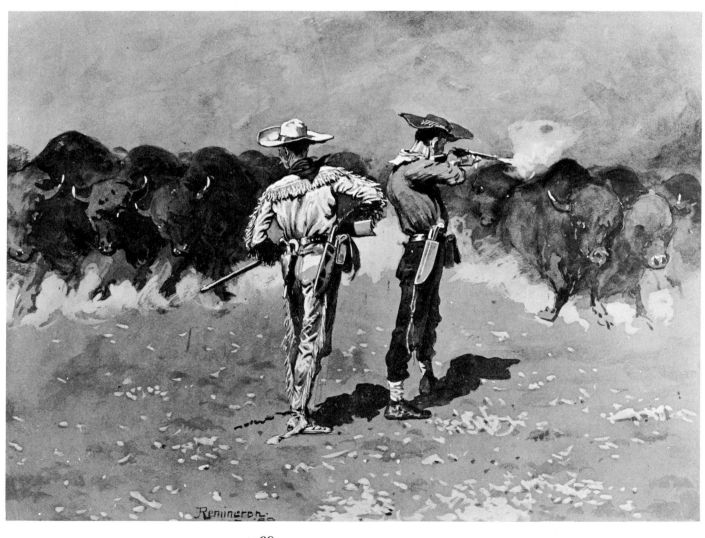

68. SPLITTING THE HERD

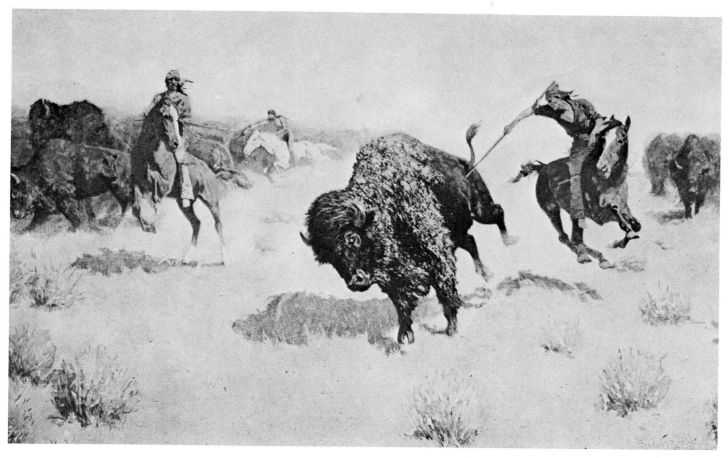

69. THE BUFFALO RUNNERS

THERE were probably more buffalo in North America than any large animal on any other continent. Authorities have estimated the number as high as 125,000,000 at the time the first Europeans arrived. The early explorers named these animals "buffalo," although scientifically they are a *bison*. The buffalo has no hump on the shoulder and has short hair.

Systematic killing of the buffalo by the white man began as early as 1820. The supply seemed inexhaustible. Thousands of the animals were killed only for their tongues, which were considered a delicacy. Professional meat hunters were employed by the large wagon trains, as well as the trading posts. Everyone fed on them. Then a market was created for buffalo hides, for making winter lap robes, as well as heavy coats for civilians and military units in both the East and West. This led to killing on a large scale. As early as 1849 a single season saw as many as 110,000 hides shipped by river boats to St. Louis from the upper Missouri. A hide brought three dollars on the market and the traffic became big business. Thus began the greatest and most wanton animal slaughter in history. It reached the climax during the years 1872, '73, and '74, when it is estimated that more than five million were killed in three years. By 1889 there were only 541 wild buffalo left in the United States.

Destruction of the buffalo imposed the most drastic hardships upon the Indians, depriving them not only of food but of hides for tepees and many other necessities. There are no records of the number of Indians who starved in areas where the buffalo were exterminated, but they were many. This is but one of the understandable circumstances that justified the Indians' bitter warfare against the white men.

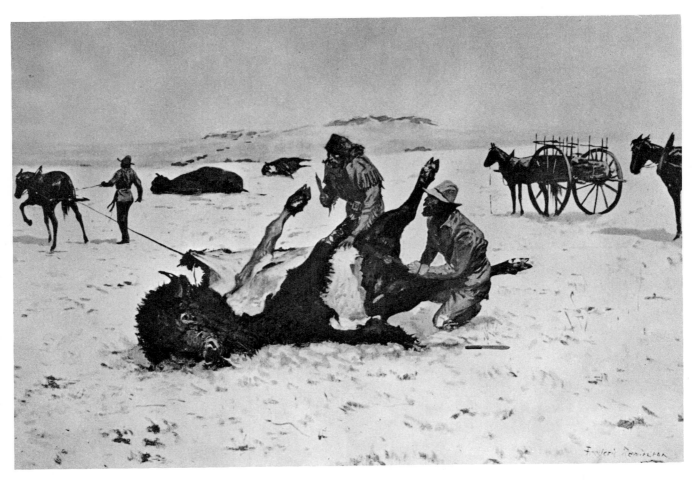

70. TAKING THE ROBE

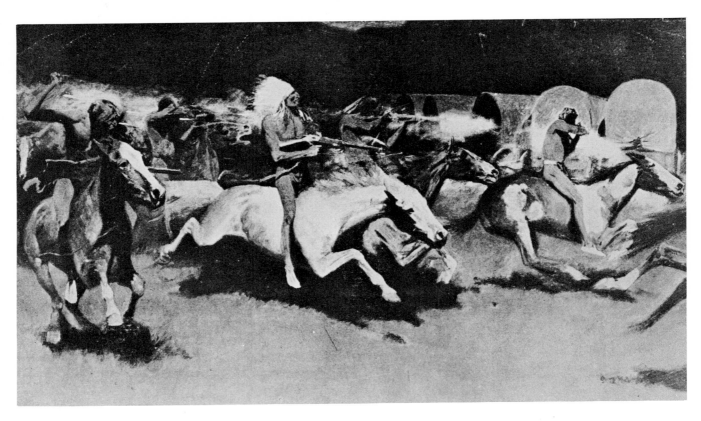

71. NIGHT ATTACK ON A GOVERNMENT WAGON TRAIN

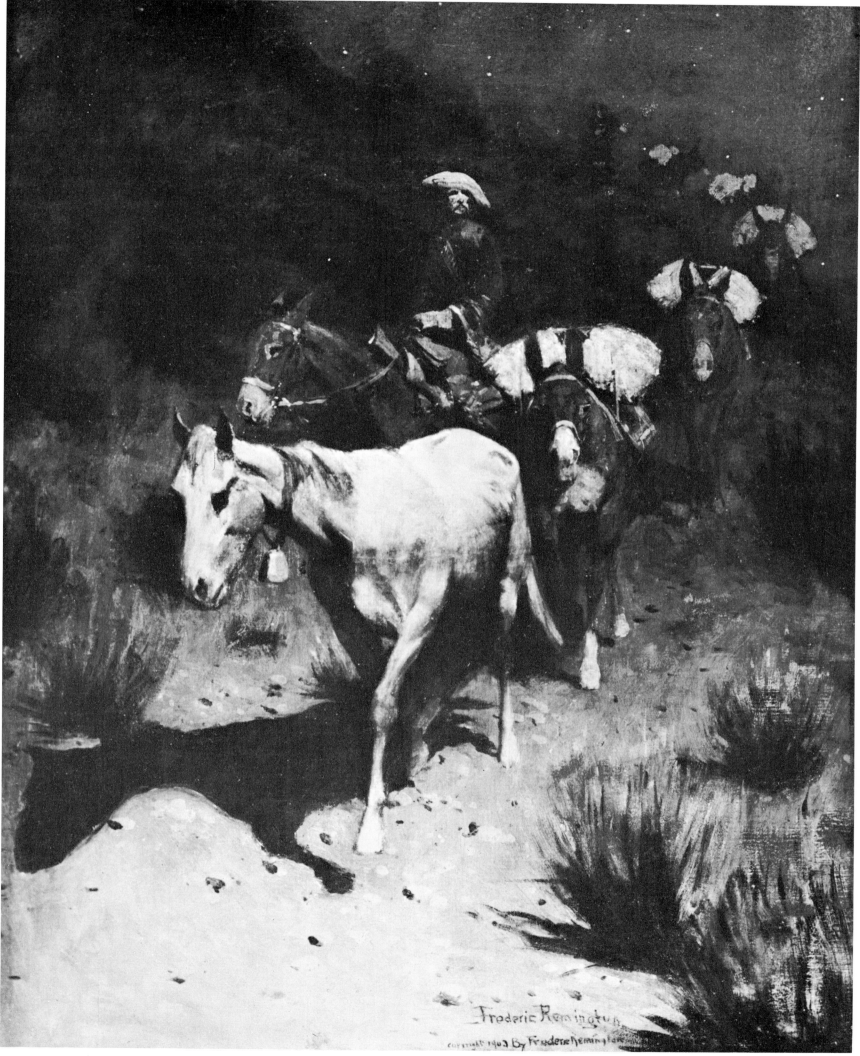

Frederic Remington

72. THE BELL MARE

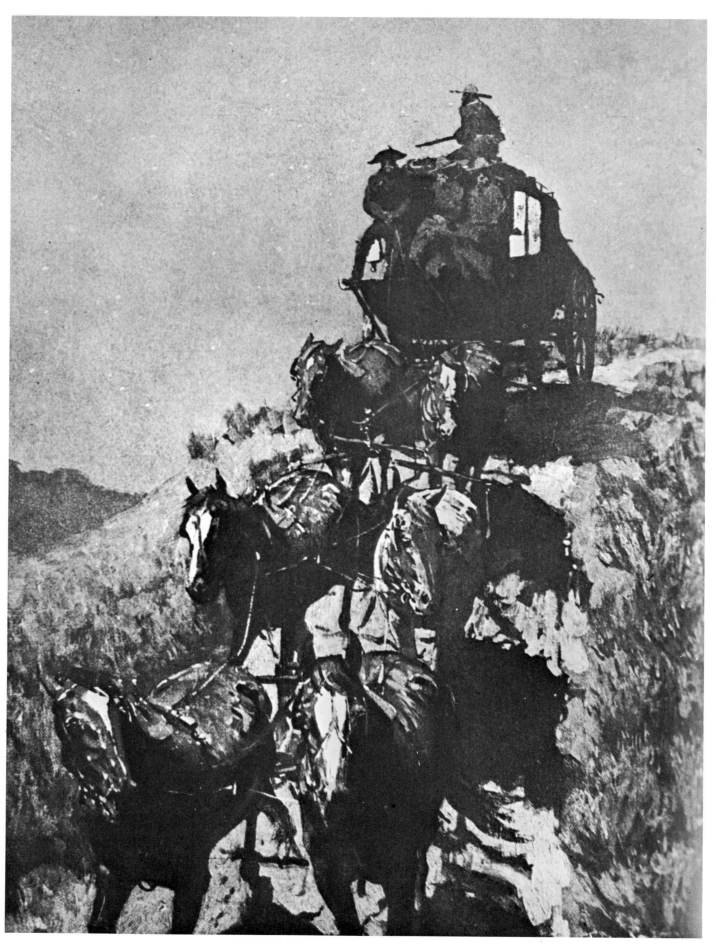

73. THE OLD STAGE-COACH OF THE PLAINS

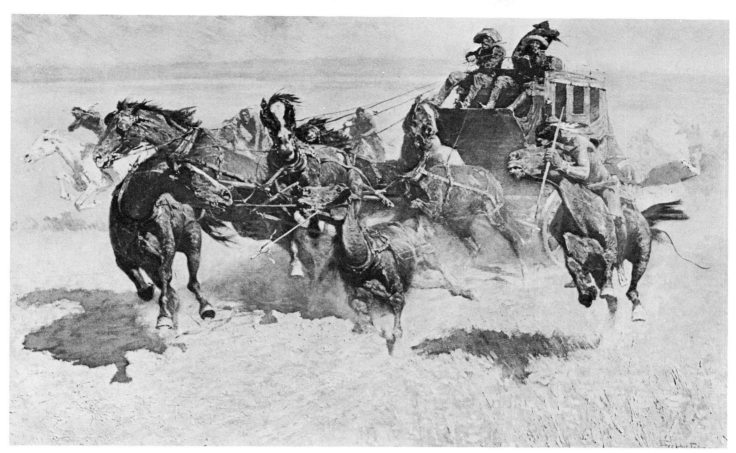

74. DOWNING THE NIGH LEADER

M. Knoedler & Company, N. Y.

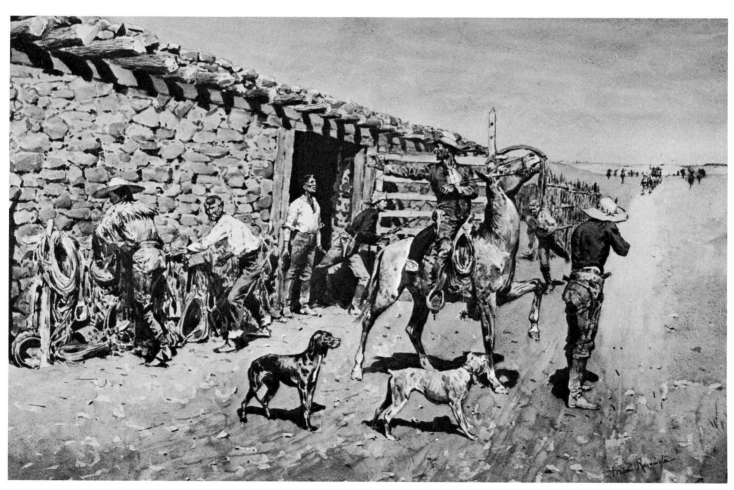

75. INDIANS COMING IN WITH THE STAGE

Whitney Gallery, Cody

TRANSITION in the West was rapid, once the sons of the United States assumed a role in the historic drama. After lying so long a vast and primitive wilderness, the western movement, under the inspiration of our national expansion, effected a transformation unique in the history of civilized man. The previous periods, when the Spanish and French were probing for treasure and riches in furs, left but little imprint of human progress or conversion. But when we began pushing our national horizon westward, the transitions from explorer to frontier pioneer and to boomer and barbed wire, moved forward in a truly remarkable historic manner.

Fortunately, Frederic Remington was a part of this early enough and intimately enough to contribute a pictorial story that will stand as a faithful documentation of that important period of our national history.

76. TWO PIKE COUNTY ARRIVALS

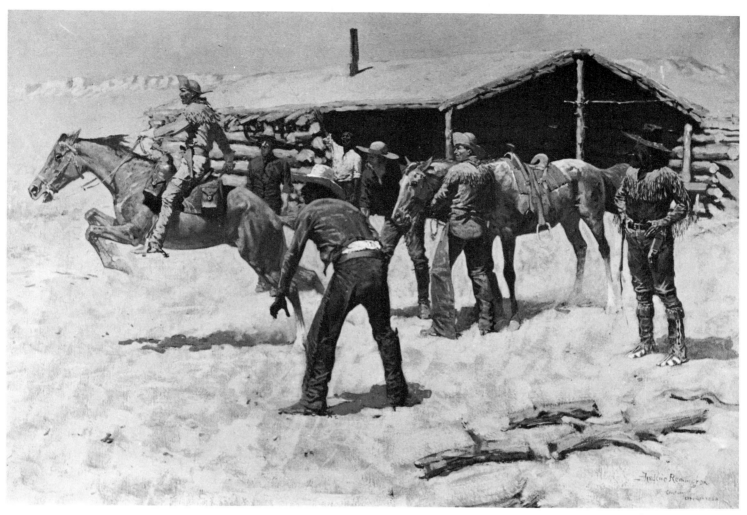

77. COMING AND GOING OF THE PONY EXPRESS

Gilcrease Museum, Tulsa

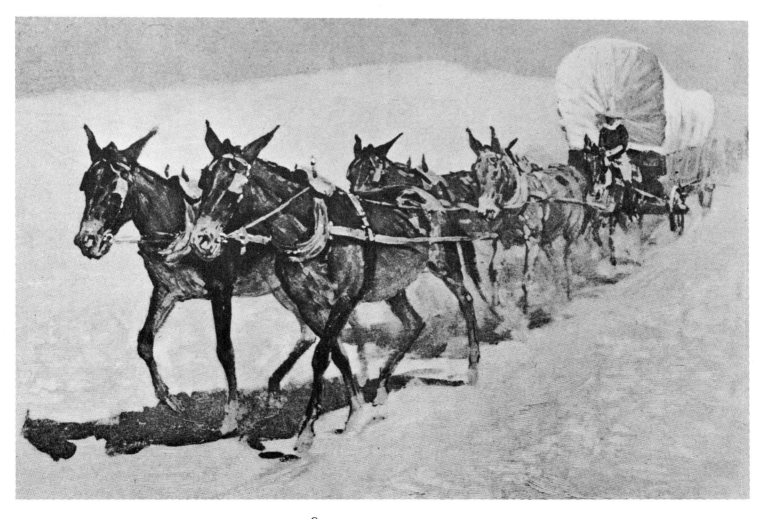

78. A PRAIRIE SCHOONER

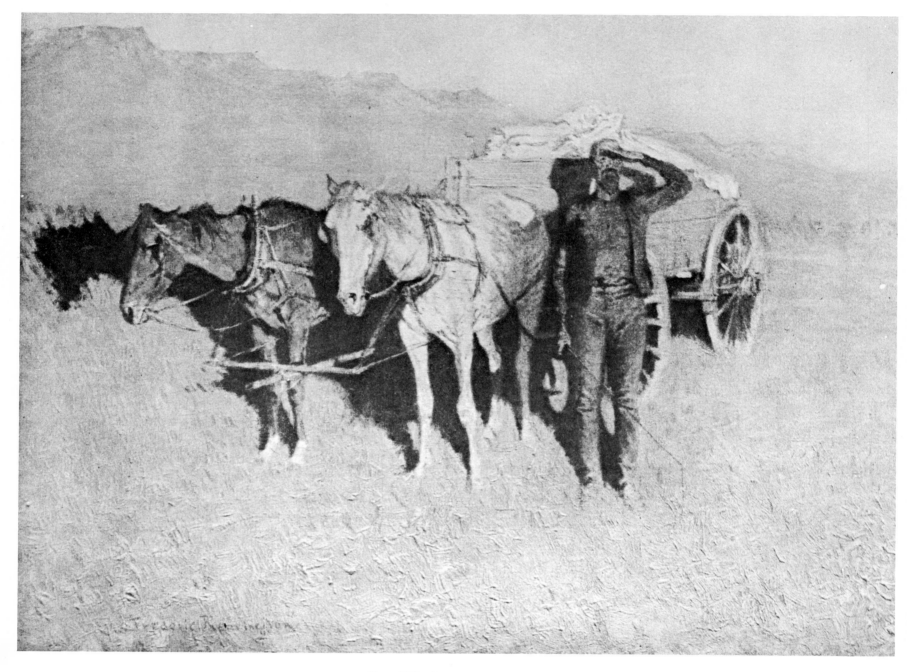

79. BENIGHTED AND A DRY CAMP

IT WAS a strange sort of conquest, the opening and settlement of the American West. Whether it was out on the broad open prairies or in the rugged mountains, it was for most of the early pioneers a lonely conquest and a lonely struggle against odds that any professional gambler would religiously avoid—hostile Indians, the search for food and water, blistering sun or blinding blizzards—and for most it was always the grueling grind of pushing on to an end of little or no reward. Even when the Army was sent West to give the white men protection against the Indians, the columns of cavalry and infantry were so few, in such a vast land, that performing the service for which they were intended was like trying to catch moonbeams in a basket.

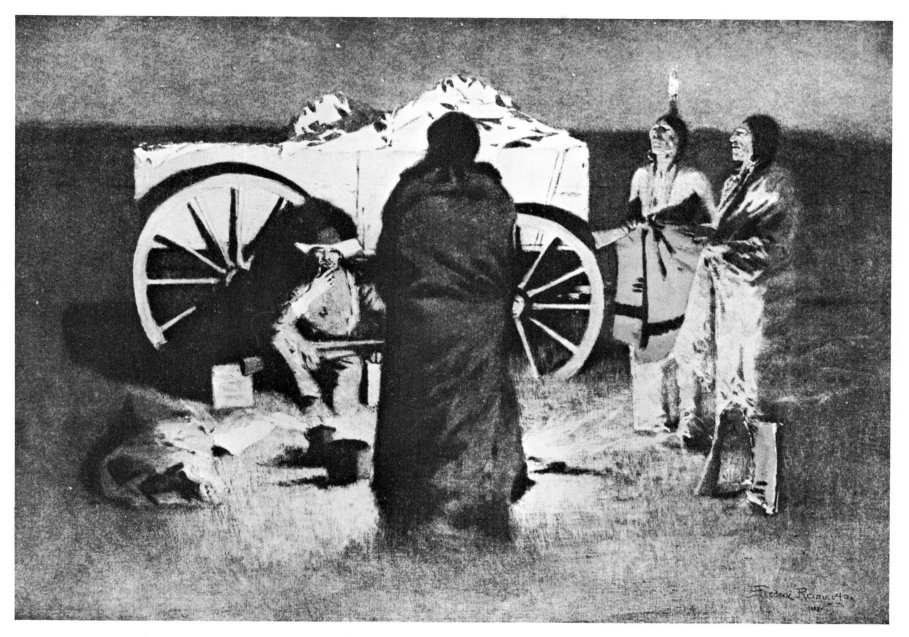

80. SHOTGUN HOSPITALITY

Out of nowhere the Indians might appear like ghosts of the night. Stealthy as the panther and cruel as the wolf, the red man and his ideas of warfare were difficult for the white man to understand. He worked best in the night, against a well-armed convoy or a traveler camped alone beside his wagon. Three or four of them might suddenly become realities within the glow of the little fire and give every indication of a friendly visit. They might show only a disposition to eat some of his grub or smoke some of his precious tobacco. But the preliminaries of getting acquainted were always best served with a gun in one's lap. For there was always the apprehension that the visitors purpose was only to gain information about the movement of wagon trains or military columns, and also the probability that a score or a hundred other red warriors were watching from the darkness all around.

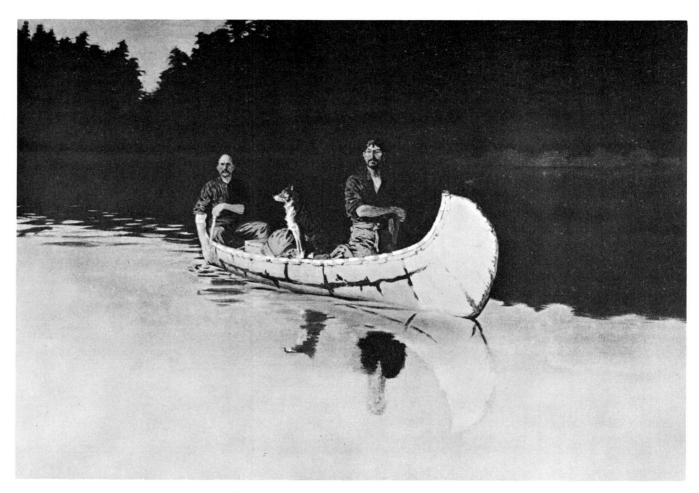

81. EVENING ON A CANADIAN LAKE

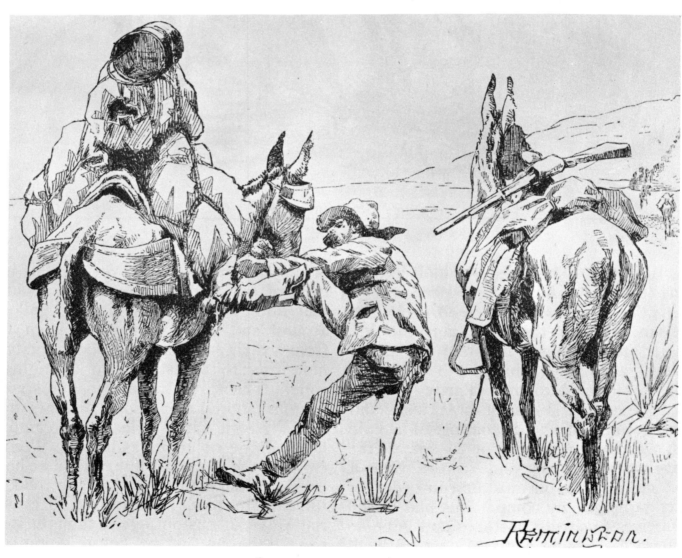

82. A PACK-HORSE MAN

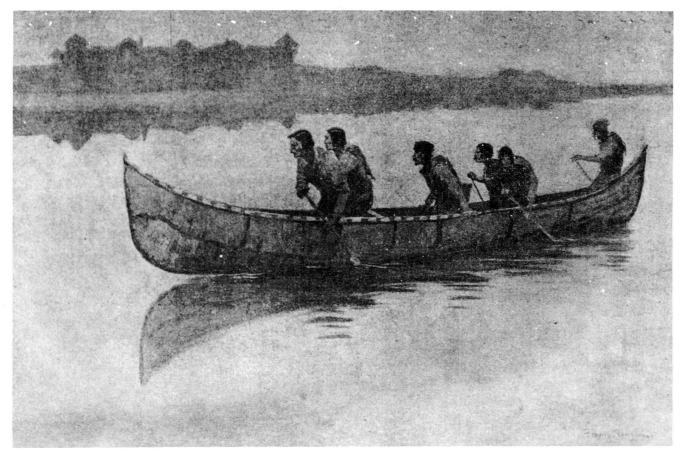

83. PASSING A RIVAL POST AT NIGHT

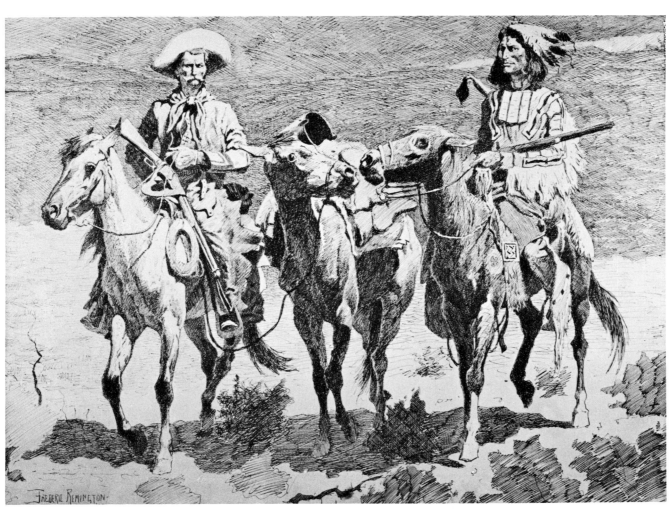

Whitney Gallery, Cody

84. QUESTIONABLE COMPANIONSHIP

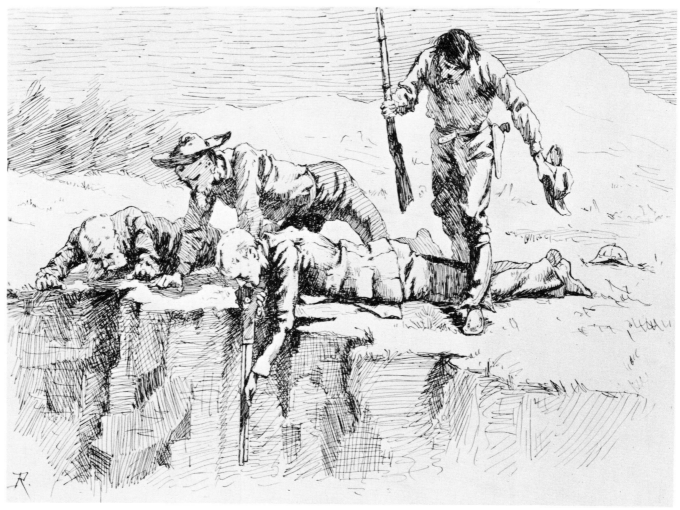

85. SHOOTING DOWN A CLIFF

Harold McCracken Collection

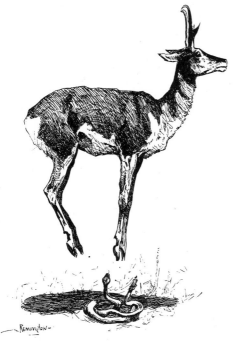

86. ANTELOPE KILLING A "RATTLER"

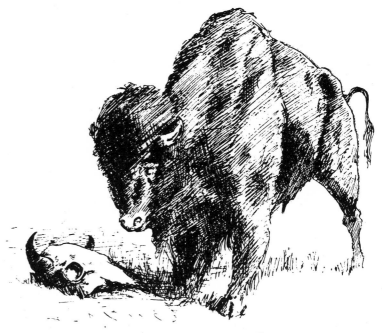

87. INDIAN BEEF

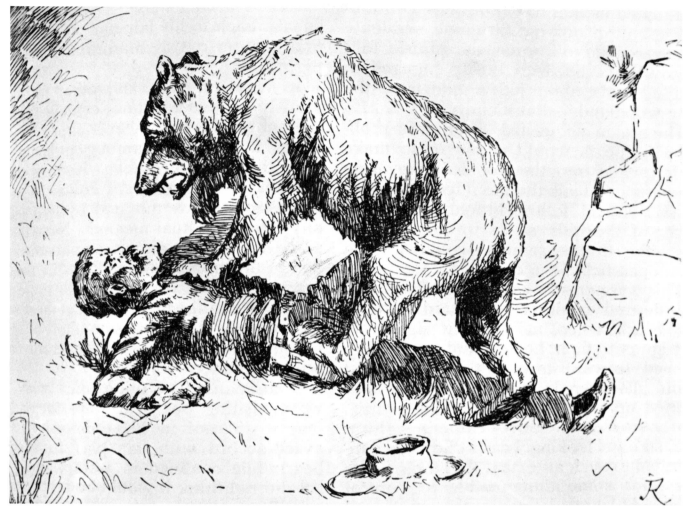

88. "THE BAR TORE CARVER TO PIECES"

LIFE for the pioneer was not all hardship and the hazard of becoming a target for Indians. The continual necessity of procuring fresh meat provided plenty of indulgence in the pleasant diversion of hunting big game. In addition to the herds of migrating buffalo on the Plains, there were generally plenty of antelope in the same areas, and in the hills and mountains there were lots of deer, elk, moose, and mountain sheep. All of these supplied fine meat as well as fine sport. Then, too, for those who would waste ammunition on such small game, there were prairie chickens, sage grouse, ducks, geese, and sand-hill cranes; and wild turkeys, which were sometimes run down on horseback, if only for the fun of it. In most regions it was seldom necessary to go far to obtain meat of one's choice. For a bit of extra excitement there was the grizzly bear, which was not much in the way of desirable food, but sometimes provided more excitement than the hunter had anticipated.

More game meat was wasted than used. Frequently only what could conveniently be carried was taken, sometimes only the tongues. In the summer heat the meat quickly spoiled. The Indians were notorious wastrels. When traveling in a small group they would often make camp beside fresh meat for a few meals and then move on leaving most of it behind.

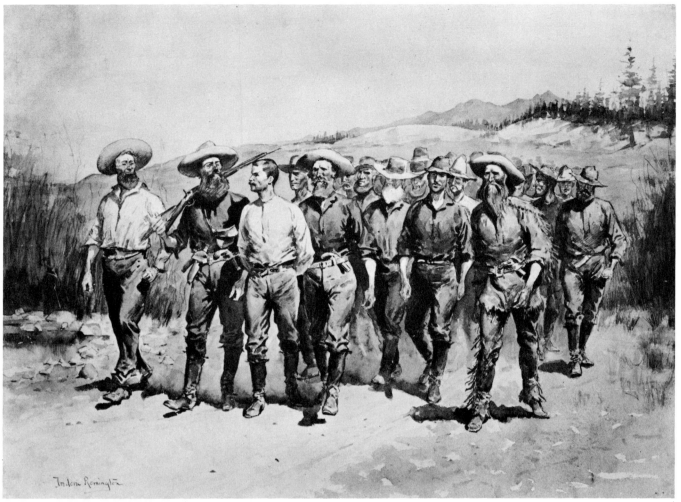

89. THE SHOT GUN MESSENGER

IN THE early days, those who seriously transgressed against their fellow men were gener-
ally dealt with summarily and without the benefit of legal statutes or any formal
processes. Individuals usually settled their own differences in one way or another. The law
of the land was a rather vague and flexible matter, influenced by circumstances as they were
chosen to be interpreted and dictated by those who made them. Differences of opinion were
frequently decided by the balance of power, individual or collective. In the realms of the big
fur companies it was the ruler of the trading post who was judge and jury to all the white
men in the region he controlled. The preponderance of rough and reckless participants
engaged in such strenuous and aggressive pursuits makes it understandable why mayhem and
the curse of Cain could be of common occurrence.

The coming of pioneers in larger and steadily increasing numbers multiplied the prob-
lems of human relationships. It brought more undesirable lawlessness into the country, and
this led to the formation of the vigilantes. These local groups were organized to be unofficial
guards, constabulary, and executioners of their self-determined laws of the area. In most
instances the vigilantes served their communities well, until judicial law was established.

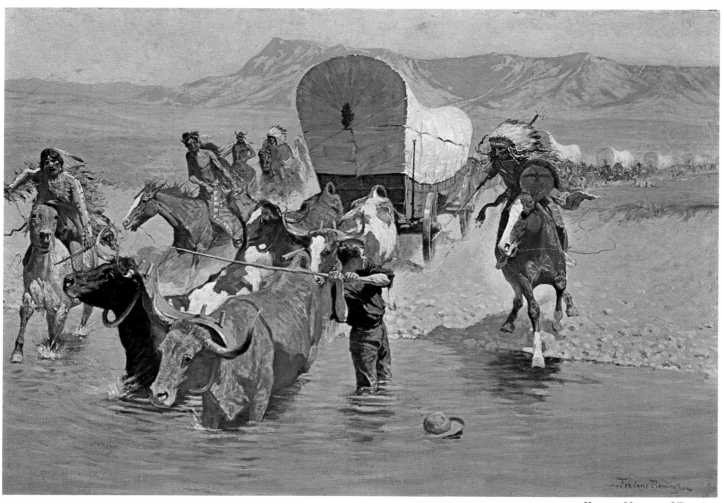

Houston Museum of Fine Arts

90. THE EMIGRANTS

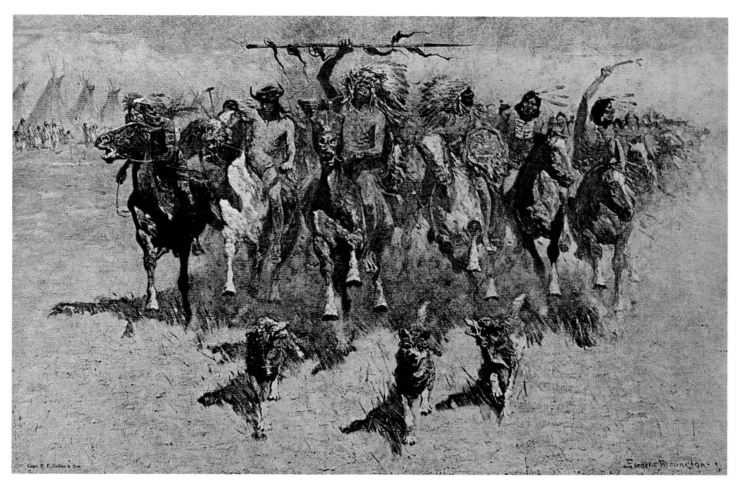

91. CEREMONY OF THE SCALPS

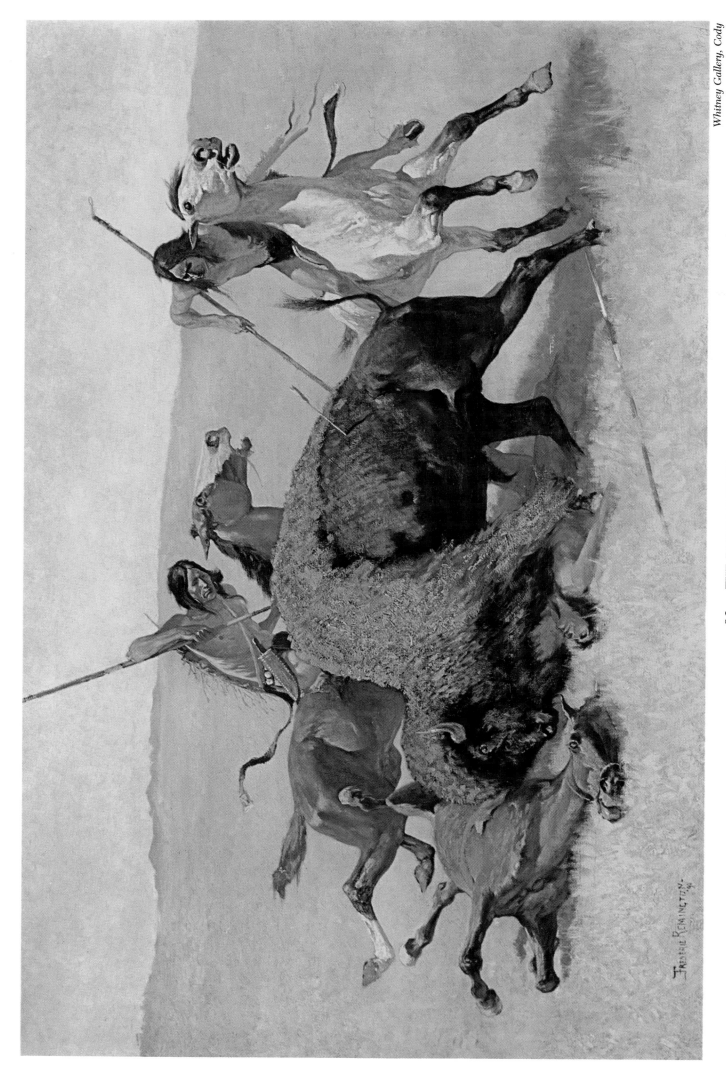

92. THE BUFFALO HUNT

CHAPTER V

The

Red Man's World

THE Indians had been living on the Western Plains for more than ten thousand years before they saw the first white man. At the time when Columbus came to this hemisphere, according to authoritative estimates, there were approximately 846,000 Indians inhabiting the area that is now the United States. These were divided into nearly seven hundred separate tribes of more than fifty linguistic groups. They were all Stone Age people, engaged in hunting and periodic tribal warfare against each other.

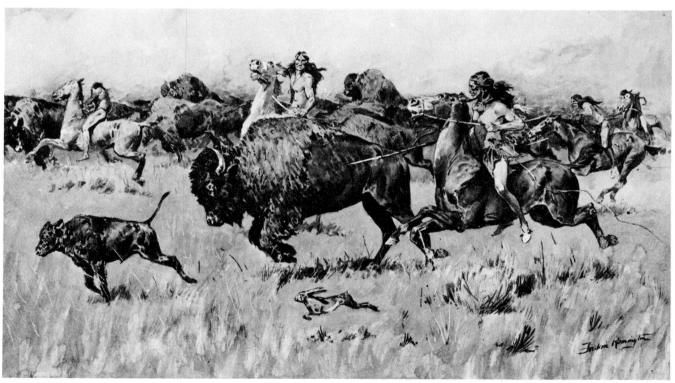

95. HER CALF

James Graham & Sons, N. Y.

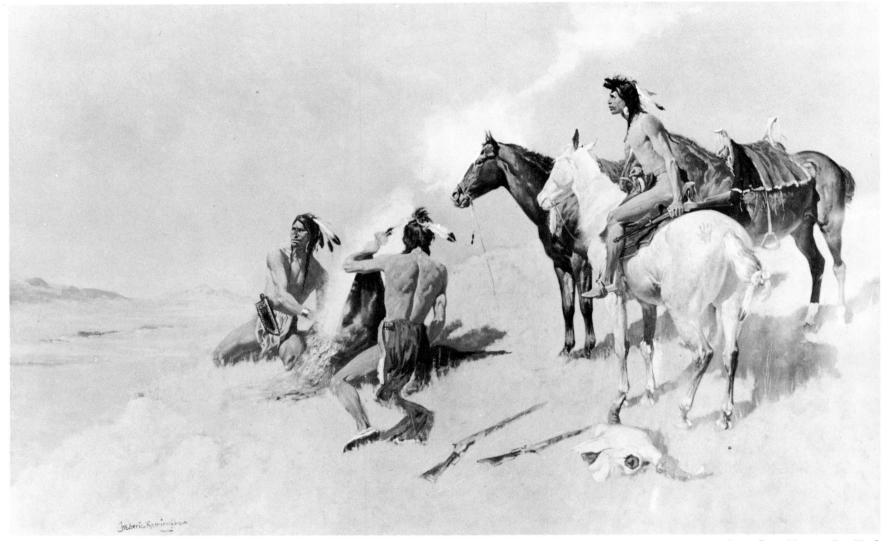

96. THE SMOKE SIGNAL

To have an objective and realistic understanding of the Plains Indians and the unfortunate relationship which developed between these people and the white man, one must recognize the motivations that were created by the white man and also have something of an understanding of the red man's philosophy and concepts of life, born of the thousands of years of isolation from the rest of mankind.

The Plains Indians were an extremely proud and primitively religious people, strangely imbued with a deeply zealous tribal dedication and independence. Through their centuries of Stone Age isolation the imaginations of their religious leaders had invested their visible and invisible world with mysterious spiritual beings that continually exerted influences upon humans, either for good or evil. They recognized an omnipotent Great Spirit, Bad Spirit, and endless lesser gods and spirits. Almost everything alive and inanimate could to some degree be invested with a spirit and be the object of veneration or fear. They had their gods and spirits of the sun, moon and stars, the north, south, east and west, the prairie, woods, wind, and blizzard, as well as the animals, birds, or the limb of a tree. The Indian could be

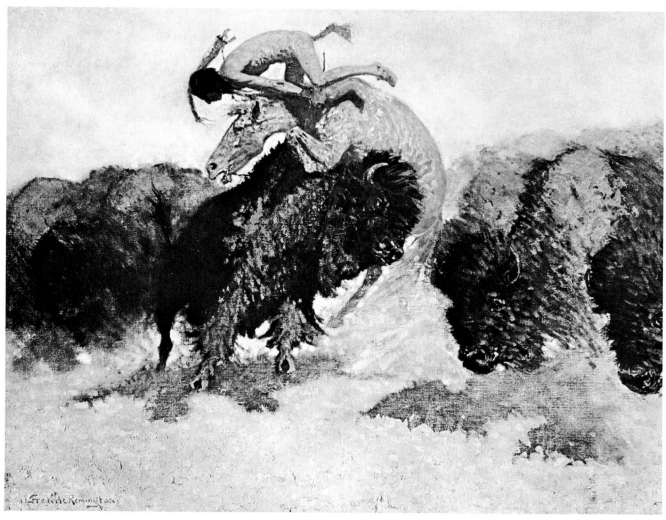

97. THE BUFFALO RUNNER *Gilcrease Museum, Tulsa*

dancing in the deepest religious homage to the sun or the moon, and at the same time spread
out his hands in prayer to a small stone which he himself had painted in a symbolic manner.
His whole world was a complicated catechism of mysterious gods, spirits, and talismans, in
which all good Indians were orthodox believers.

Two professions were the principle purpose and necessity of Indian manhood—hunting
and warfare. Both required stealth, stamina, skill, and courage; and the highest distinction
in the tribe was based on proficiency in these fields of endeavor. Another basic standard of
manhood was the ability to withstand pain. The transition from boyhood to manhood was
frequently the individual's demonstration of this, performed in a ritualistic ceremony in the
presence of a critical court of elders and acknowledged by the assembled people of the tribe.
To fail was a disgrace, and to give sympathy was heresy. This attitude found expression in
tribal warfare and against captives—as a sadistic evaluation of what sort of men their enemies
were. A tortured captive who won the admiration of his captors was sometimes released to
go home or even made a new member of the tribe. There were no tribal or religious laws
against murder or mayhem to an enemy—no white man's Ten Commandments for the
primitive Indians.

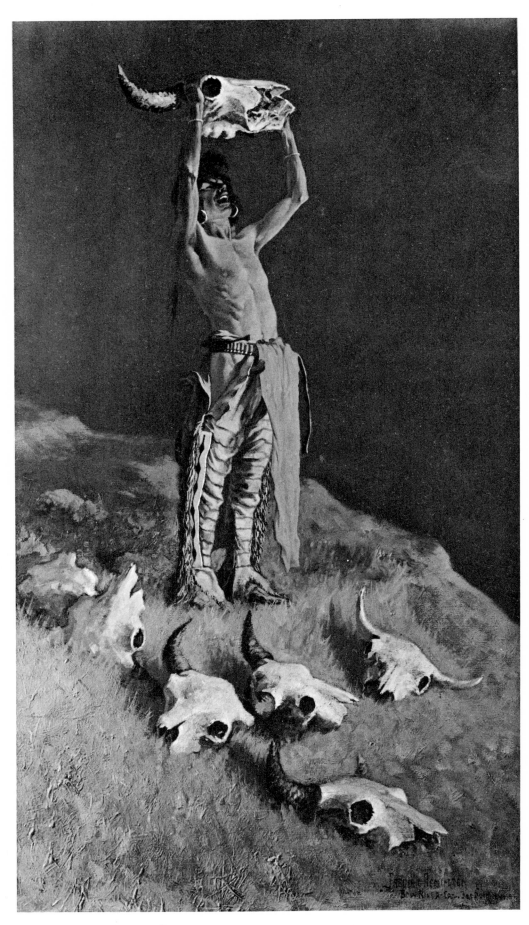

98. CONJURING BACK THE BUFFALO

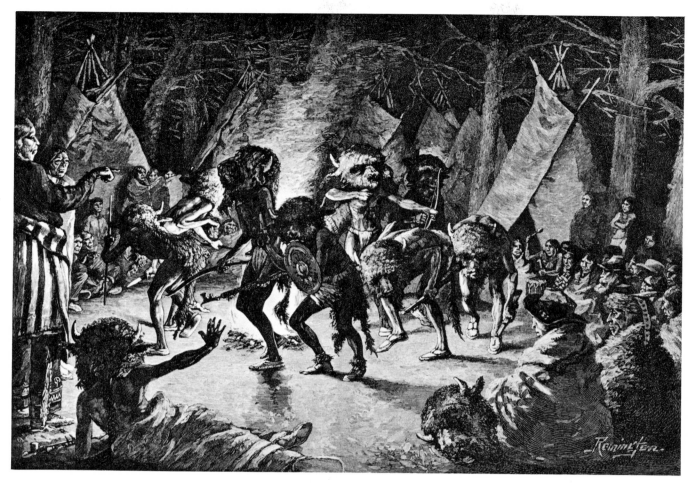

99. THE BUFFALO DANCE OF THE CROWS

THE buffalo was the mainstay of life for most of the Plains tribes. It was therefore the subject of some of the most significant of their religious ceremonies and tribal lore. The powerful Dakotas, whom the white men referred to as Sioux, called the buffalo *tatanka*, which indicated a close relationship to a god, Wakantanka.

The big herds of buffalo migrated with the seasons—north in spring and south when the snows drifted over the feeding grounds. Acquisition of the horse had made it possible for the Indians to ride out to find the herds, to kill the animals with greater success, and to carry home more meat and hides than ever before. The extra meat they could dry for jerky and pemmican, the bone marrow they could preserve in bladder skins, and the tallow in bags. The skins were tanned for new tepees, bedding, winter robes, war shields, bull boats, ropes, saddle bags, and lacings for snowshoes. The sinew was used for sewing bowstrings, cord, and rope; the horns made into spoons and the insignia of high rank on their war bonnets. Even the bones were shaped into scrapers for dressing the hides; the brains used for tanning; and the dry dung was collected for the fires in their tepees. Previously they had been compelled to do all their hunting on foot and carry everything on their own backs, except the little their dogs might carry. Thus the horse had carried them into the greatest period of prosperity in their history. But when the buffalo failed to appear, the people became hungry and destitute.

F ROM early childhood the Indian was so impressively indoctrinated into his people's lore, legend, mysticism, and mythology that it became the dominating influence in his life and made him a tribal zealot. The storyteller was an important personage. Usually he was a wise old patriarch who had gained his knowledge from long experience in listening to others and had acquired his ability as a speaker from many meetings in the council lodge. His repertoire was always abundant, and exciting enough to enthrall the young or to impress properly the bravest warrior. His dramatic vignettes were both historical and religious, and in each and all there was the basic motive of strengthening the Indian's pride of race and dedication to his own tribe. Mostly what he told had been handed down verbally from generation to generation, and elaborated or modified as each storyteller's talents permitted.

Popular themes involved the accomplishments of ancestral demigods, performing supernatural feats against tribal enemies, generally aided by some lesser god or patronizing spirit. The heroes were always brave men and the villians were always cowards and weaklings. The whole storyteller's world was an extravaganza of phenominal feats and amazing happenings, based on ancestral worship and tribal devotion, in which the life of the individual mortal was relatively insignificant.

100. THE DRY LEAVES LASTED LONGER THAN SHE

101. THE STORY TELLER

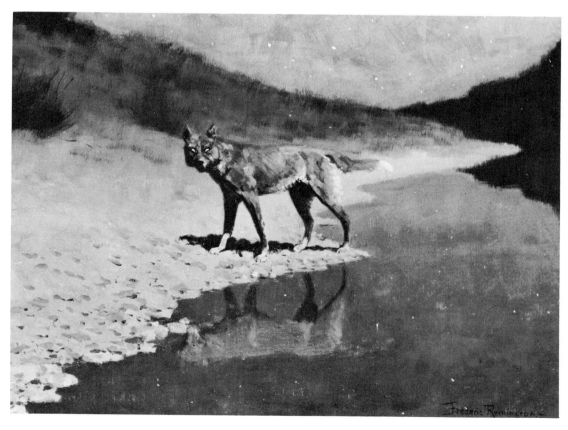

102. WOLF IN THE MOONLIGHT

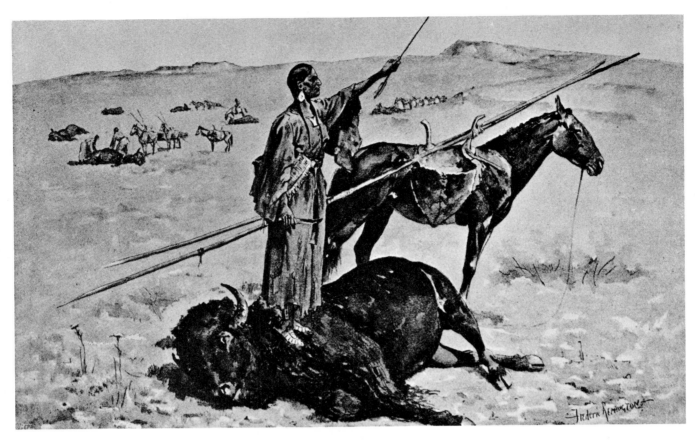

103. WHEN HER MAN'S WORK WAS DONE

T HERE was a time when the buffalo ranged from Georgia to Alaska. Within the time of Europeans the range was chiefly between the Allegheny and Rocky mountains and from below the Rio Grande northward to Great Slave Lake.

While waiting for the migrating herds to come north in the spring, the tribesmen held elaborate ceremonies and religious incantations and prayers by the medicine men were performed to ensure and hasten the return of the buffalo. During this time the scouts roamed out as far as they could to hasten back with the good news. When the first of the animals were taken there were celebration and feasting.

In the days before the horse, the Indian foot hunters resorted to every possible manner of killing the buffalo—driving them over low cliffs and then attacking the injured animals with arrows, spears, and stone axes; surrounding small bunches with a large circle of hunters; setting up pens to confine the animals temporarily; and by camouflaging themselves so the hunter might get close enough to shoot his arrows. The horse provided the means of riding alongside or into the stampeding herd and selecting the animals of their choice.

The tribes were governed by a communal form of life. Regulations controlled the cutting up of the animals and the distribution of the parts. The skin and certain choice sections belonged to the man who had slain the buffalo. This was determined by the personal identification mark on his arrow, as indicated in the above picture. The remainder of the carcass was usually divided among the helpers, according to tribal rules, which provided an opportunity for the less fortunate to share the food.

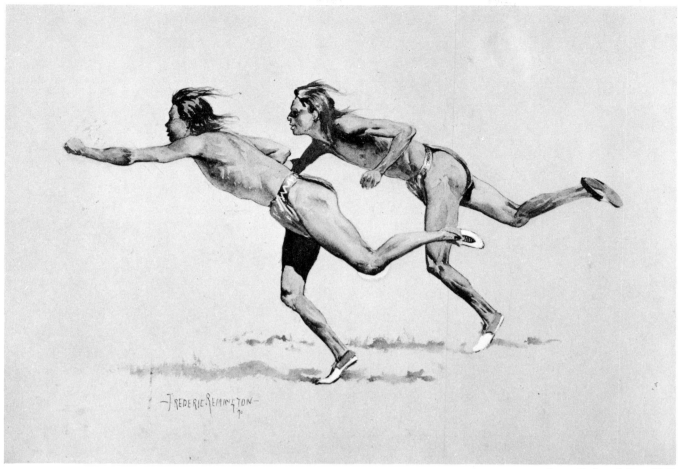

James Graham & Sons, N. Y.

104. INDIAN BOYS RUNNING A RACE

PHYSICAL fitness of the individual was of such major importance in so many aspects of Indian life that competitions of endurance and dexterity were very popular among all ages and classes. Foot races and horse races were the frequent result of impulse or well-organized planning. The same was the case with the bow and arrow, to see who could shoot the greatest distance or put the most arrows into the air before the first one fell to the ground; and for accuracy shoot at a small round webbed hoop rolled rapidly along the ground. They also played a variety of games, from bareback polo to lacrosse and hockey on bare ground or ice.

Among most of the Plains Indians every boy looked forward to participating in the sun dance, when by the ordeal of pain he could prove himself ready to be officially accepted into the status of manhood. This was always an occasion for celebrations of great tribal importance and religious significance. At the appointed time all the adolescent candidates would present themselves, and under the observation of a court of their elders, they would fast for several days without food or water, then individually have holes cut in the skin of their chests or backs and thonged skewers thrust through the holes, then dance while staring at the sun, or be hoisted by the thongs into the air, to display how long and well they could endure the pain before losing consciousness.

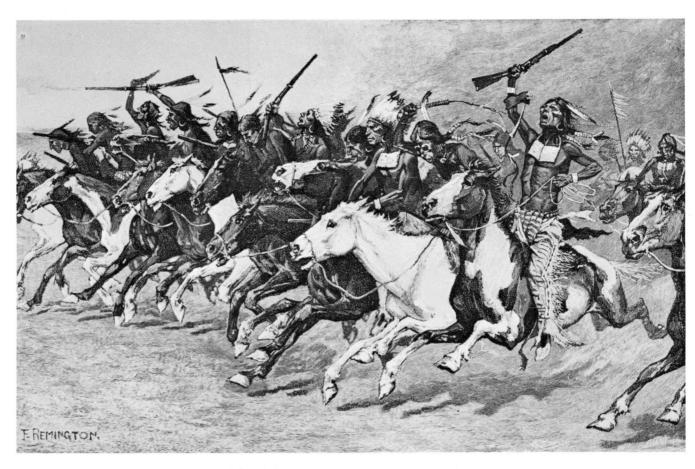

105. SIOUX—CHARGING THE SUN-POLE

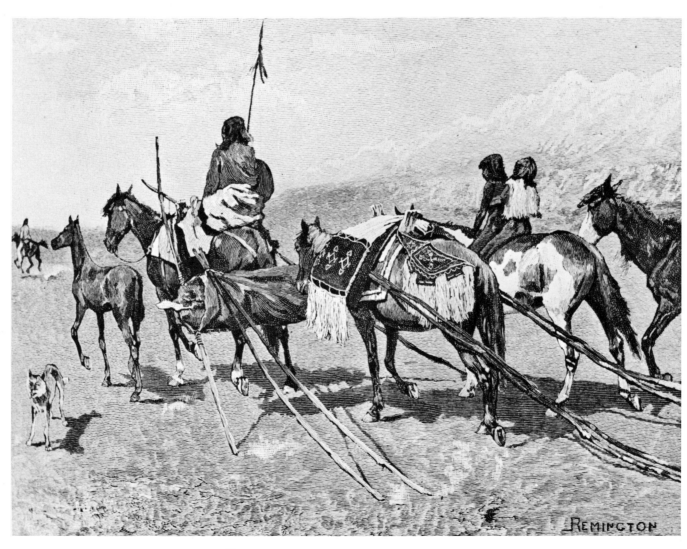

106. SIOUX—GOING TO THE SUN-DANCE

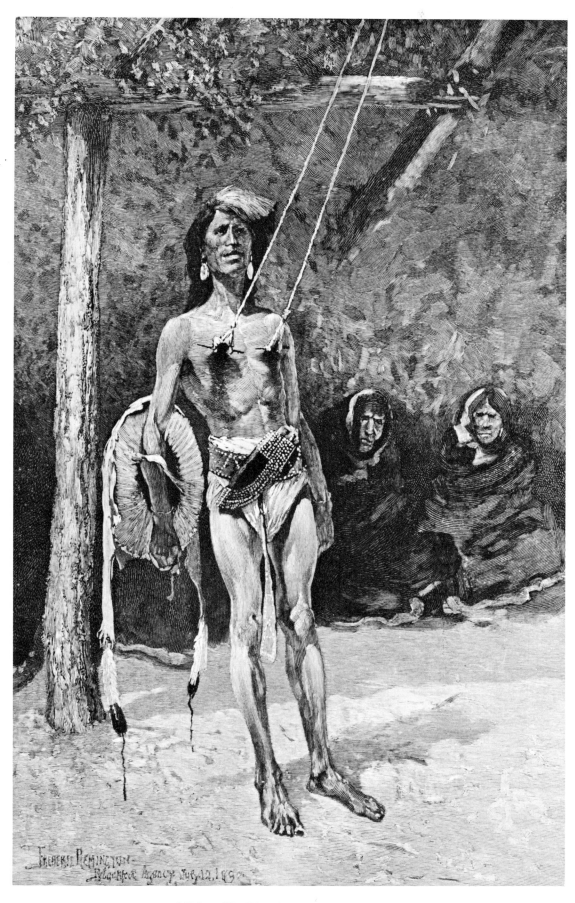

107. ORDEAL OF THE SUN DANCE

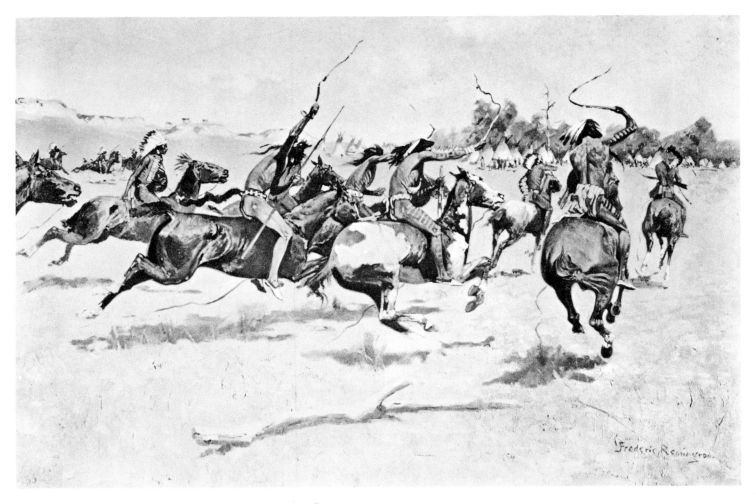

108. THE PONY WAR DANCE

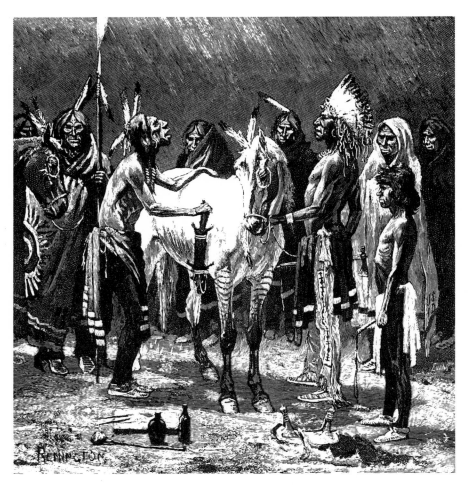

109. MAKING MEDICINE PONIES

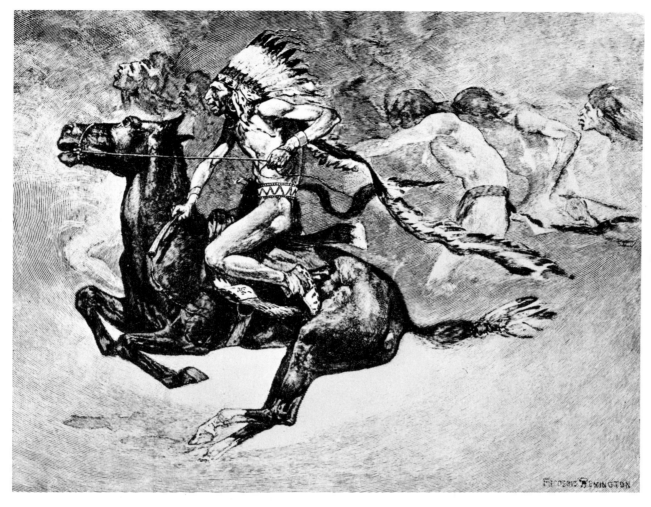

110. A FANTASY FROM THE PONY WAR DANCE

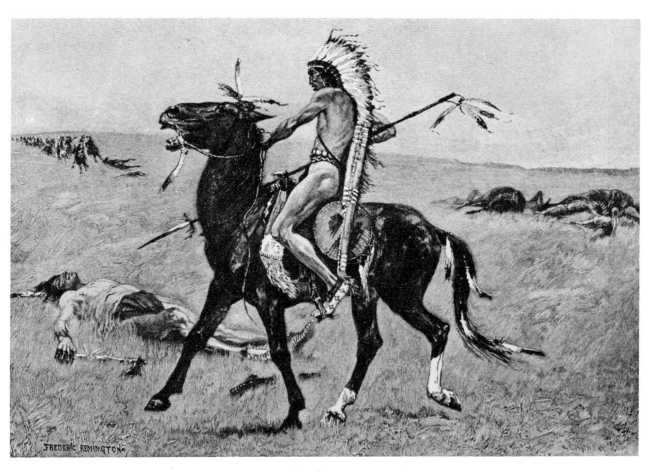

111. AN OLD TIME NORTHERN PLAINS INDIAN—THE COUP

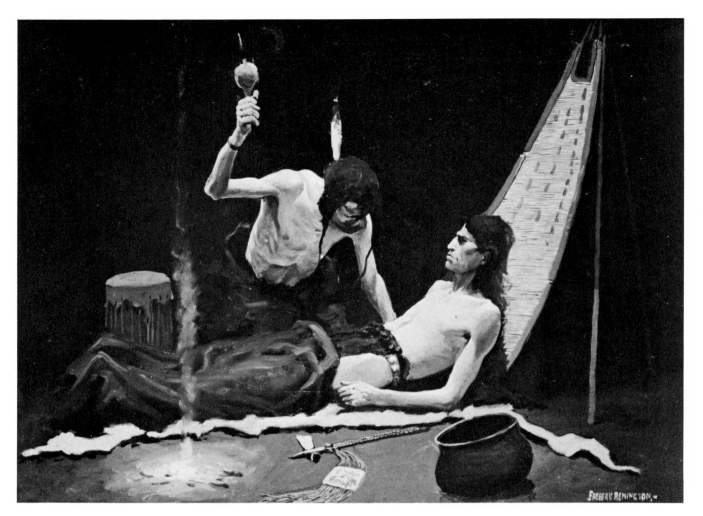

112. "I CAN HEAL YOU, HIAWATHA."

ONE of the finest literary expositions on the culture and ethos of the primitive American Indians by a white man is Henry Wadsworth Longfellow's book-length verse *The Song Of Hiawatha*. Allegorical as this writing is, it was based on one of the traditions prevalent among the North American tribes. It is true that no Indian storyteller ever told the story as Longfellow expressed it, and there are bits woven into it which the poet himself footnoted as drawn from many sources. The poem begins with the explanation: *"Should you ask me, whence these stories? Whence the legends and traditions . . . With the curling smoke of wigwams, With the rushing of great rivers . . . I should answer, I should tell you, 'From the forest and the prairies, From the great lakes of the Northland, From the land of the Ojibways, From the land of the Dacotahs . . .'"* One of the best known and most cherished poetic works in American literature, it is as appropriate to the Plains Indians and their tribal beliefs as any such work could be; and it should be required reading for an understanding of these people and their involvement in the struggle against the conquest of their native land by the white man.

Hiawatha was written in 1854–55. The book was published November 10, 1855, in text without pictures. It was a small voice, at a time when the American conquest of the West

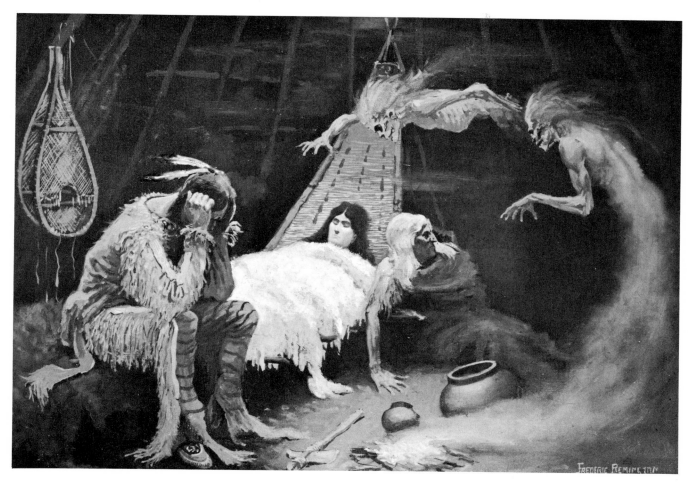

113. THE DEATH OF MINNEHAHA

was flaring into a bitter and bloody conflict, when the most popular American attitude was: "The only good Indian is a dead Indian." In spite of criticism and condemnation from many sources, however, *Hiawatha* became very popular and its popularity increased with the passing of time.

On December 3, 1888, Eva Caten Remington wrote a letter to her husband's maternal uncle and her favorite relative, Henry D. Sackrider, giving a chitchat account of what the striving artist was doing. As an item of family information, she wrote: "Fred has just left for Boston as he wants to get there in the morning. He goes to see Houghton, Mifflin and Co. about illustrating 'Hiawatha' and hopes to make satisfactory arrangements. Ever since he has done any illustrating he has dreamed about doing that and now he hopes he can. . . . (Signed) Missie!"

Frederic Remington had a sympathetic attitude toward the Indians, gained from personal friendships with many of the tribesmen and an understanding of them as a people. He did twenty-two oil paintings, reproduced as full-page photogravures, and 379 drawings for the first illustrated edition of *Hiawatha*, published in 1891. His pictures added a great deal of meaning to a literary classic, as well as providing Remington a very important step toward recognition as an artist.

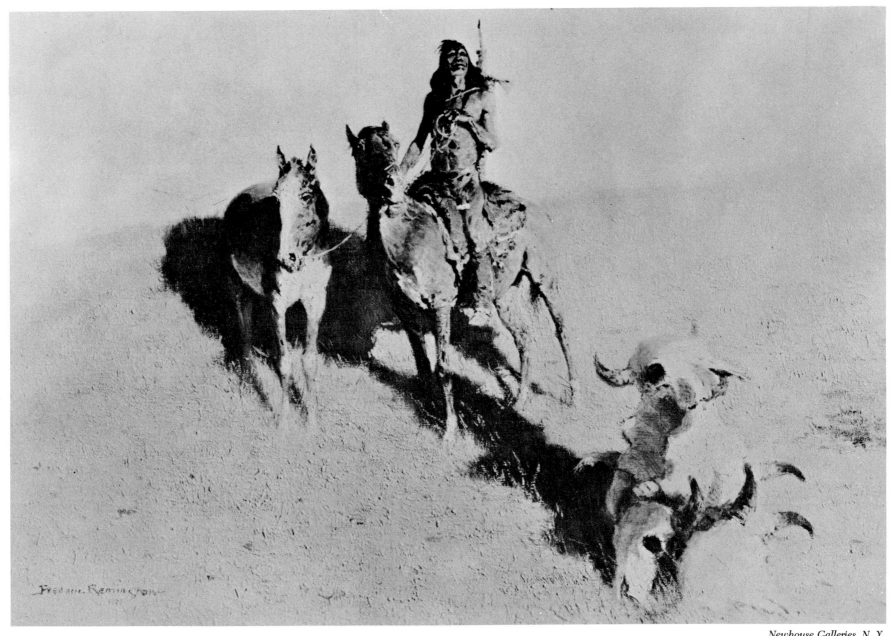

114. EDGE OF THEIR HUNTING GROUNDS

WANDERING nomads though most of the Plains Indians had been for centuries, the tribes usually had their central villages to which they could return with a homelike feeling; and each had a more or less well defined area that was considered its own territorial domain. The location of these shifted from time to time and the size varied in accordance to the strength and aggressiveness of their warriors, as compared to those of their neighbors. Sometimes the tribes were pushed on by encroachment of stronger enemies and sometimes they moved on to find new hunting grounds or just because of their wandering instinct.

The borderland of the other tribe marked the edge of their hunting ground. These boundaries were generally well-defined geographical landmarks such as a river or ridge of hills. Out on the open prairie they sometimes erected markers of sun-bleached buffalo skulls or piles of rock. These were a warning and challenge to their enemies and were generally respected by the other tribes. To trespass was considered justification for warfare. When the white man came, and trespassed, he was no exception.

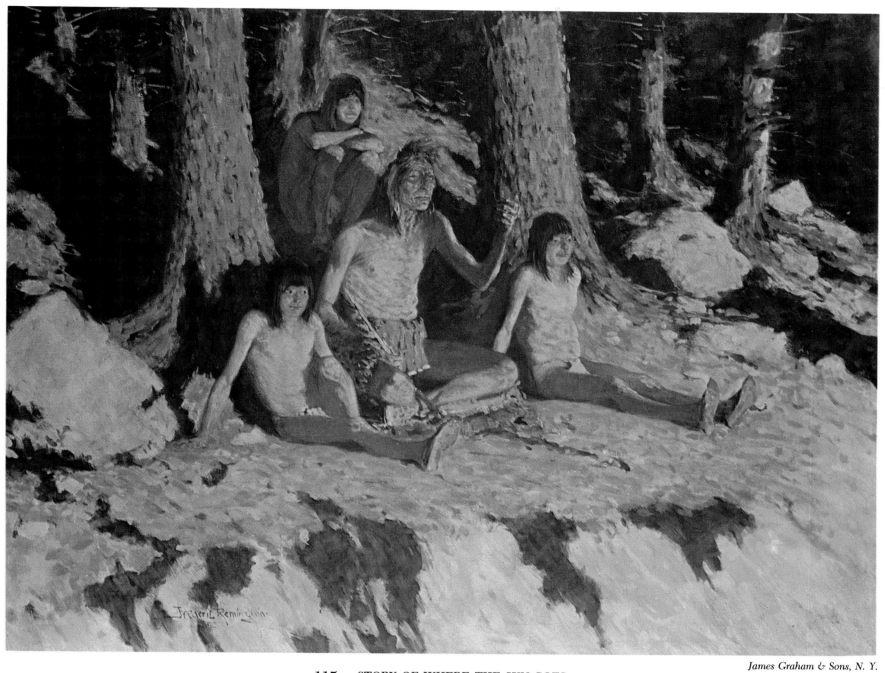

115. STORY OF WHERE THE SUN GOES

James Graham & Sons, N. Y.

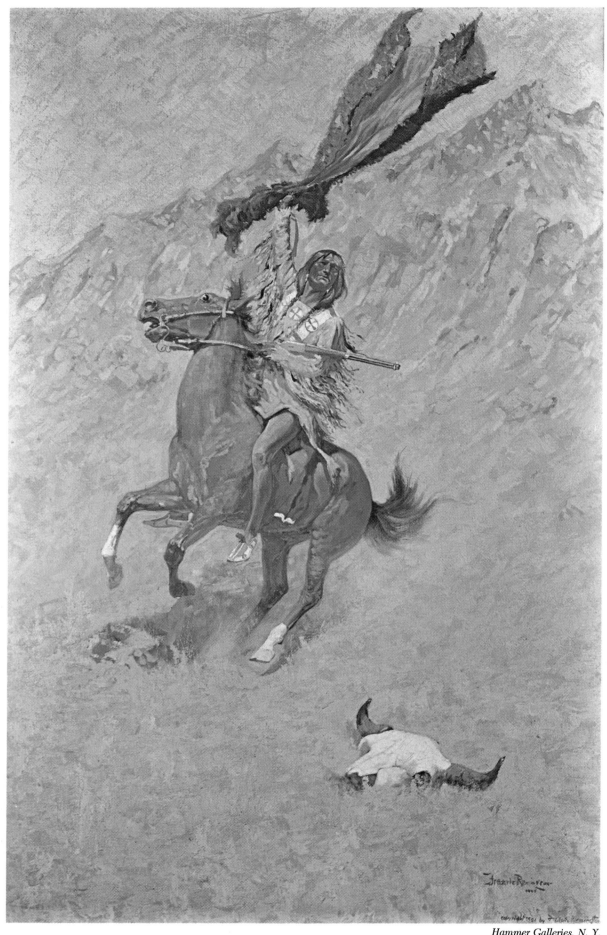

Hammer Galleries, N. Y.

116. IF SKULLS COULD SPEAK

CHAPTER VI

When the Land Was Still Theirs

THE Indians were friendly toward the first white men who visited the western Plains. The Lewis and Clark Expedition was well received by nearly all of the natives they met as they traveled from tribe to tribe. George Catlin was always made welcome when he visited many of the tribes from present Montana to Texas. Others had similar experiences. As long as the white men were friendly visitors and until they became undesirable trespassers upon the traditional rights of the Indians, there was little trouble between them.

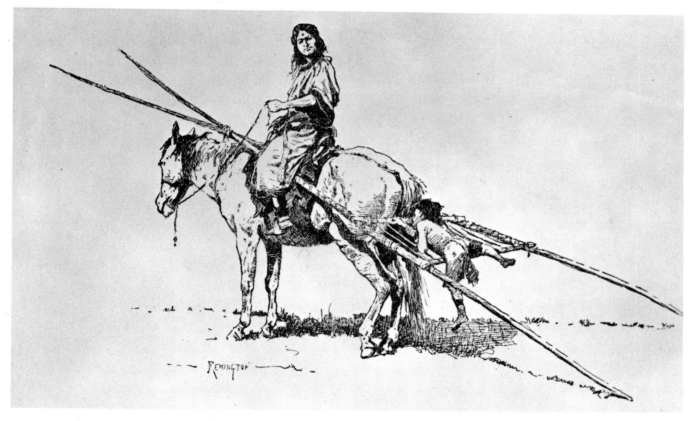

118. INDIAN MOTHER AND BOY—BLACKFOOT

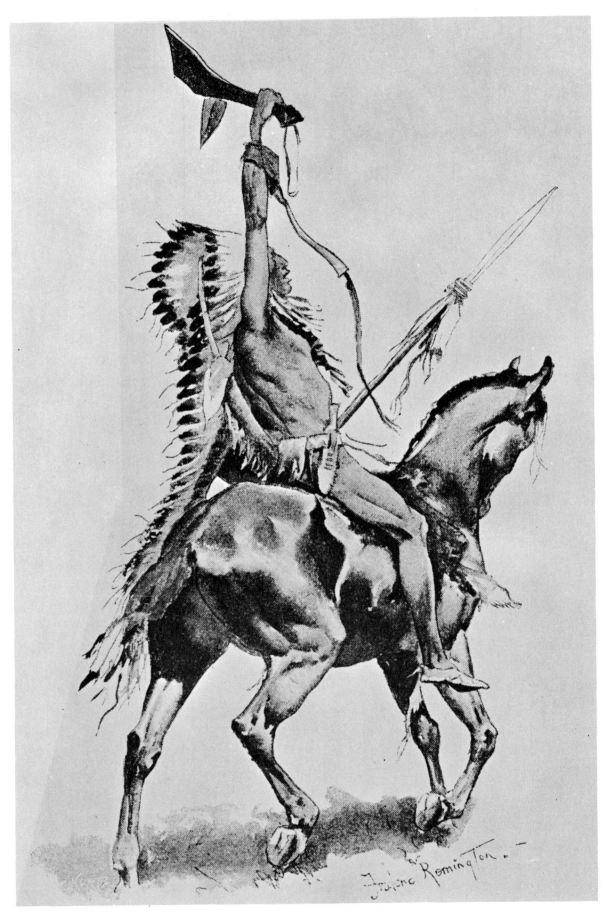

119. A WAR CHIEF OF THE SIOUX—PROUD AND DEFIANT

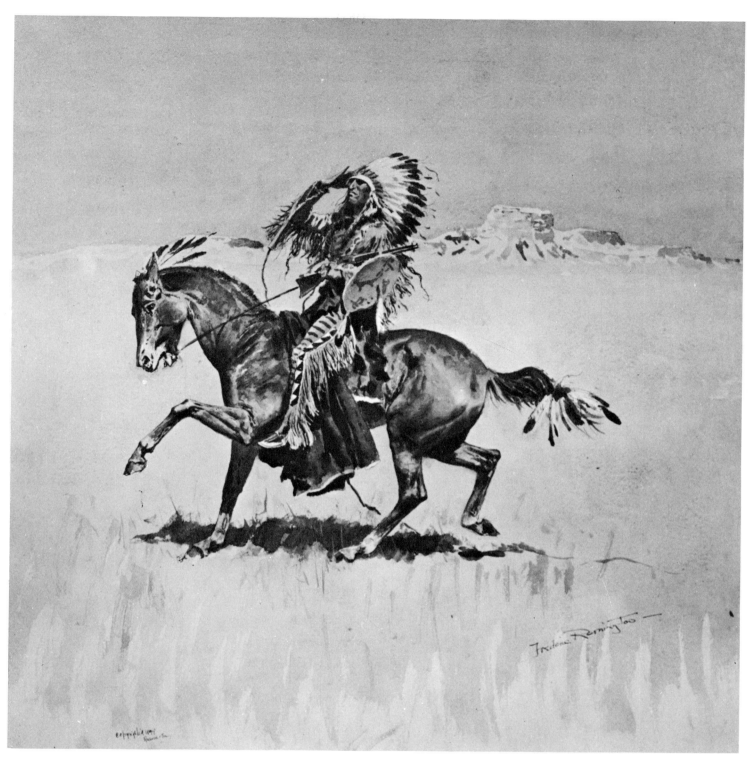

120. A CHEYENNE WAR CHIEF

ALTHOUGH the individual was subordinate to the communal responsibilities of his tribe, there was no lack of pride in personal prowess among the warriors. This was particularly true of those who had risen to become war chiefs of their people. In most instances the rank had been gained in the field of warfare. These became the despotic leaders and custodians of tribal dignity and tradition. They wore their badge with rare pomp and gusto—in the council lodge, on parade, and on the field of battle—and to boast about their feats was a virtue in which they were equally accomplished.

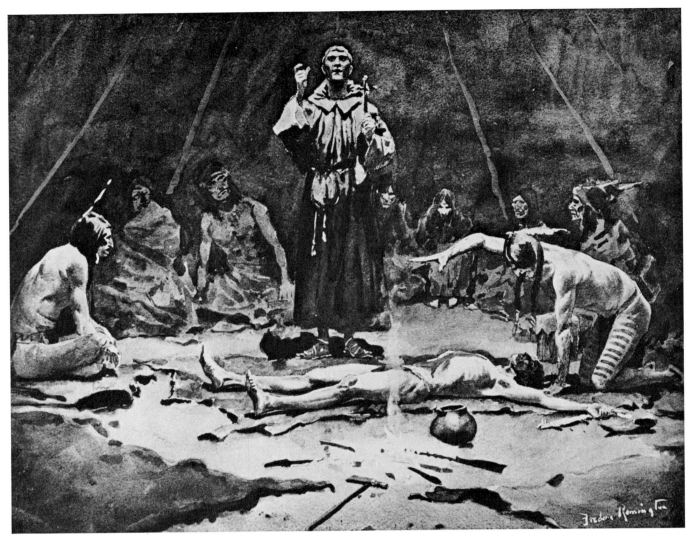

121. THE MISSIONARY AND THE MEDICINE MAN

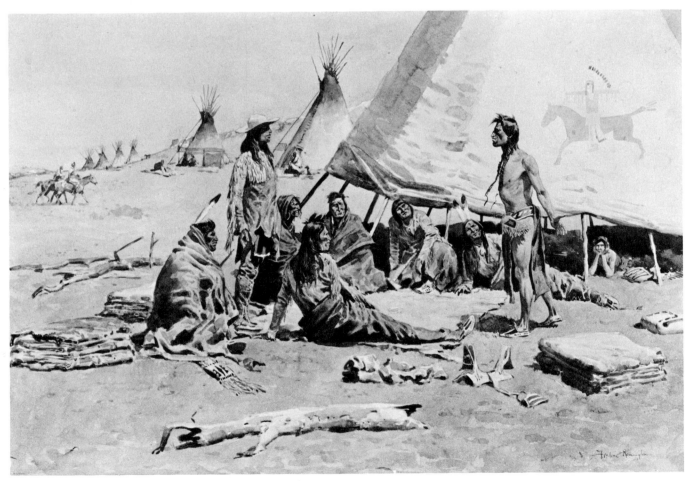

122. BARTERING FOR A BRIDE

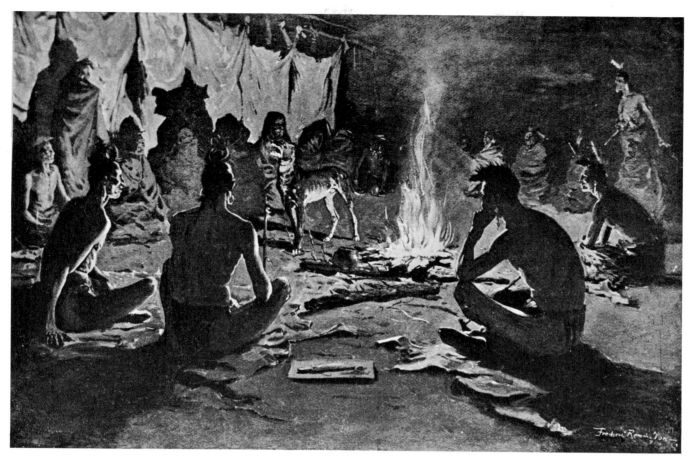

123. "YE SPIRIT DOG . . . SAID IT WAS TIME."

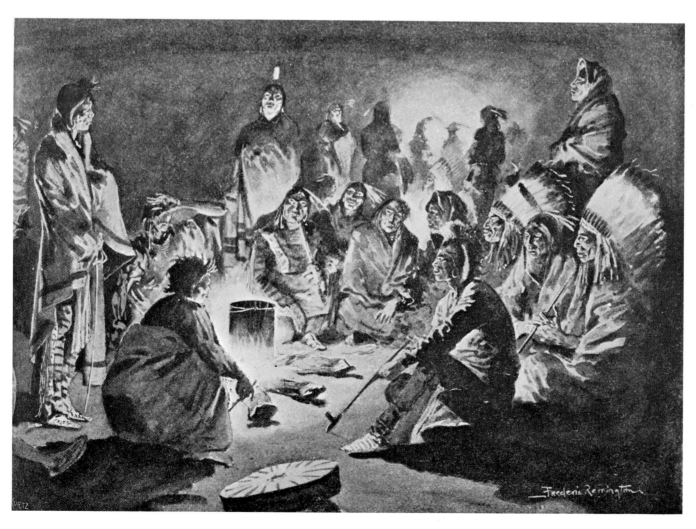

124. BOASTING IN INDIAN FASHION

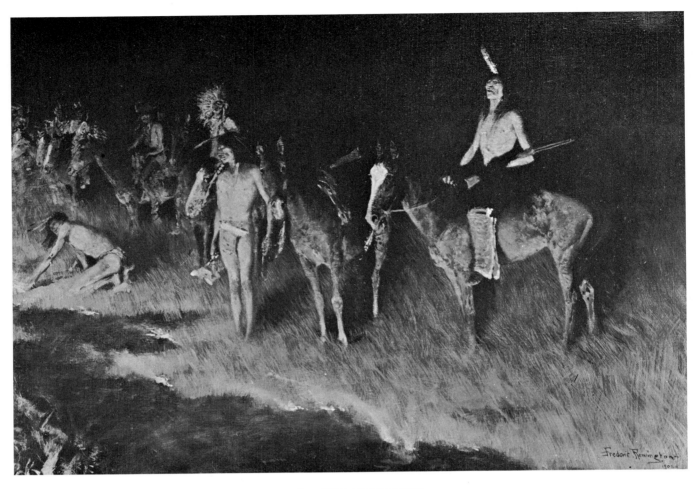

125. THE GRASS FIRE

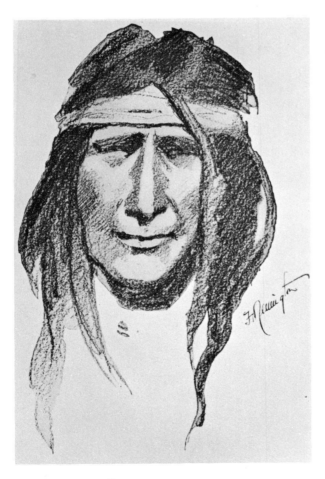

126. AN INDIAN MAN

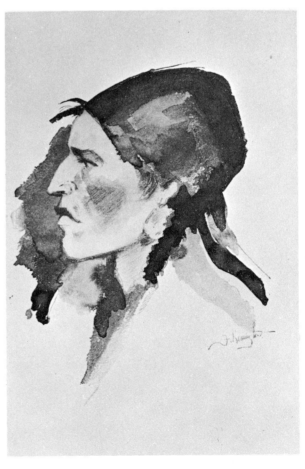

127. AN INDIAN WOMAN

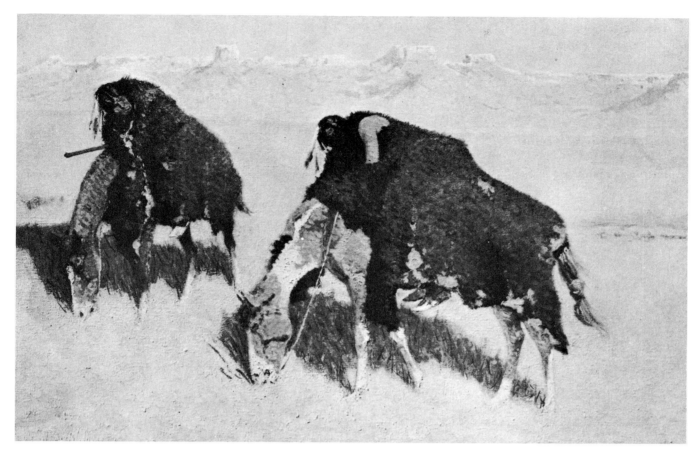

128. INDIANS SIMULATING BUFFALO

FROM long experience in hunting wild game, as well as involvements in their primitive type of warfare, the Indians had learned the wisdom of being wary, cautious, and prepared for the unexpected. In their early relationships with the white men they had been suspicious long before they adopted any hostile attitude.

Drawing from a common hunting practice found advantageous long before the days of the horse or the white man, as a means of stalking close to game without arousing their suspicion, the scouts sometimes camouflaged themselves in the same manner as when buffalo were scarce, spooky, and in open spaces where it was difficult to approach within arrow range. With a softly tanned buffalo robe draped over his own body and spread back over the rump of his pony, as he crouched forward and let the horse feed leisurely across an open area, a hunter presented the appearance of a live buffalo in the distance. With the Indian's extraordinary fine eyesight they could in this manner approach close enough to watch a camped wagon train or group of newly arrived white men to find out what they were doing, without their presence being known. Later on they used this same method in scouting the columns and camps of the U. S. Army units that were sent to protect the immigrant wagon trains and pioneer settlers, and in planning attacks against the white men.

When the grass was dry and there was a favorable wind, they sometimes started a prairie fire to drive intruders from their tribal territory. This was a better way to get rid of undesirables than launching a battle attack against them.

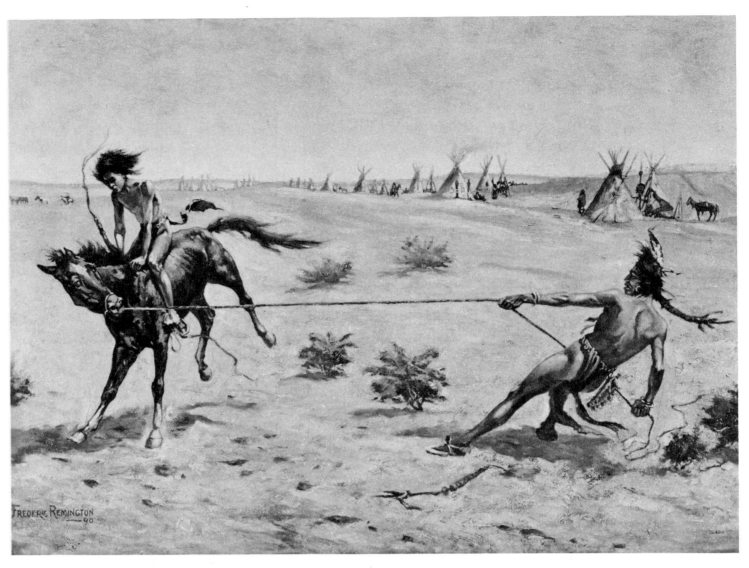

129. INDIAN METHOD OF BREAKING A PONY

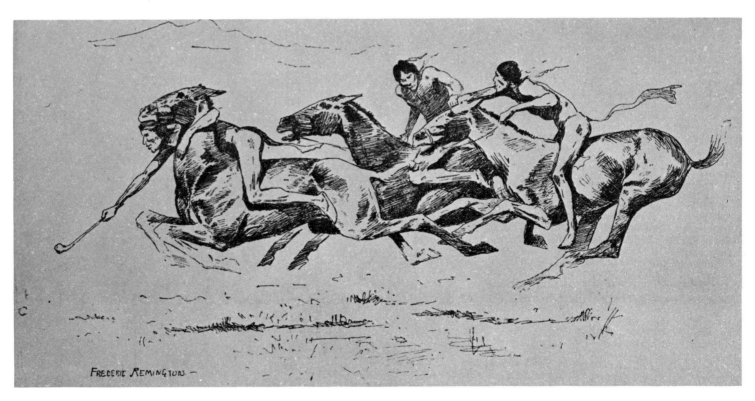

130. THE INDIAN GAME OF POLO

THE Plains Indians were the finest horsemen on earth. This was attested by some of our best U. S. cavalry leaders during the organized warfare against the red warriors in the West. The vast grass-covered plains were an ideal habitat for horses and they thrived and multiplied remarkably. Even more remarkable was the manner in which the Indian adapted himself to the horse and the horse to his own advantages. The Indian took to his back as though they had been brought up together through a thousand generations.

The Indian bred and trained the horse extremely well, for the uses for which these animals could serve him best. The finest stock was reserved for buffalo hunting and warfare. Some of these horses were as well trained as the best quarter horses of today. Ridden bare-back by almost naked riders, with both hands completely occupied with the use of weapons, the horses were taught to respond instantly to the slightest pressure of the rider's leg. Even the muscular reaction at the instant of shooting an arrow or thrusting a spear was sufficient to send the well-trained pony swerving aside to avoid the horns of a wounded buffalo or the retaliatory thrust of an enemy. Sometimes in warfare the Indians used the horse as a shield for his own body, riding the racing steed like a tick on the animal's protected side.

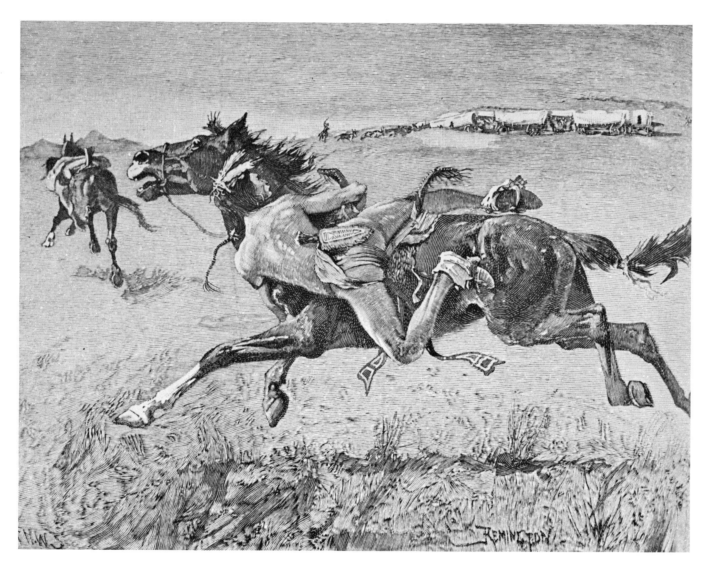

131. A PERIL OF THE PLAINS

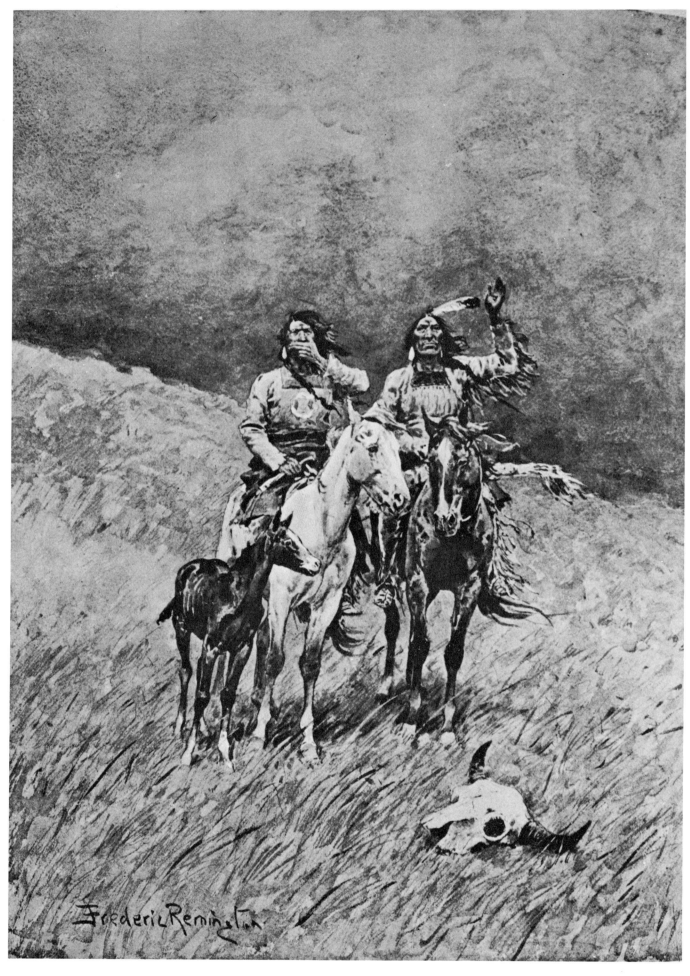

132. THE MYSTERY OF THE THUNDER

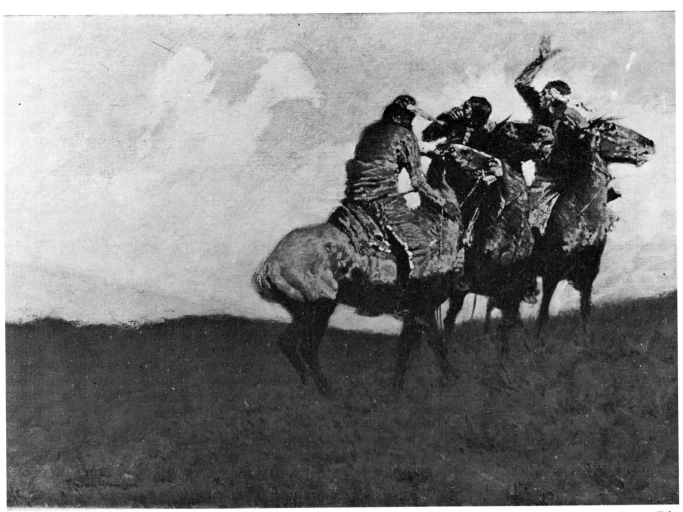

133. WITH THE EYE OF THE MIND

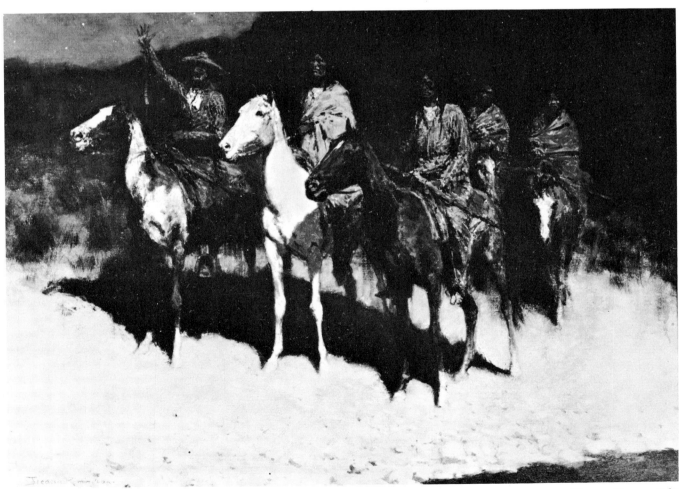

134. MOONLIGHT SCOUTING PARTY

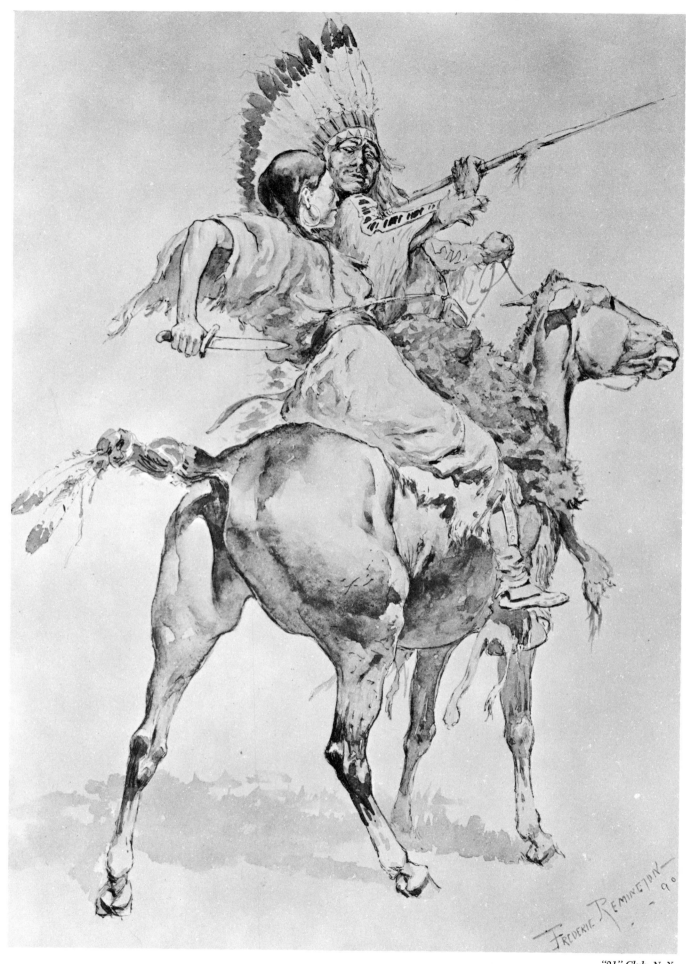

135. THE ADVENTURE OF OLD SUN'S WIFE

"21" Club, N. Y.

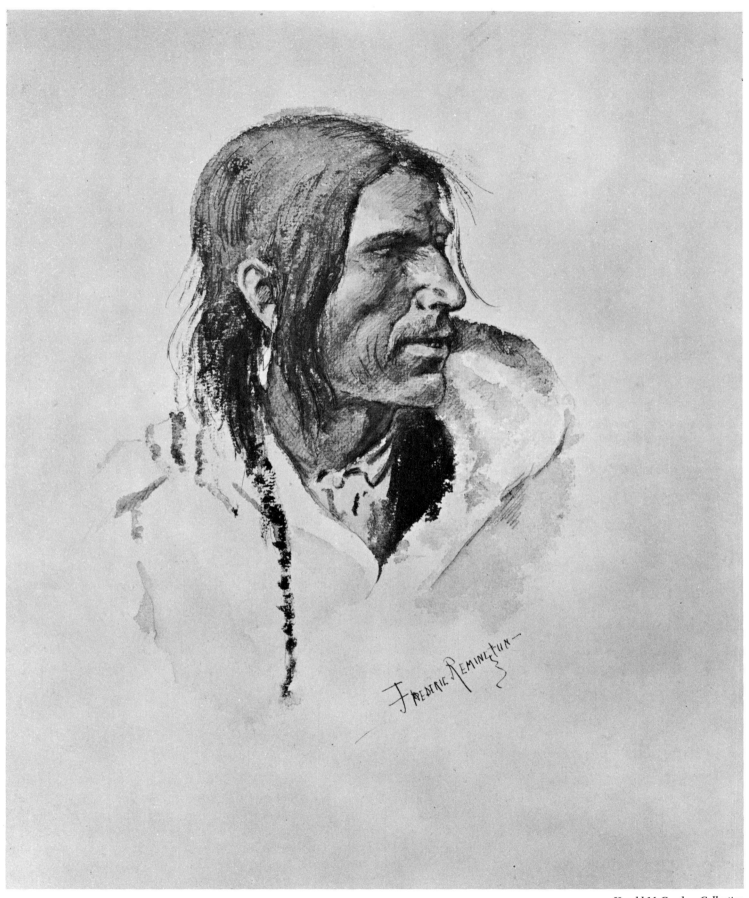

Harold McCracken Collection

136. A HUDSON BAY MAN

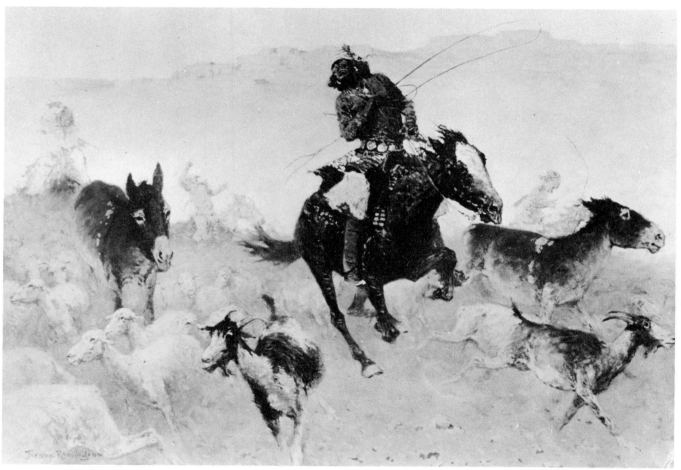

Newhouse Galleries, N. Y.

137. THE NAVAJO RAID

O N THE southern Plains and in the mountains of the Southwest, the Indians had the
advantage of previous experience with the conquistadors and Spanish colonials from
Mexico, through a considerable period before the *americanos* began invading their native
land. The old fire of Spanish conquest had died to smoldering embers, as one dream
of virgin treasure after another had evaporated into myth. However, a large segment
of the continent had come under the imperious rule of the early invaders, and, unproductive
though most of it had proved to be, there were those who held tenaciously to this frontier
dominion. Most of the communities had their well-entrenched oligarchy of despotic officials
who had grown relatively fat on the crumbs of industry and tributes imposed upon the
people. For the most part their pretense of governmental justice was self-determined and
strongly enforced by their own constabularies of military irregulars. In other areas the
padres had become the masters of tiny domains of their own, centered in large, bare adobe
churches, surrounded by subservient little native villages. Then too there were some of the
Indian tribes, such as the Apaches, who were too wild and independent for even the
Spanish lords to control.

When the *americanos* came, the Indians had known the meaning of oppression by one
invader long enough to rise up with bitter hatred against another, and the Spanish colonials
were compelled to fight to retain what they had gained.

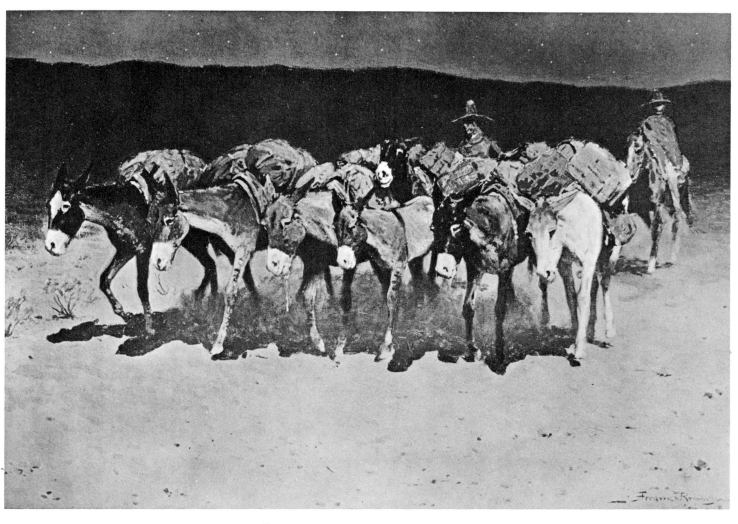

138. AN EARLY START FOR MARKET

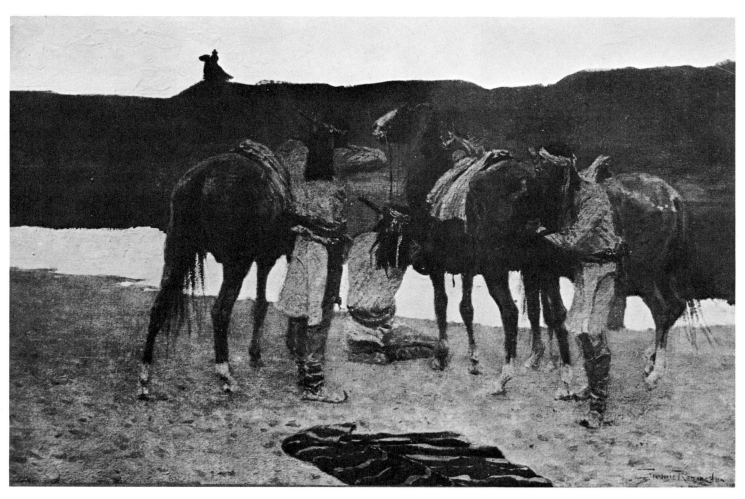

139. SHADOWS AT THE WATER HOLE

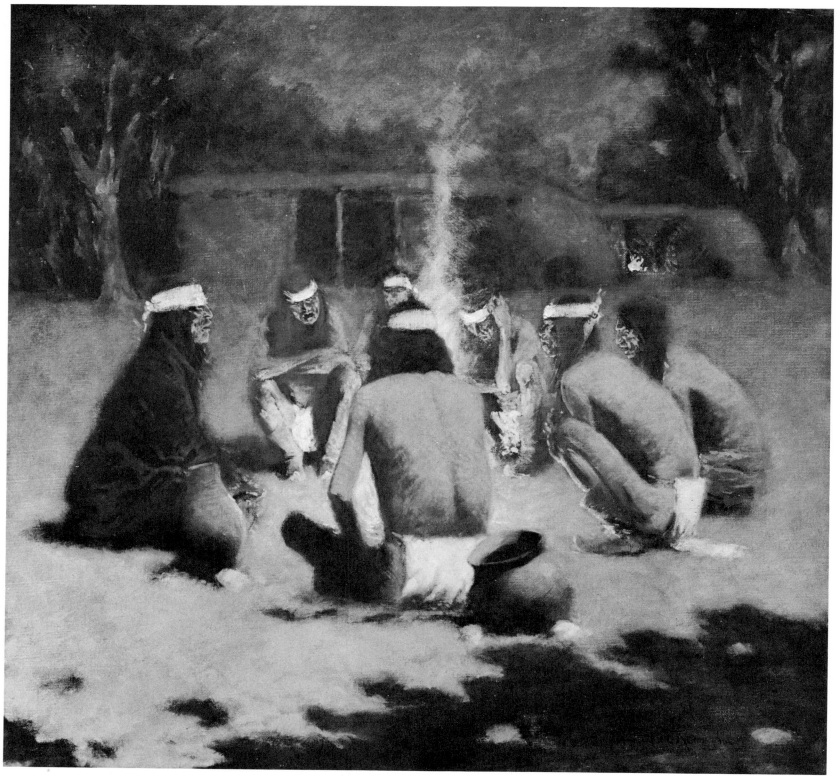

140. APACHE MEDICINE SONG

THE name Apache means "enemy." They were notorious and proud of their warlike disposition, hostile and defiant toward all others, and scourge of human destruction wherever they roamed. When their leaders chanted the tribal medicine song, death was in the making.

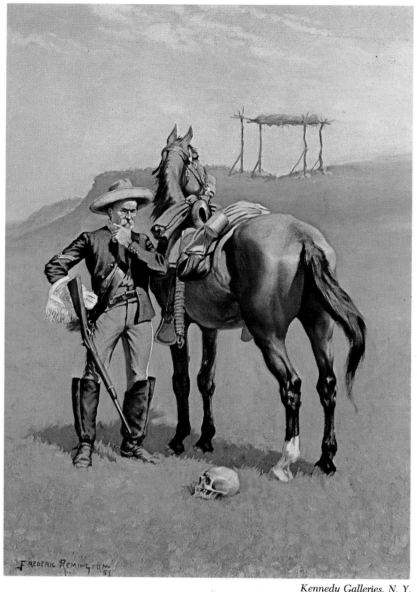

141. A TROOPER'S THANATOPSIS

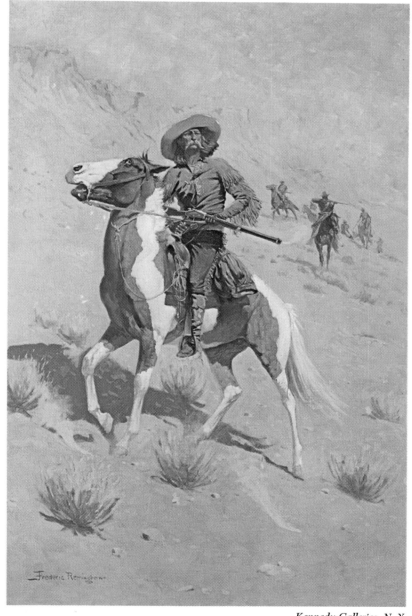

142. THE SCOUT

M. Knoedler & Company, N. Y.

143. "HALT—DISMOUNT!"

CHAPTER VII

Conquest for Empire

THE first United States military escort across the Great Plains was as early as 1829. This was the result of petition by those involved in the Santa Fe trade. But the army escorts were not permitted to go farther than the boundary with Mexico, just beyond the present state line of Colorado. From there on, for more than a third the distance to Santa Fe, the caravans were at the mercy of their own protection against the Indians as well as Mexican renegades. Up to this time, the majority of the trading expeditions had met with disaster. The military escort plan was a failure and was abandoned until 1843, although the American adventurers continued to go out over the Santa Fe Trail.

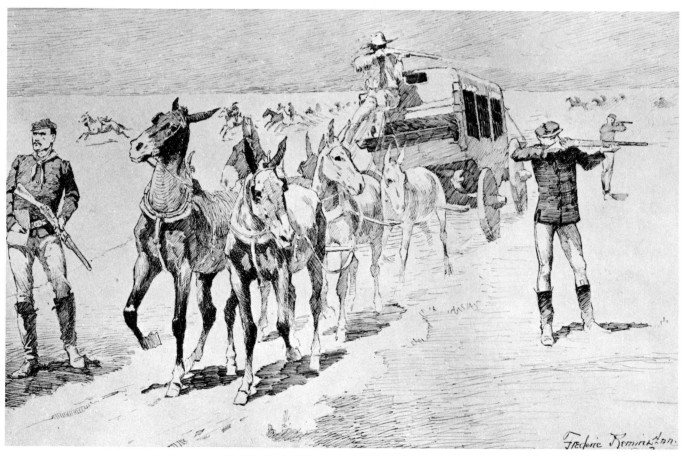

Whitney Gallery, Cody

145. THE FIGHT WITH THE STAGE COACH

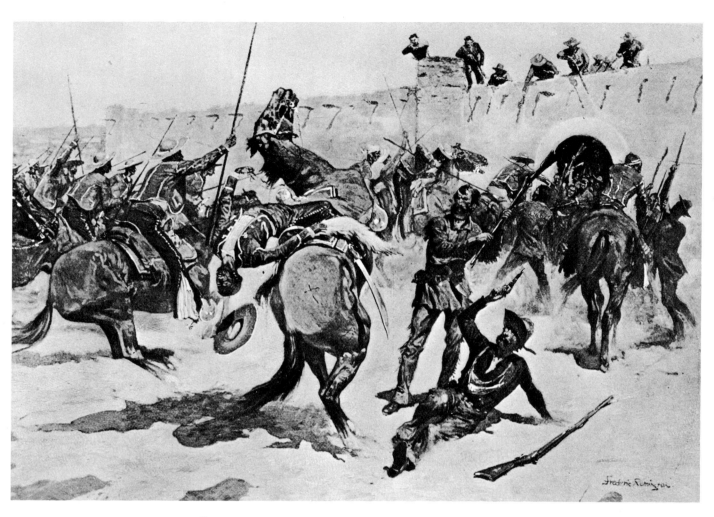

146. THE CHARGE AND KILLING OF PADRE JARANTE

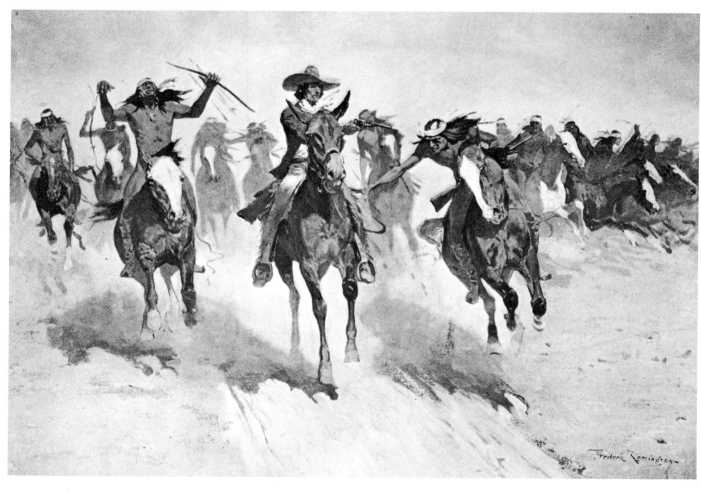

147. AN INCIDENT WITH APACHES

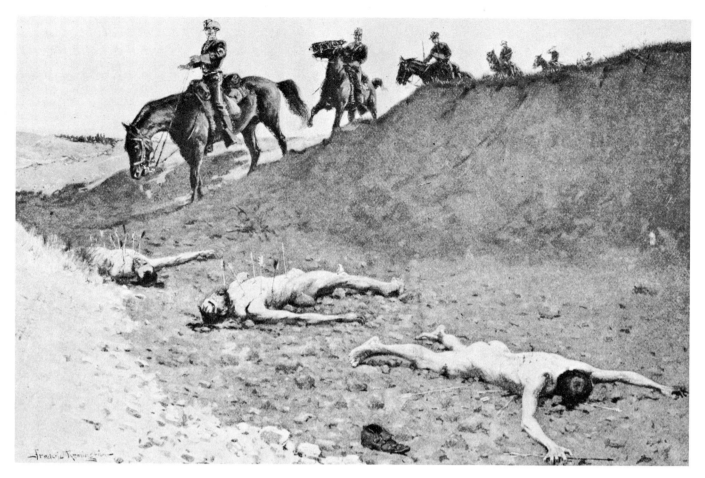

148. "THREE MEN . . . FULL OF ARROWS."

As THE Santa Fe trade continued to increase, in spite of all its vicissitudes, the Comanches, Pawnees, and Apaches continued to intensify their depredations against the mule and wagon trains that persisted in pushing their way westward. It was firmly believed that the Indians as well as the Mexican renegades were largely incited to their devilish acts by the Mexican officials, who themselves held a jealous hatred against all *americanos*. It was not uncommon for those who had survived the long journey over the Santa Fe Trail, to be permitted to dispose of the goods they had protected and brought to the Mexican colonial market, and then be imprisoned for months as spies. Furthermore, bands of Mexican irregulars were attacking and looting the caravans and making frontal attacks upon the trading posts that the Americans were beginning to build along the indefinite frontier border between the two countries.

The United States Government had made its first move toward possible acquisition of the Mexican-controlled region in the Southwest as early as 1834. At that time the recently organized First Regiment of Mounted Dragoons was sent westward from the outpost Fort Gibson, in present Oklahoma, to reconnoiter the Mexican military and Indian situations along the border. That expedition was not particularly successful, and nearly one-third of the personnel were lost, mostly from illness contracted on the undertaking. Subsequently, the Government had been reluctant to make any antagonizing show of force, and the pioneers were left largely to their own means of protection.

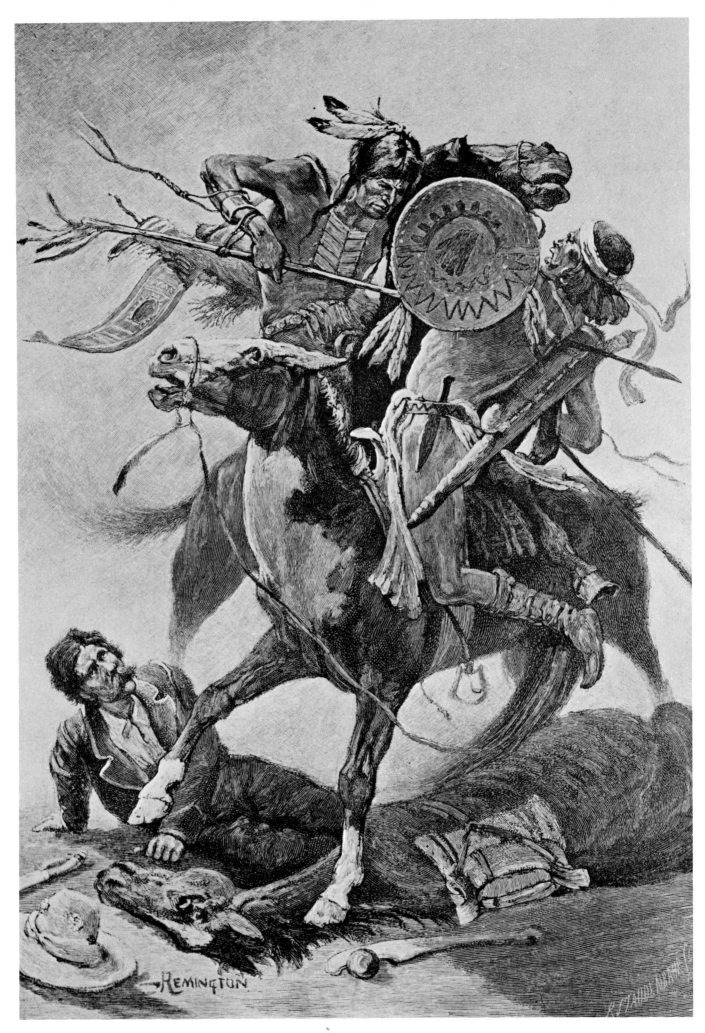

149. THRUST HIS LANCE THROUGH THE BODY

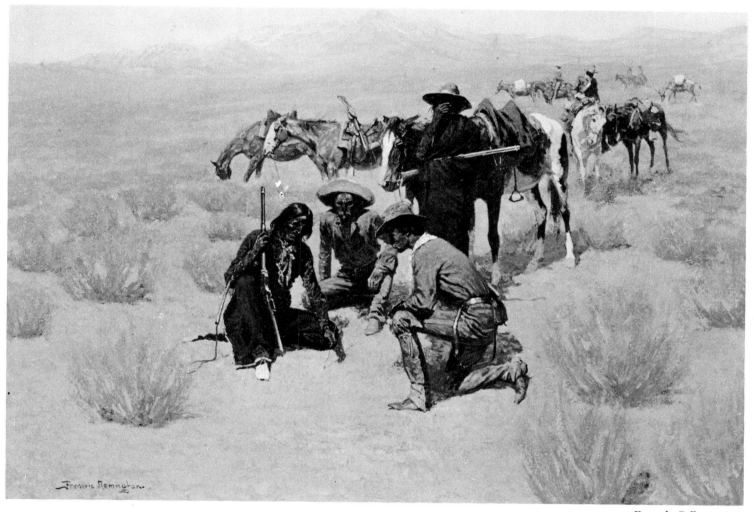

150. THE MAP IN THE SAND

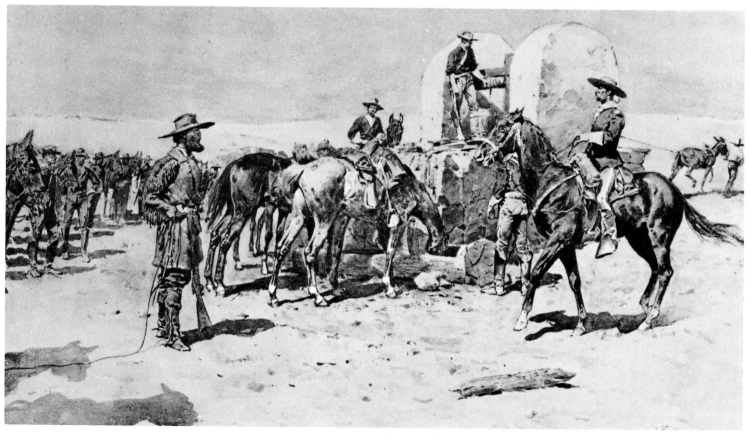

151. THE WELL IN THE DESERT

THE Southwest was more dangerous and difficult for American pioneers than the Northern Plains. The Spanish and Mexicans undertook to defend their colonial empire by whatever manner they could devise; and the Indians were more hostile and brutal in their practices of warfare. Also the country and the climate were extremely difficult and unfriendly.

Frederic Remington was intimately familiar with the Southwest. From the early 1880's to the late 1890's he traveled extensively on horseback through Arizona, New Mexico, and western Texas. He accompanied numerous details of the famous U. S. Tenth Dragoons on assignments to track down and apprehend or kill groups of Apaches who had been on killing sprees. He knew what it was to be under fire from these desert renegades, and the fear of ambush and sudden death in the darkness of night, or capture and the worst kinds of torture. He knew the same red men, when they were playing "good Indians" on the reservations. He had experienced the biting thirst without water on the blistering desert; and the pains of struggling up and down over the mountains of rock, under a blistering sun. And he knew the rest of the people of the country, from riding with them and staying in their homes; and he had learned about the tribulations and disasters of earlier days from listening to those whose memories were still clear.

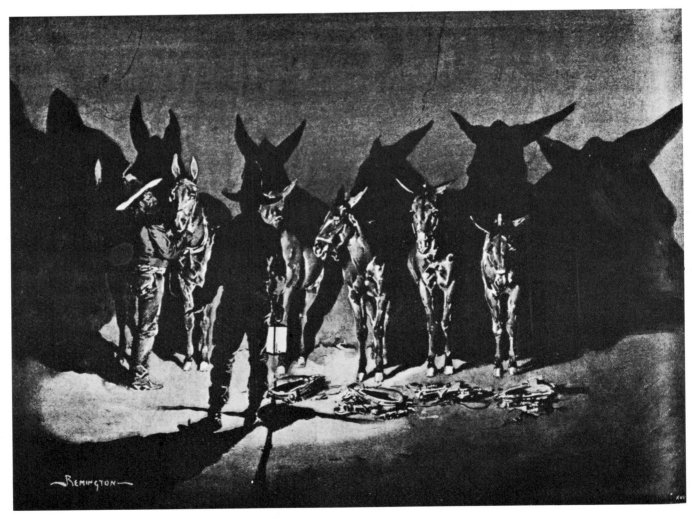

152. HARNESSING IN THE PATIO

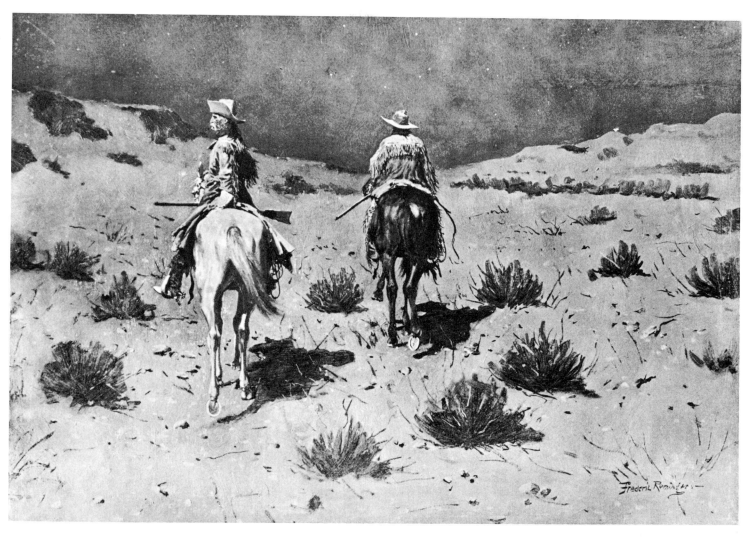

153. GOVERNMENT SCOUTS—MOONLIGHT

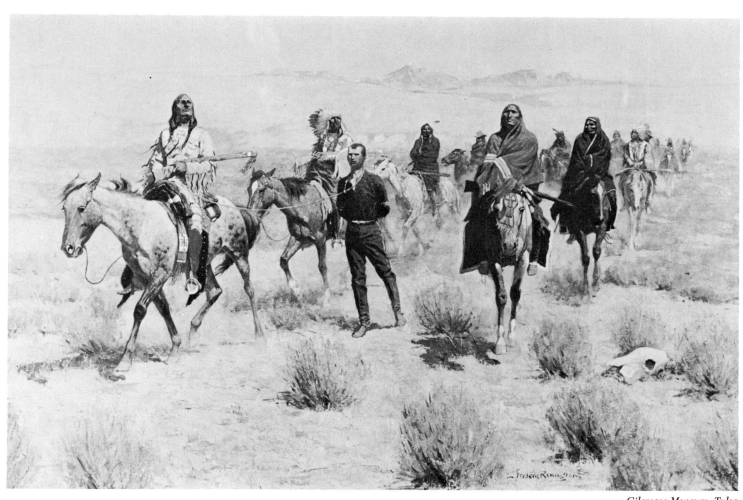

Gilcrease Museum, Tulsa

154. MISSING

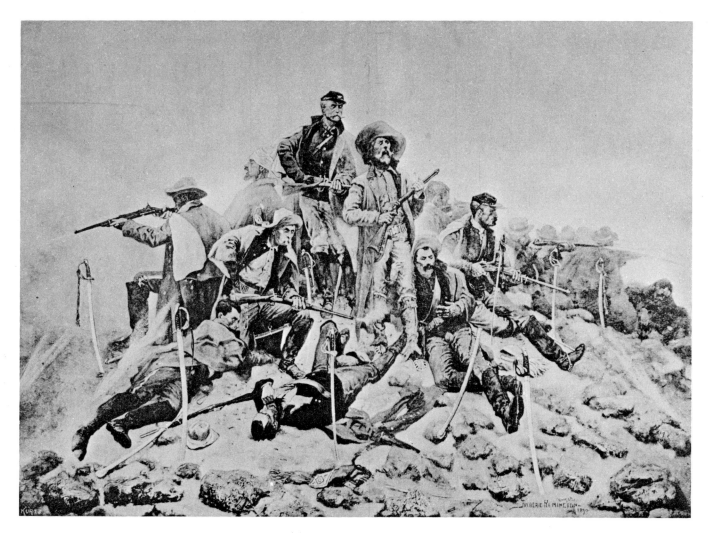

155.　THE LAST STAND

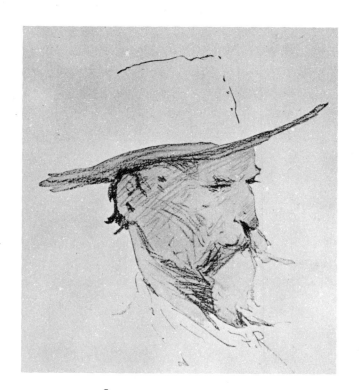

156.　A PIONEER OF EMPIRE

157.　A DEFENDER OF HIS LAND

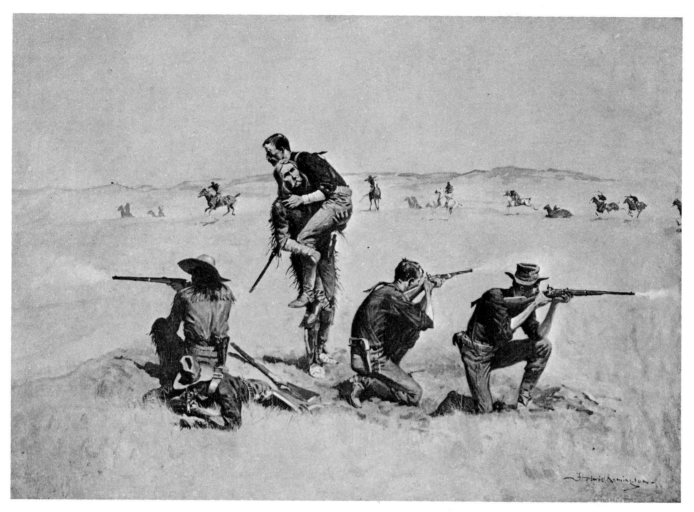

158. TWENTY-FIVE TO ONE

TWENTY-FIVE to one was the sort of odds the Indians liked best, and they were experts in contriving situations in which such odds were in their favor. This was a type of warfare in which the units of our army that were first sent into the West had very little instruction or training.

The following is taken from the text accompanying the reproduction of Remington's picture *The Last Stand* (opposite page) which appeared in *Harper's Weekly*, January 10, 1891: "Its immediate story is vividly told to the eye, and the imagination supplies the sequel. The remnants of a body of United States troops, surrounded by an overwhelming force of hostiles . . . until all that remains is for officers and men to sell their lives as dearly as possible . . . The dead and dying, the acts of aiming and firing, show that the final moments are at hand, the enemy coming in from all sides . . . There is no sign of quailing in this party of doomed men . . . The last survivors will perhaps have a spare cartridge left, with which to save themselves from capture by a merciless foe . . . How many scenes of which this is typical have been enacted on this continent . . . No one left to tell the tale."

These pictures are examples of the characterization of Frederic Remington's work as "hard as nails," although to study them is more enlightening than reading any text that might be written.

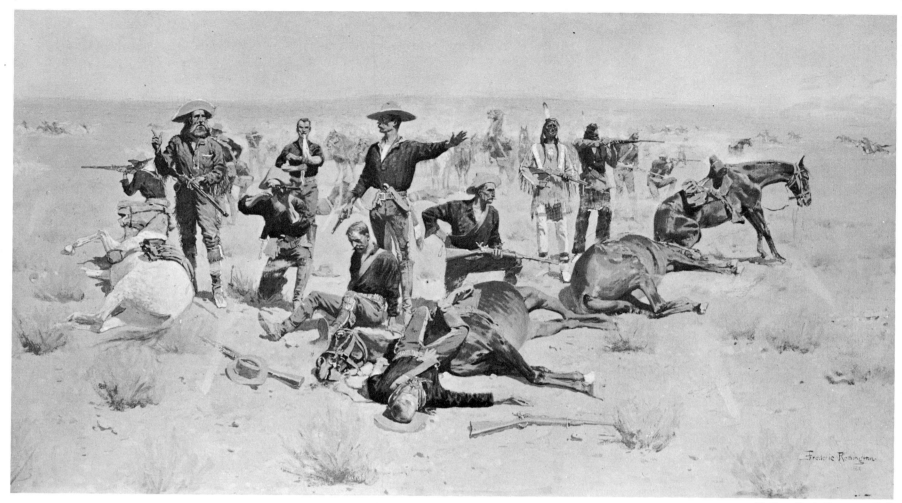

M. Knoedler & Company, N. Y.

159. SURROUNDED

IN ANY historic recounting of the Apache War, the soldier must come in for his share," wrote Frederic Remington in an article on "Soldiering in the Southwest." In this he gave his own appraisal of the U. S. Army soldier on service on the Western frontier, and it will be difficult to find a better evaluation. "No man earns his wages half as hard as the soldier doing campaign duty on the Southwest frontier. He may not do thirteen dollars' worth of fighting every month (his pay), but he does marching which under special contract he might agree to furnish for $5,000 per turn of the moon. Altogether, the duties imposed on these troops are as onerous and unprofitable as any within the category of military operations . . . Their heroism is called duty, and it probably is. It is also their duty to eat the scanty fare and perchance to carry off a vicious wound or be buried in the sand . . . Oh, very matter-of-fact persons these, with no sense of the heroic, with a lack of moral fiber perhaps, rude of manners and soldiers because of circumstances once and force of habit now . . .

"Indeed, he is a strange soldier. His brass *sans* glitter, his accoutrements unblackened, he is covered with dust and much that was dust is a firmer deposit now, all plainly saying 'the regulations be damned.' His boots are red, one spur is gone, his pants are reinforced with buckskin and worn to the state of impropriety; his shirt is open at the neck, his blue coat is a dull mauve, his hat is a battered ruin, and his skin burned carmine or swarthily tanned, while a good stubble of beard completes all that is lacking to metamorphose our soldier into a veritable buccaneer."

In the same article Remington gave an equally graphic impression of the enemy Apache: "Today the Indian is mounted fresh, and tomorrow morning he is remounted on stolen stock; he can subsist himself in competition with the coyote of the desert; he has an abundance of ammunition; and at his back is a mountain stronghold known only to himself and all but impossible to his enemies, from which he sallies out, dealing a demoralizing guerrilla warfare on defenseless white inhabitants of the valley. Before the news reaches the soldiers, he has stretched miles of desolate desert behind the flying feet of his pony. Still, realizing the obstinate pursuit, he pricks on his flagging horse until the heaving flanks and faltering gait show inability to keep the terrible pace, when, with an ungrateful stab of the knife, he takes to his heels and leaves the poor panting, bleeding pony to die on the trail. Thus the animal is rewarded for his gallant effort by his fiendish rider and thus is the Apache at war even with the beasts of the field."

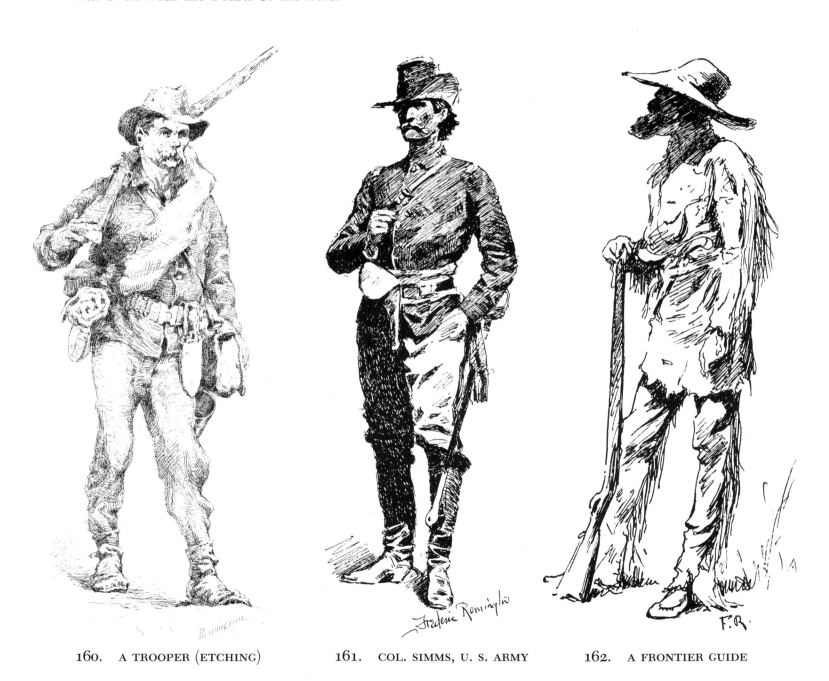

160. A TROOPER (ETCHING) 161. COL. SIMMS, U. S. ARMY 162. A FRONTIER GUIDE

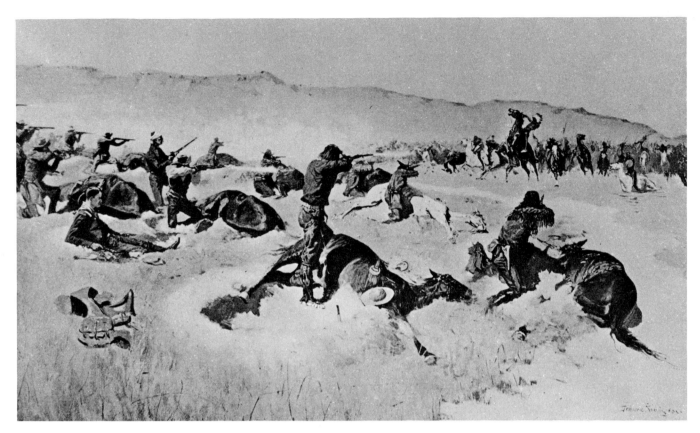

163. FORSYTHE'S FIGHT ON THE REPUBLIC RIVER—1868

THE Indian hostilities intensified throughout the West. It had become obvious to most of the tribesmen that the American conquest was going to sweep over the whole land, and the Indians everywhere rose up in defense and defiance, in their own traditional manner.

There were not enough army troops to control the situation; and as a means of self-preservation the pioneers organized their own irregular units. Some of these were aided by U. S. Army officers. One of the most historic of these was a group of fifty pioneers led by Colonel George A. Forsyth. They were operating in northern Kansas when unexpectedly attacked by about three hundred red warriors under the leadership of the notorious Cheyenne Chief Roman Nose. It was later learned that an additional six hundred Cheyennes, Sioux, and other renegades completely surrounded the small group of Americans. Roman Nose was killed in the first attack, with many of his followers. The white men were not wiped out as planned, although every horse was shot. The hostiles launched another attack, although this was repulsed. Only six of Forsyth's fifty men were killed and seventeen seriously wounded, including the colonel himself.

The nearest military post was a hundred miles away. The frontiersmen had little food, a scant supply of water, and their suffering was intense. Their only protection was their dead horses, the meat of which was also used for food. The Indians repeatedly attacked, but each time they were repulsed with heavy losses. After nine days of this hell, the Indians finally departed. Most of those still alive were too badly wounded and weak to travel, and in this desperate state they were found by a rescue party.

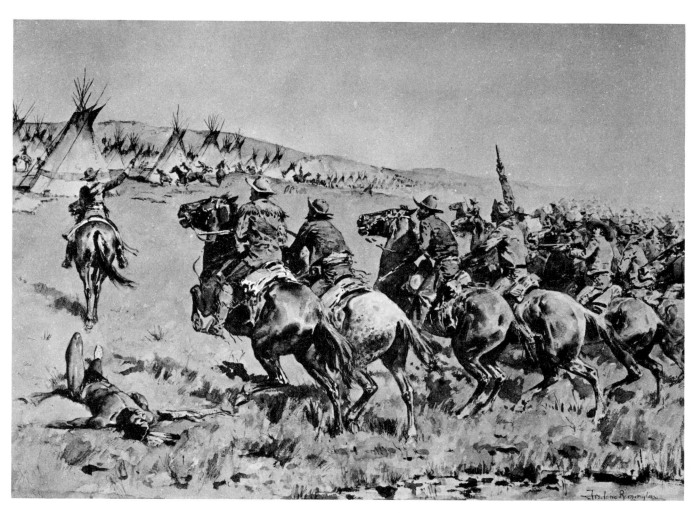

164. ATTACK ON THE INDIAN VILLAGE

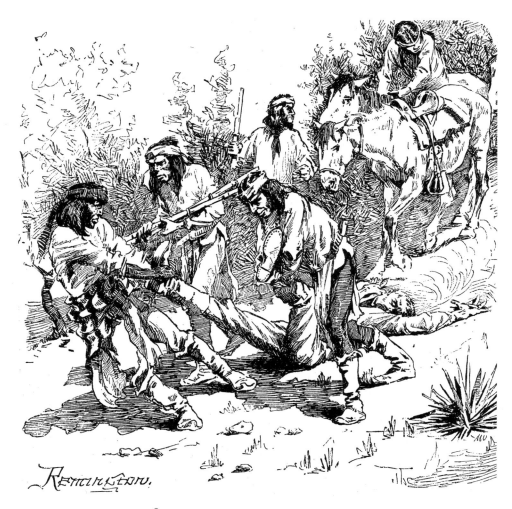

165. THE FATE OF ONE TROOPER

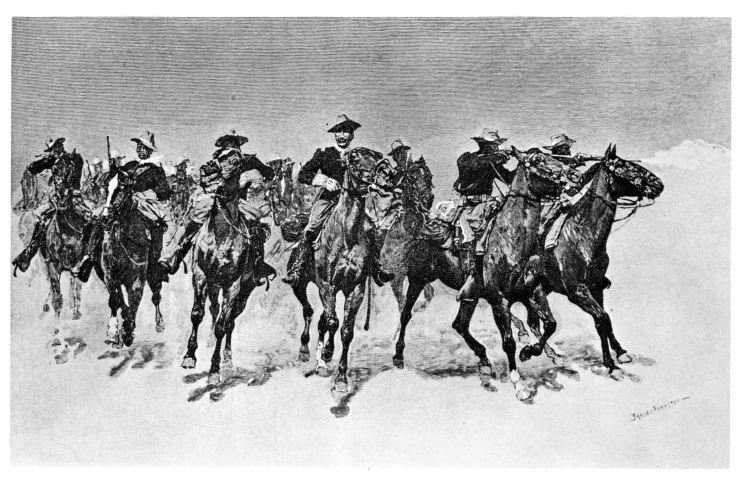

166. CAPTAIN DODGE'S TROOPERS TO THE RESCUE

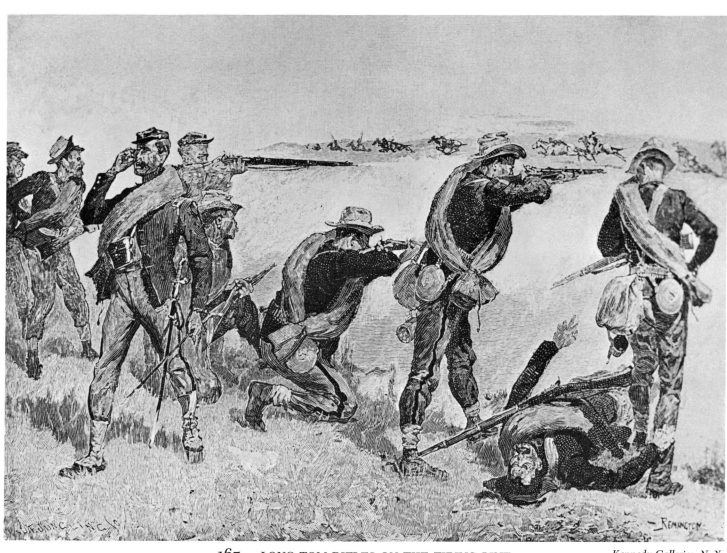

167. LONG-TOM RIFLES ON THE FIRING LINE *Kennedy Galleries, N. Y.*

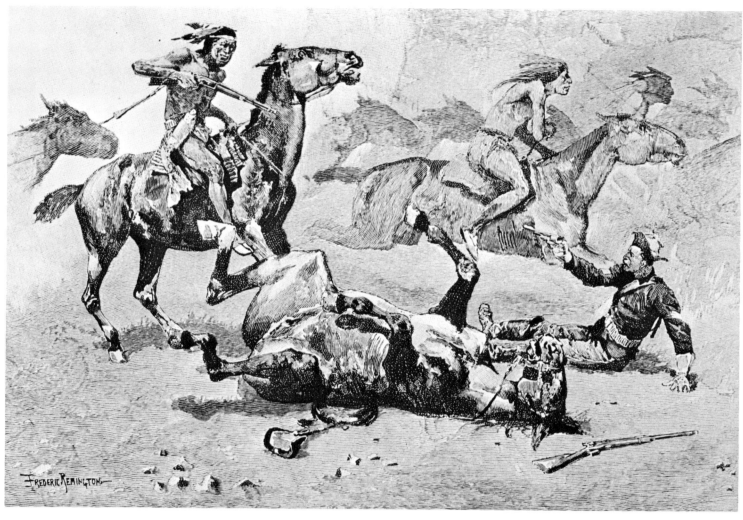

168. UNHORSED

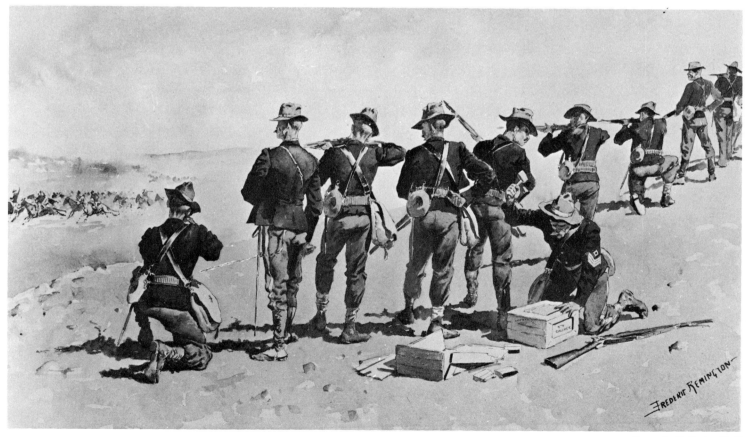

Kennedy Galleries, N. Y.

169. INFANTRY COVERING WITHDRAWAL OF CAVALRY

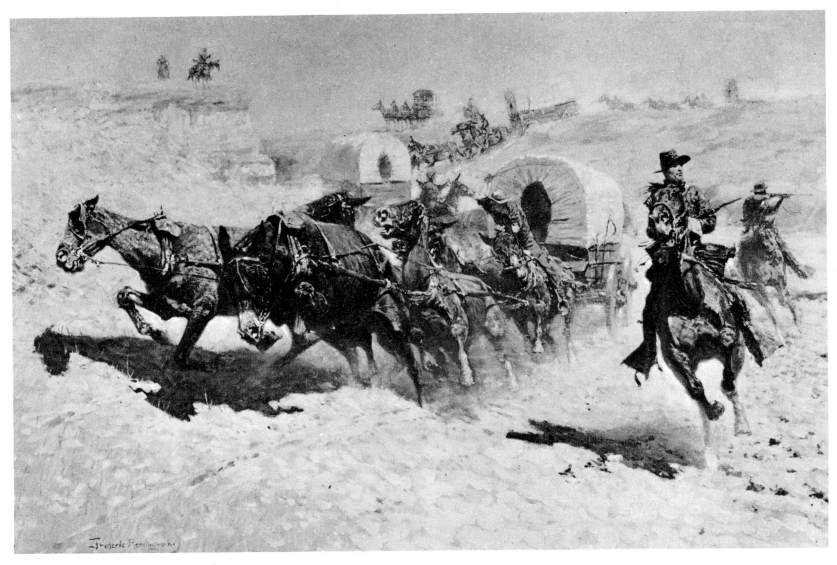

170. ATTACK ON THE SUPPLY TRAIN

EVER gaining in momentum and volume, the American conquest moved on. The first immigrant train went through to California in 1841; Texas was voted by annexation into the United States in 1845 and three years later, after a brief war, Mexico was forced to cede all her territorial claims from the Rio Grande northward into Colorado, as well as California. The discovery of gold in California in January 1848 provided a tremendous additional impetus to our western movement; in 1860 the first pony express went through from St. Joseph, Missouri, to Sacramento; and the first transcontinental railroad was being constructed to take the place of slow-moving little strings of packhorses and wagon trains. The pioneer movement was rapidly becoming a great juggernaut against which the Indians, divided because of centuries of intertribal prides, enemities, and warfare among themselves, faced the inevitable eventuality of complete destruction or subjugation. True to their ancestral responsibilities and traditions, they continued to wage their losing fight, in the manner their forefathers had taught them—striking with the suddenness and venom of the rattlesnake, then withdrawing, to strike again.

171. INDIAN SCOUTS IN MOONLIGHT

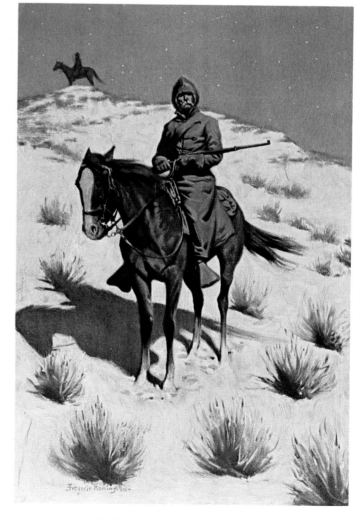

172. THE COSSACK POST

173. ON THE SOUTHERN PLAINS IN 1860

CHAPTER VIII

Army of the West

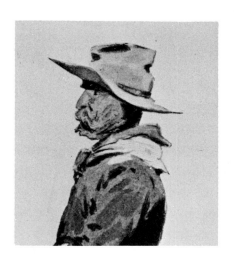

THE end of the Civil War in 1865 released a considerable number of contingents of the Regular Army for detail to service on the Western frontier, where they were desperately needed. Most of the war volunteers, however, had already had enough fighting and were scrambling to be mustered out to return to their families and occupations. But there was a crusading glamour about fighting wild Indians in the West and in seeing the herds of buffalo and maybe finding a gold mine; and this attracted many adventurous individuals who were willing to take what the Army offered.

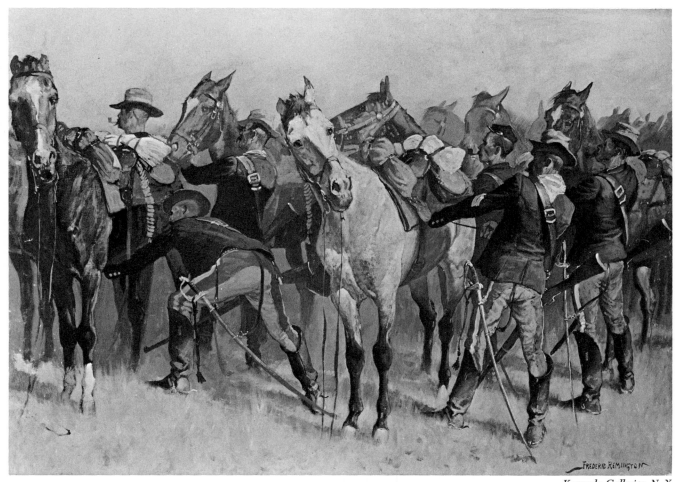

Kennedy Galleries, N. Y.

175. BOOTS AND SADDLES

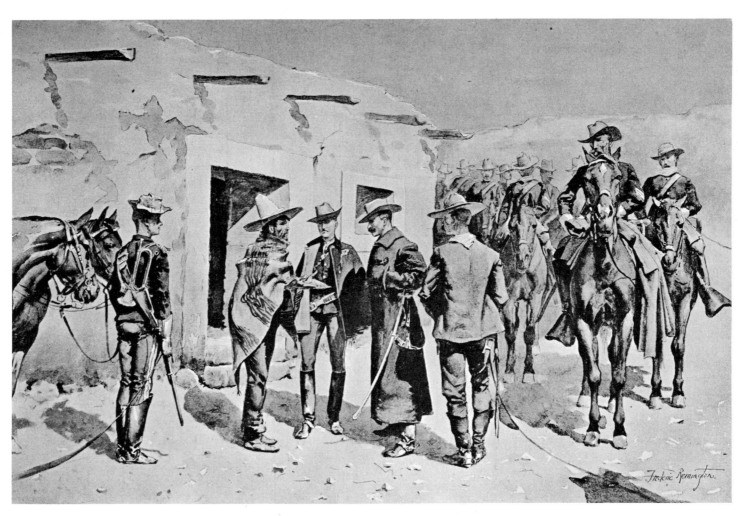

176. U. S. CAVALRY . . . ON THE RIO GRANDE

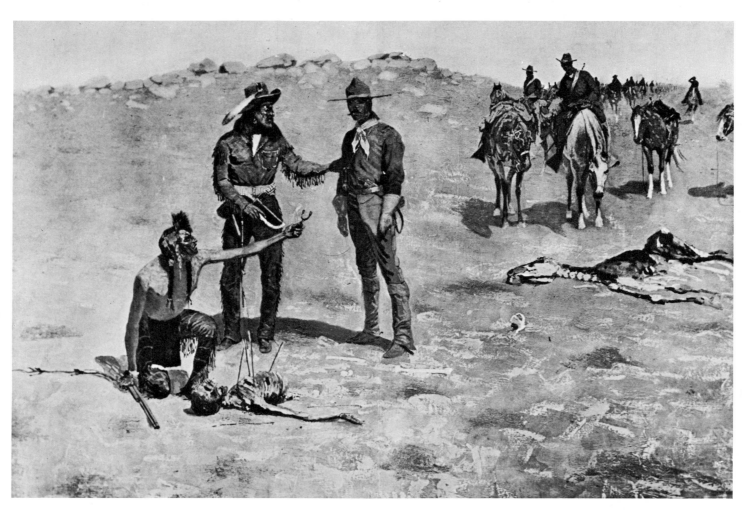

177. THE LAST TOKEN

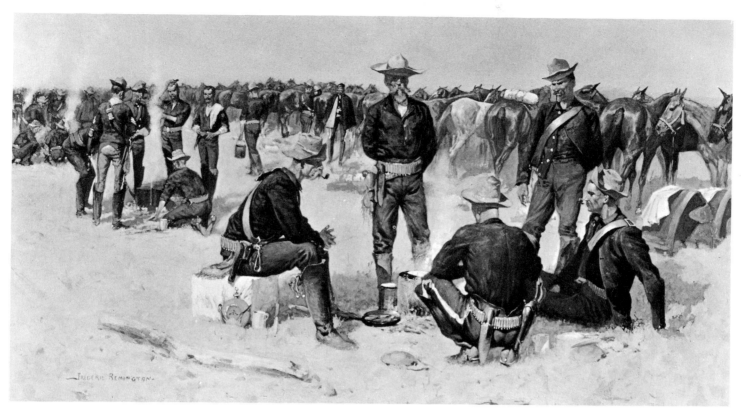

178. THE SCOUT'S REPORT AT BREAKFAST

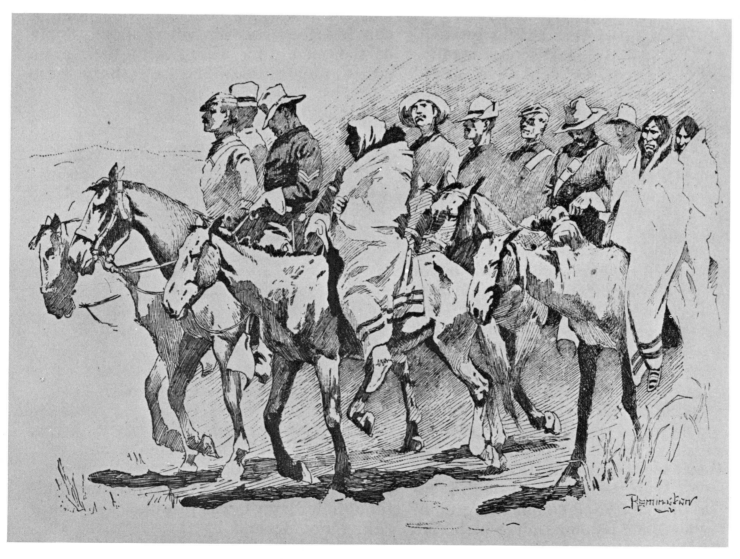

179. RETURN OF A SCOUTING PARTY

THE most intensive period of organized United States military action against the Indians in the West began when General Sheridan was ordered to inaugurate his memorable "winter campaign" of 1868–69 against the allied Plains tribes. This was aimed at forcing the red men onto their respective reservations and controlling them there. Also, during and following the Civil War, the country from Arizona to Montana became infested with desperadoes and outlaws, at the time when there was a struggle to introduce and establish law and order into the rapidly growing communities throughout the country. Support of this added another burden of responsibility on the U. S. Army that was as difficult as the Indian problem.

Frederic Remington was just coming into professional success when the situation in the West was rising to its most dramatic stage. In 1888, two years after the first national publication of his work, Remington was commissioned by *Century Magazine* to return to his old adventuring haunts in the Southwest, to write and illustrate a series of articles on how the Army was progressing in getting the pioneer state of affairs under control. For this assignment he joined his old friends the U. S. Tenth Cavalry on their toughest mission against Geronimo and his scattered bands of Apache renegades. In the picture below, the artist depicted himself in civilian khaki and tropical helmet, riding behind the officer in charge of one of these expeditions. And from that time on there was hardly a year that Remington did not spend some time in the West, personally following the progress of events until the final episode in the Indians Wars, which ended the historic period of the Old West.

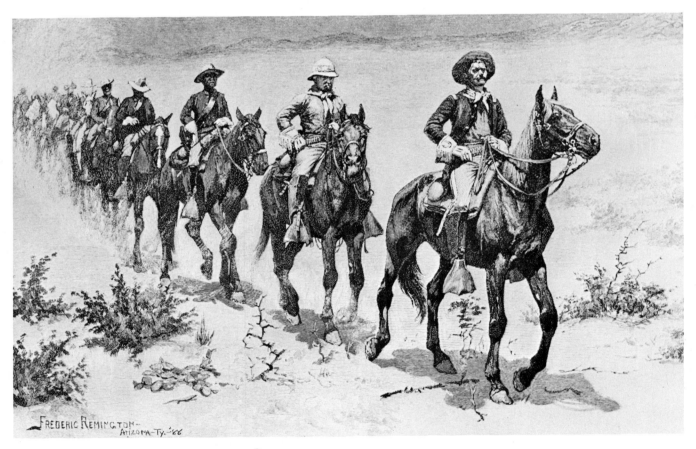

180. MARCHING IN THE DESERT
(Remington second in line)

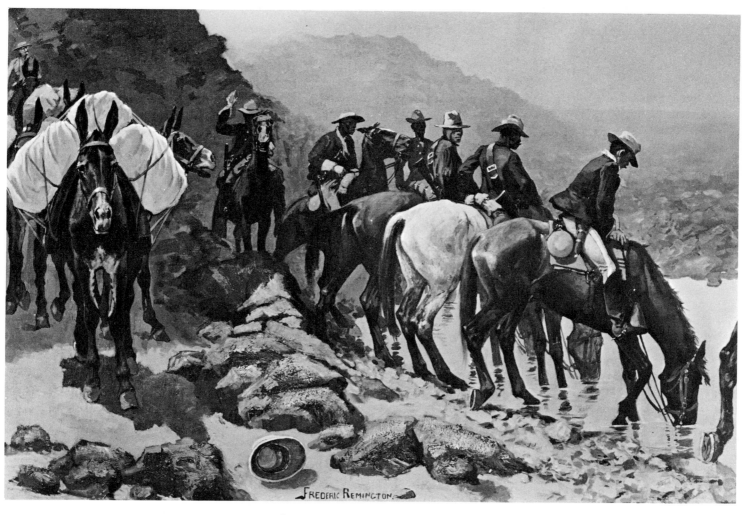

181. A POOL IN THE DESERT

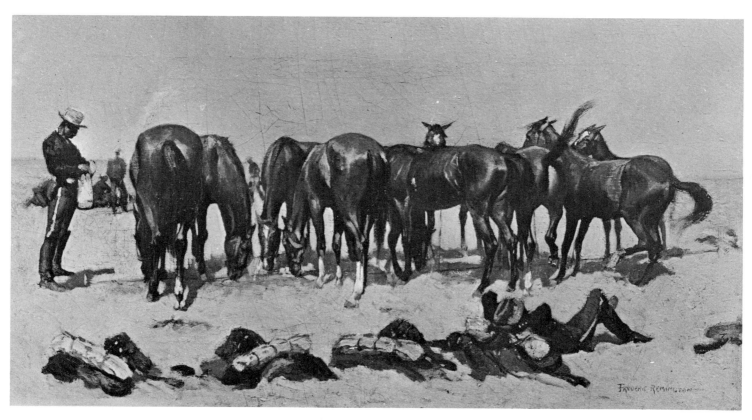

182. A HALT TO FEED

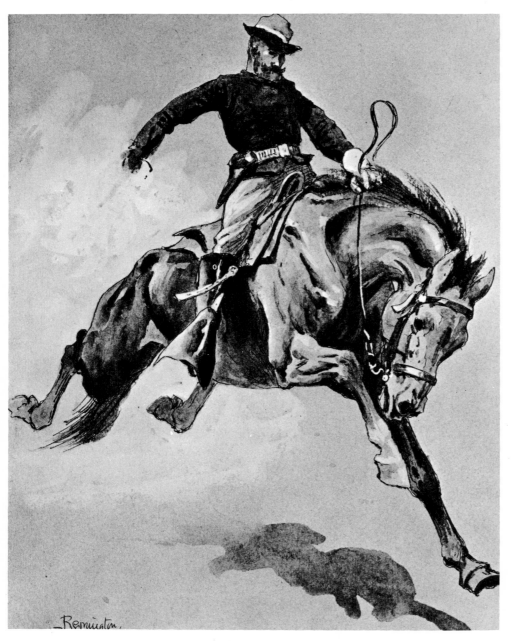

183.　A PLUNGER

184.　THE FLASH OF CURVED STEEL

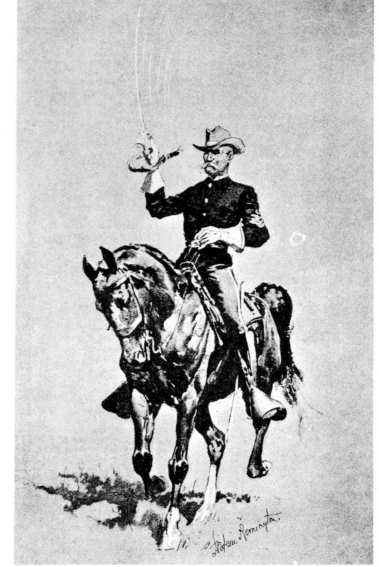

THE cavalry was the mainstay and pride of the Army of the West. It was necessary for the Army units to travel rapidly, through a vast and rough country of no roads. Even the open desert and plains were frequently cut by perpendicular walls where erosion and ancient streams had chiseled deep little canyons in the hard clay or rock formations, making it impossible for the supply wagons to follow. Retreating Indian bands always knew the country far better than their white pursuers and the odds were always in favor of the red warriors. Sometimes overly anxious to make contact, the cavalry would over extend themselves from their source of supplies and pay the penalty of being without food or water for extended periods of time. When a column of cavalry was on the trail of hostiles in arid country and might come to a small pool where famished men and horses could quench their burning thirst, there was always the chance that the awful water had been poisoned by the retreating Indians, who had satisfied their own thirst before continuing on their flight.

The troopers were a motley breed of mortals—from all walks of life, both high and low—some new in the service, but mostly veterans upon whom experience had put the deep stamp of indifference to whatever might befall them. But they were all welded together in a strong fraternity of their own branch of the service, their own regiment, down to their own smallest unit. The officers were no exception—from West Point up through the ranks. Some of the latter, in Remington's favorite Tenth Cavalry, are shown below.

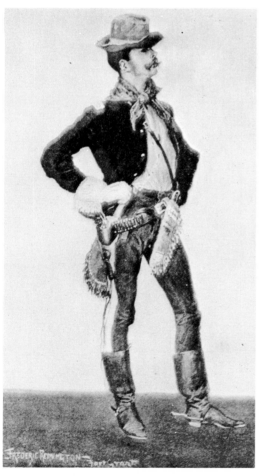

185. LIEUT. POWHATAN CLARK 186. LIEUT. JAMES M. WATSON 187. LIEUT. CARTER T. JOHNSON

For the soldier on frontier service, life was not all chasing hostiles and keeping order in growing communities. Like the civilian pioneer, the Army depended on the fresh meat that was available, and although some professional hunters were employed, the soldiers enjoyed hunting their own game. Some of the officers went in for more exciting sport. General Randolph B. Marcy enjoyed the thrill of chasing a grizzly bear on horseback. He wrote a long series of articles on "Big Game Hunting in the West" for *Outing Magazine*, October 1887 to April 1889, illustrated by Remington. These recounted the big-game hunting experiences of his long active duty on the frontier. Regarding the incident portrayed below, he wrote: "I once chased a grizzly for several miles, and it was all I could do to keep up on a fleet horse."

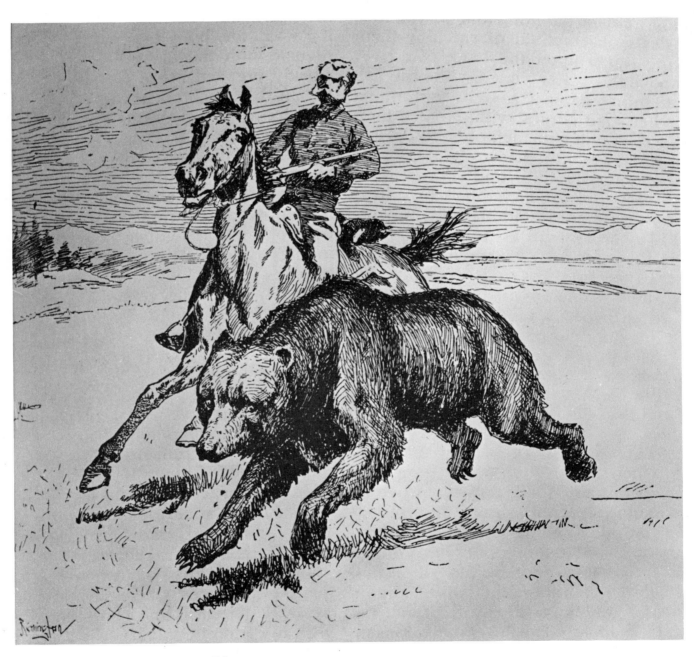

188. GENERAL MARCY CHASING A GRIZZLY

IN ANOTHER article in *Outing*, October 1887, an officer of the Fourth Cavalry describes a less sportsmanlike incident, during a march across Texas in 1871, illustrated below.

When a herd of buffalo stampeded and almost overran the column of troopers, the gigantic bull leader was shot to turn the herd and was badly wounded. A large white bulldog mascot of the regiment, trained to pull down beeves at the slaughter corral, raced out and sprang at the throat of the massive bull, and "the fight commenced, with the column as silent spectators . . . The wounded bull went down upon his knees, but quickly arose and whirled the dog in great circles over his head. The entire command now watched with breathless attention, expecting every moment to see the dog crushed to death. Down went the bull again on his knees, to gore the dog; rising, he would stamp his feet in rage, then shaking the dog a while he would resume swinging him like a whip . . . The foam, now bloody, flecked the long, tawny beard of the bull . . . The dog, which had commenced the fight a pure white, now turned to spotted crimson . . . Had he let go a moment, the crazed bull would have gored him to death . . . The bull grew perceptibly weaker . . ." Finally, the buffalo was mercifully shot. But not until the great buffalo fell to the ground did the proud dog let go.

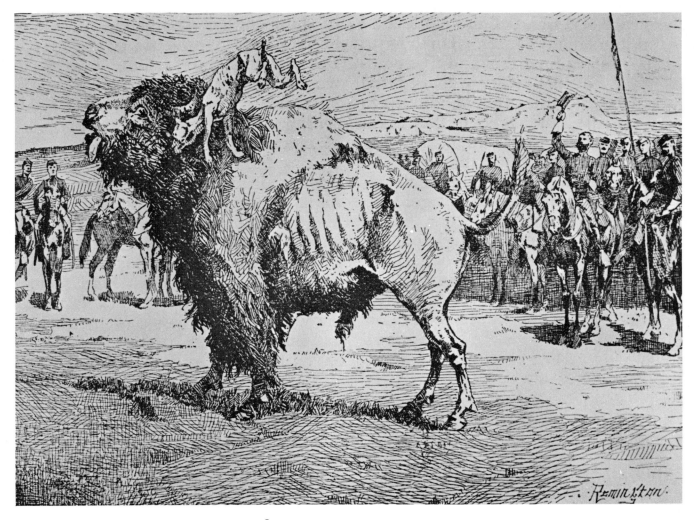

189. BUFFALO VS. BULLDOG

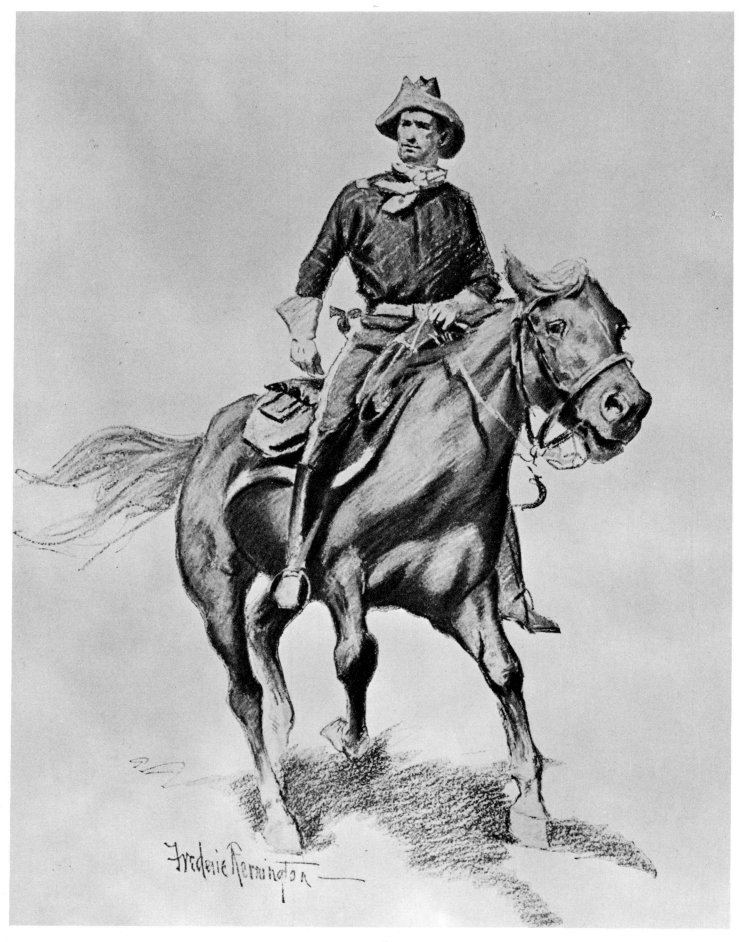

190. UNCLE SAM'S CAVALRYMAN

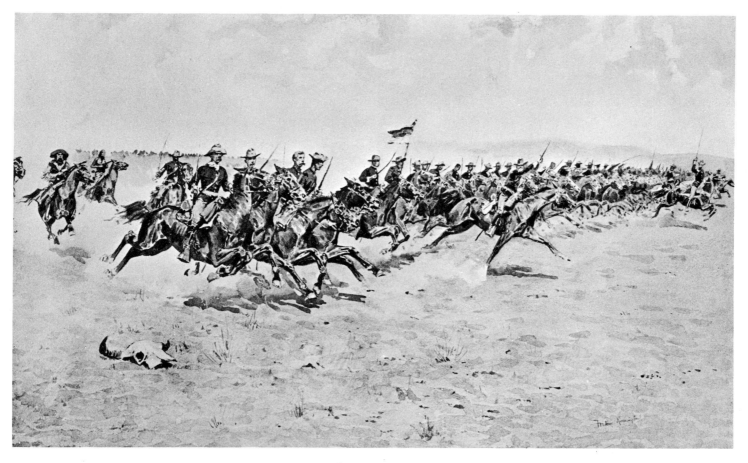

191. THE CHARGE

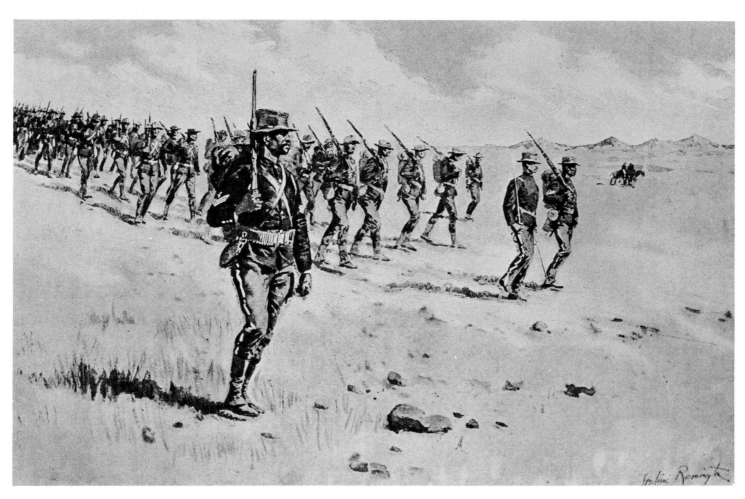

192. THE "DOUGH BOYS" ON THE MARCH

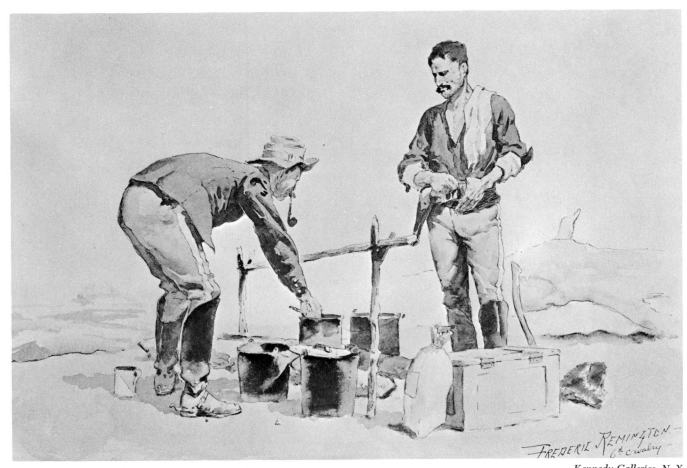

193. COOKING IN CAMP

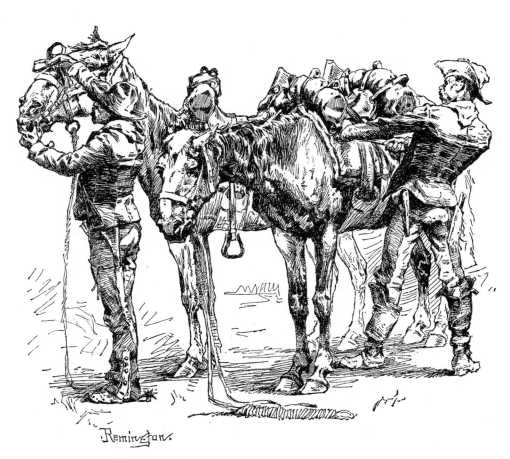

194. SADDLE UP

Aᴌᴛʜᴏᴜɢʜ Remington was strongly partial to the cavalry and its troopers, he did not slight any of the other branches of the Army on the frontier, in his pictures or the verbal portrayals in his article on "Soldiering in the Southwest."

"The infantryman in his brown canvas clothes has more the look of a navvy than a smart military character, and frequently a toe worked through a shoe until it resembles a mud-turtle, imparting to its wearer the social air of a tramp. The villainous knives issued to the 'doughboys' completes the sinister aspect . . . still they have their use in his domestic affairs while serving in place of the discarded bayonet . . . A big tin cup flaps from its fastening on the haversack, and the 'set' of the pantaloons tucked and wrinkled in the service boots, is far from fashionable.

"The scouts, packers and teamsters add artistic qualities in their strongly moulded faces and businesslike make-up . . . It readily occurs to one that he would not care to meet them in the dark . . . Should one be disposed to ferret out strange characters, here is his feast; for these men have not followed their dangerous callings and made personal histories rivaling the yellow-novel heroes without a mind peculiar, a character sturdy, a training far from matter of fact, and a thorough lack of conventionality . . . If you *sabe* them, you may feel fortunate if you never sleep with worse company.

"Here, all of these men have their interest . . . With the Almighty Dollar as the gage of every phase of civil life, brass buttons rank as a baser metal; but when well tarnished by exposure to a long campaign, they grace the dusty trooper on his jaded mount, appeal to every sentiment, and shine like gold."

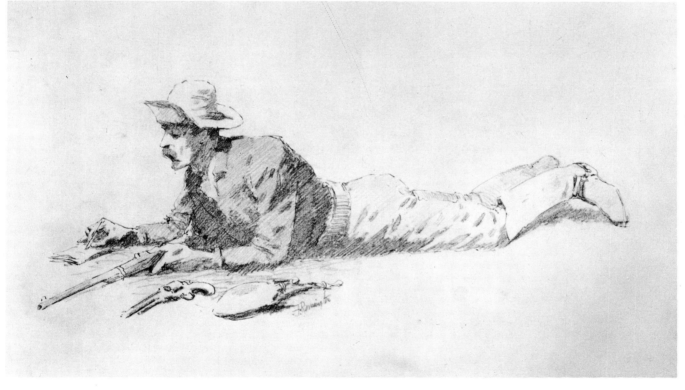

195. WRITING HOME

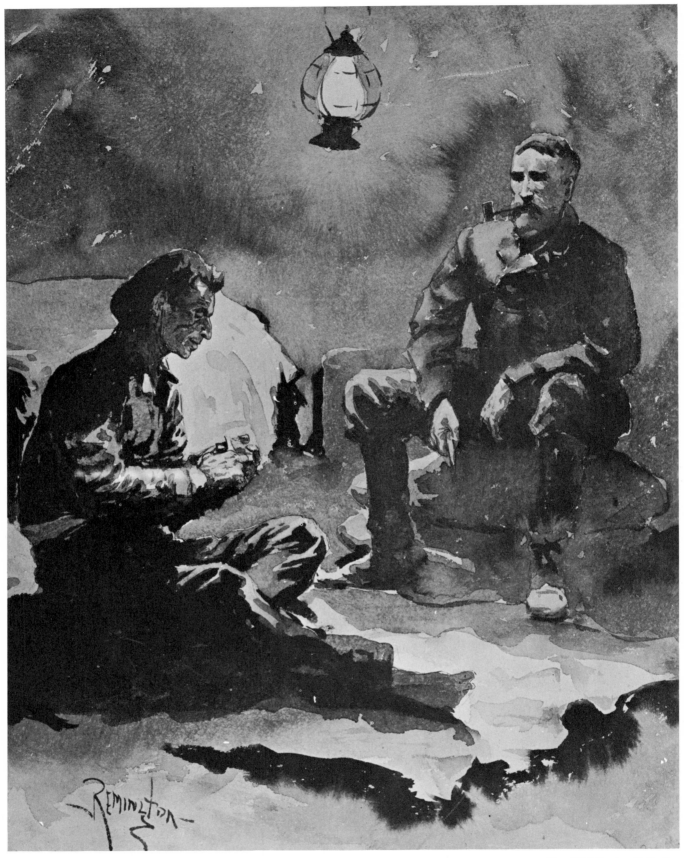

196. A QUIET EVENING IN THE TENT

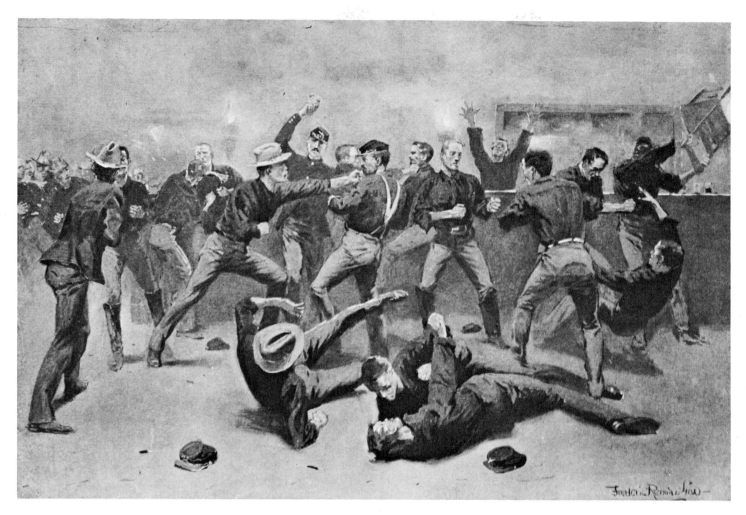

197. A BEAUTIFUL FIGHT ENSUED

THE real long-service soldiers of the Army of the West took the Government very much as a matter of course. But their own regiment and their own troop were always a very personal matter. On the old rolls of the regiment were the names of many men long dead, but men who in the snow and on the red-hot sands had laid down their lives for the honor of their troop. These names were legend to every outfit worthy of holding its own guidon high and following it proudly on parade ground or field of battle.

Every troop had its "old man" who had been captain for umpteen years and before that the "toughest sergeant" in the regiment for as many years. And in the really good outfits about every buck soldier harbored a little secret hatred for every officer, but would unhesitatingly follow his troop guidon all the way to hell, or clobber any outsider who lived who would make the mistake of slandering anything or anyone belonging to his troop or regiment. This was as explosive as a lighted match in a keg of powder, when it happened on a payday night off in a frontier town that happened to have a couple of saloons, and particularly if it happened to involve the cavalry and the infantry—then some beautiful fights ensued.

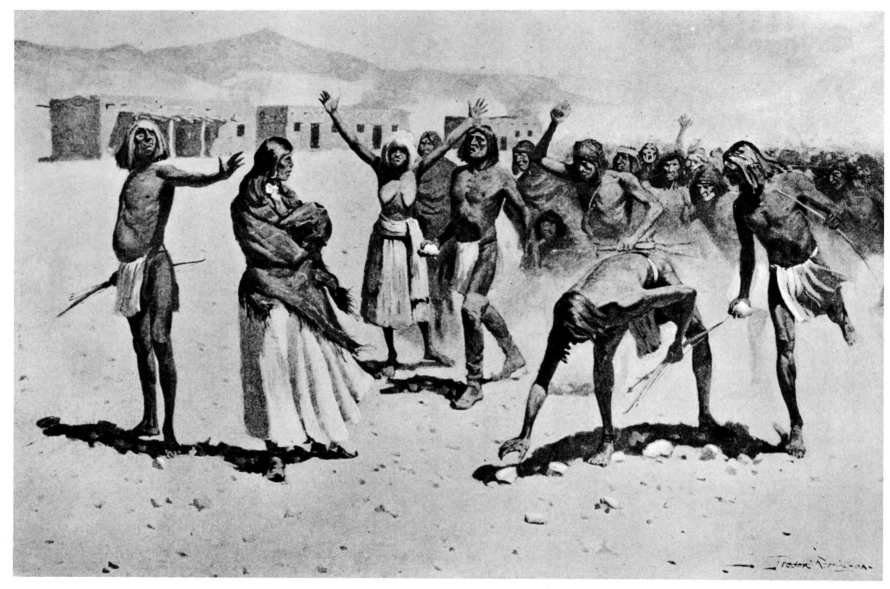

198. THEY GATHERED STONES AS THEY WENT

THE scene was Fort Buchanan, southern Arizona, 1861. The troops were leaving for the Civil War. A young soldier had paid his last visit to a nearby adobe and an attractive Papago girl with a baby in her arms. She pleaded to go with him and followed as far as she could. Hardly were the soldiers gone when the Indians came into the deserted fort. They found the girl, holding the baby tightly and weeping. An old man jerked the shawl away and pointed at the infant, and harangued the gathering crowd. They took the girl to the parade ground, each gathering stones as they went. Standing alone, she suddenly ran toward where the soldiers had departed. A stone hit her in the head; the baby fell from her arms; and she sank down to cover it with her own body. The old man came and raised a large stone high and brought it down with great force. The others kept throwing rocks until mother and child were completely covered. A law of the Papagos was fulfilled.

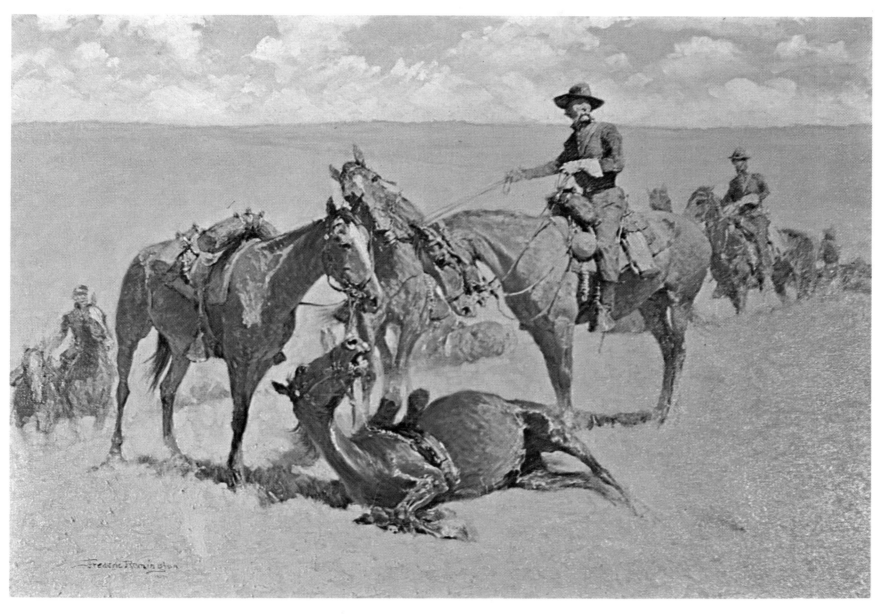

199.　AMONG THE LED HORSES

Frederic Remington '08

M. Knoedler & Company, N. Y.

200. NIGHT HALT OF CAVALRY

CHAPTER IX

Struggle for the Northern Plains

THE northern prairies with their fertile abundance of buffalo grass, the broken hills with their streams and shady old cottonwood trees, and along the west the high majestic mountains were a wonderful home for the wilderness-loving Indians. The prairies and hills, broken here and there by outcroppings of mountains, stretched eastward for many days' travel on the best of horses, and throughout this vast land were great herds of buffalo, antelope, and elk. In the hills along the wooded streams were many deer. It was the home of the sage-grouse, sand-hill crane, wild turkey, swans, geese, rabbits, and other varieties of food-providing wild creatures. In the Rocky Mountains the tribesmen could camp with satisfaction in the silent valleys, besides rushing streams, at the edge of the sweet-smelling forest, where there were plenty of mule deer, elk, black and grizzly bears; with the mighty mountains all around with snow-capped peaks rising high into the heavens, where there were flocks of wild sheep to be brought home to families in tepees or caves. Little wonder was it that this land of primitive plenty had produced the finest, most prosperous, and most colorful types of Indians on the whole continent; and it was only natural that these people should fight with determination and vengeance to protect what was traditionally their own, against the conquest of the white invaders.

202. WATCHING THE INVADERS

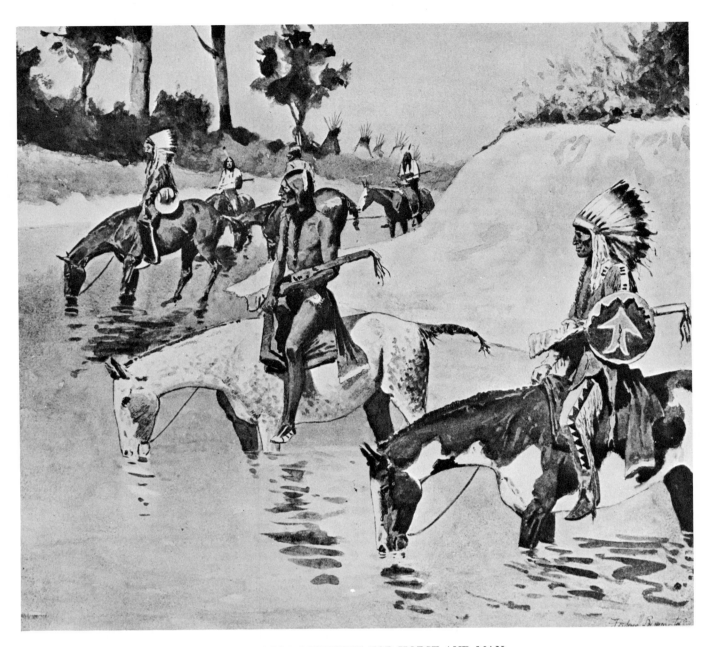

203. GOOD MEDICINE FOR HORSE AND MAN

The Northern Plains Indians had many advantages over the Army. They operated in rough country known best to themselves and beneficial to their own type of warfare. They could live off the country and had amazing stamina. Their tactics of ambush, strike, and retreat were the nemesis of the Army's slow means of communication and travel. They were clever in making the troopers fight the Indian's way; and all the while they were striking vulnerable blows at the nonmilitary intruders. The cavalry was the Army's most effective means of fighting the Indians, although there were seldom enough troopers to meet requirements, and when it appeared that they had a band of warriors in the pocket, they would disappear like ghosts. But the Indians had one cardinal disadvantage—their own deeply rooted tribal rivalries. This prohibited their joining together against a common enemy and doomed them to a common failure.

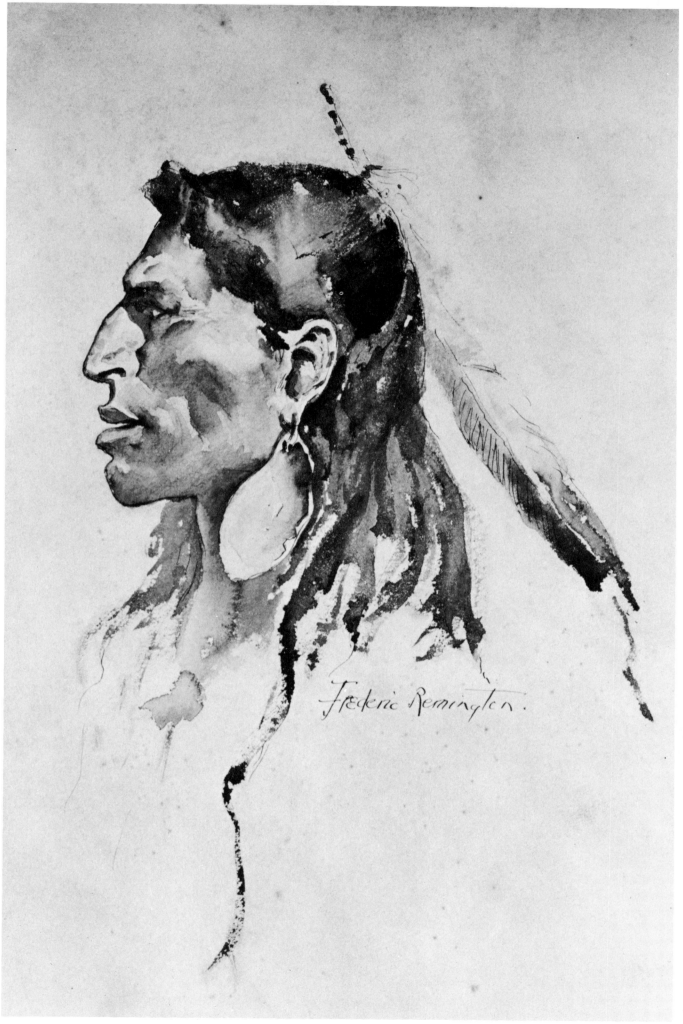

Frederic Remington.

204. THE CHEYENNE TYPE

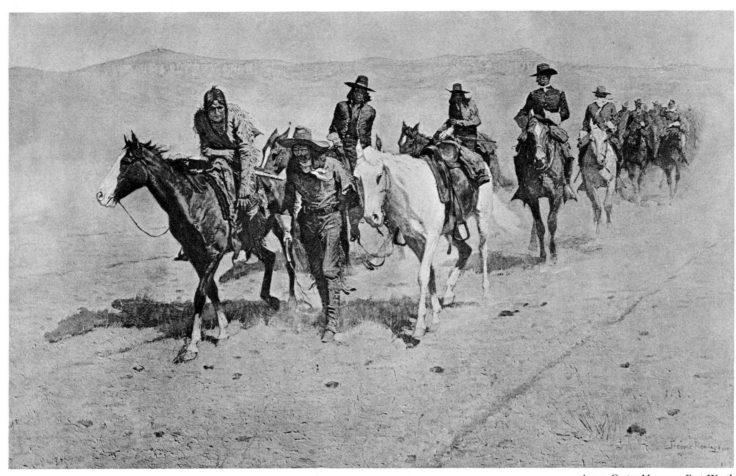

205. PONY TRACKS IN THE BUFFALO TRAIL

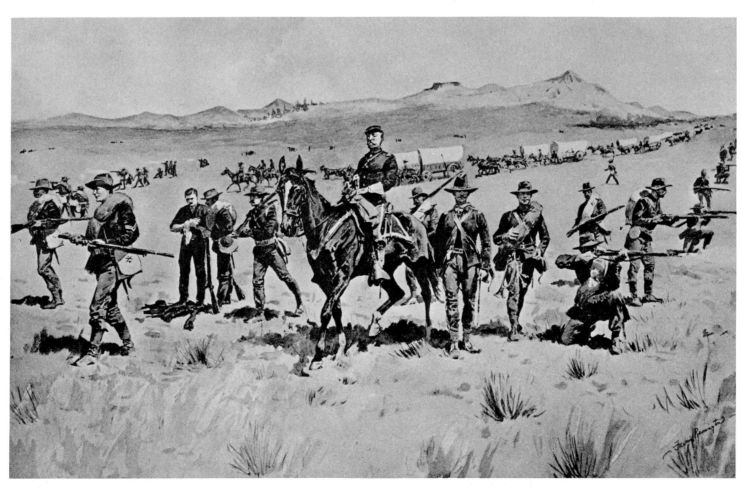

206. PROTECTING THE WAGON TRAIN

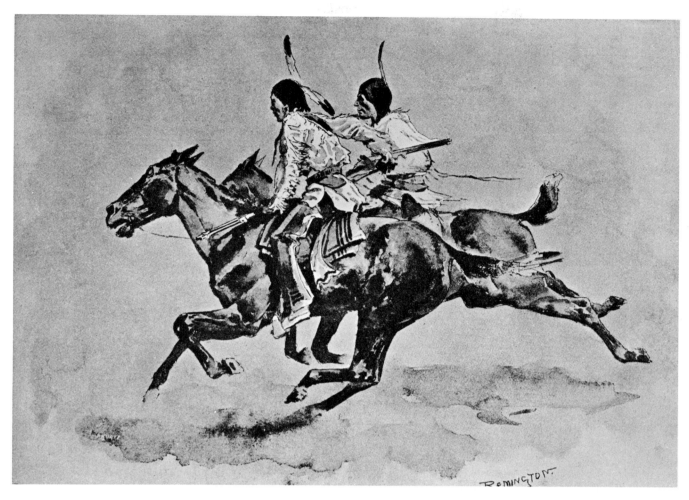

207. TWO FLEETING GHOSTS I SAW

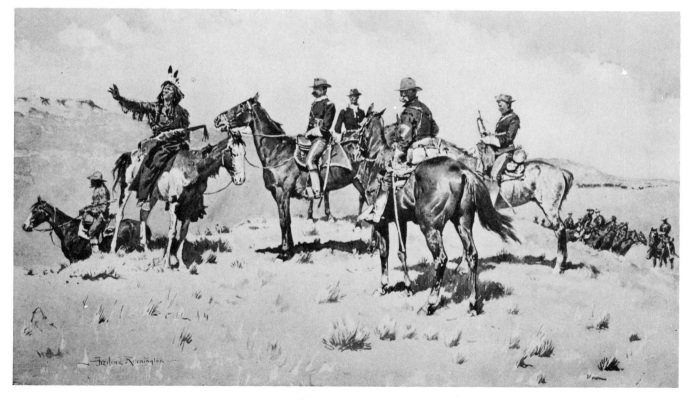

208. THE BORDERLAND OF THE OTHER TRIBE

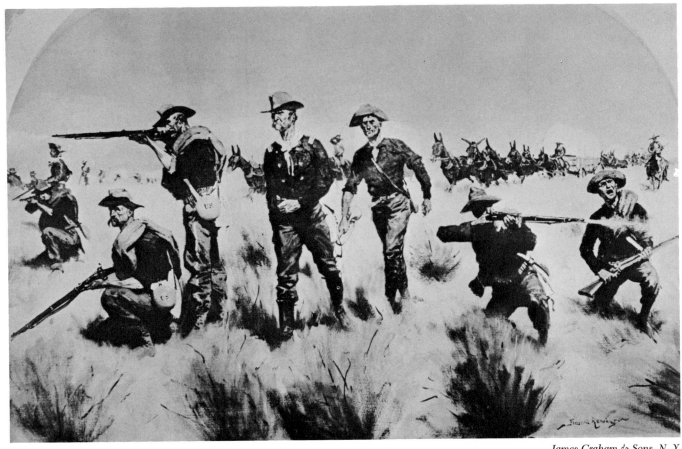

209. PURSUING THE INDIANS

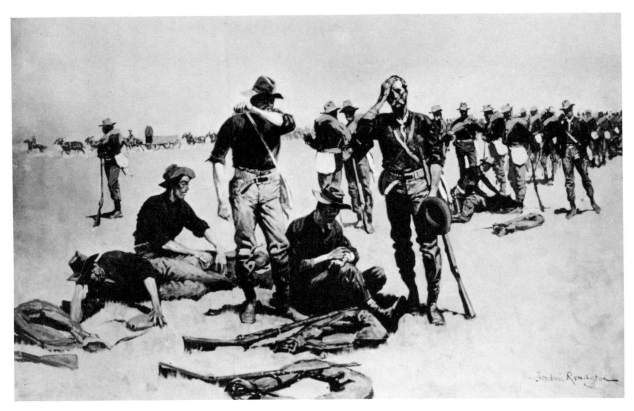

210. SOLDIERS OPENING THEIR VEINS FOR WANT OF WATER

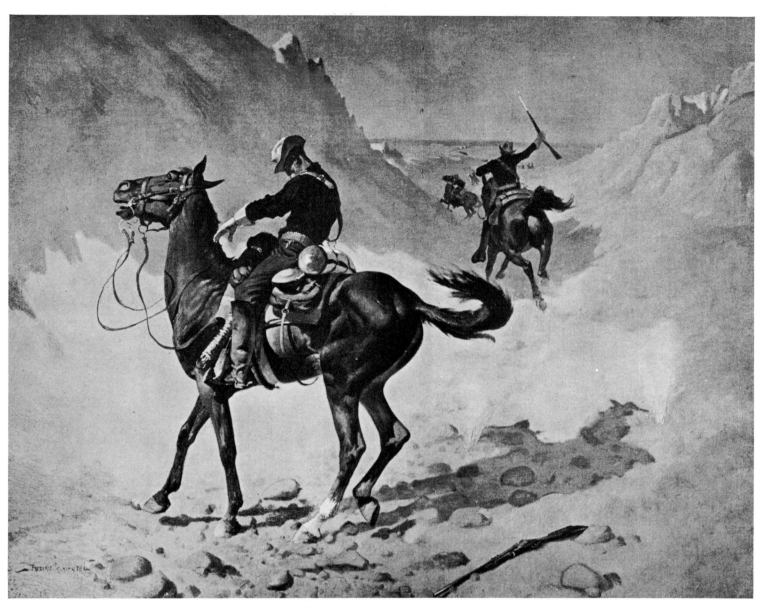

211. THE ADVANCE GUARD—THE MILITARY SACRIFICE

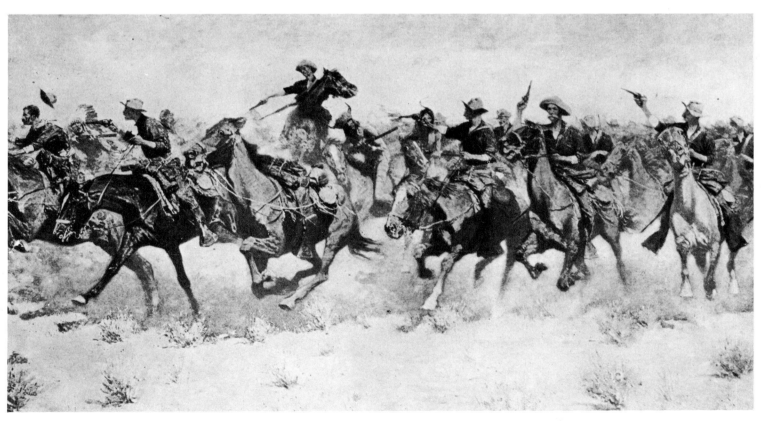

212. THE CHARGE

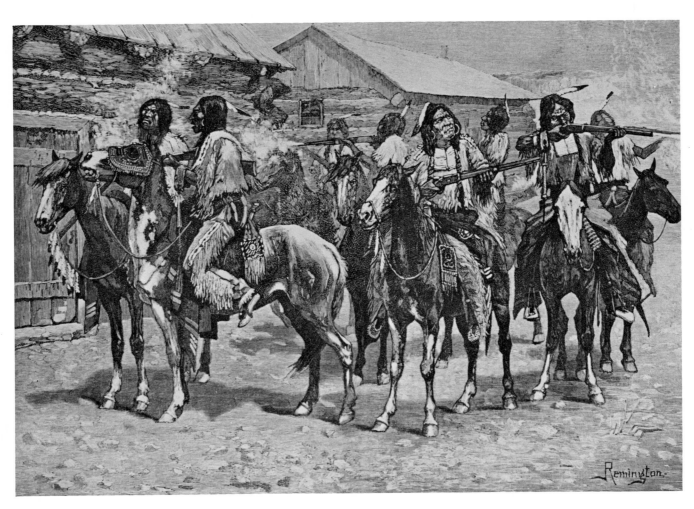

213. CROW INDIANS FIRING INTO THE AGENCY

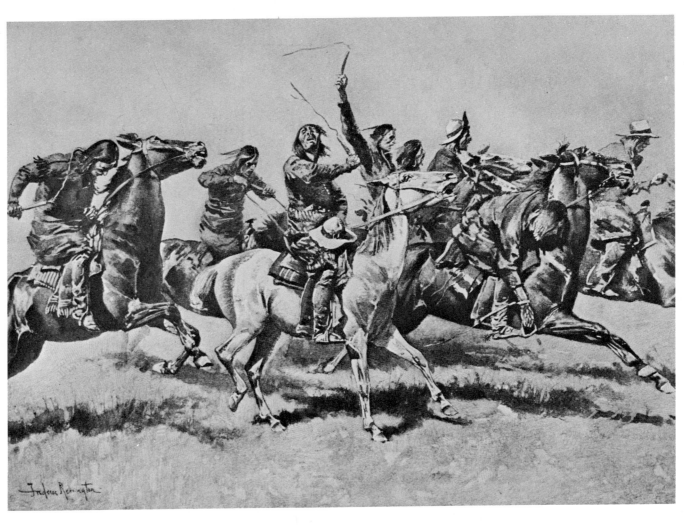

214. SET UP A WAILING LIKE VULTURES

IT IS historically ironic that the Europeans should have made it possible for the Indians to acquire the horse as well as the gun, which elevated these primitive people to their highest form of culture, and also introduced the greatest deterrence to the white man's conquest of the West. In spite of the relatively short period of time the Indians had the horse, nowhere were there better horsemen. Intensive experience in hunting the buffalo on horseback had made them the most expert of mounted marksmen. Shooting at a gallop, the average warrior was far superior to the average trooper. Their ambush, strike, and retreat were no indication of lack of courage, but born of custom in the tribal warfare. As more troops were committed to the conflict and the Indian's situation became more obviously serious to them, they became bolder. What had begun as a friendly toleration of the white man finally became outright and bitter warfare against the United States Army.

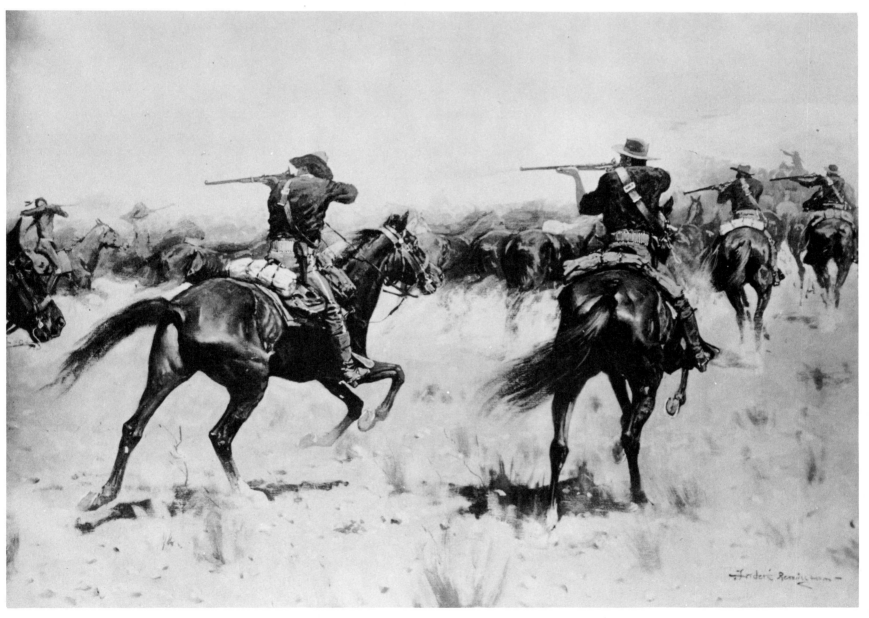

215. FIGHTING OVER A STOLEN HERD

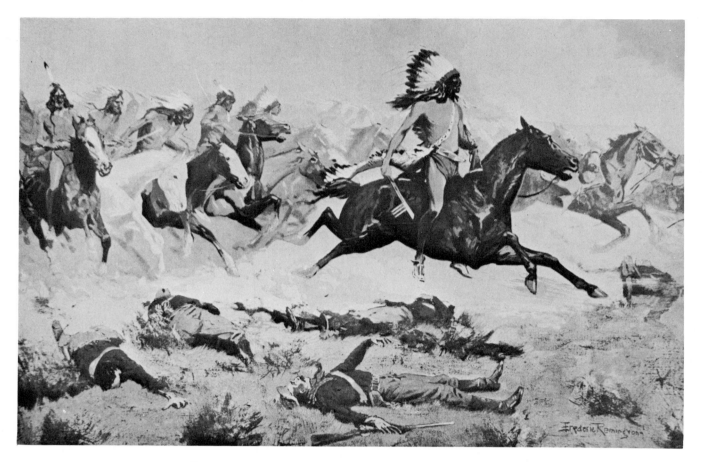

216. THE RED LODGES PASSED THROUGH THE LINES

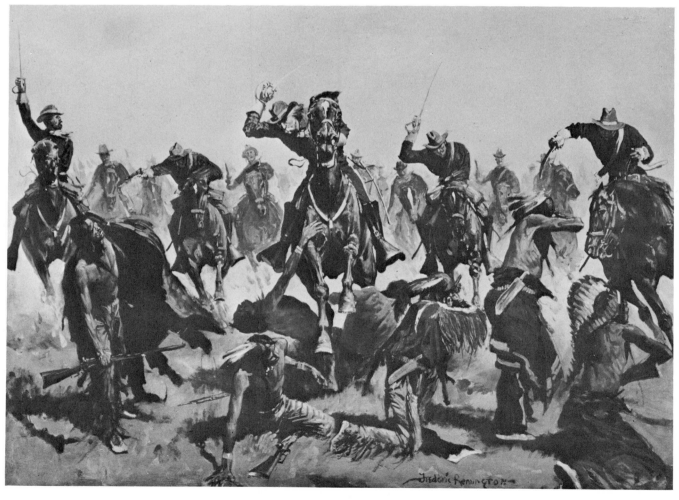

217. A SABER CHARGE

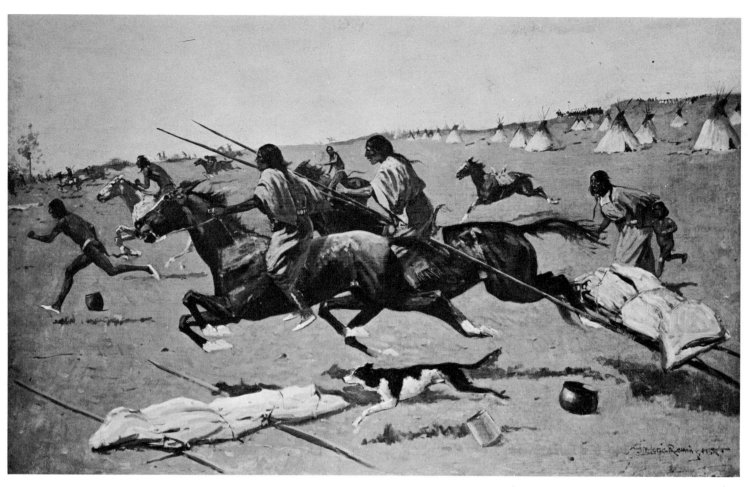

218. INDIAN VILLAGE ROUTED

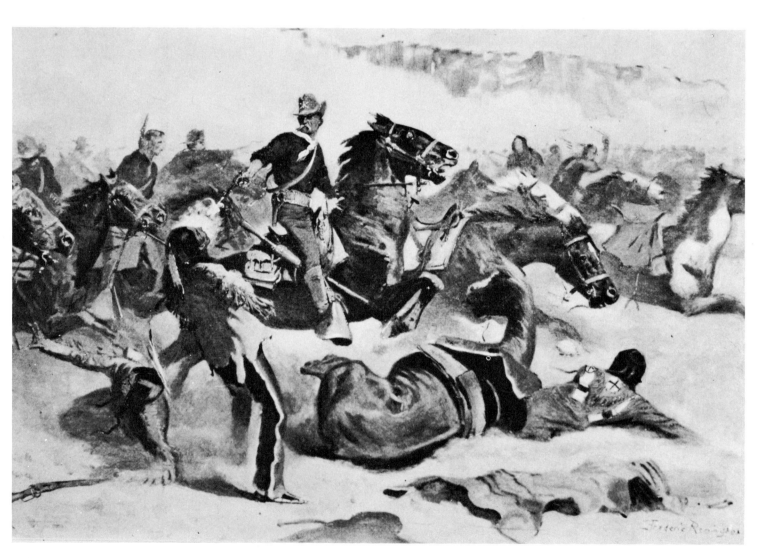

219. TROOPER JACKSON

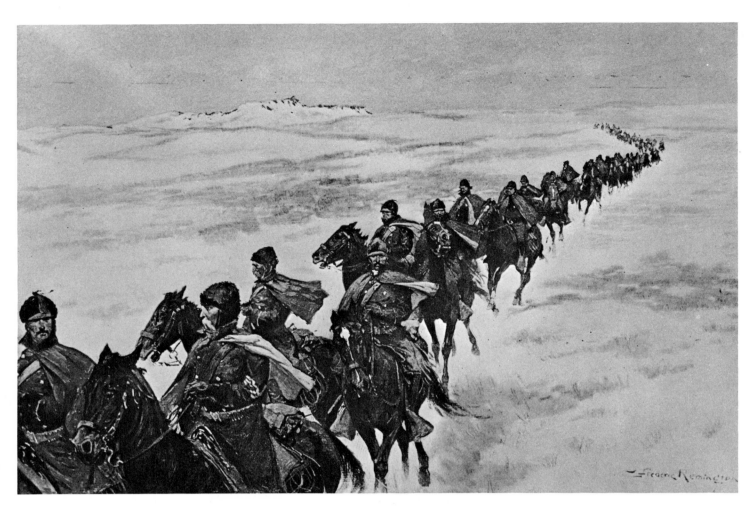

220.　MILE AFTER MILE RODE THE COLUMN

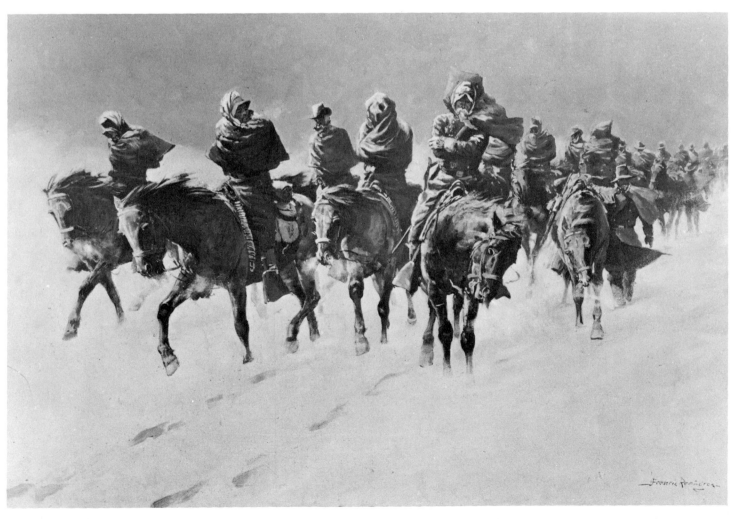

221.　THIRTY BELOW AND A BLIZZARD RAGING

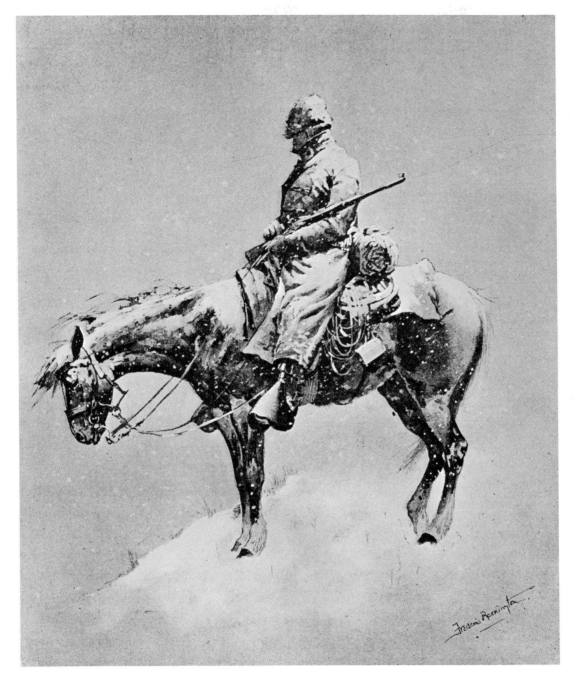

222. THE AMERICAN TOMMY ATKINS

Winter warfare put an additional disadvantage upon the trooper and virtually put the infantryman out of business. This sort of thing was new to most of the soldiers. Many were from the Southern states and most had been brought up in environments far removed from fighting Indians in blizzards and subzero weather in a wilderness where everything was hostile to them. It was a tough and frustrating sort of warfare.

For the Indians, however, this was to a large extent what they had been accustomed to throughout their lives and past generations. Many of the advantages enjoyed in the summer were increased when the winter weather was at its worst. There was suffering on both sides, but even in this the Indians were more accustomed.

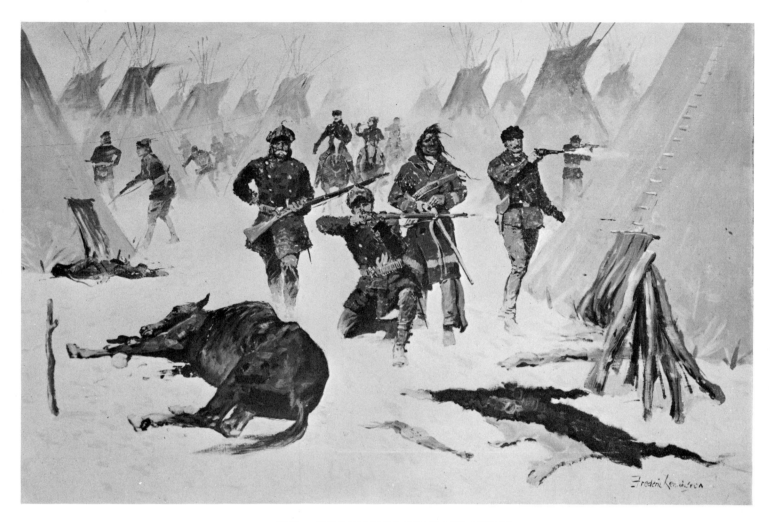

223. THE DEFEAT OF CRAZY HORSE

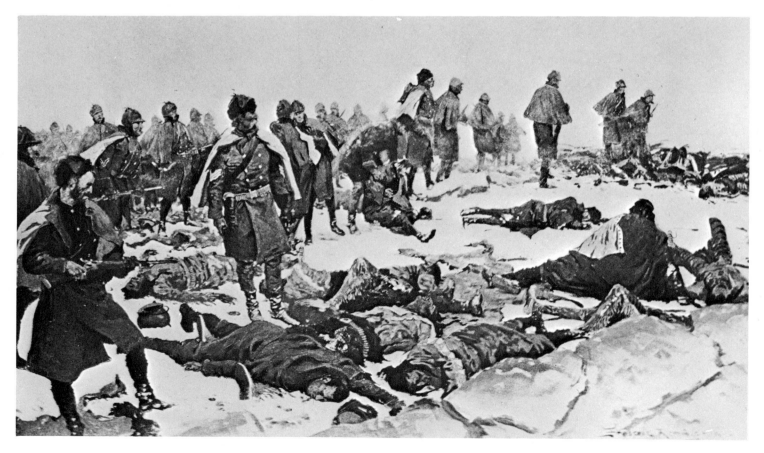

224. AFTER THE FIGHT

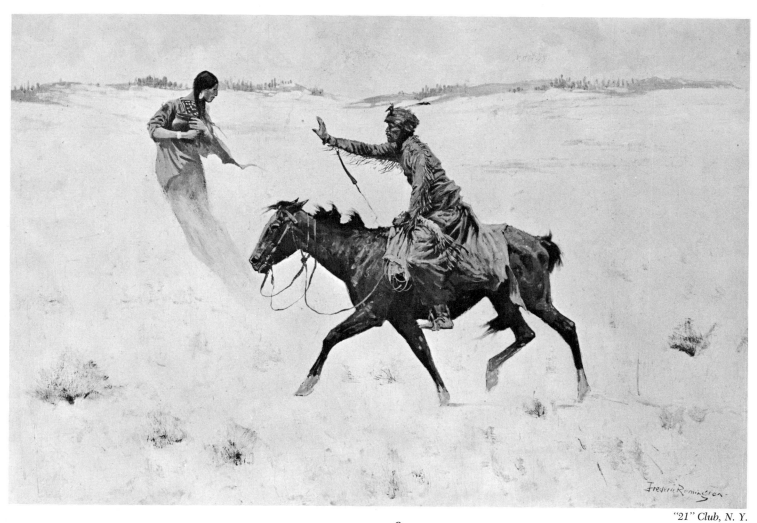

225. HOW ORDER NO. 6 WENT THROUGH

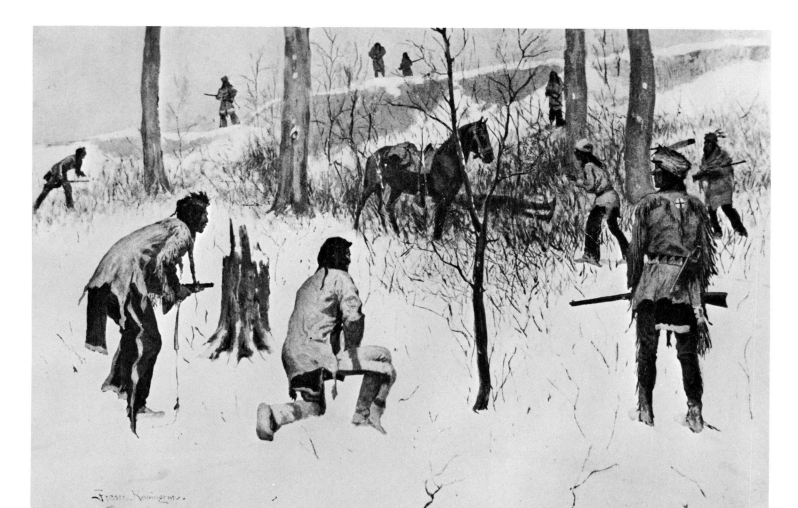

226. THE FATE OF ONE DISPATCH BEARER

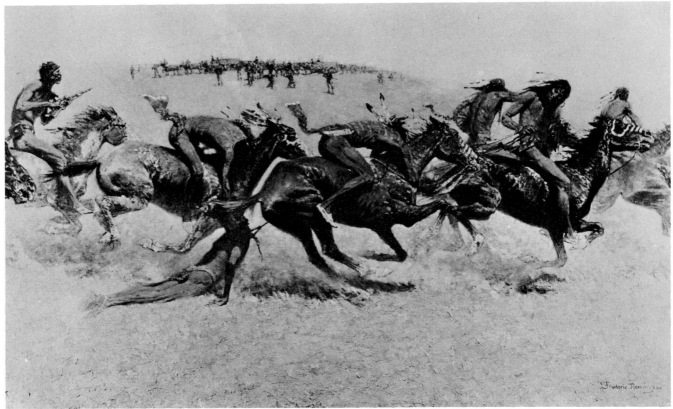

Gilcrease Museum, Tulsa

227. INDIAN WARFARE

THE greatest single contribution toward the settlement and development of the West
was the completion of the first transcontinental railroad across the Great Plains and
through the Rocky Mountains to the Pacific Coast. This was accomplished on May 10, 1869,
with the driving of a golden spike at Ogden, Utah. Other railroads were also being built and
planned, to spread out like a gigantic iron spider web, to carry a deluge of pioneer settlers
and all by-products of the white man's civilization to every part of the land.

It probably never occurred to a great many Americans, at the time at least, that
we were engaged in an actual war of conquest against the Plains Indians, very unorthodox
though it was. It was largely taken for granted that we were entirely entitled to go
out across the Plains, as trappers or fur traders, buffalo hunters, gold seekers, or land
grabbers, and take what we wanted. It is true that representatives of our government had
from the beginning held council meetings with the chieftains of the primitive Indian tribes,
for the purpose of making treaties and agreeing to purchase large areas of their fertile tribal
lands for a few cents an acre, plus other agreed-upon promises. We would even set aside
areas of the Indians own land, which we called "reservations," for their special benefit.
These agreements, unfortunately, had usually been respected and kept with far greater
faithfulness by the Indians than the white men. But the pioneers, whether they came from
the States or were newly arrived immigrants from the European countries, considered the
whole West an open grab bag, and the Indian residents were considered little more than a
dangerous and undesirable nuisance, which the United States Army should quickly eliminate.

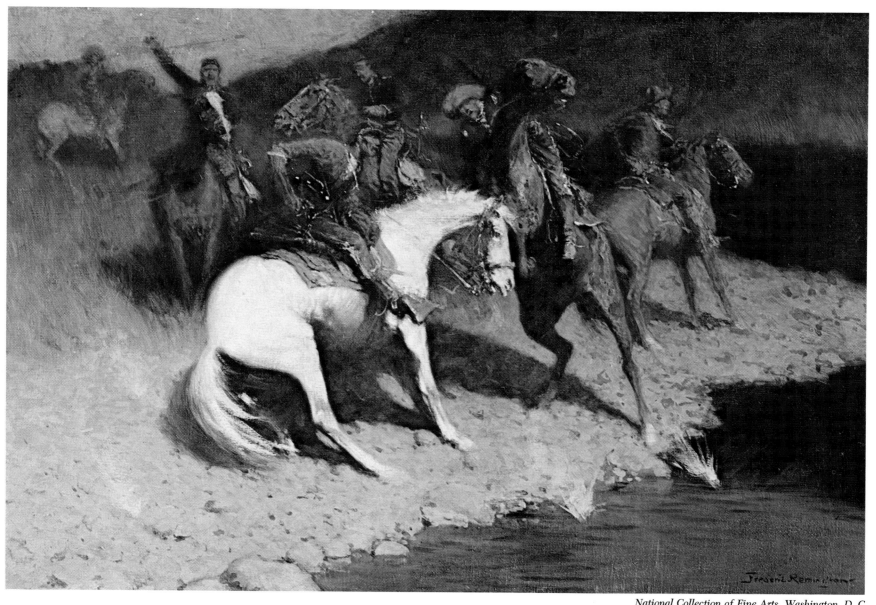

228. **FIRED ON**

229. THE PURSUIT

CHAPTER X

Subjugation and Transition

THE Army did not cause the Indian Wars, but it had to fight them. The conflict was the result of a combination of causes brought about by the civilian conquest of the natural resources and the land upon which the Indian depended for a living, and the Government's apathy toward the human rights of the Indians and its repeated violations of the treaties that had been made with the red men.

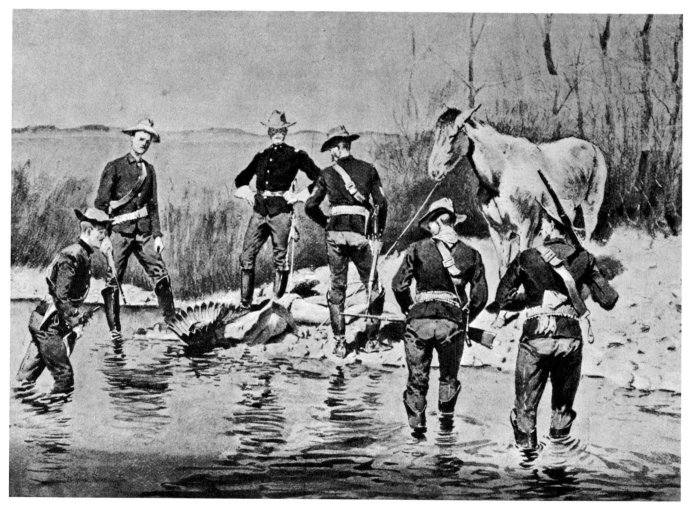

231. "THE ONLY GOOD INDIAN IS A DEAD INDIAN."

Virtually every area, tribe, and period in the history of the conflict between the Indians and the Army of the West had its condemnatory tragedy born of injustice or broken governmental promises made with the Indians. To recount all of these would require several volumes and involve a comprehensive history of every tribe and subtribe. Two historic examples are portrayed on these facing pages.

The picture below is one of fifteen done by Remington to illustrate important episodes in his book *Personal Recollections of General Nelson A. Miles* (1897) recounting his long experience as a leader of the Army of the West. This one portrays the historic meeting between the then Colonel Miles and the noted Sioux warrior and tribal leader Sitting Bull (Tatanka Yotanka) on October 21, 1876. The occasion was just four months after the disastrous "Custer Massacre," when Sitting Bull had led what was probably the most powerful and rebellious body of hostiles ever assembled, and marked the triumphant climax of his seven years of continuous and intensive refusal to be incarcerated on a government reservation, a confinement that was a contradiction to a treaty of 1869. At the time, Colonel Miles believed that he had brought the Sioux leader and his followers at bay; and when they met between the lines the Army ultimation of confinement was given. To this Sitting Bull made his defiant and classic reply: "God Almighty made me an Indian, but He did not make me a reservation Indian, and He did not intend me to be one." The Army attacked, but Sitting Bull escaped and went into exile in Canada, where he remained until 1881.

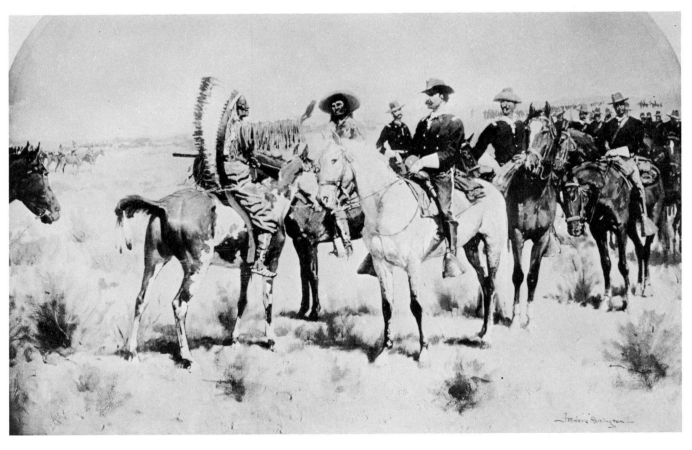

232. THE MEETING BETWEEN THE LINES

ONE of the greatest injustices against the Indians involved Chief Joseph and his Nez Percé. Always friendly, never had one of these tribesmen killed a white man—until 1877. By treaty in 1855 they had been assigned a reservation in northeastern Oregon, where they lived peacefully. But the white settlers coveted their rich land and in 1863 enlisted political influence in Washington, D. C., to have a new treaty signed, without proper Nez Percé authority, opening the land to white settlement. Chief Joseph rightfully refused to recognize the new treaty. The whites made increasing encroachments and trouble, although the Nez Percé held out peacefully until 1877, when the U. S. Army was ordered in to remove the "hostiles" from their land.

Chief Joseph and his warriors, women, and children took to the mountains. When they were overtaken, there was a fight in which the troops were defeated. The Indians went on, crossing Yellowstone Park from west to east and through the Rocky Mountains; then headed northward across Montana toward sanctuary in Canada. All available cavalry and infantry in the area were ordered to capture or kill Chief Joseph and all his tribesmen.

Believing that they were safely in Canada, the weary Nez Percé stopped to rest. But they were overtaken and defeated. On October 5, 1877, standing among his dead tribesmen, Chief Joseph made his ironic surrender: "From where the sun now stands, I fight no more against the white men." Even promises made to him then were shortly afterward repudiated. Chief Joseph and his survivors were taken as prisoners to Fort Leavenworth, Kansas, and incarcerated as outlaws who had committed unpardonable crimes against white men.

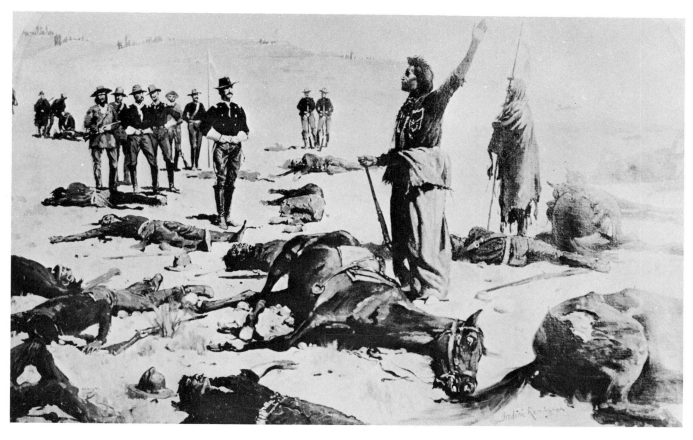

233. THE SURRENDER OF CHIEF JOSEPH

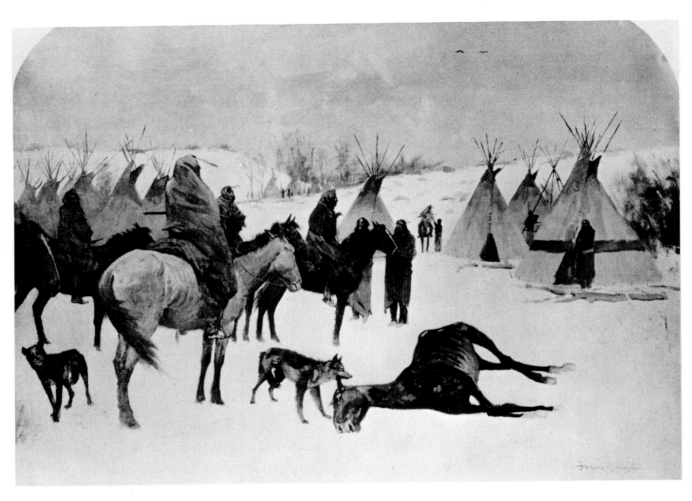

234. HOSTILES ON THE STAKED PLAINS

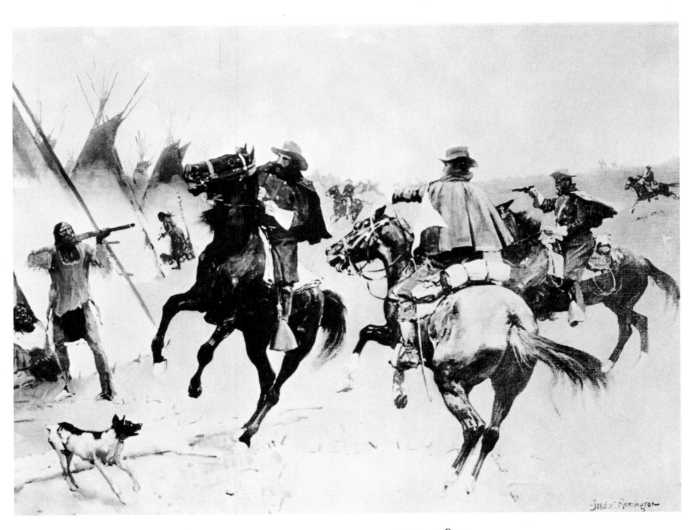

235. THE LAME DEER FIGHT—1877

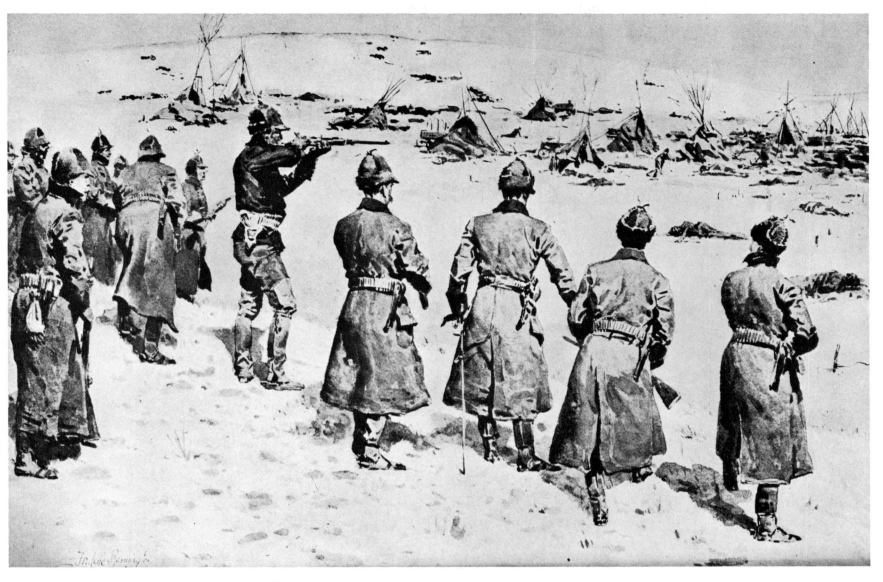

236. TAKING A LONG, COOL AIM AT THE FLEEING FIGURE

GENERAL Miles was a hard-nosed army officer to whom duty was a categorical dogma. But he had a humanistic sympathy for the Indians as a people and high esteem for their warriors. "Our relations with the Indians have been governed by treaties, trade, war and subjugation . . ." Miles wrote in his autobiography, "and we find the record of broken promises all the way from the Atlantic to the Pacific . . . The natives have been steadily driven toward the setting sun—a subjugated, doomed race . . . In our treaty relations extravagant and yet sacred promises have been given by the highest authorities, and these have been frequently disregarded. The intrusions of the white race and non-compliance with treaty obligations, have been followed by atrocities that could only satisfy a savage and revengeful spirit."

General George Crook, an early veteran of the Army of the West and who saw about as much of frontier service as anyone, when asked what he considered the hardest part in the Indian wars, made the following reply: "The hardest thing is to fight against those whom you know are right."

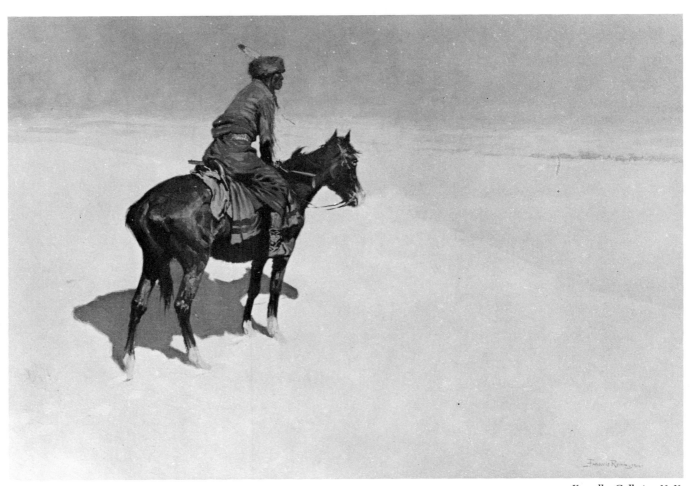

Knoedler Galleries, N. Y.

237. FRIENDS OR ENEMIES?

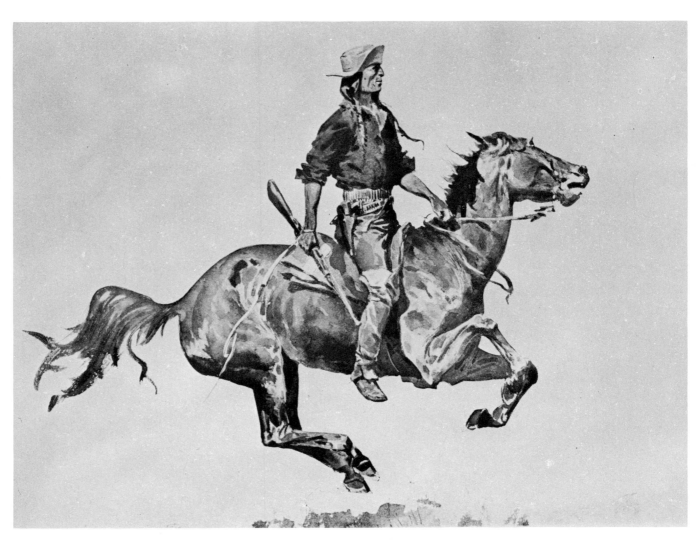

238. A CROW SCOUT

THE flooding movement of settlers and urban developments demanded complete control of the land. The government treaties were aimed at confining the Indians on reservations set aside for the purpose. The designated tracts of land were generally areas less desirable for the uses of the white man and in remote parts of the region. The inducements were basically the payment of money and the providing of shelter, clothing, and food by the Government. This policy was inaugurated by the act of March 1, 1793, and stipulated that all dealings with the Indians should be pursuant to our constitution. The policy was carried westward with the frontier, remaining fundamentally the same.

Being restricted to a reservation imposed radical changes in the habits and culture of the Indians, and was as difficult as it was distasteful. Each reservation was controlled by a "bonded agent," generally a political appointee, with power over life and property. Many of these agents abused their authority, becoming involved in graft in the handling and distribution of money, food, and supplies intended as treaty payments to the Indians, and even subversion against the Army and settlers. It was only natural that the Indians should lose faith and seek revenge against the white men.

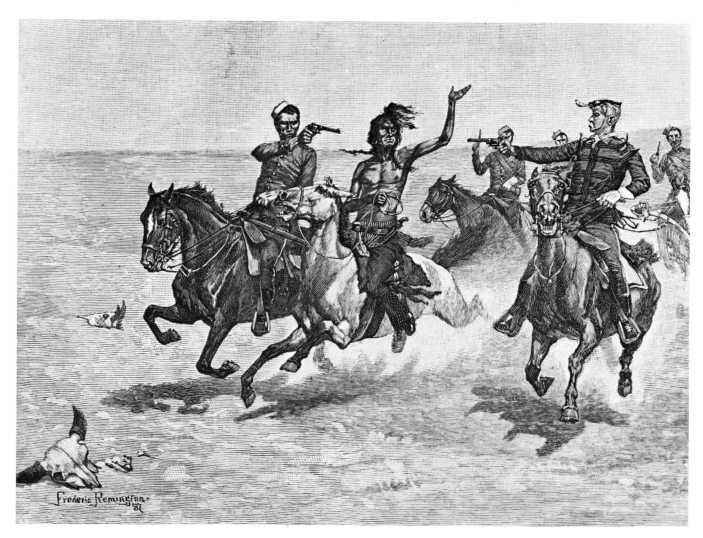

239. ARREST OF A BLACKFOOT MURDERER

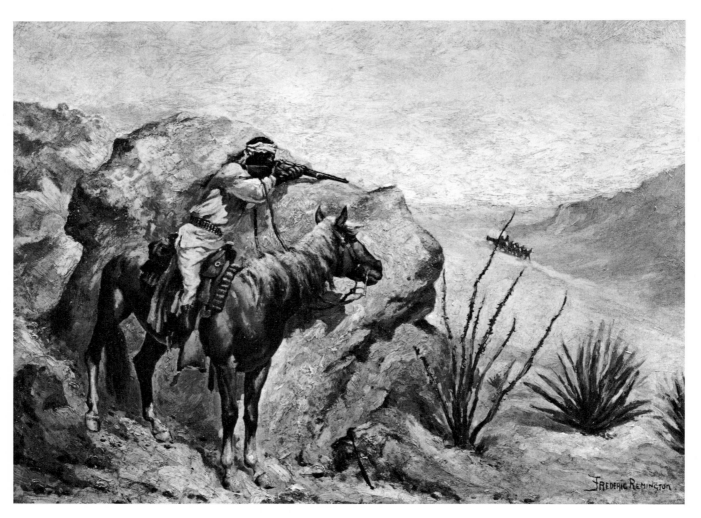

240. AN APACHE INDIAN

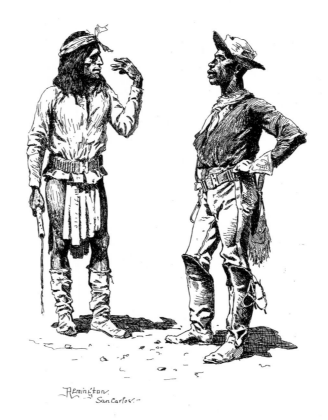

241. LEARNING SIGN LANGUAGE

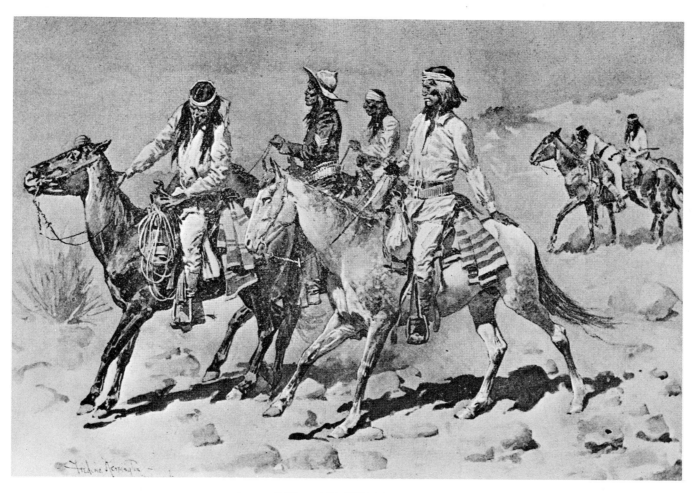

242. APACHE SCOUTS

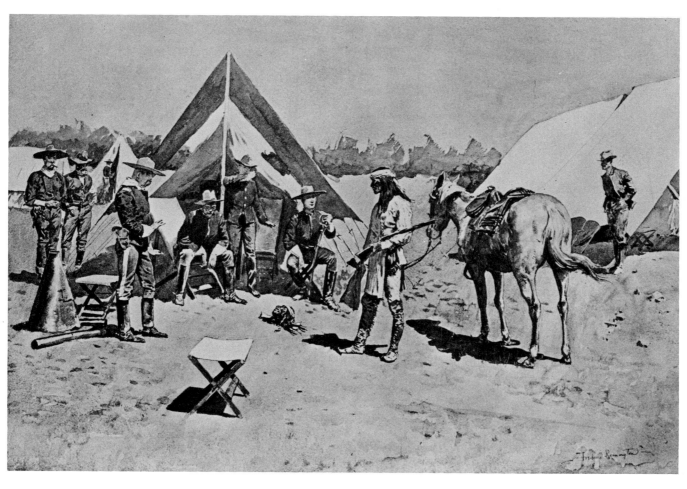

243. SATISFYING THE DEMANDS OF JUSTICE—THE HEAD

Few of the tribesmen could adapt themselves to reservation life and the abrupt transition into the white man's civilization. The reservation was at best not good for the Indian. It took away from him his centuries-old tribal pride and dignity, his deeply rooted devotion to the religious, beliefs of his ancestors, and deprived him of that freedom of soul which is the precious possession of every living thing.

The reservation deprived the Indian of his eagle feather war bonnet and beautifully decorated war shirt of finely tanned buckskin, and gave him the worn-out coat and pants of some store clerk back in Pennsylvania. It gave the young men nothing more inspiring than a strange schoolbook and taught them that all they had believed was good in the past was really bad. It gave the men nothing but time to gamble, become soft in body and mind, to dream secretly of the forbidden past, and to drown what little of soul was left in the firewater the white man so willingly sold them. As Owen Wister so aptly put it:

> *No more are Sun and clouds his banners,*
> *The Stars and Stripes above him wave,*
> *And he hath drunk the White Man's Burden*
> *Deep as is the grave.*

(See page 180)

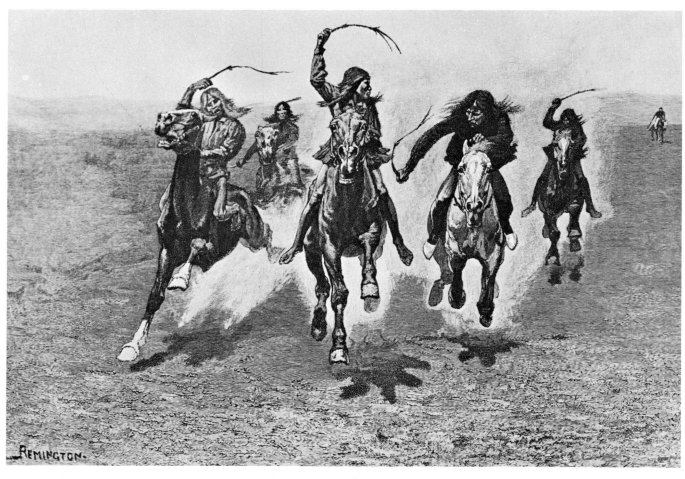

244. INDIAN RESERVATION HORSE RACE

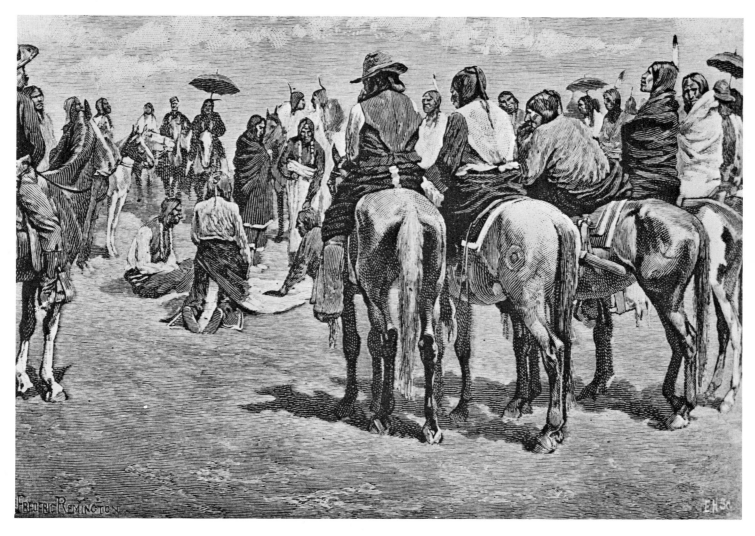

245. IN THE BETTING RING—COMANCHES

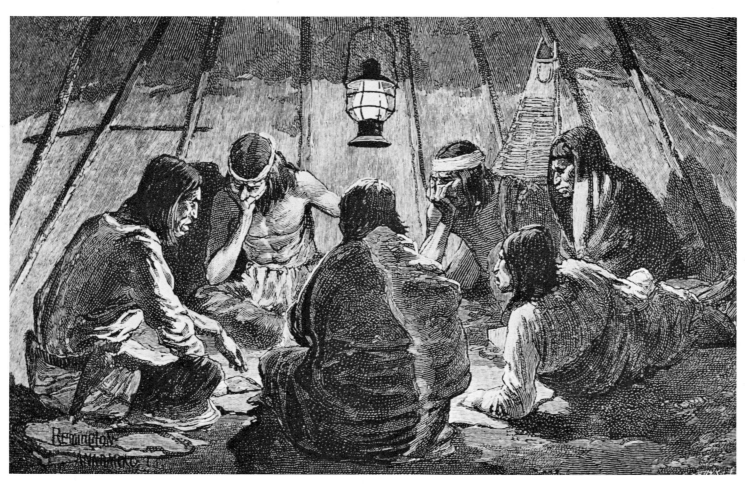

246. APACHES PLAYING MONTE—ANADARKO, I. T.

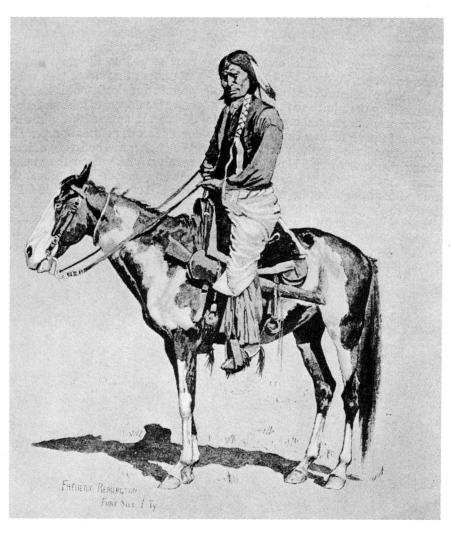

247. A RESERVATION COMANCHE

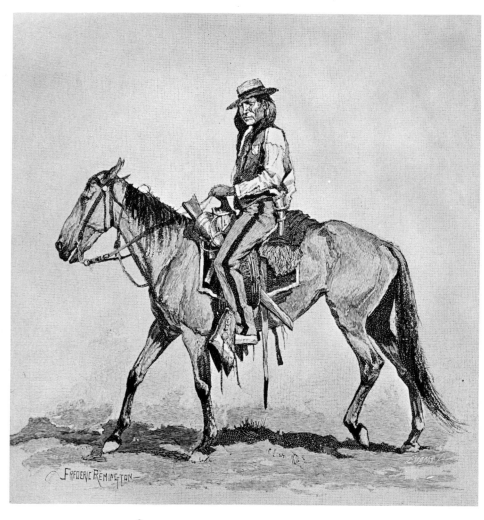

248. CHEYENNE AGENCY POLICEMAN

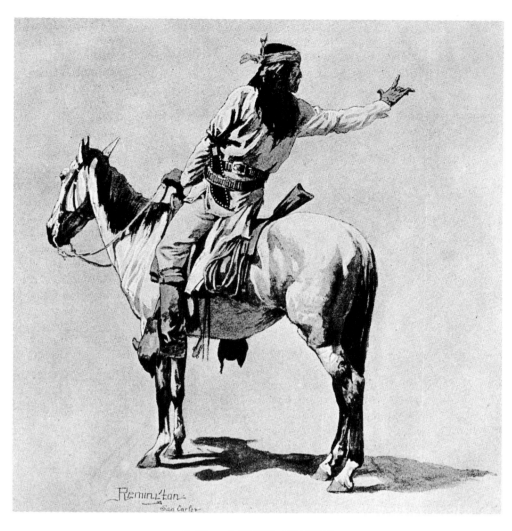

249. A YUMA APACHE

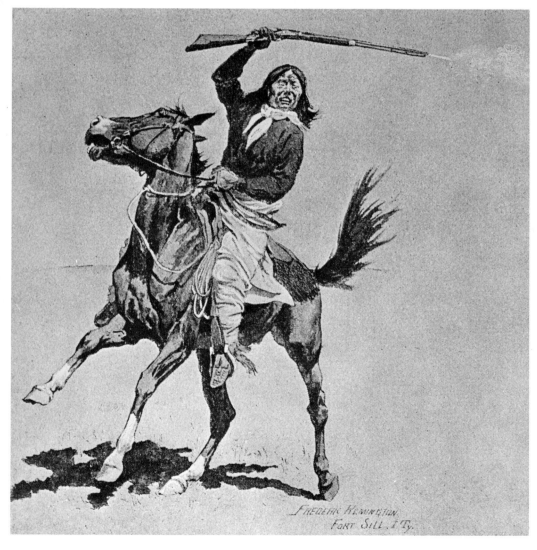

250. A KIOWA BUCK

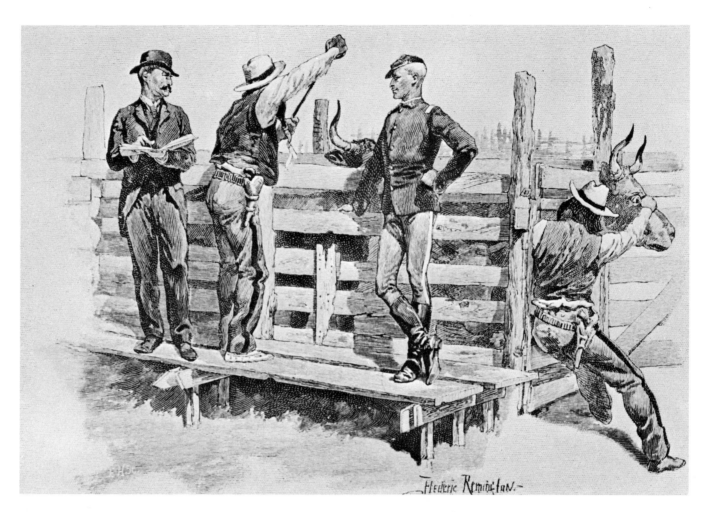

251. THE BRANDING CHUTE AT THE BEEF ISSUE

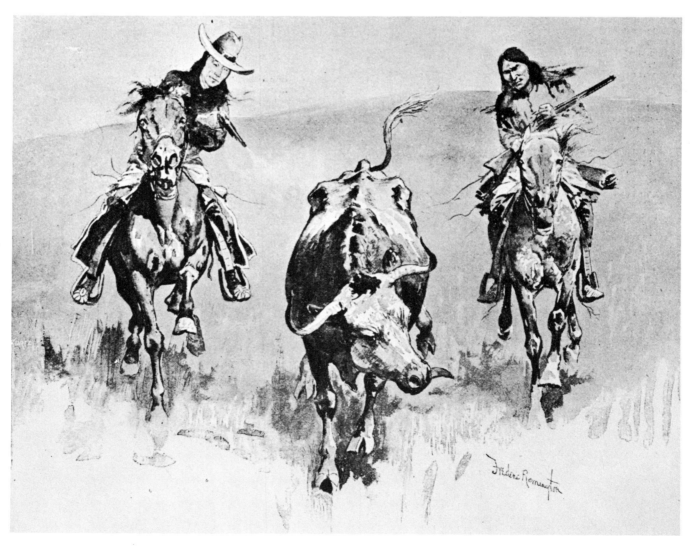

252. THE BEEF ISSUE AT ANADARKO, I. T.

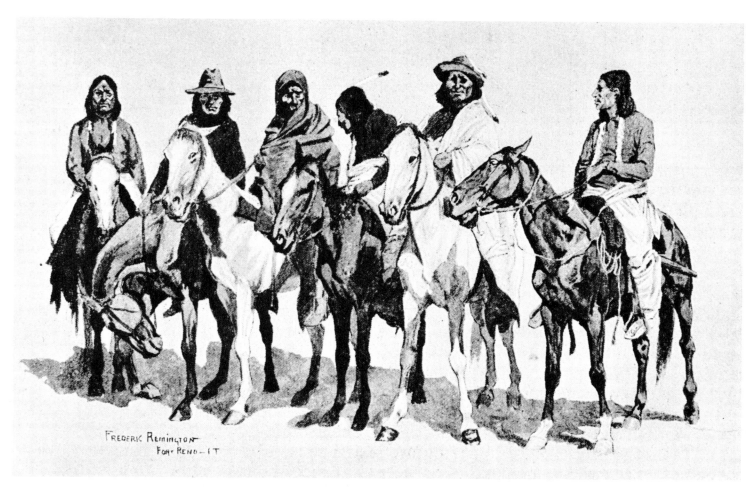

253. WAITING FOR THE BEEF ISSUE—FORT RENO, I. T.

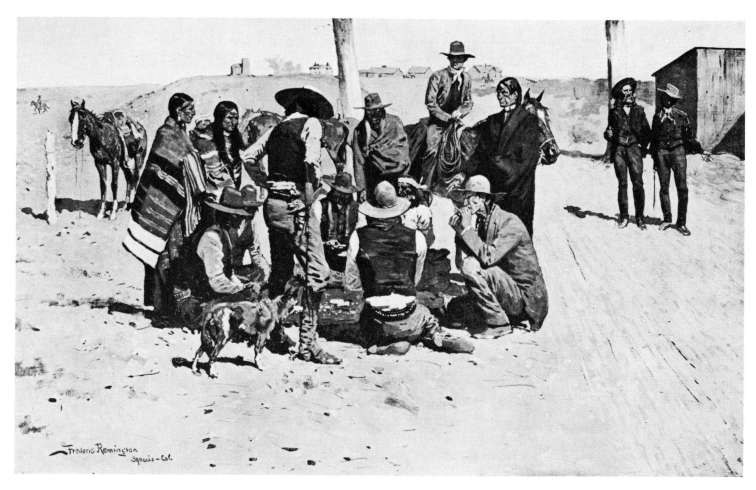

254. A MONTE GAME AT SOUTHERN UTE AGENCY

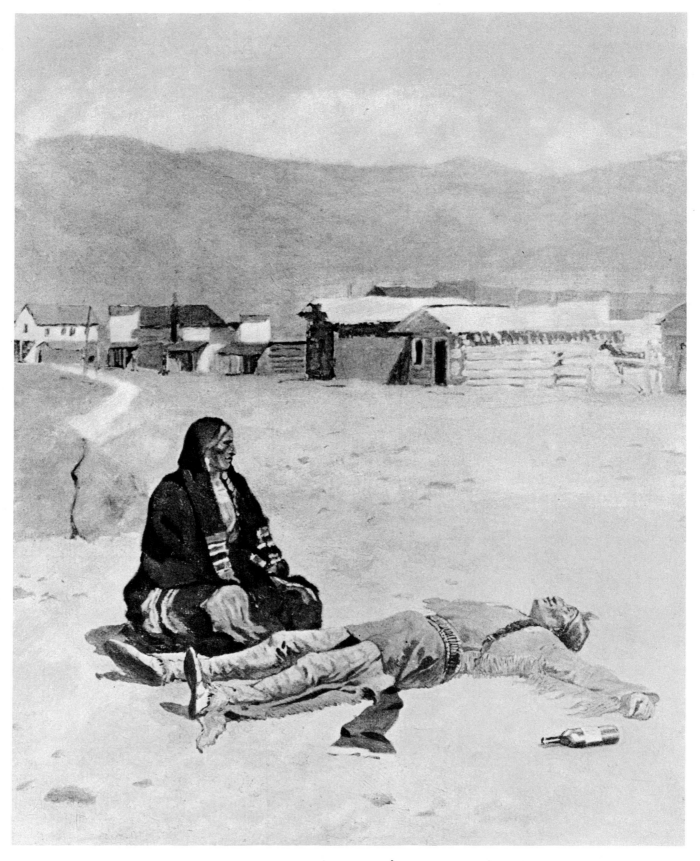

255. THE RED MAN'S LOAD

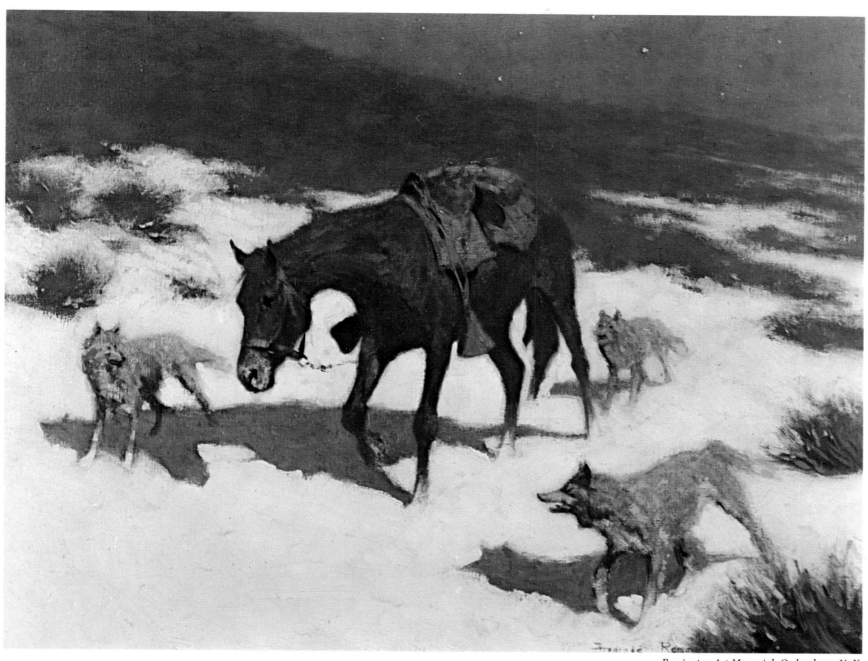

256. THE LAST MARCH

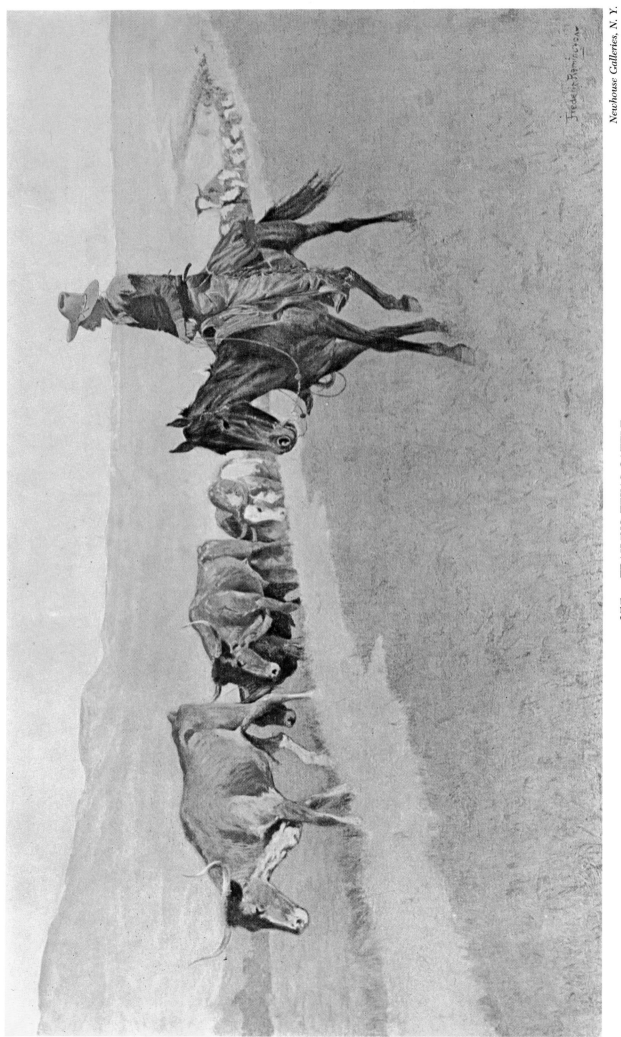

257. TRAILING TEXAS CATTLE

CHAPTER XI

Buffalo to Cattle

THE FIRST COWBOYS

IT WAS the early Spanish who introduced cattle to our continent, just as they did the horse. The first cattle were brought across the Atlantic in the explorers' big galleons in the early sixteenth century and landed in Florida. There the first herds were established and the first cowboys (*vaqueros*) rode herd and roundup among the palmettos and palm trees of the sun-scorched pampas. Even today cattle raising in the interior of Florida is a surprisingly extensive industry and some of the big outfits are controlled by descendants of the early Spanish pioneers. The Florida cowboys still use the long bull whip and ketch-dog in preference to the lasso, and they are as tough and rough a bunch of hombres as ever gathered around a Wyoming roundup chuck wagon.

The early Spanish also took cattle to Mexico, where some extensive ranches were established south of the Rio Grande. But it was on the grassy buffalo plains of Texas that Spanish colonial cattle raising blossomed into an industry of broad proportions.

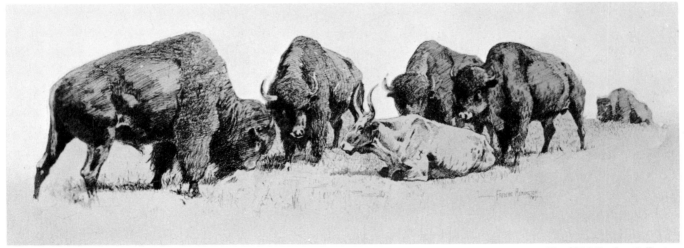

Harold McCracken Collection

259. A RECRUIT FROM CIVILIZATION

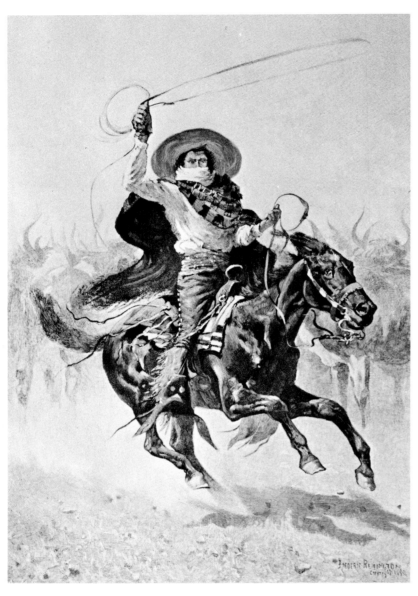

260. "TORO, TORO!" AN OLD TIME CALIFORNIA VAQUERO

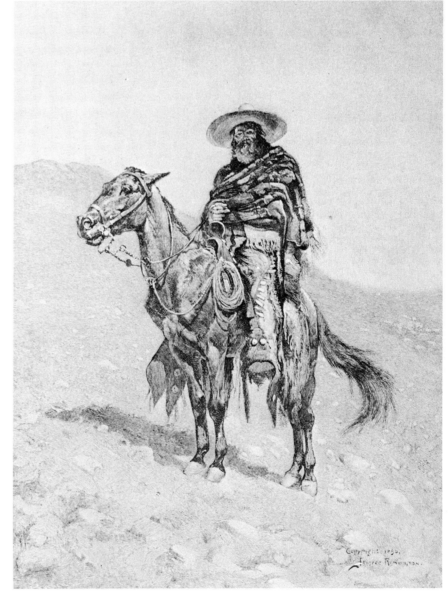

261. A MEXICAN VAQUERO

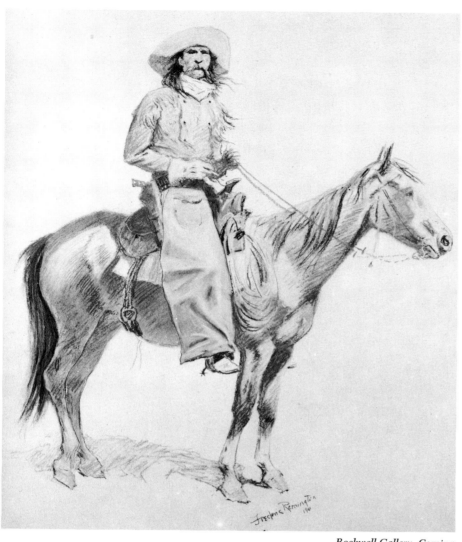

262. AN ARIZONA COWBOY

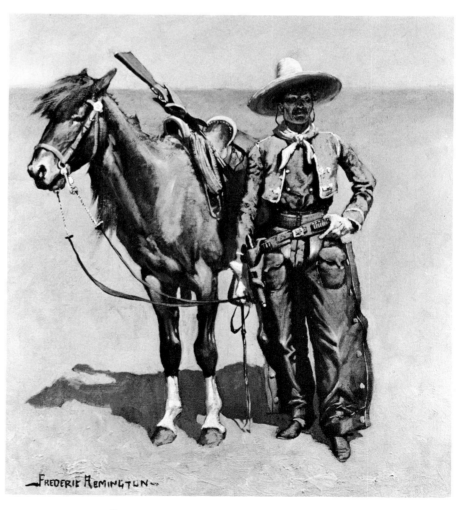

263. A MEXICAN BUCCARO—IN TEXAS

IT WAS the explorer Coronado who took the first cattle onto the western Plains. According to documents recorded when the expedition left Compostela, Mexico, February 22, 1540: "The leader rode proudly at its front . . . and there were a thousand horses in the train . . . and upwards of a thousand servants and followers . . . and thousands of cattle, sheep and swine for food." The expedition wandered across present Arizona, New Mexico, Texas, Oklahoma, Colorado, Kansas and Nebraska. The explorers finally returned to Mexico two years later, "empty handed." It is natural that some of the cattle should have wandered off, and with such a natural habitat for their good health and propogation they provided the beginnings of wild herds that continued to increase and spread over the buffalo plains, just as the horse did.

The expeditions of Spanish explorers who followed Coronado also drove cattle with them for food, and when the colonization began, cattle raising became part of the developing economy. The herds were permitted to roam half wild and required skilled, hard-riding *vaqueros* to round them up. It was during this period that many of the practices and cowboy equipment were developed which later became common to the Northern Plains. Among these were the characteristic *chaparajos* ("chaps") to protect the rider's legs from thorn-bushes, chaparral, mesquite, Spanish dagger, etc.; as well as the *lasso, cavvy, remuda, bronco, rodeo* and many more.

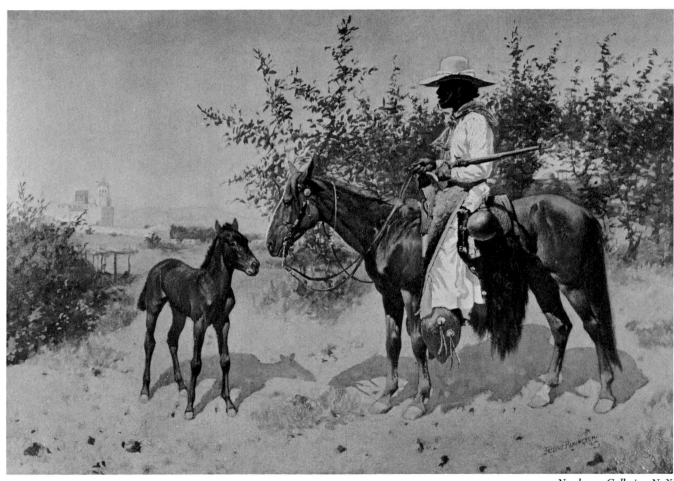

Newhouse Galleries, N. Y.

264. IN THE LAND OF SPANISH MISSIONS

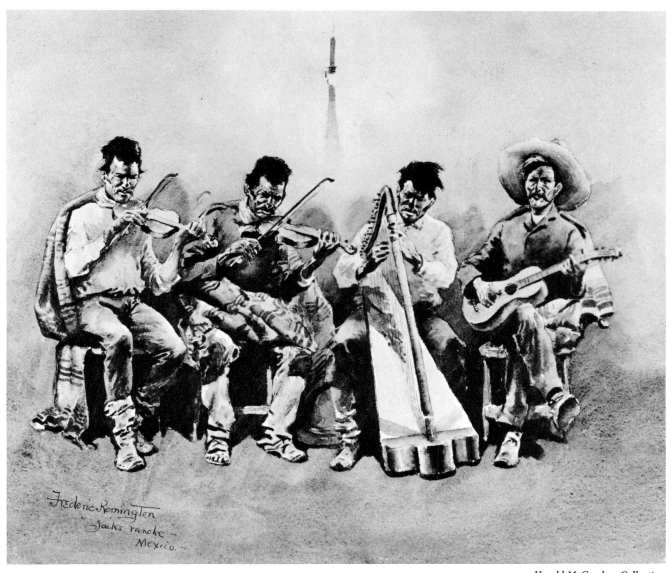

265. MEXICAN COWBOY MUSICIANS

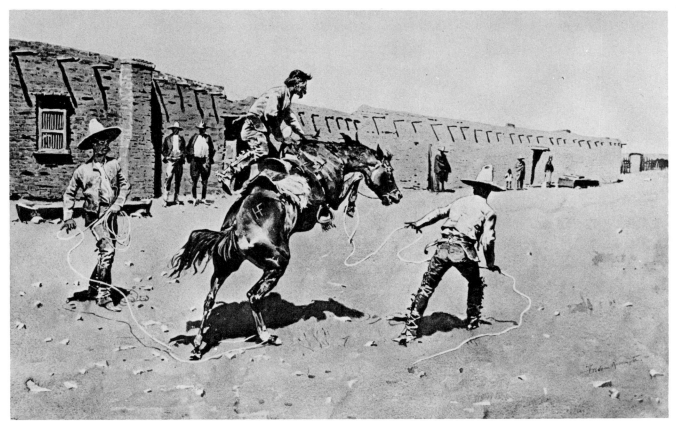

266. MEXICAN VAQUEROS BREAKING A BRONCO

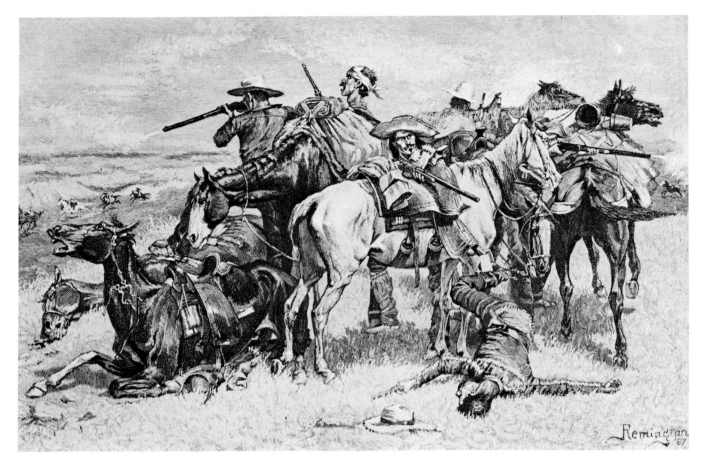

267. OPENING UP THE CATTLE COUNTRY

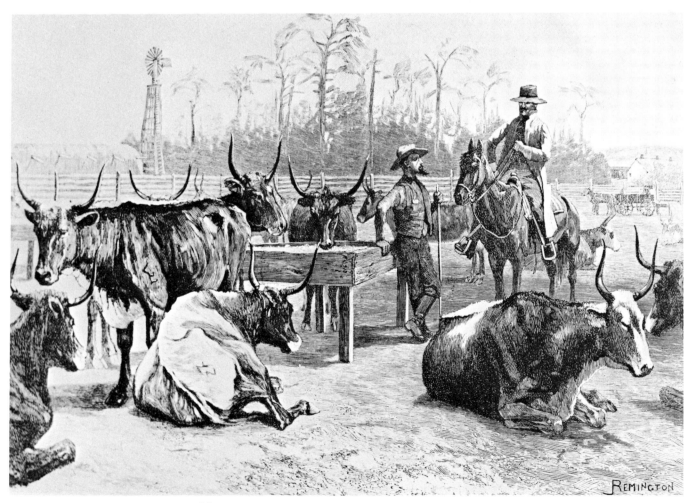

268. TEXAS CATTLE IN A KANSAS CORN CORRAL

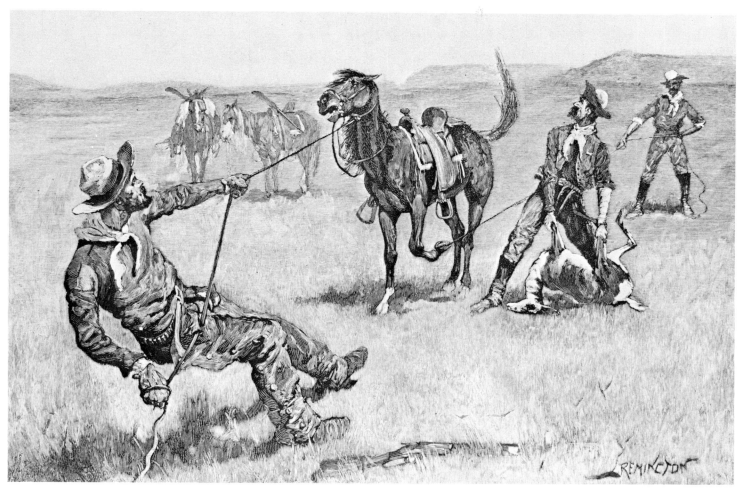

269. TEACHING A MUSTANG TO PACK GAME

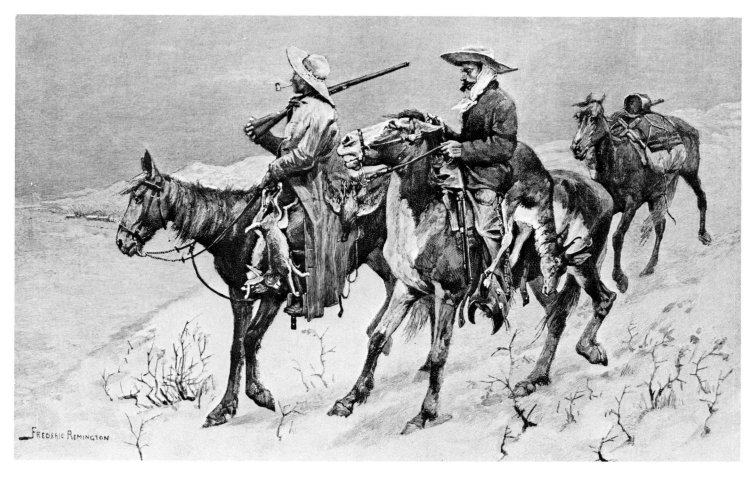

270. THANKSGIVING DINNER FOR THE RANCH

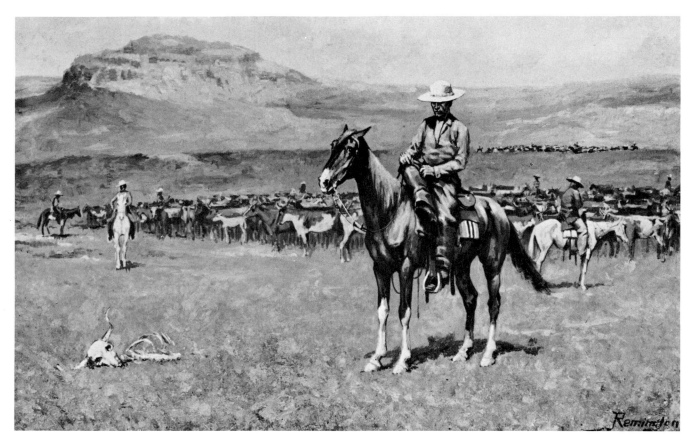

271. THE ROUND-UP

THE cattle which the conquistadors unintentionally seeded on the southern Plains did
not produce the interest among the Indians that the horse created. The meat of the
Spanish cattle was considered less desirable for food than that of the buffalo, and the latter
provided a greater variety of necessities for the red man's life. Also, the wild cattle were
more difficult and dangerous to kill. Theodore Roosevelt once made the remark that a wild
Texas longhorn steer could be the meanest and most dangerous game in North America.

The cattle industry, which made such an important and widespread contribution to
the life, development, and economy of the whole West, had its beginning on the lower Texas
range. There were some radical changes when the Anglo-Saxon Yankee business skills
replaced the languid attitudes of the Spanish-Mexican *rancheros,* although many of the
methods and practices of the *caballeros* and *vaqueros* were also brought to the Northern
Plains with the cattle.

According to the "Report upon the Statistics of Agriculture," in the *Tenth Census of
the United States* (1880), there were in the year 1830 an estimated 100,000 head of cattle
in Texas; in 1850 these had increased to about 330,000; and by 1860 the official figure was
put at 3,525,768. This increase was almost entirely the result of the natural processes of
nature and with the benefit of extremely little planning or control of the Mexican *rancheros*
who claimed them. They ran wild on a vast open range and had very little value because
of the lack of an adequate market. He who wanted meat for food or hide for leather went
out and killed for himself.

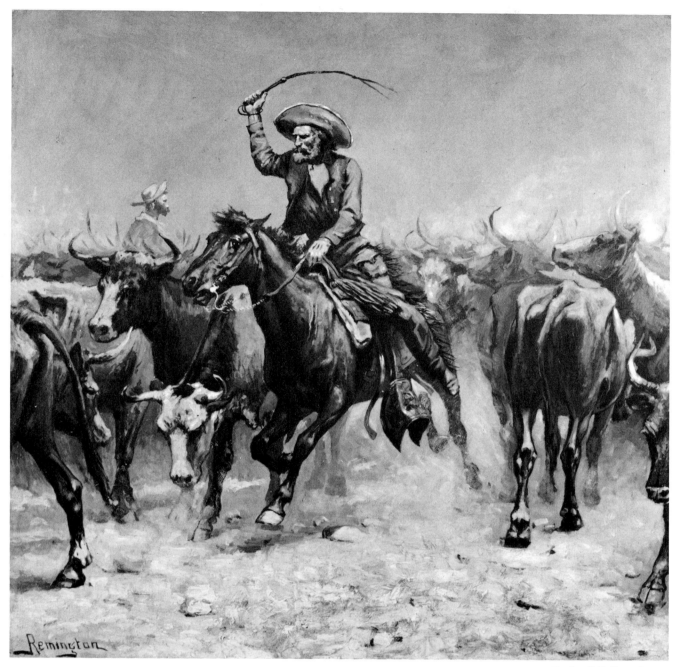

272. CUTTING OUT A STEER

Rockwell Gallery, Corning

UP NORTH, when settlers swarmed onto the Plains and towns mushroomed, there was a healthy demand for beef at thirty to forty dollars a head for cattle that in Texas could be bought for three to four dollars. All that separated supply and demand was 1000 to 1500 miles of rough, dangerous Indian country. To get the product to market required driving it on the hoof. But the profits plus Yankee incentive were sufficient to get the job done. The first small herd was driven north in 1837; the first drive of a thousand head was in 1846; and between 1866 and 1880 an estimated five million head of Texas cattle were driven north. Thus a market was supplied and, more important, the cattle industry on the Northern Plains was established.

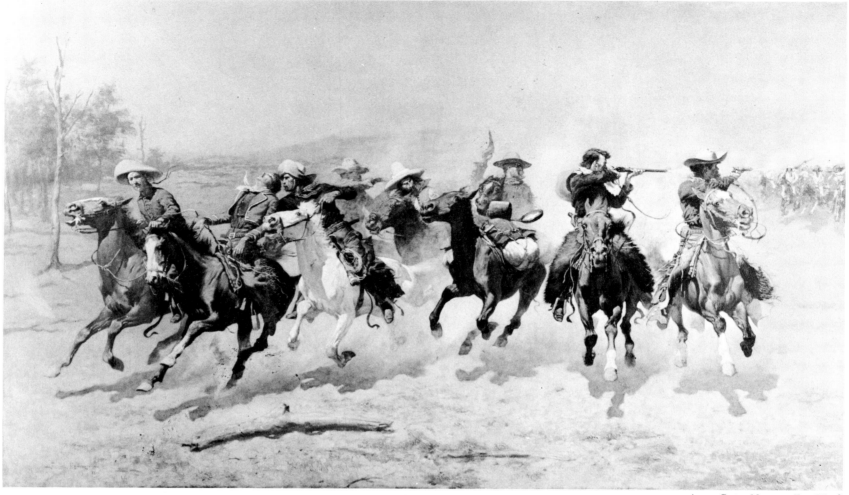

273. A DASH FOR TIMBER

Amon Carter Museum, Fort Worth

THE historical era of the big American cattle industry was a relatively short one, although it spread over most of the West from the Mississippi to the Pacific coast. Those marvelously blusterous days on the open range, of great herds, bronco riding, cowboys, cattle barons, little cow-town saloons, and uninhibited masculine drama, put on its biggest show in the Northern Plains, where this extravaganza flourished from the early 1870's to the early 1890's. In some areas it was a little longer, but in those few years there was written on the pages of American history one of its most virile, rough, and memorable chapters, and the cowboy became an epitome of the American image, which came to be held in high regard the world over. The nemesis of that era was the flood of settlers that swept rapidly over the West, to become landowners and cut up the wide open spaces into homesteads, fenced in with barbed wire. The big free-land cattle outfits were pushed northward or into restricted and less desirable areas, just as the Indians were pushed aside and incarcerated on reservations, by the onmarch of civilization. Some of the cattlemen fought to survive, but the old days were soon gone. Frederic Remington was a part of that exciting era, from Old Mexico to northern Montana, and the pictorial record that he made is the most comprehensive and clearly understandable that we have of that period and its participants.

Tʜᴇ characteristics of the American cowboy, both in dress and disposition, were much the same throughout the West. There were some minor regional differences and certainly nothing stereotyped about any of them. But you could tell a cowboy as far as you could see him. He was always mounted on a spirited horse and showed by the way he rode that he would boast that there didn't live any horse he couldn't ride; and he held in low contempt all men who walked.

The cowboy appeared as natural and indigenous to the western Plains as the buffalo or the badger; in spite of the ineradicable influence of the early Spanish-Mexican *vaquero* in the basic concept of the most northern cowboy's gear and even many of the Anglicized names and terms he used. His universal badge of identity was his "chaps" (*chaparajos*), which varied from "shotguns" to "batwings" or "woolies," but all of the same basic pattern. His wide-brimmed, high-crowned felt hat showed regional modifications of its ancestor the *sombrero*, as did his spurs, his lariat (*la reata*), high-heeled, pinch-toed leather boots, and the holstered revolver that invariably hung handily on his wide belt. The only fancy stuff was the fringe that sometimes adorned the edges of his leather chaps, sleeves of shirt or jacket, and softly tanned gloves; and rarely a few small silver *conchos* on chaps or belt. Some wore the traditional big belt knife for extracurricular social involvements. What their fists couldn't take care of, most preferred a more lethal weapon.

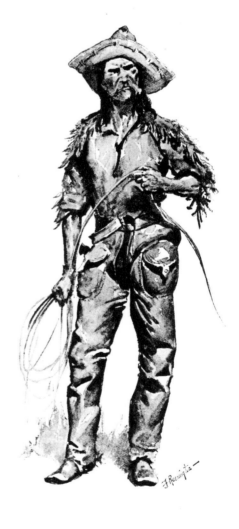

274. AN ARIZONA TYPE 275. OLD-STYLE COWMAN 276. A SHATTERED IDOL

THE cowboys were a motley but gregarious tribe. The development of the cattle industry on the Northern Plains brought into being this new and very distinctive type of American pioneer. Richly abundant in glamorous as well as strenuous Wild West adventure, it attracted those too late to be explorers or to join the mountain men.

The making of a cowboy required a lot more than just the acquisition of a horse and pair of chaps. But from far and wide they came, from every conceivable family and social background, from tenement streets and the baccalaureate halls of ivy, from Tidewater Virginia, quiet New England hamlets, the backwoods hills of Tennessee, the farms of Ohio, and from the gold camps of California, ships from the sea, and forty other places. How so many of these adventurers from such widely separated backgrounds became so quickly but thoroughly skilled, indoctrinated, and welded into such a strenuous, demanding, and exclusive frontier profession is one of the extraordinary things about the development of the West.

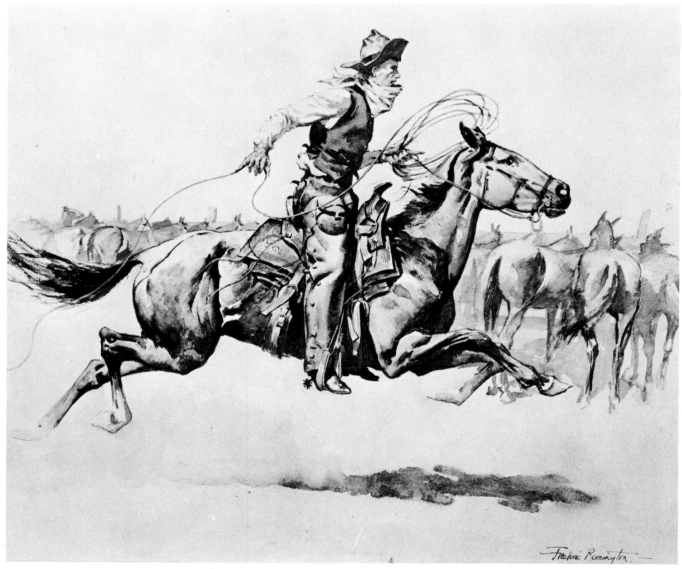

Harold McCracken Collection

277. GATHERING THE ROPE

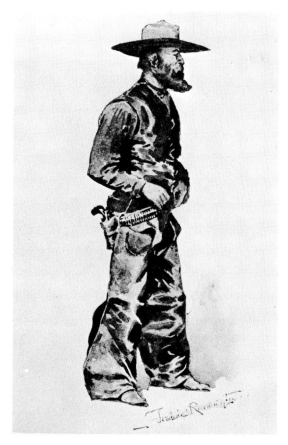 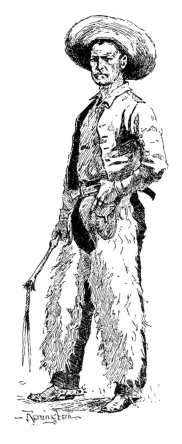

278. OLD MAN ENRIGHT 279. A MONTANA TYPE

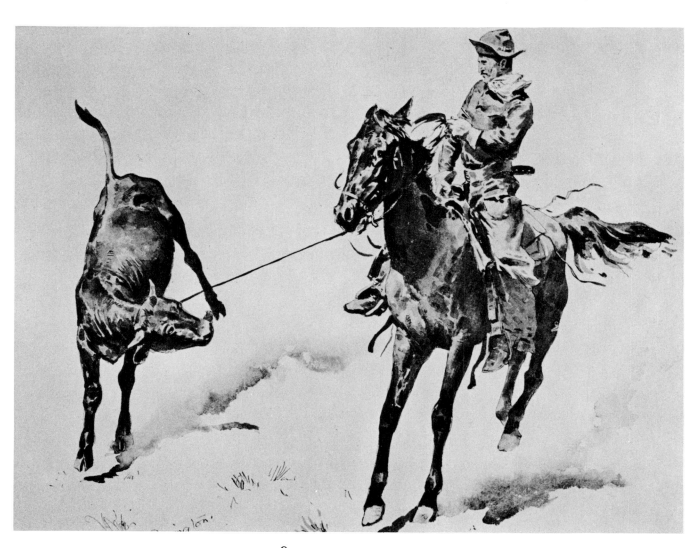

280. LEADING A CALF

IT WAS not for the opportunity to get rich that caused men to become cowboys. Changing places with a gold prospector, however, was unthinkable; and getting four times the pay of a soldier was of small importance. Being a roughneck knight of the saddle was a way of life, and little else mattered. Even when laid off in a stormy winter, the cowboy preferred to ride the grub line like a hobo looking for handouts and free lodging, rather than hole up in some little town where he might get a temporary job, below the dignity of his profession.

The cowboy's real compensation came from the freedom to go rioting over the plains and hills with his own tribesmen, in the companionship of adventure and spirt of freedom. For this he paid the price of chasing cattle wild as deer, across the prairies or out of rocky ravines; an occasional skirmish with Indians or rustlers; swimming his horse across a spring torrent; sleeping in rain or snow with only a saddle for a pillow; and the risk of being trampled into the dust by a thousand stampeding hoofs in the blackness of night. These were the things that made his life worth while. And for this he paid an additional price of living without a home, wife, or family to raise. There was also another side of his nature. He sometimes sang to himself, when out alone on night herd—songs that he remembered from childhood, in a church, or maybe something he made up about a girl he once knew. On the outside he was the roughest cuss you might find, but a man couldn't find a better friend. Their first consideration was one of self preservation; and beyond that to get their pay when a roundup job was done and then hit the trail for the nearest place, where a guy might have some fun.

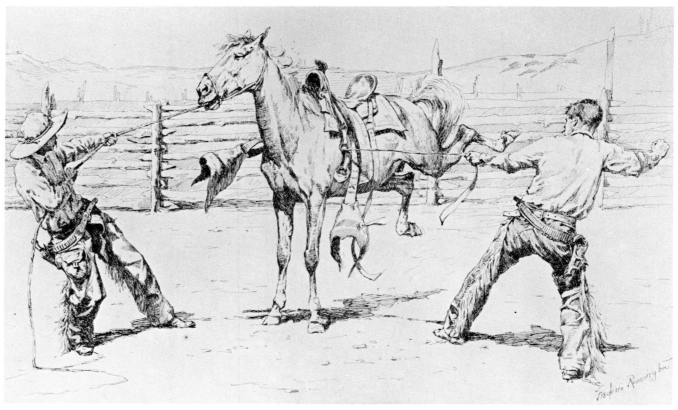

Kennedy Galleries, N. Y.

281. BRONCO BUSTERS SADDLING

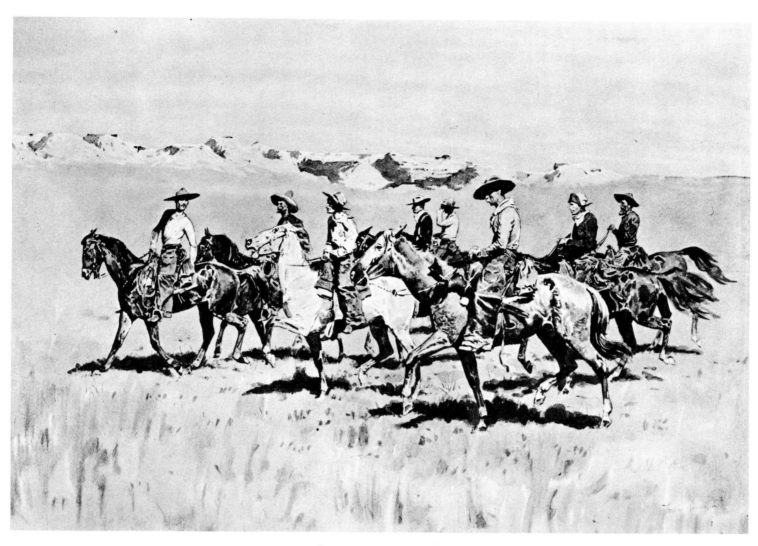

282. THE PUNCHERS

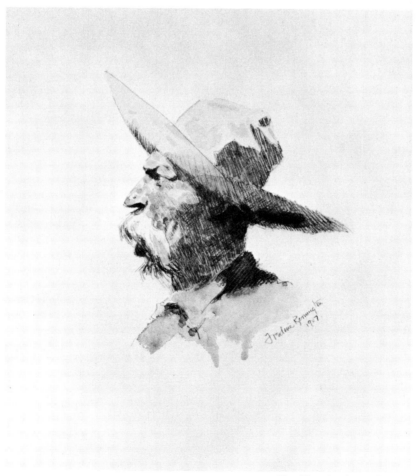

283. A FUTURE CATTLE BARON

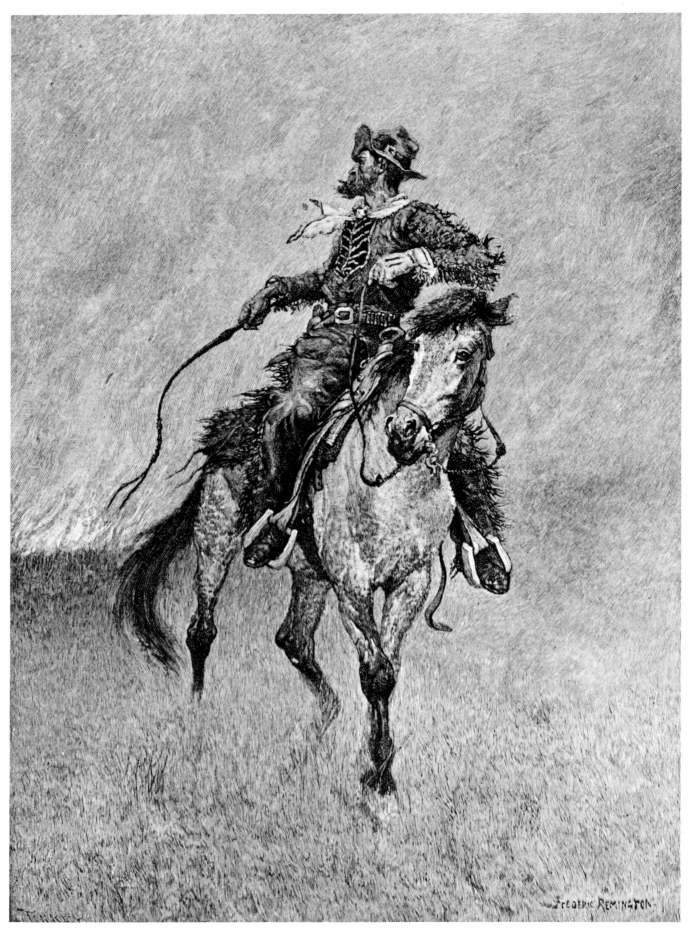

284. COWBOY LIGHTING THE RANGE

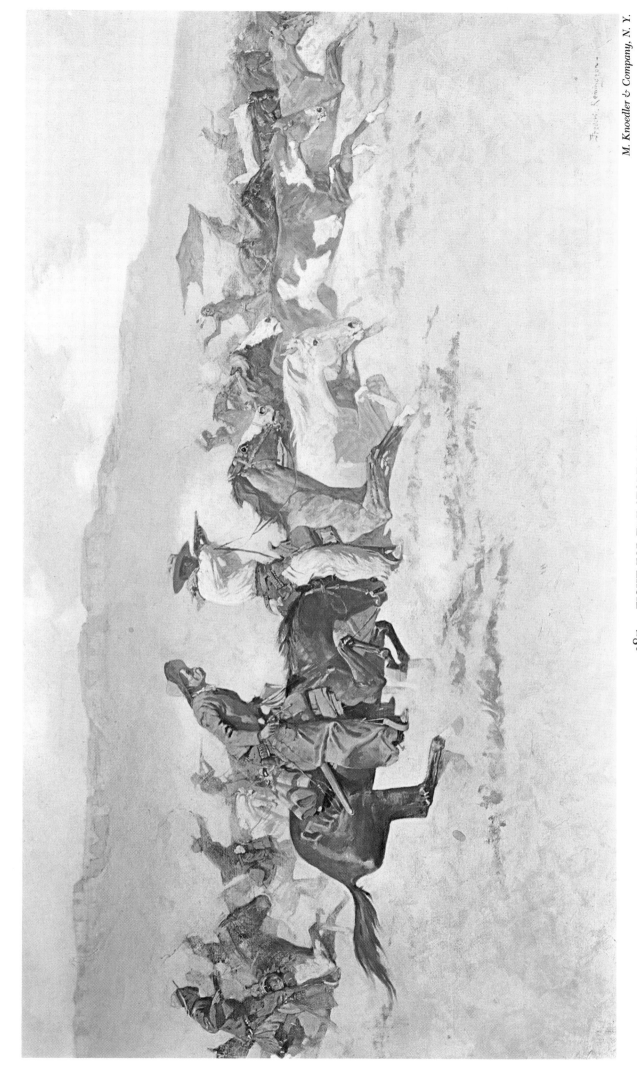

285. FIGHT FOR THE STOLEN HERD

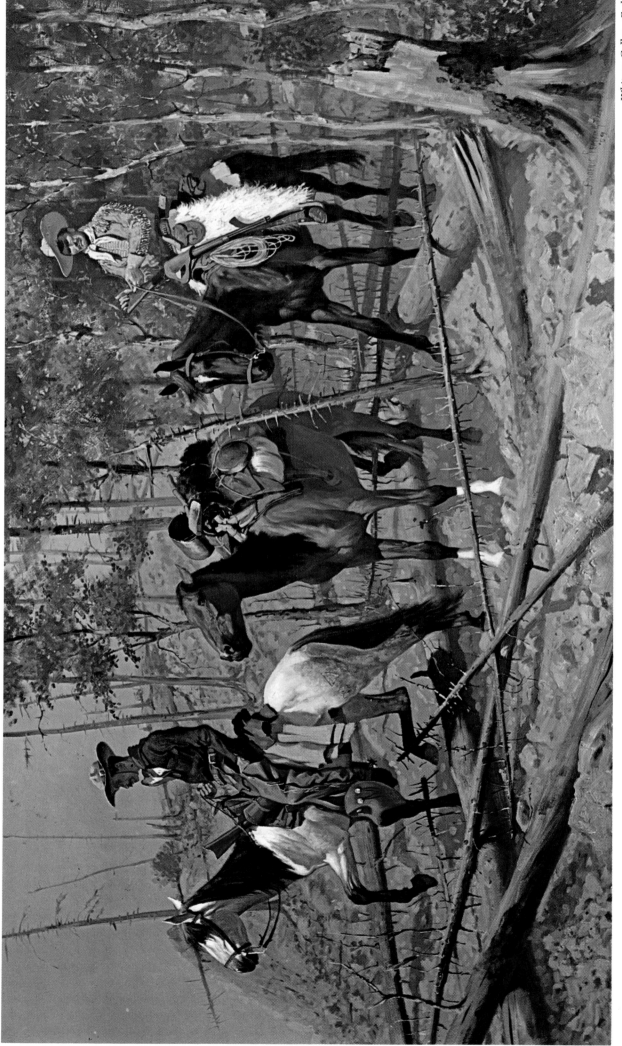

286. PROSPECTING FOR CATTLE RANGE

CHAPTER XII

The Cowboy in His Day

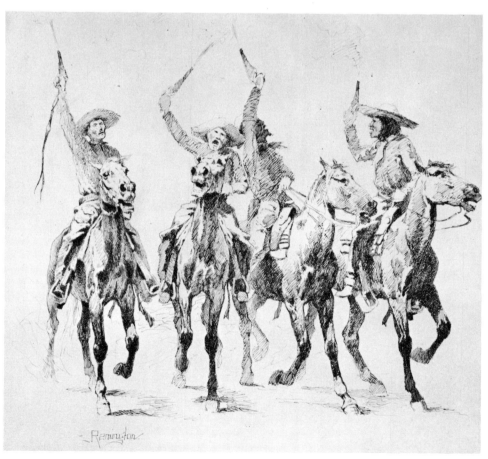

MUCH of the old-time cattle range was rough country. It was not all flat land. The rolling prairies had for centuries been deeply cut by streams and rivers, muddy torrents in spring and ice-jammed in winter. Here and there rose rim-rocked plateaus and isolated hulks of high mountains. The higher country of hills, benches, basins, and valleys provided the best grazing during the heat of summer. Moving and handling the big herds in such terrain, where escape into the badlands was always a temptation to half-wild cattle, made life in the saddle as rough as the country. Throughout the summer and winter the cowboy's job was more continually demanding of strenuous existence than that of any other early Western pioneer.

Harold McCracken Collection

288. COMING THROUGH THE RYE

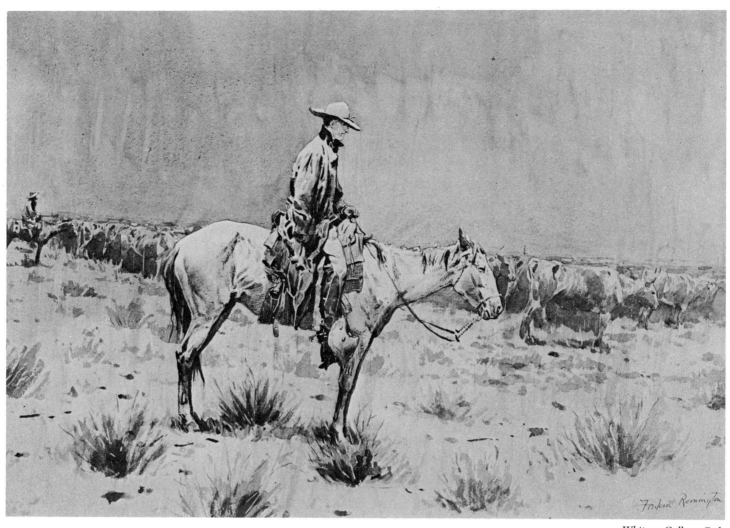

289. RIDING HERD IN THE RAIN

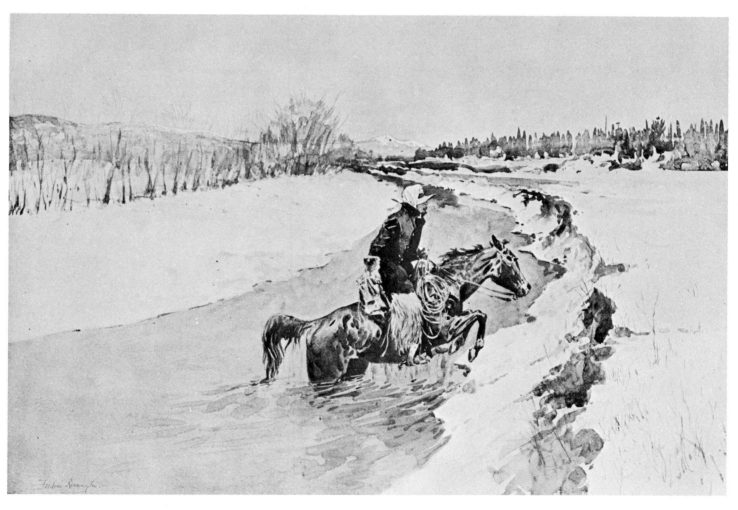

290. RIDING THE RANGE IN WINTER

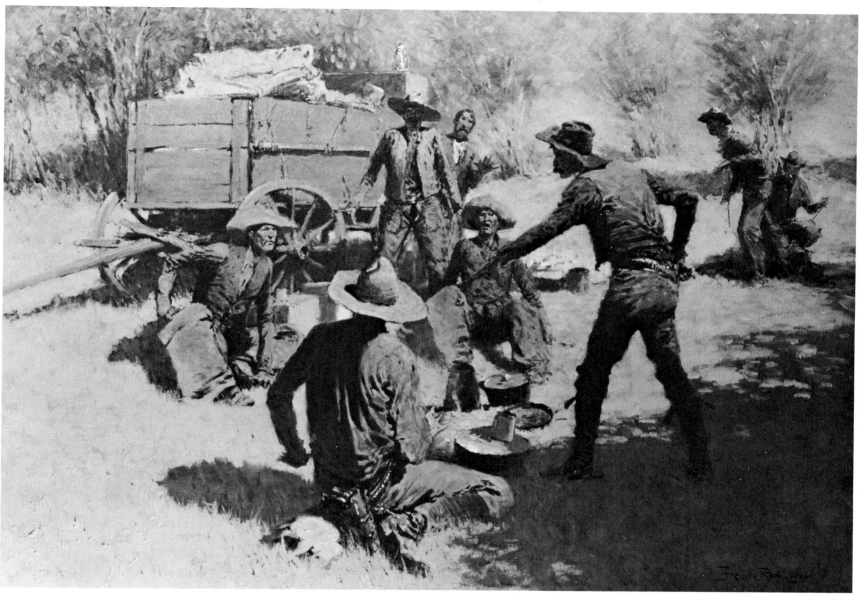

M. Knoedler & Company, N. Y.

291. THE QUARREL

PUGNACIOUS as an old she grizzly bear, the cowboy knew no half way between violence and sentimental tenderness. Being continually at war with all the natural elements of an abominably rough country, in heat, rain, or snow, forever fighting to control his cantankerous herds, was quite enough to bring out in these cavaliers a throwback to the medieval militancy of their Saxon ancestors. Certainly no lengendary knight of Camelot could have more enjoyed a fight or been prouder of his weapons and his horse.

The horse was always the cowboy's best friend, and then came his six-shooter. In the big outfits each working cowboy had from six to ten horses in his string. The number varied according to the number of cattle to be handled and the work to be done. At roundup time for cutting out and branding, a top hand could wear out a good cutting horse about every two hours; and for range work and trailing he could use up two to four a day.

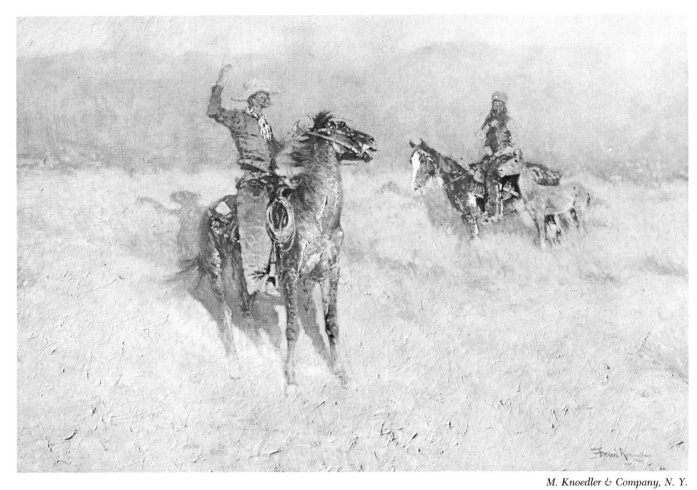

M. Knoedler & Company, N. Y.

292. THE LONG HORN CATTLE SIGN

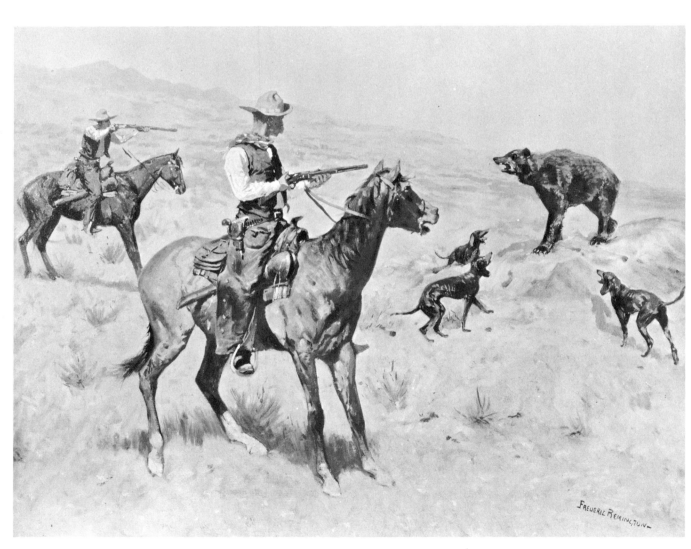

293. READY FOR TROUBLE

THERE was as much difference in cow ponies as there was in cowboys. Where a top-hand cowboy was found, he usually had at least one first-rate cow pony in his string, and this was generally a cutting and roping horse. Such a combination of man and horse was the ultimate in cattle country performance. Both were called upon to the fullest extent of ability and stamina during the spring roundup, when the calves were big enough to be branded. Bosses from adjoining outfits were on hand to make sure that the wrong brand was not burned on any of their own calves.

The roundup herd was kept bunched, and cowboy and cutting horse had to make their way into the milling, crowding, unruly mass. Finding the calves was not easy, half hidden in the thick dust and the densely packed herd. When one was singled out, the cutting horse knew what was to be done as well as the rider, and never taking eyes off mother and calf, the horse kept right on their heels and began cutting them out toward the edge of the herd. Dodging and twisting, lunging forward through the surging jungle of bodies, there was no stopping until cow and calf were out in the open. Then the cowboy would rope the calf and it was dragged to where the branding irons were heated and ready. Ownership of the calf was established by the brand mark on the mother—although sometimes a serious dispute developed.

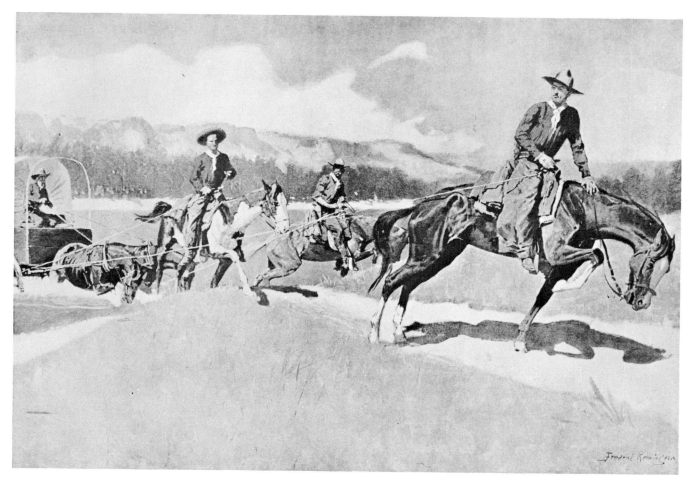

294. THE CAYUSE

295. OLD MONTE 296. A MEXICAN VAQUERO

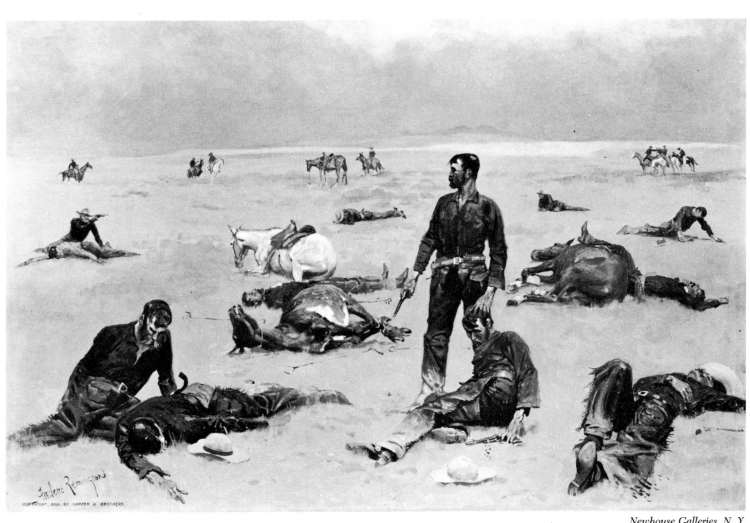

297. WHAT AN UNBRANDED COW HAS COST

ATTLE country stories of fights and feuds over the ownership of an unbranded calf are many and sometimes bloody. One of these was recorded by Owen Wister, for which Frederic Remington made the picture on the opposite page. The story is presumably factual: "One high noon the long irons lay hot in the fire. The young cattle were being branded, and the gathered herd covered the plain. Two owners claimed one animal. They talked at first quietly around the fire, then the dispute quickened. One roped the animal, throwing it to the ground to burn his mark upon it. A third came, saying the calf was his. The friends of each drew close to hear, and the claimant thrust his red-hot iron against the tied animal on the ground. Another seized it from him, and they fell struggling. Their adherents flung themselves upon their horses, and massing into clans, volleyed their guns across the fire. In a few minutes fourteen lay dead on the plain, and the tied animal over which they had quarreled bawled and bleated in the silence."

The life which these men lived with such zeal could only result in producing some extreme and at times rather strange individuals, in many respects unlike any other breed of American pioneers. Their apparent enthusiasm for conflict, against nature or man, and their indifference to death were the most extraordinary of their idiosyncrasies, like a throwback to far into primitive ancestry, although entirely similar to that of the Indians of their own era. Intensively clannish, nationalistic, and with few interests beyond the narrow confines of their own activities, they held all others in some degree of low regard; and one of their most patent dislikes was for the Mexicans, from whom they had inherited their own profession.

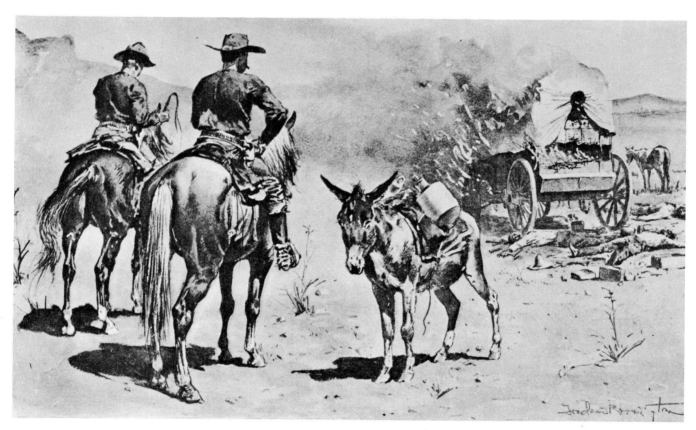

298. END OF A MEXICAN FREIGHT OUTFIT

Mᴏsᴛ who went West to become cowboys or to engage in the cattle industry remained to the end of the era. A notable exception was a Harvard graduate who became the twenty-sixth and youngest president of the United States. This was Theodore Roosevelt. As boss of his own cattle outfit on the Little Missouri River in North Dakota, he followed the intensive life in the early 1880's and gained the stamina and pugnacious personality which marked his illustrious career. Roosevelt knew the life of the cowboy and wrote a series of articles about it for *Century Magazine* (1883) which also became an early steppingstone for Frederic Remington as illustrator, and this began a lifelong friendship between these two men. One of the pictures showing the future president is shown below.

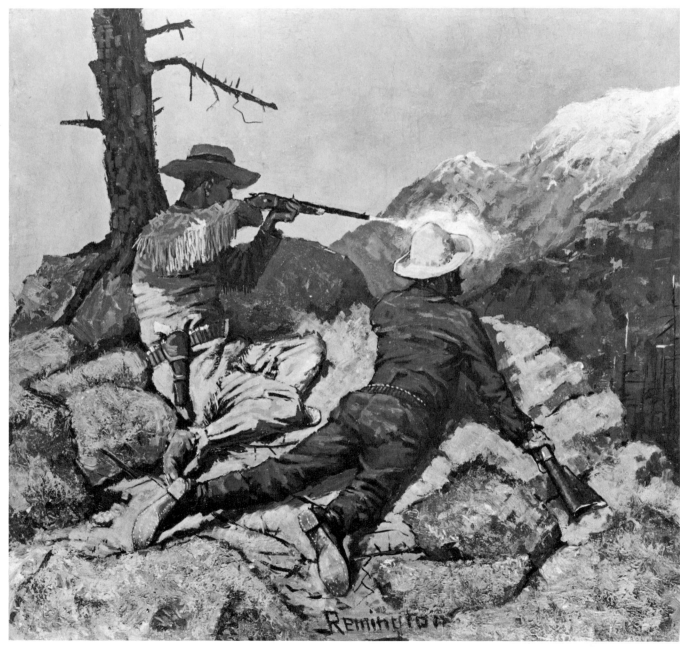

Rockwell Galleries, N. Y.

299. THE FIRST SHOT

Not all of the time was spent in running and roping cattle. Sometimes they had to hunt game for food, when out too far from the home ranch or the chuck wagon. Idleness had a small place in their daily routine and little to do but sleep at night. When out alone with no strenuous duties at hand, about the only diversion was counting prairie dogs or watching an eagle in the sky. Occasionally, they might have a race, to prove whose horse was the fastest; or in devilry practice their skill by roping one another. About the only time they went looking for fun was when they rode in to "paint up" the nearest town.

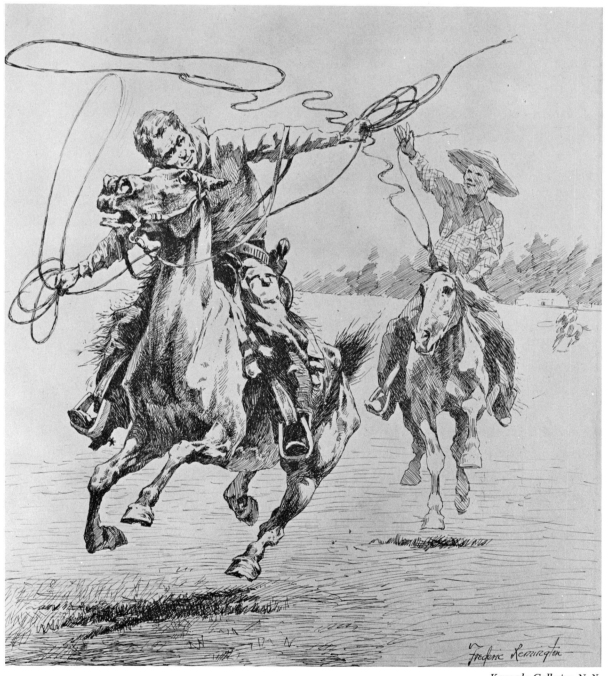

Kennedy Galleries, N. Y.

300. COWBOY FUN

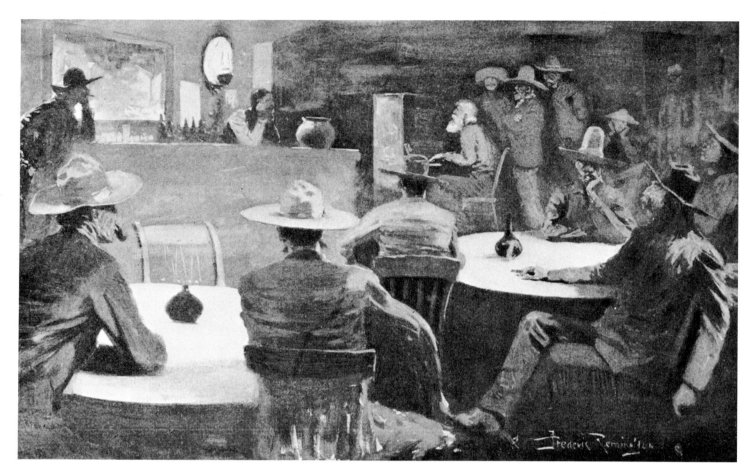

301. A CHRISTMAS CAROL

CHRISTMAS was one time when most cowboys gave way to some open expression of sentimentality—if they had any spark of weakness at all and most did. They usually made acknowledgments on Fourth of July and Thanksgiving, if there was anyone around who knew what day of the month it was, but Christmas was the special day that wasn't to be overlooked. There was usually a Christmas dinner at the home ranch for all and a big dance (all stag) in the bunkhouse, with somebody playing a fiddle and plenty of drinks-on-the-boss. Some went to town—and most got drunk—if only to drown the thoughts that Christmas always resurrected from the past.

Owen Wister wrote the text for the above Remington picture:*

> *Thar weren't no laughin' goin' on in the house*
> *When Singing Joe played for the boys;*
> *The barkeep and punchers kept still as a mouse,*
> *The greaser mule-boys quit their jabberin' noise.*
> *His voice sounded cracked, the pianner weren't right,*
> *But nobody had no fault to find;*
> *The tune was "Home, Sweet Home"—'twas Christmas night,*
> *And poor old Singing Joe was blind.*

° "Done in the Open" (1902)

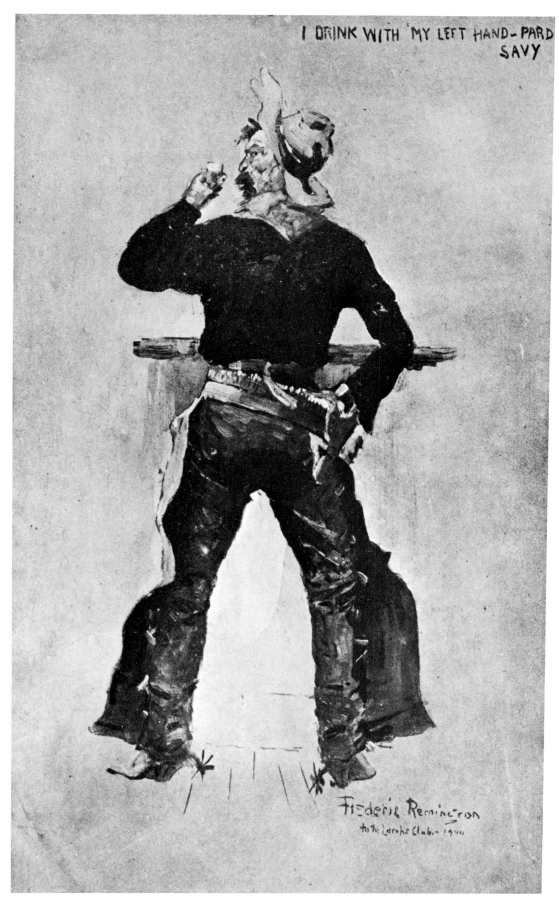

302. "I DRINK WITH MY LEFT HAND—PARD."

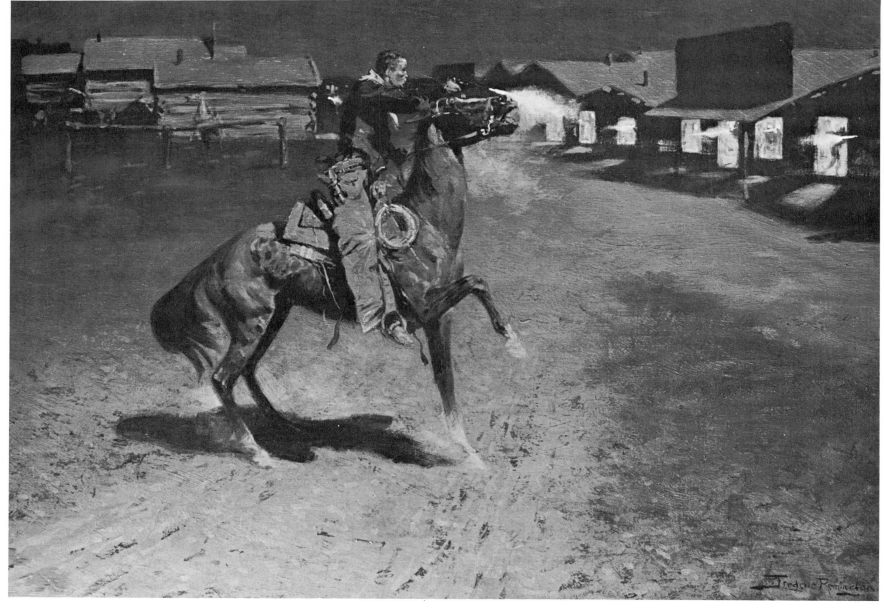

303. ARGUMENT WITH THE TOWN MARSHALL

THE boys weren't really troublemakers; they were just independent and didn't like to be fenced in, by barbed wire or the law. Sometimes, when they drew their pay and went to town for a bit of diversion and relaxation, their temperaments got the best of them. Situations developed into more trouble than even a good town marshall could handle. Little arguments between a couple of friends might spread to a lot of other folks who enjoyed a brawl—some who might not even know what the argument was about. But at least it gave the participants something to talk about, when they returned to sit around the chuck-wagon fire on a dull quiet evening.

Nor were the cowboys the only ones in the region with rough and obstreperous characteristics. This was still the general temperment of most of those involved in the development of the West. The cowboys led a more strenuous life than others and their trade attracted those of similar nature. But their roughness was an earthy, healthy sort; and there were no tin-horn gamblers, land sharks, or road agents in their tribe.

THERE wasn't a wide range of diversion to be found in the average early day cow town—at least before the days of female entertainers. It was strictly a man's world. Some of the ranch bosses had wives and kids; and the unwelcome nesters who were beginning to mark out little homesteads, build sod-covered living hovels, and scratch the earth to plant things to eat, mostly had good womenfolk to share their struggles. But that sort didn't frequent the places cowboys came to town to visit, and the quiet folk got out of town before the sun went down.

Most any cowboy in town after dark had money and was looking for a place to spend it. Before the girls came there were only two such places—at a bar or the card tables. When there was more than one saloon, the different cattle outfits had their favorite emporiums. Cowboys were quite unilateral in their friendships, especially when drinking or gambling, and there was less trouble when they kept to themselves. The ponies tied outside told how many and who was inside. But the tin-horn gamblers played the field. It was, however, a dangerous field; for an intentional misdeal at a card table sometimes caused much the same eventuality as a misbranded calf.

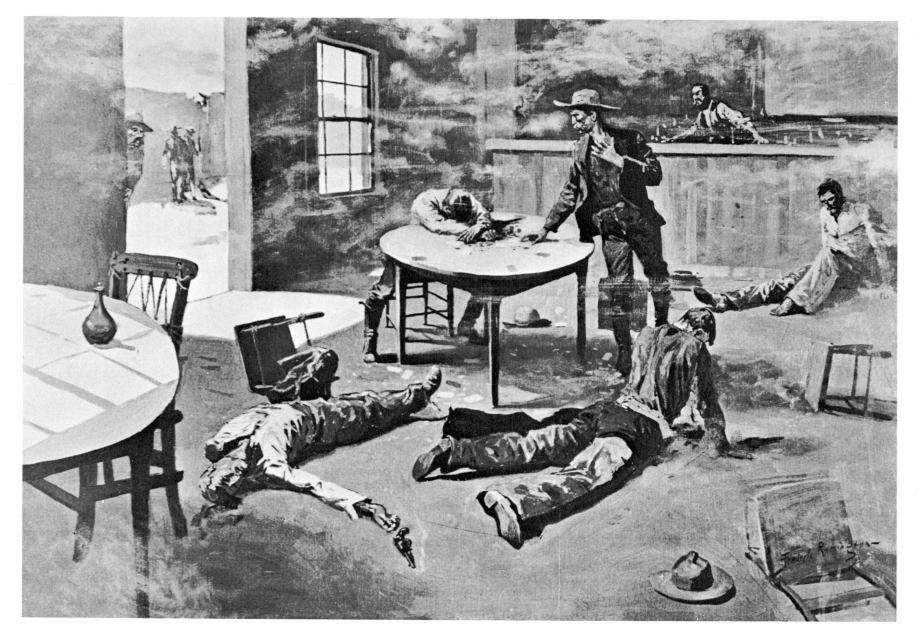

304. A MISDEAL

THE chuck wagon was considerably more than a cattle country mess hall on wheels. Furnishing food to hungry cowboys out on roundup was very important, but that was only one function of *the wagon*. It was invariably driven by "cookie," who presided over the preparing of meals and was himself a personage of considerable self-importance. Wherever he camped his chuck wagon, there the *remuda* of spare horses was held, there the herds were brought in, and there was centered all business and social activities, until "cookie" moved *the wagon* to some new location or back to the home ranch.

The chuck wagon was a by-product of the northern cattle industry and its development. It came into being in the days of the cattle drives north from Texas and the necessity of having some means of transporting food and other essentials. Later it became equally indispensable to the cattle roundups on the northern Prairies. It transported not only the cowboys' grub, but also their bedrolls, branding irons, spare saddles, medicines for man and beast, in fact everything of sheer necessity for the duties involved. The grub might not be fancy or elaborate, not well prepared and partaken by juggling a heaped tin plate in one's lap, but to a tired cowboy, hungry as a wolf, it was something always to be looked forward to, and the sociability of sitting and sleeping in the night glow of "cookie's" fire, with the coffeepot nearby, made the chuck wagon the nearest thing to home for the cowboys on roundup.

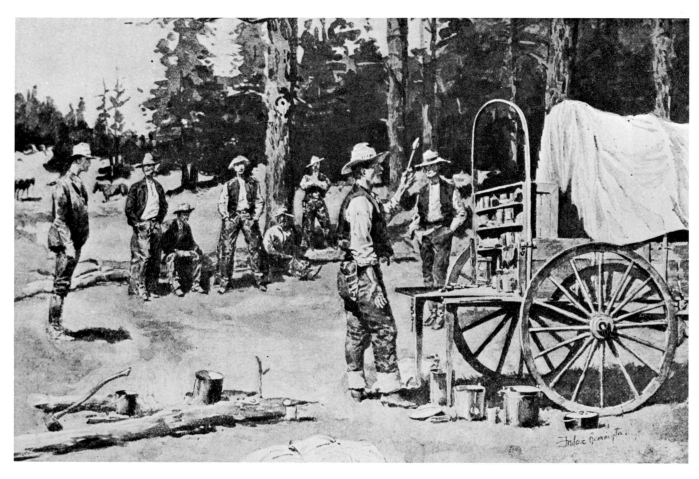

305. THE CHUCK-WAGON

IN THE early days, carrying a holstered six-shooter on a cartridge belt was common practice. Most cowboys considered such a weapon a part of their equipment. The guns were mostly forty-fours or forty-fives—calibers big enough to knock down about anything that walked. But this does not mean that every man who wore a six-gun was a gunman or killer. There were professional outlaws and bad men of course, but they were far fewer than their notoriety has led the average person to believe. Men like Jesse James, Doc Holliday, Wyatt Earp, Clay Allison, Luke Short, and others have been popular grist for the mill of fiction writers and movie makers, but, all gathered together, they make a very small part of the personnel of the Old West.

The cowboy carried a six-shooter because it was far more convenient than carrying a rifle, especially when roping or when his horse got a notion to do some bucking. There were times when a gun was a necessity, for use against renegade Indians, rustlers, or horse thieves, occasionally to put away a horse that fell and broke a leg, and many a cowboy was expert enough to kill any variety of game from antelope to grizzly bear. There were many who carried a six-gun for many years without using it against another man, although there were a good many others, of the brawler type, who did have more than one notch on their weapons.

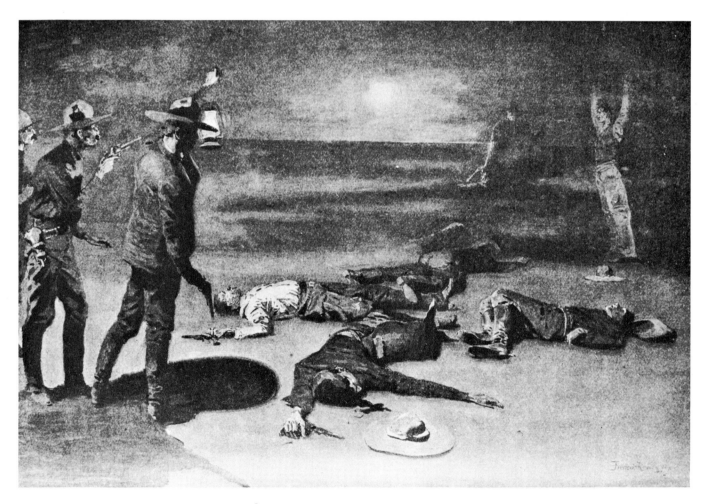

306. END OF A LITTLE ARGUMENT

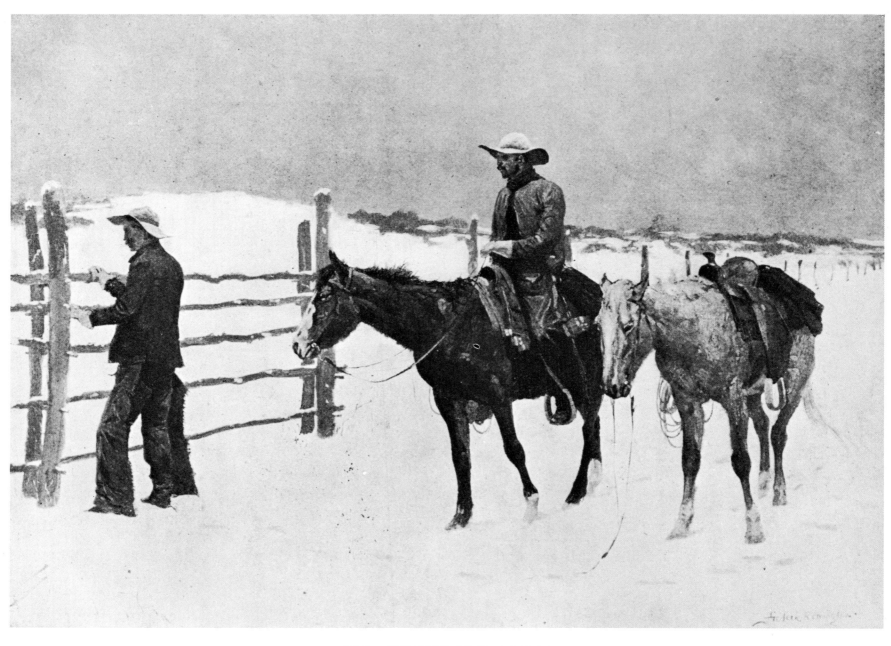

307. THE FALL OF THE COWBOY

THERE was one thing that all of the cowboys, roundup bosses, and cattle barons couldn't whip, and that was the "damned barbed wire fence." It was the nemesis of one era and the salvation of another. The cattlemen also fought the sheepmen, whose nibbling woolies would crop the range so close that a hungry cow couldn't find enough feed to make a cud. The cattlemen fought the homesteaders and sheepmen with more vengeance than they did the Indians. They resorted to every conceivable means of running the intruding despoilers off the open range, from cutting the barbed wire fences to shooting the builders. They even engaged gangs of hired killers and carried on openly declared warfare. More blood was spilled than in all the other cowboy involvements put together. But the cattlemen waged a losing fight. The big herds of the open free range slipped into the limbo of history; and along with them passed the exciting days of the roundups, the chuck wagons and all their open-range associations, and the old time cowboy, like the proverbial old soldier, just quietly faded away.

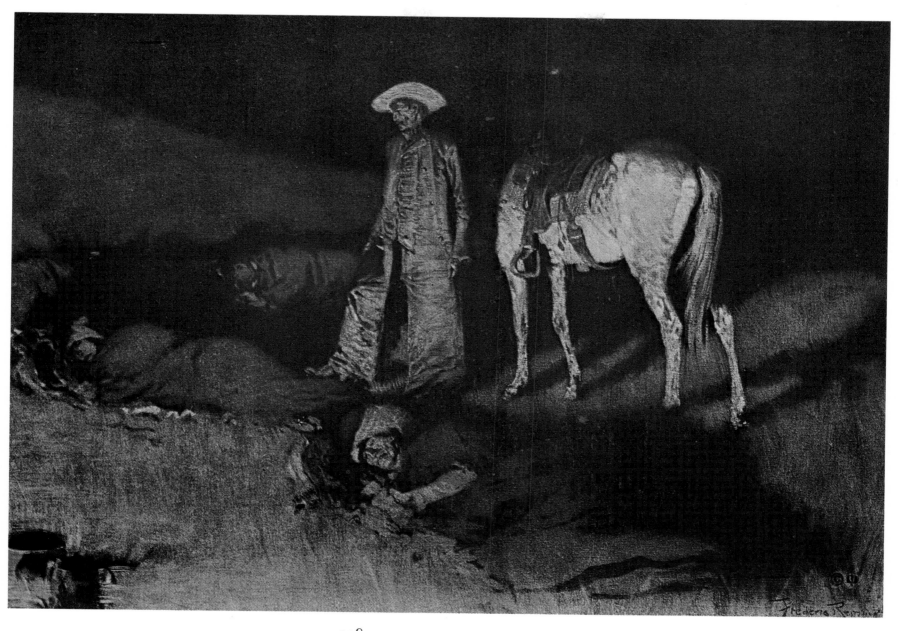

308. IN FROM THE NIGHT HERD

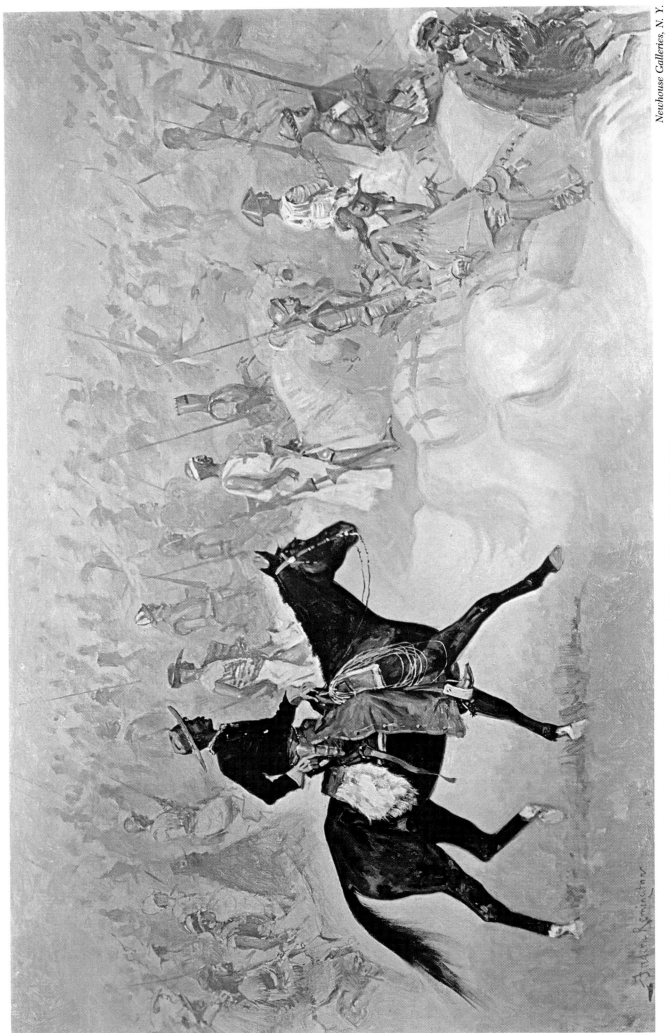

309. THE LAST CAVALIER

CHAPTER XIII

The Last Cavalier

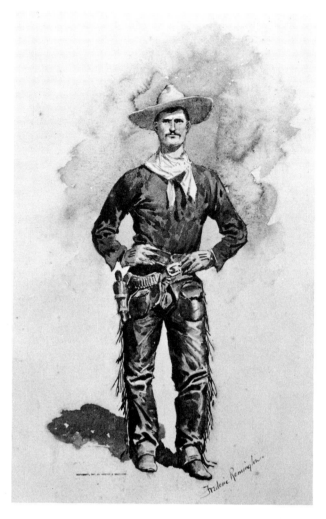

310. LIN MCLEAN

O F ALL the offspring of the Old West, the Yankee cowboy is perhaps the one who stands
out the boldest on the pages of our history. Maybe it is because he was the last
Anglo-Saxon cavalier to ride the trail of strenuous adventure, and the last of old
Mother West's family of rawboned sons. They all rode to renown—the explorer, frontier
guide, mountain man, cavalry scout, and lastly the cowboy. For such a vigorous family
engaged in such rigorous life, and with such a demanding mother, it is unreasonable to expect
that all should be Homeric in character and without worldly blemish—especially the last-
born, who had such a hectic inheritance to fulfill. And as all of these rugged characters slip
further into retrospective and objective appraisal, we come more and more to realize what
an admirable bunch of Americans they really were; how much they contributed to the estab-
lishment of the broad and prosperous nation we enjoy today, as well as our pride of race;
and the continuing advantages of our being influenced by the traditions which they so
deeply engraved upon our history.

The cowboy was entirely American, of the most virile sort; and there is a lot of differ-
ence between a cowboy on a rampant bronco and a knight of King Arthur riding garbed
in a shining suit of mail and carrying an eight-foot spear. But under the skin these
two Anglo-Saxon adventurers had much in common. Both were truculent cavaliers, and the
cowboy was the last of their kind to ride.

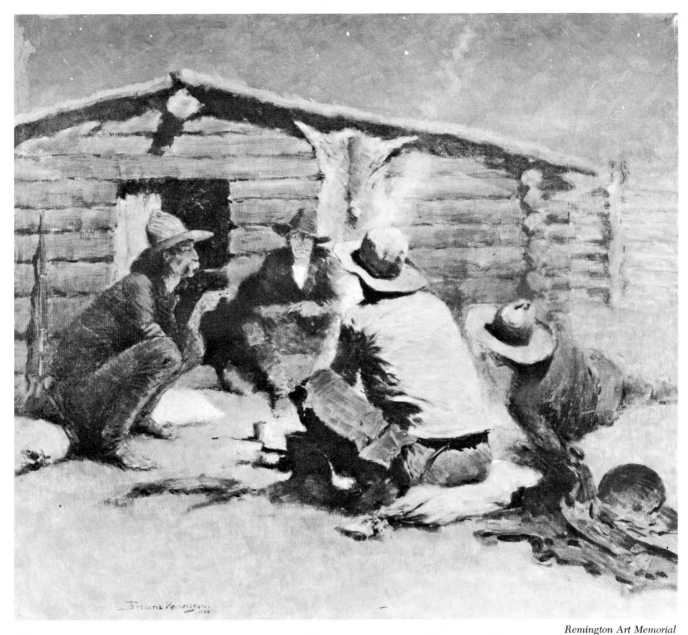

311. REMINGTON'S LAST PAINTING (UNTITLED)

THESE riders of the range didn't leave their occupation in the saddle. "Talkin' hoss," in the flickering shadows of an evening campfire, was rest and relaxation after a long day with a herd in rough country. Cow ponies were their specialty, and most every cowboy in any outfit knew every trail and idiosyncrasy of every horse the outfit possessed. It is also probable that the horses had an equal understanding of the cowboys. Proud as these men were of their mounts, they were as critical of the animals' errors and shortcomings as they were boastful of the good qualities. It was their favorite topic of conversation. For some it was the only topic. They didn't usually talk very much about the cattle, and then it was generally about some cantankerous old critter, going out of its way to cause trouble. Whatever the cause might be, the cattle were but lowly pawns and the topic was always approached from the standpoint of the rider and his horse.

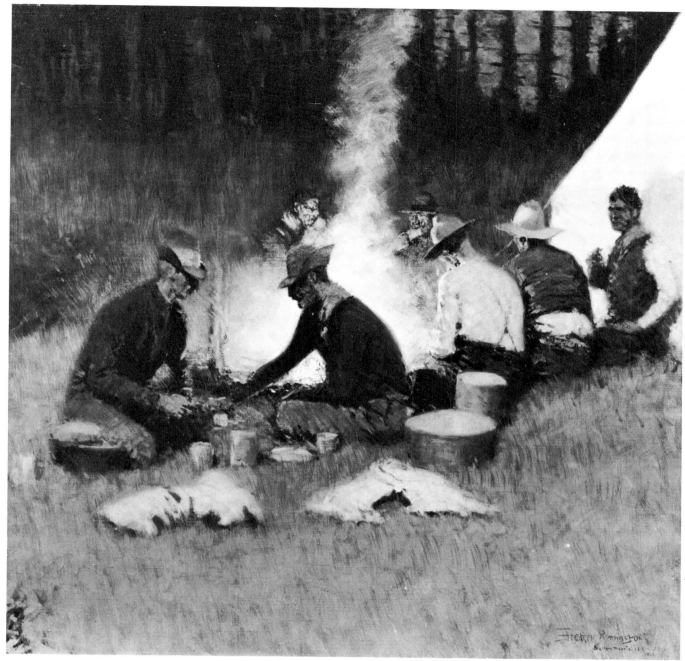

312. THE HUNTER'S SUPPER *Kennedy Galleries, N. Y.*

M ANY of Frederic Remington's pictures were done from scenes he personally wit-
nessed. This was particularly true of the cowboy. The artist was a periodic guest on
the home ranch of Colonel William F. "Buffalo Bill" Cody near Cody, Wyoming, at the
edge of the Rockies and Big Horn Basin. There the famous buffalo hunter, cavalry scout,
and impresario of the Wild West show gathered a galaxy of his favorite classic cowboys and
other early day associates, to enjoy together the last vestages of the Old West, which held
out tenaciously in that rugged region. A long-time friend of Buffalo Bill, Remington looked
upon these visits to the sprawling TE Ranch as an open book of inspiration and informa-
tion. The pictures on these two pages, and many others in this book, are examples.

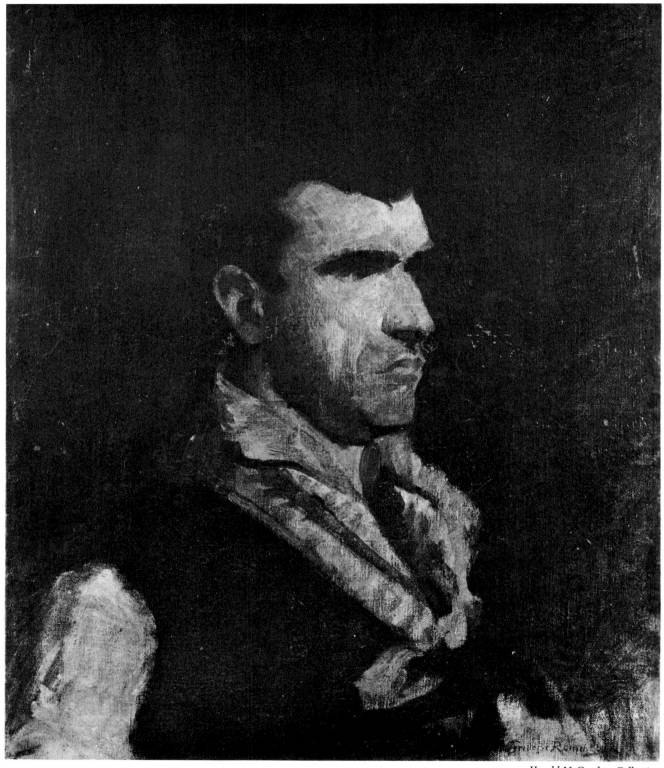

Harold McCracken Collection

313. PORTRAIT OF A COWBOY

IN 1883 Remington spent considerable time around the big terminal stockyards at Kansas City, making sketches of the cowboys and cattle. The above portrait is an example, painted from life in the artist's first studio, on his little ranch at nearby Peabody.

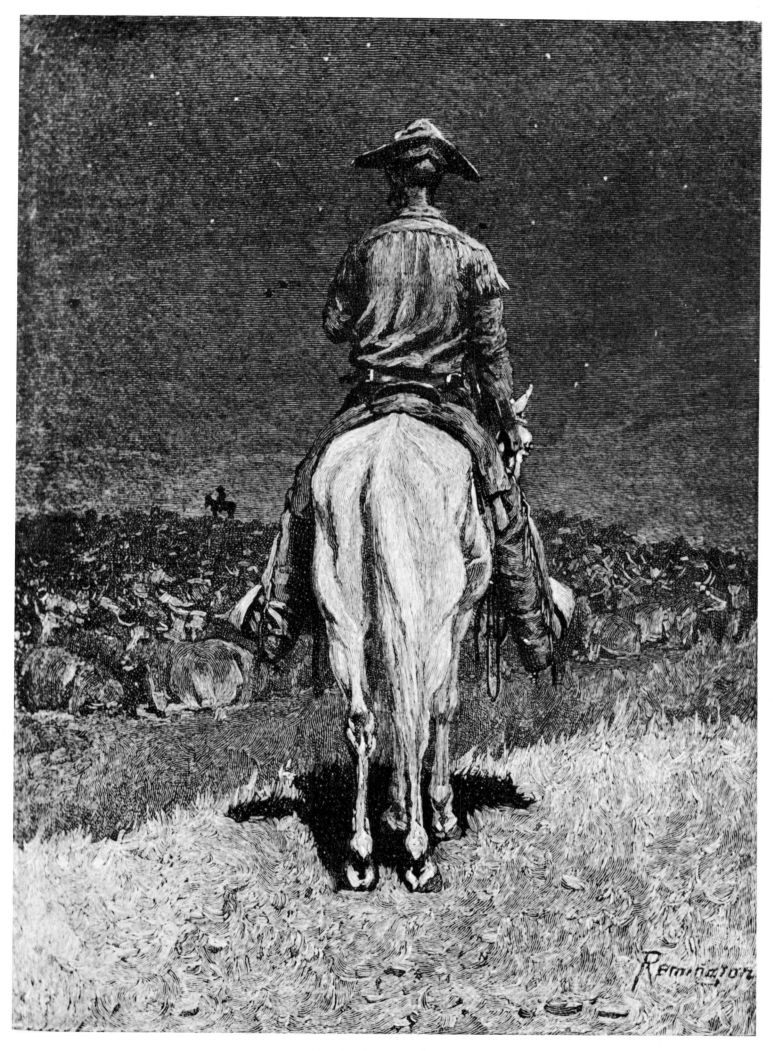

314. THE HERD AT NIGHT

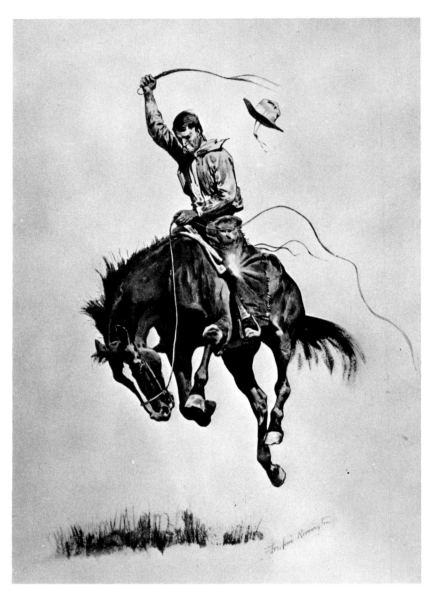

315. A RUNNING BUCKER

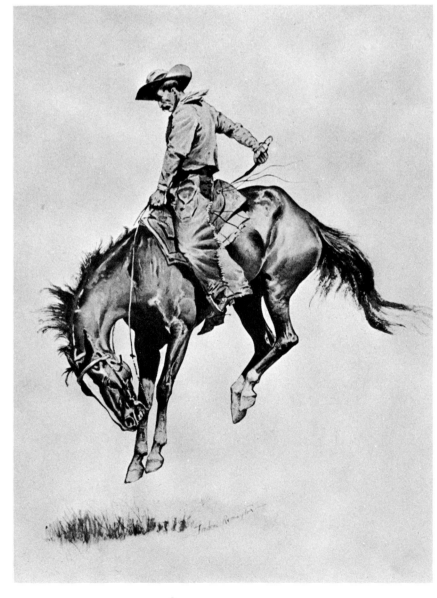

316. A SUN FISHER

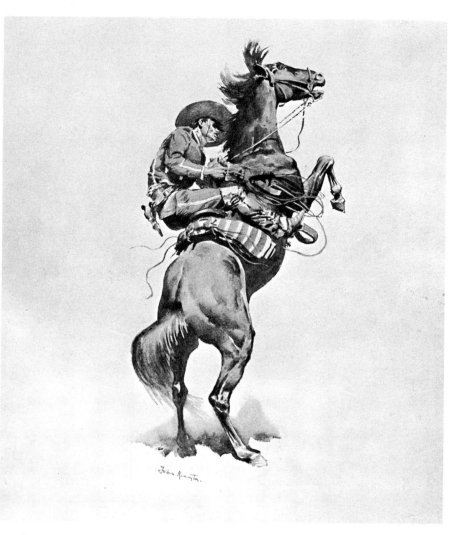

317. MOUNTING A WILD ONE

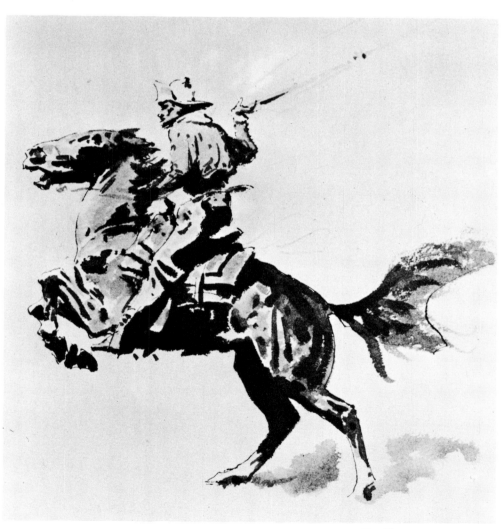

318. WHIRLING THE ROPE

Harold McCracken, Collection

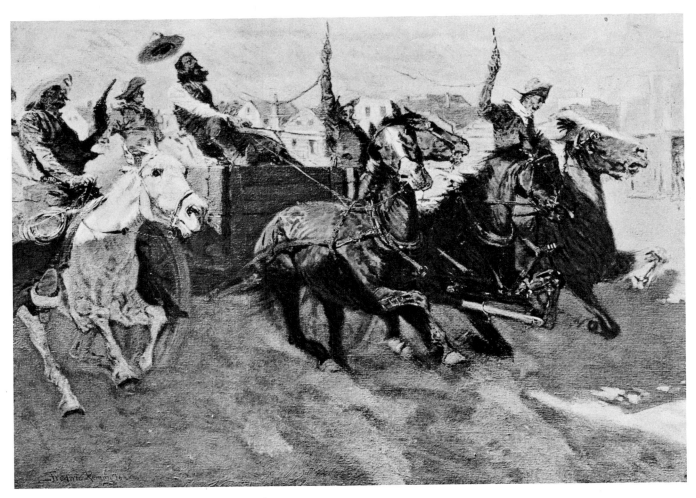

319. BRINGING HOME THE NEW COOK

THE rough little cow towns became as much a part of the cowboys' life as the big herds on the open range. They were to these men what the trading posts had been to the trappers. Even if they were not visited very often, they were to the hermited horseman their own kind of rendezvous and their only link with the outside world. They were also a stopping place for the overland stage, which brought the cattle outfit's strongbox containing pay money for the men and information for the bosses about the beef market on which they were all dependent. And sometimes, there might even be a letter for one of the boys.

The signs of urban development taking permanent roots in the little cow towns intensely displeased the cowboys—the freight wagons dumping off more and more of the damned-barbed-wire, the new buildings, and the appearance of an ever-increasing number of the strange new faces of homesteaders and other outlanders. All this aggravated their independent aversion toward other breeds of humans. When they came into the changing little communities it was often a-racin' and a-shootin', just to let the intruders know they were in town, different from the rest, and that it was best for all to keep out of their way. Then, they would ride quietly back to their outfit's home ranch, hoping that what had been seen and inwardly feared was only a bad dream.

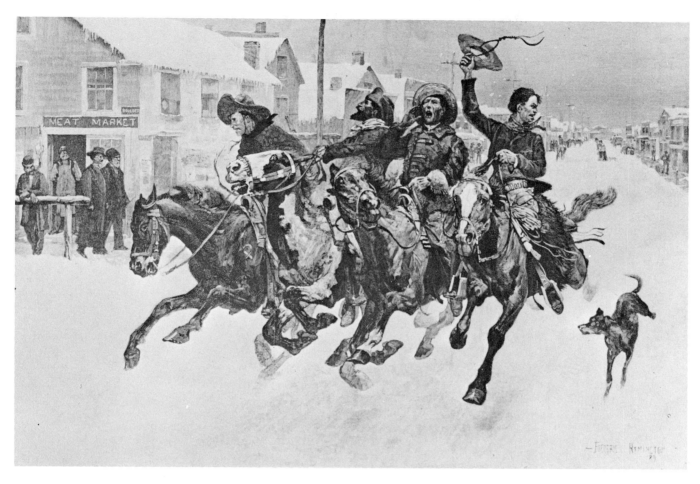

320. COWBOYS COMING TO TOWN FOR CHRISTMAS

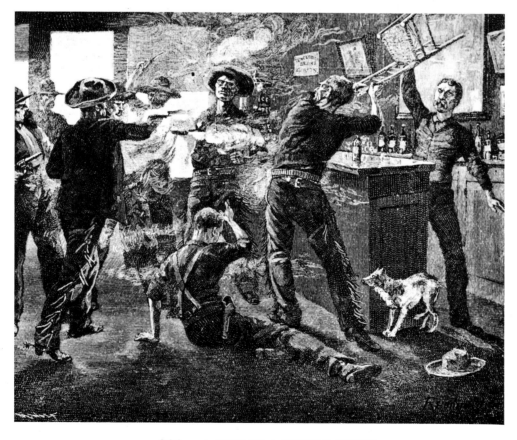

321. A ROW IN A CATTLE TOWN

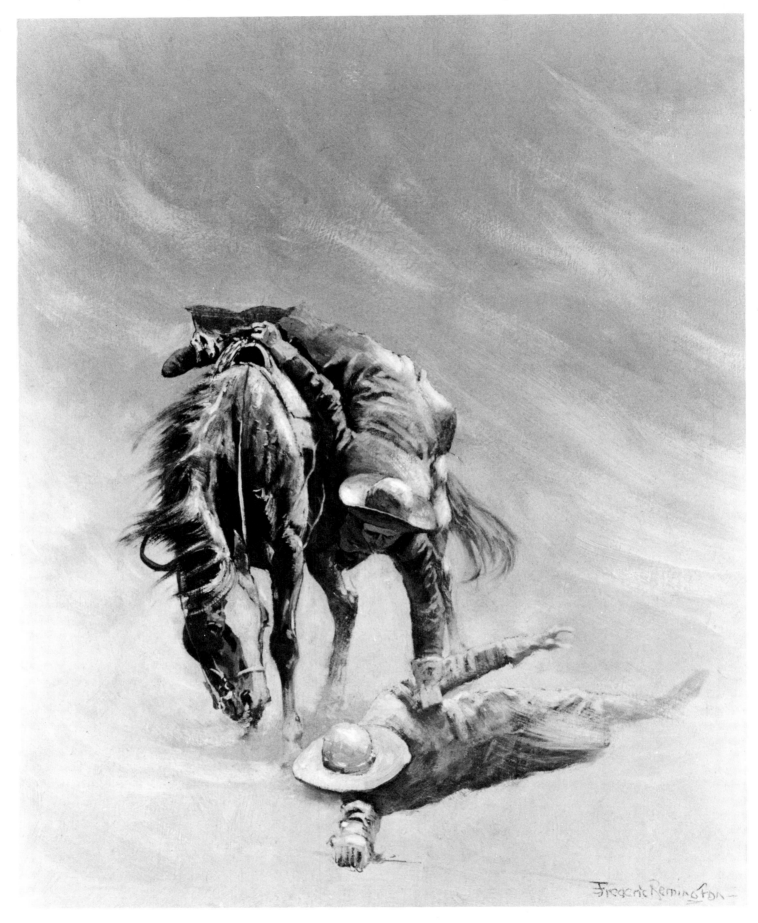

322. LEANED DOWN . . . AND TURNED HIM OVER

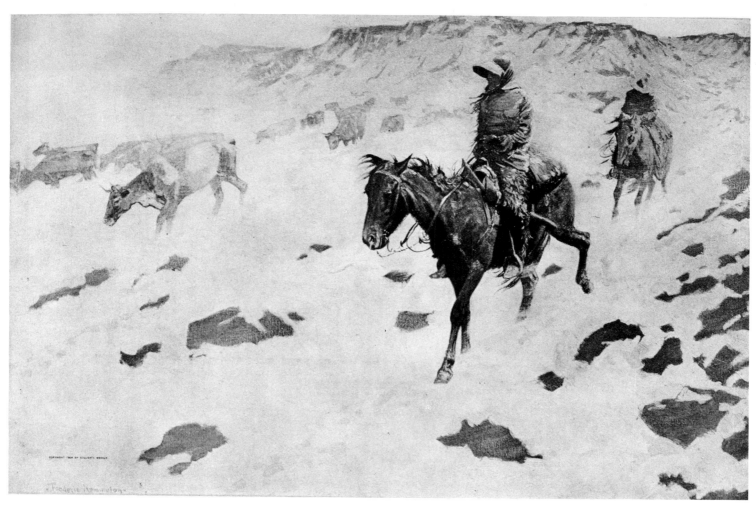

323. DRIFTING BEFORE THE STORM

324. THE CALL FOR HELP

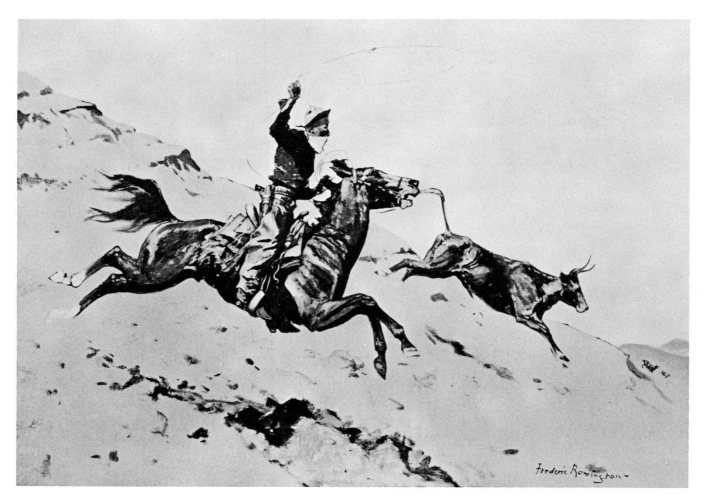

325. OVER THE FOOTHILLS

IN THE beginning, the cattlemen gave but little more than apathetic disdain to the home-
steaders and other intruders into their rugged domain. There was even a bit of sympathy
for those who believed they could avoid starvation by scratching little patches of the wild
prairie to plant things that had never grown there before. But that first little vanguard was
to multiply and grow with an incontestable strength, sufficient to bring an end to the whole
cattle industry and the cowboys' way of life.

The cattlemen fought to preserve what they believed was rightfully theirs, "I was here
first" had been accepted as an unwritten law of the land and respected as such. But in the
new deal, dictated by the Government in Washington, D. C., the balance of power was given
to the weak minority. In 1885, under authorization of Congress, President Cleveland signed
the federal law making it illegal for any person or association to prevent the peaceful occu-
pation of public land by homesteaders. New officers of the law were designated to enforce
the new order of things; former tin-horn gamblers became political bosses; and the land-
boomers and all the other *avant-garde* of civilization came crowding in upon what they con-
sidered the "wild men" of the West. Barbed wire, property rights, and political influence
began supplanting human independence and rugged individualism, and the day of the old-
time cowboy and big herds on the open range became doomed to the pages of history.

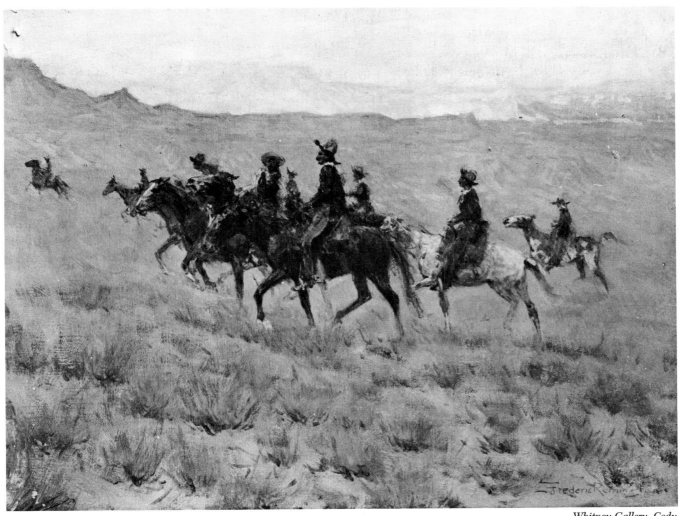

326. RUGGED AMERICANISM IN BLOOM

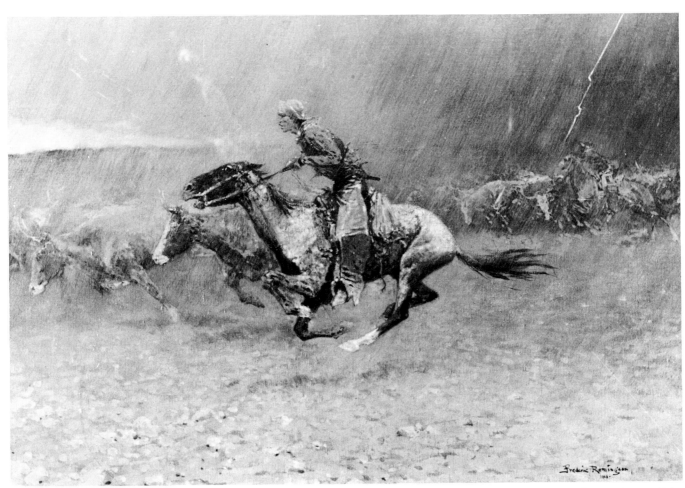

327. STAMPEDED BY LIGHTNING

THE American West was the scene of many rapid historical transitions, quite extraordinary for the manner in which the story of a country is usually recorded. Nearly all of these changes took place under Yankee American influence. Perhaps the greatest of the transitions was the sudden emergence of the Plains Indians from their prehistoric Stone Age culture into that of the nineteenth-century civilization. Also, the historically brief period of about 1825 to 1890 saw the whole Indian race transposed from the free dominance of their ancestral land to complete subjugation, cultural destruction, and permanent confinement on reservations; the lonely first American explorers were followed by hundreds of thousands of home-seeking pioneers; millions of buffalo were slaughtered to the brink of extermination, replaced by almost as many domestic cattle, and these pushed into virtual oblivion; ancient Indian trails were transposed to wagon roads, then highways and railroad tracks; and the smoke of millions of permanent homes and industrial centers rose throughout the vast part of a continent that before had been unknown to the civilized world. It was also this period in the settlement of the West which inspired the extensive influx of emigrants from Europe, which so largely contributed to making the United States the cosmopolitan melting pot that has marked it so distinctively among the nations of the earth.

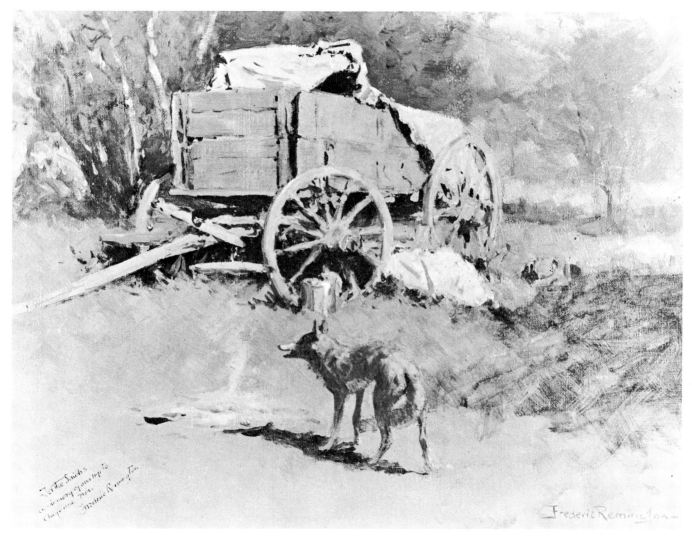

328. THE SMELL OF BACON RIND

329. THE HOME RANCH—WYOMING

330. THE CATTLE OUTFIT FREIGHT WAGON

331. COW PONY PATHOS

Our frontier and pioneer days have passed into history, along with all those bold breeds of men who tamed the vast wilderness and opened the trails to the development we enjoy today. We can be proud of the heritage which those American empire builders left to us. Sadly diluted and weakened as it has become by foreign and contrary ideologies, the spirit of the rough frontier still remains as one of the strongest and most ineradicable influences in our unconquerable resolution in all fields of endeavor; an undying grass-roots symbol of our faith in what we believe is right; and our fighting determination when fighting becomes necessary. There are a few stains on the sword, but what nation in conquest has none. It cannot be claimed that all those motley clans were lily-white, but neither can it be denied that they were the strong backbone of spreading and establishing the breadth and strength of our nation, as well as the image of rugged Americanism, individual liberties, great hopes, and strong lessons, which we can do well to retain as standards through the generations to come.

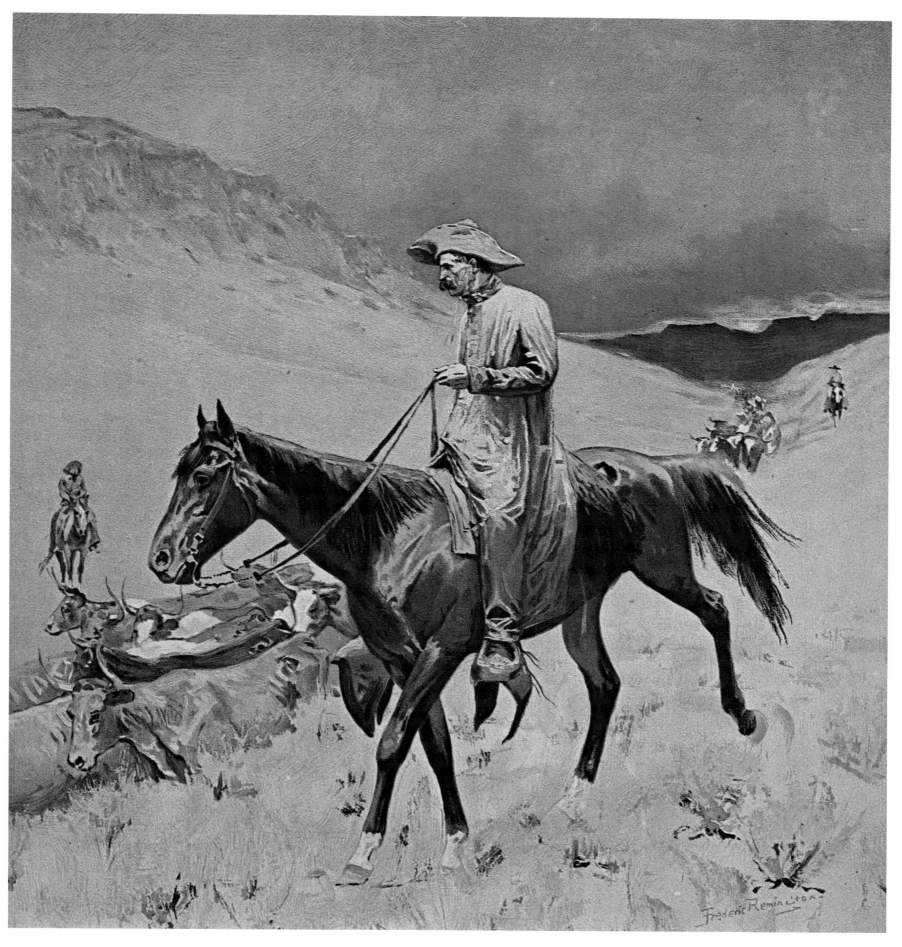

332. ON THE TRAIL

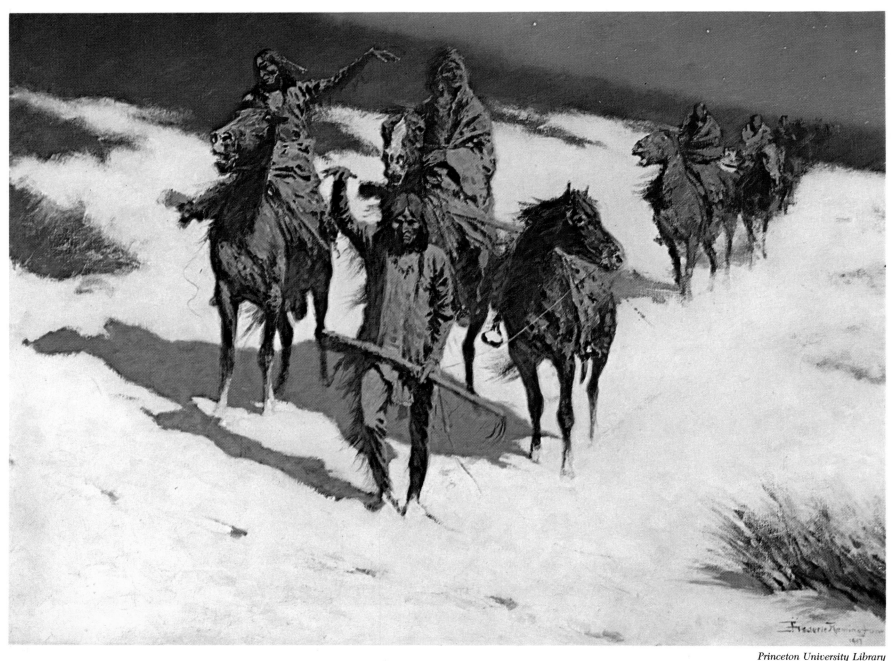

333. TRAIL OF THE SHOD HORSE

CHAPTER XIV

The Last of the Indian Wars

THE Sioux War of 1890 in the Dakotas was not a war in the ordinary sense, although it was a typical Indian war in the ancestral tradition. It brought to an end the American conquest of the West. The Sioux were the most powerful and belligerent of all the Plains Indians. Their two principal leaders, Sitting Bull and Red Cloud, had remained only half reconciled to reservation regimentation, and they had never ceased to stand staunchly and defiantly against the continuing aggressive policies of the Government toward the red man. A final showdown had been building to a climax. Frederic Remington was on the scene to record pictorially this final episode which brought to conclusion the historical period known as the Old West.

335. TROOPERS SINGING THE INDIAN MEDICINE SONG

WHEN a proud and religious people are bent beneath the yoke of subjugation by invaders whose ideologies and principles are strongly contrary to their own, it is natural they should dream of a Messiah to return to earth and free his people from all their worldly woes and transgressors. Sometimes these dreams become a serious hope, the hope becomes a faith, and the faith the creed of prophets and priests. Such was the case among the Plains Indians during the terminal period of the American conquest of the West. There had been previous prophets and self-styled Messiahs who tried to unite all the Indians against the white man, although none had succeeded until the introduction of the "Ghost Dance" doctrine, which swept like a prairie fire from tribe to tribe. If this had happened half a century earlier, our history of the West could be a different story.

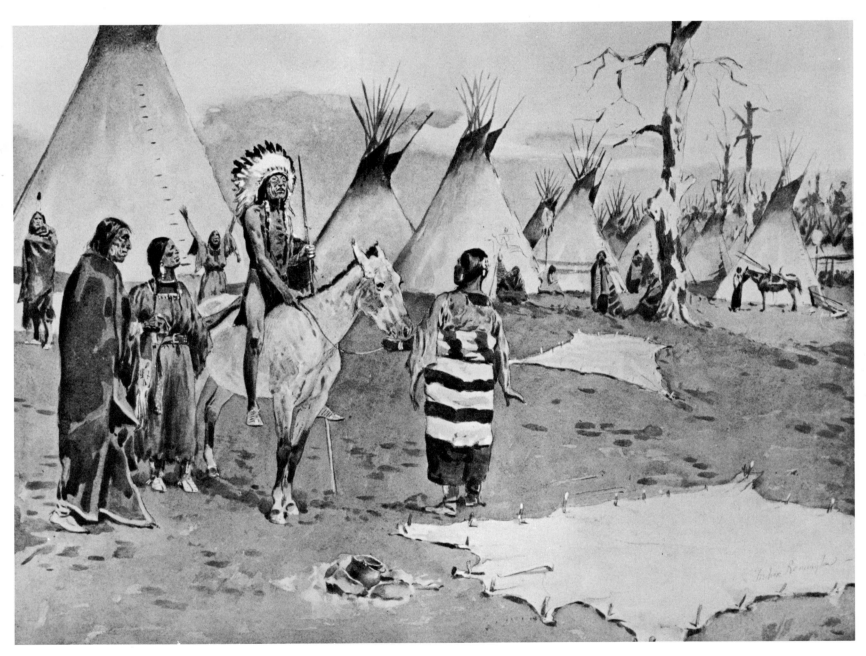

336. HIS DEATH SONG

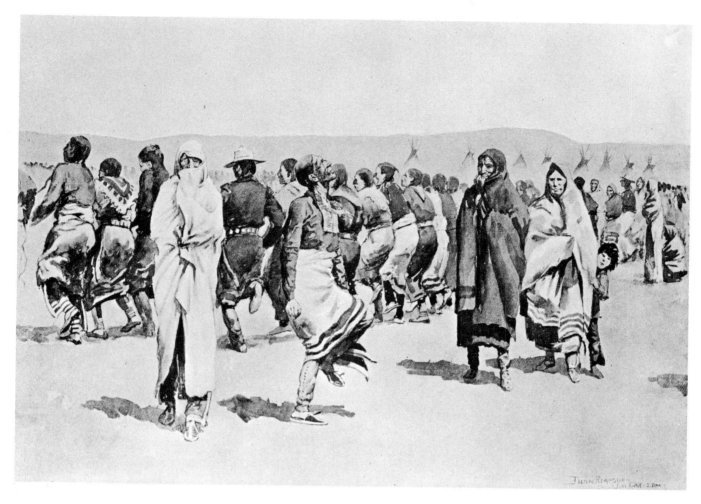

337. GHOST DANCE OF THE OGLALA SIOUX

THE Ghost Dance doctrine originated when there was a total eclipse of sun, about January 1, 1889. This caused great consternation among the Indians, who believed the world was coming to an end. At the time there was a venerated Paiute medicine man in Nevada, by the name of Wovoka The Prophet, who became delirious, and during his seizure believed he had visited the Great Spirit in heaven, and been told of the coming of a Messiah who would restore all the dead tribesmen to their families, to live in their former aboriginal happiness forever free from death, misery, and the oppressions of the white man. All were exhorted to make themselves worthy of the forthcoming utopia by ending all warfare and practicing peace and good will. It was even thought the white men might join in this state of universal felicity. To prepare for the wonderful event, all men and women of all the various tribes should participate in the Ghost Dance and sing the songs that the Great Spirit had revealed to Wovoka The Prophet.

Within an amazingly short time the doctrine spread throughout the Northern Plains. Ghost Dances were held everywhere, secretly and openly. Even Sitting Bull and Red Cloud instigated it among the powerful Sioux, where it took on a strongly anti-white-man aspect, because of their long-standing hatred, aggravated by the grievances in their struggle to exist. It was this combination of circumstances that precipitated the outbreak of hostilities in 1890.

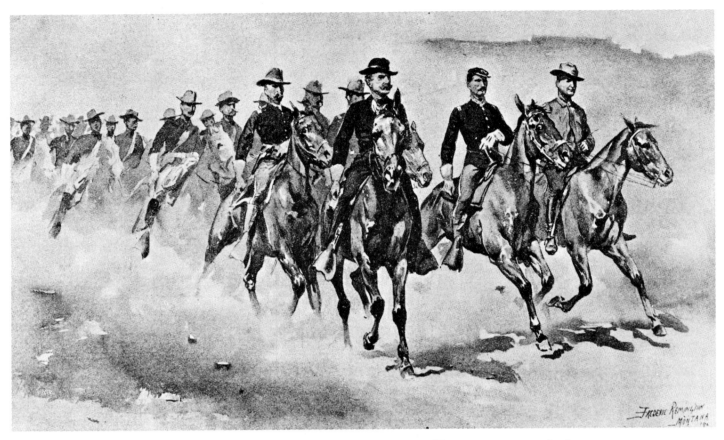

338. GENERAL MILES AND HIS ESCORT (Remington at right)

Four large Indian reservations sprawled across South Dakota—the Pine Ridge and adjoining Rosebud across the south; the Cheyenne River and Standing Rock, extending into North Dakota; plus the small Lower Brule Reservation to the east. The Sioux numbered over twenty-five thousand, with about seven thousand able and well-armed warriors, many of whom had participated in the Custer Massacre of fourteen years before and were anxious for a similar fight with the paleface soldiers.

The land-boomers, increasing settlers, and gold miners had set up political pressure for opening the reservation lands, and government commissioners were instructed to negotiate further cession with the Sioux. A majority of the Indians were strongly against giving up more of their land, although this was effected in spite of opposition. The government treaty rations had also been reduced from 8,125,000 pounds in 1886 to 4,000,000 in 1889, although there were more Indians to feed. Furthermore, orders were issued prohibiting the recent Ghost Dances; and Sitting Bull's refusal of this interference in the religious practices of the Indians led to a demand for his arrest. The local reservation agents reported the situation beyond their control; some resigned; and the War Department was called upon for aid. On November 13, 1890 the President ordered troops to the scene.

The campaign was put under General Miles; and cavalry, artillery, and infantry began converging on the Sioux. His orders included the arrest of Sitting Bull but avoidance of warfare if possible. When the first troops arrived at Pine Ridge, the rebellious Indians began retreating into the Badlands, destroying property and stealing agency cattle as they went.

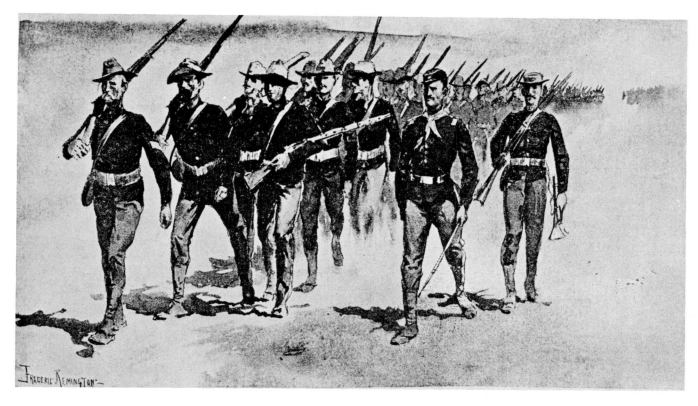

339. INFANTRY ON THE MARCH

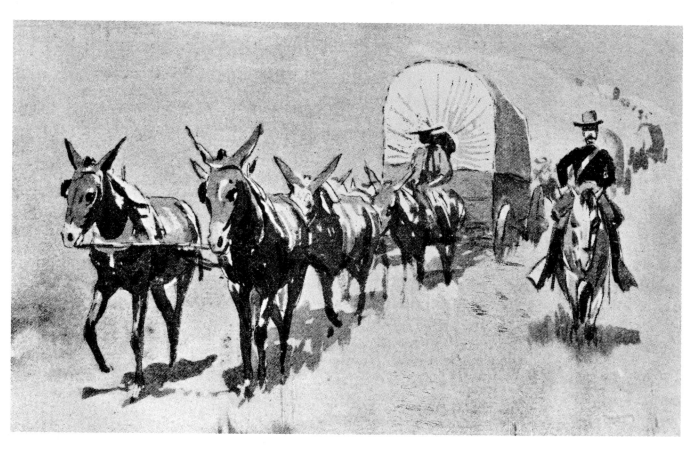

340. THE SUPPLY TRAIN

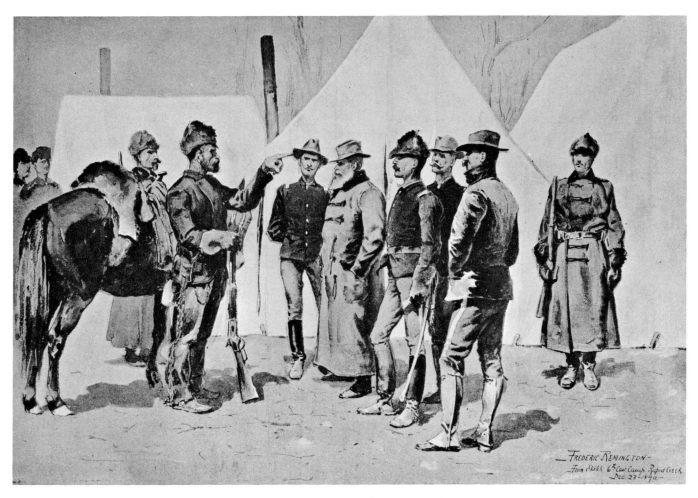

341. GENERAL CARR RECEIVING THE REPORT OF A SCOUT

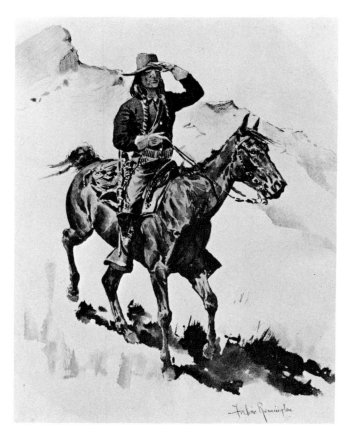

342. CAVALRY INDIAN SCOUT

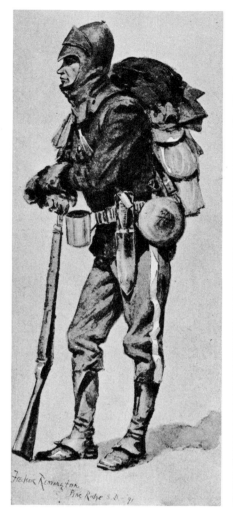
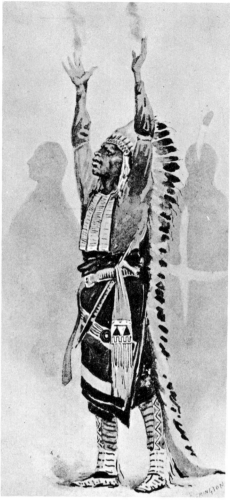
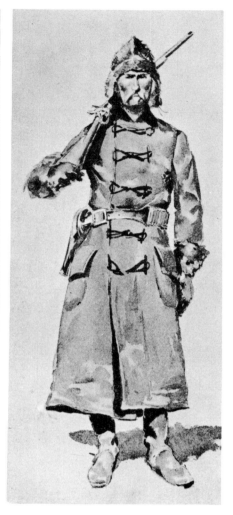

343. INFANTRY WINTER UNIFORM 344. MEDICINE MAN'S SIGNAL 345. TROOPER'S WINTER UNIFORM

CONVERGING from all directions, the U. S. Army set up a cordon of troops at strategic or convenient points around the perimeter of the whole Sioux territory. This embraced a region extending approximately 240 miles from north to south and 165 miles from east to west. It would have been almost impossible to patrol adequately the entire perimeter with several times the number of troops; and within the area were large sections of badlands, intimately known to the Indians, ideal for the large bands of red warriors to practice their own tactics of ambush and flight warfare, to the disadvantage of any army contingent sent in to challenge them. And deep within this inhospitable wilderness bulwark, in the heart of the northern Standing Rock Reservation, Sitting Bull had his remote and well-protected home and headquarters camp. So venerated was the old war chief among all the Sioux that it was possible the entire tribe might rise to his defense. Red Cloud was somewhat less of a problem, being more accessible on the southern Rosebud Reservation, more aged, and more realistically and politically mindful to the sad eventuality that ultimately faced his people.

The rebellious Sioux could escape westward into Montana or northward into Canada. But everywhere now their old time wilderness was gone, and subsistence on the buffalo herds was only a memory. There was no sanctuary better than their own.

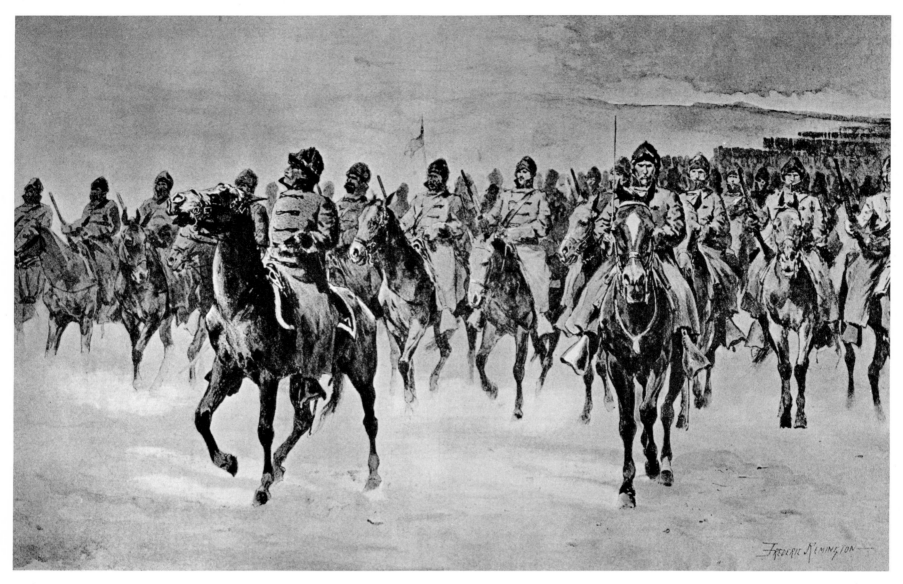

346. GENERAL MILES'S CAVALRY AT PINE RIDGE

GENERAL Miles realized that to fail in the objective could invite wholesale rebellion
among other tribes to rise up and cause incalculable bloodshed, and set back civilized
progress many years. But some calculated risks must be taken.

Colonel William F. "Buffalo Bill" Cody, most dependable of the army scouts, was sent
to induce Sitting Bull to come in peacefully—or attempt his arrest. However, when he
arrived at Standing Rock Agency on November 28, 1890, enroute to Sitting Bull's camp,
the orders were countermanded on the remonstrances of the reservation agent, who insisted
that sending his Indian police would be far less apt to provoke a general conflict with
all the Sioux.

At daybreak on Monday, December 15, a group of forty-three Indian police and three
officers surrounded Sitting Bull's log house on Grand River. His bodyguard had danced the
Ghost Dance all night and everyone was asleep. The war chief was awakened and told he
was under arrest. He made no resistance and said he would come out after dressing. Soon

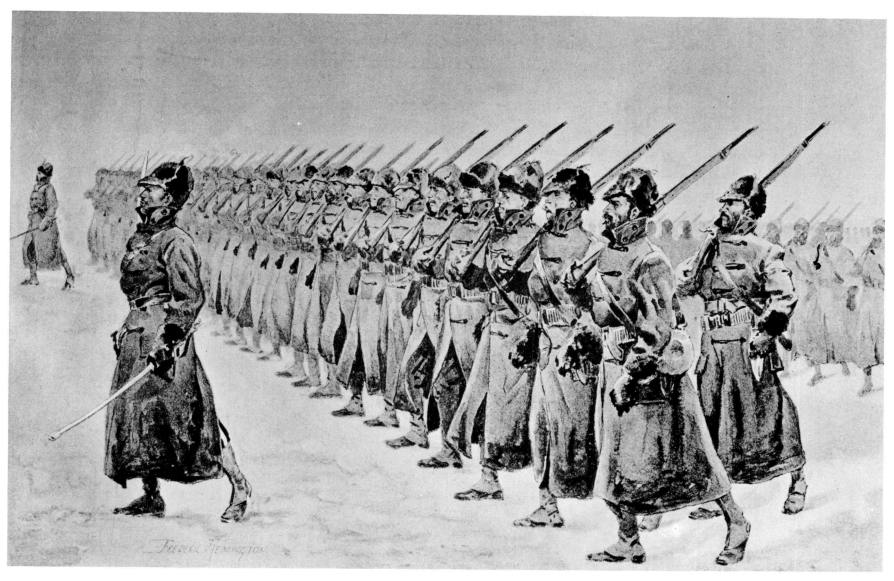

347. GENERAL MILES'S INFANTRY AT PINE RIDGE

about 150 of his followers surrounded the police, and when Sitting Bull appeared he called upon them to rescue him. Lieutenant Bull Head and Sergeant Shave Head quickly took places on either side and Sergeant Red Tomahawk stepped behind the war chief, while the rest of the police tried to clear a way through the angry mob. One of Sitting Bull's men shot Lieutenant Bull Head, who turned and shot Sitting Bull before he fell, and Sergeant Red Tomahawk also shot the old war chief in the head. Then began a desperate fight, in which the Police held off the assailants until the arrival of a detachment of army troops, which had been deployed a short distance away. Upon appearance of the troops the hostiles fled.

Thus ended the career of perhaps the most colorful and influential figure in the Indian Wars in the West. There is historical irony in the fact that Sitting Bull came to the end of his long and torturous trail at the hands of converted agents of his enemies rather than the guns of those whom the old Sioux war chief so long had fought and hated with such dedicated and honest patriotism.

THE killing of Sitting Bull precipitated a situation like waiting for the fuse to ignite a great explosion. Sioux messengers riding like shadows through the subzero night carried the word to every warrior band in the Badlands, and there were intensive strategy meetings in the army officers' quarters. It was a frustrating sort of warfare for the soldiers, who had waited and hoped for a long time to avenge their buddies who had been wiped out by these same Indians on the Little Big Horn. Encamped at Pine Ridge Agency and led by Colonel Forsyth, a fine name in the tradition of the outfit, were eight troops of that same Seventh Cavalry, a part of which the Sioux had so bitterly cut to pieces. There was more scuttlebutt in the soldiers' Sibley tepees at night than heat in the puffing Sibley stoves around which the men gathered. These men had come to fight and they were not to be denied.

There were reports that Indians who had not previously participated in the Ghost Dance were joining the groups, although others, their fighting spirit frosted by the bitter cold which had moved down from the arctic, came in peacefully to lay down their arms. General Miles took the initiative, ordering three thousand troops in the field to begin closing in around the hostiles in the Badlands. The orders were to seek surrender of the leaders but to avoid conflicts if possible. This was an optimistic hope which was not shared by the soldiers.

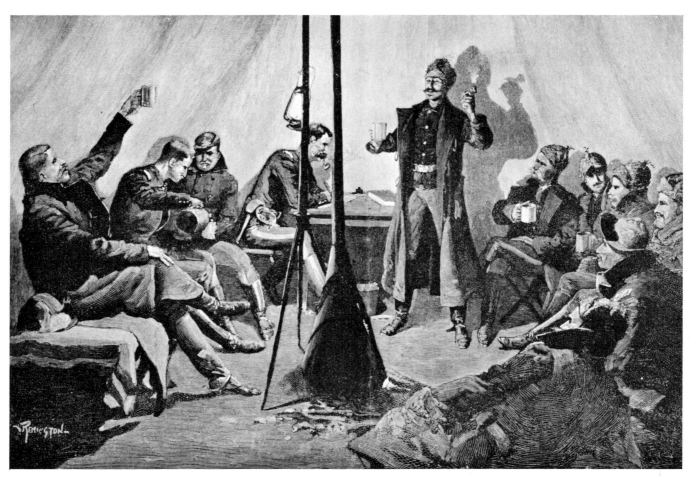

348. MERRY CHRISTMAS IN A SIBLEY TEPEE

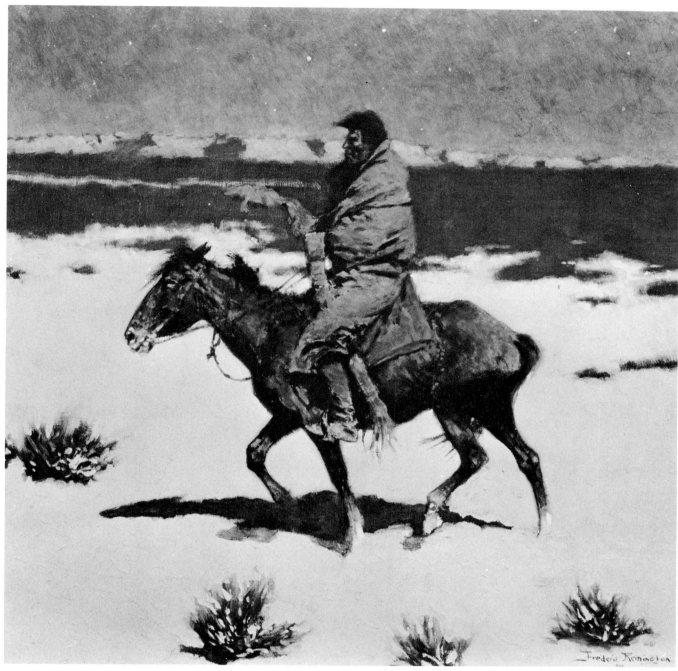

Newhouse Galleries, N. Y.

349. NIGHT ON THE TRAIL

THE pictures in this section were made from on-the-spot observations while Frederic Remington was living with the troops at Pine Ridge and elsewhere, with the approval of General Miles. Wanting to see some of the intensive action, he was permitted to accompany a scouting unit into the Badlands. Led by Lieutenant Casey, the unit included several veteran army Indian scouts who were old friends of the artist. They followed the Cheyenne River into the hostile country, swam horses and supply wagon across the ice-filled river, and followed an Indian trail through a terribly rough approach to a high mesa where a large band of the hostiles had their main camp. The trail was strewn with dead cattle and ponies, abandoned in the Indians' flight. Before the top was reached the unit were ambushed and fired upon by Sioux who had been posted to guard against any army attempt to penetrate their stronghold.

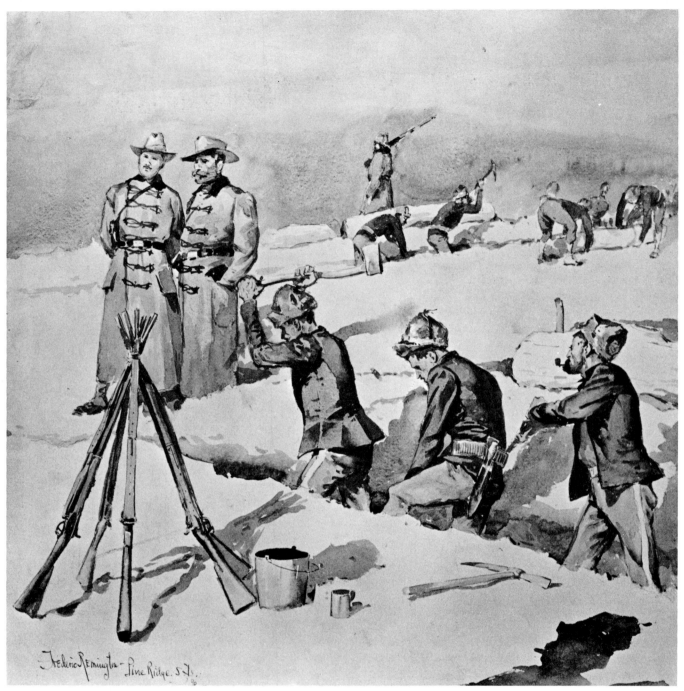

Kennedy Galleries, N. Y.

350. IN THE TRENCHES AT PINE RIDGE

THE experience in the Badlands was an adventurous one for Remington. He accompanied Lieutenant Casey on most of his dangerous reconnaissance trips (No. 352, opposite page) and at the end rode alongside a supply wagon that made a spectacular dash through the hostile Sioux lines back to Pine Ridge (No. 351). Shortly afterward, Lieutenant Casey was killed.

Remington's pictures of this and other incidents in the Sioux War are important pictorial documents on the close of a historical era. They appeared in *Harper's Weekly* with a series of articles he wrote for that national weekly.

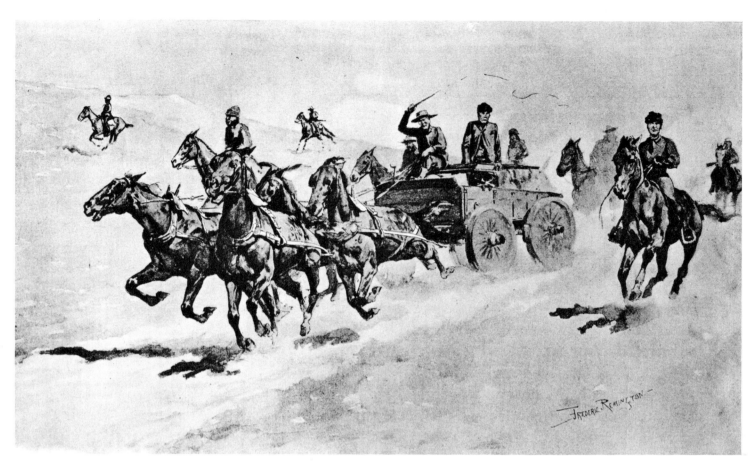

351. A RUN FOR THE SCOUT CAMP (Remington at right)

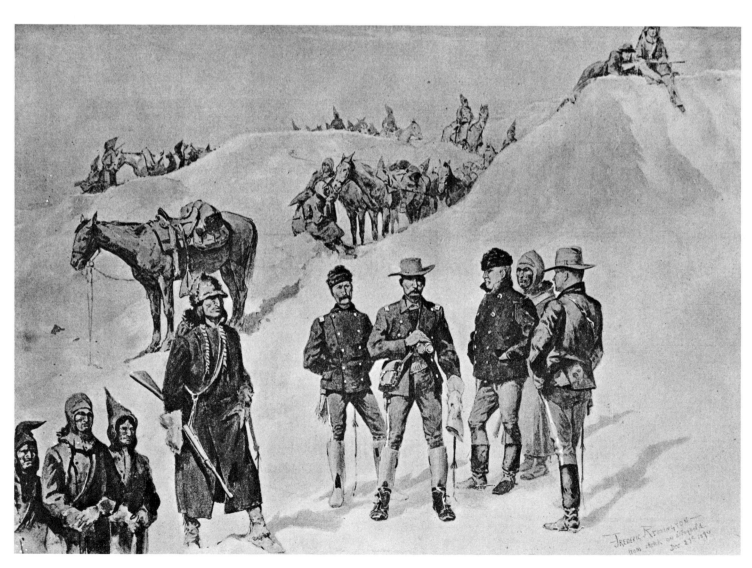

352. WATCHING THE HOSTILES FROM THE BLUFFS (Remington third from right)

HE episode at Wounded Knee, on December 29, 1890, brought down the curtain on the Indian Wars and our conquest of the West—inglorious last scene though it was. The previous day Major Whiteside and his Seventh Cavalry troops closed in on the camp of Big Foot in the Badlands. They raised a white flag and asked for a parley. Unconditional surrender and return to Pine Ridge under military guard were demanded. The Indians agreed, broke camp, and the march to the agency began. That night they camped on Wounded Knee Creek, about twenty miles northeast of Pine Ridge Agency. There were an estimated 106 warriors, and with women and children a total of 370 Indians. The troops had been reinforced to 470 men, including four pieces of light artillery.

Disarming the Indians began in the morning, preparatory to going on to the agency. Their camp was circled by soldiers and the Hotchkiss artillery trained upon them. In the center of their camp the Indians had hoisted the white flag. When ordered to do so, the warriors came out of their tepees and sat down in front of the troops. Then they were ordered to go into their tepees in groups of twenty and surrender their guns. The first group returned with only two rifles and it was evident they were reluctant to give up their weapons. When further demands failed, the order was given for soldiers to search the tepees. This produced considerable excitement and tension, as the soldiers invaded the tepees

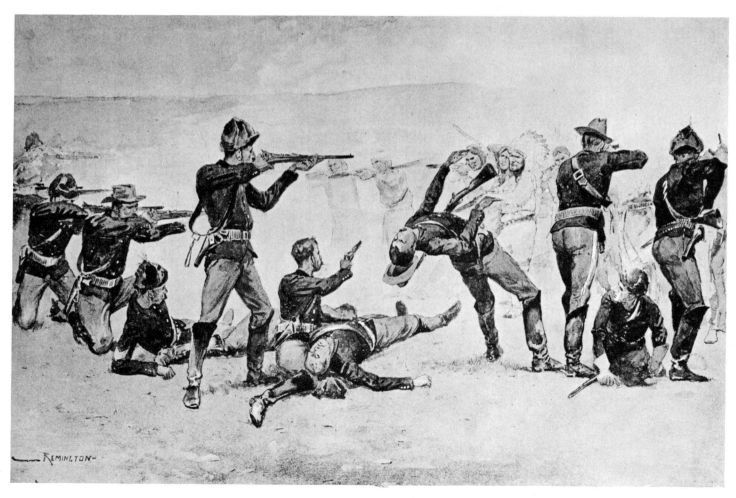

353. OPENING OF THE FIGHT AT WOUNDED KNEE

and the women and children came running outside in fear. Their medicine man began walking about among the warriors, blowing on his Ghost-Dance whistle and urging them to rise against the soldiers. Then he suddenly stooped down and threw a handful of dust into the air as a signal (No. 344). Immediately one of the warriors drew a rifle from under his blanket and killed a nearby soldier. Instantly every soldier raised his rifle and the volley killed nearly half of the warriors grouped in front of them. The survivors leaped to their feet and with revolvers and knives attacked the soldiers like infuriated wild animals. The Hotchkiss guns poured two-pound explosive shells at fifty per minute with devastating destruction among the women and children grouped in front of the tepees. Within a few minutes over two hundred Indian men, women, and children, with sixty of the soldiers, lay dead and wounded on the ground. The few surviving Sioux fled in panic, but the soldiers' rifles and the Hotchkiss shells cut down most of them before they could escape.

New Year's Day 1891, three days after the massacre, troops were sent to bury the Indian dead. A blizzard had covered the bodies, although a baby girl was found under the snow, carefully wrapped in a blanket, beside her dead mother. On the child's head was a cap of soft buckskin, on which was embroidered in beadwork the American flag. She was still alive, and survived. Her name was Zitkola-noni, "Lost Bird."

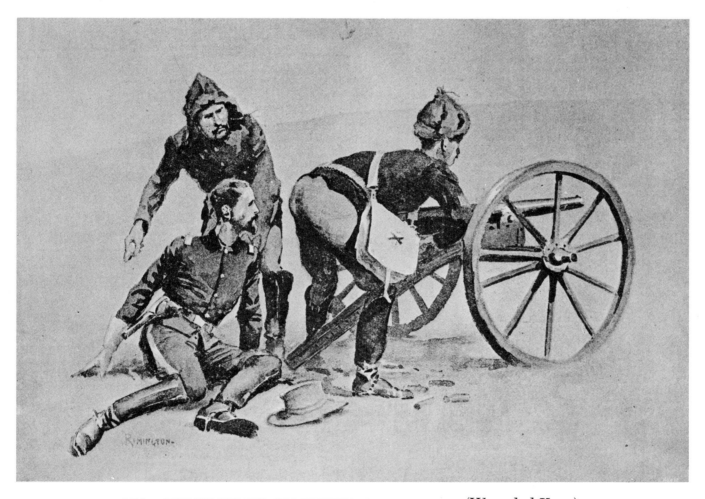

354. THE WOUNDING OF LIEUTENANT HAWTHORNE (Wounded Knee)

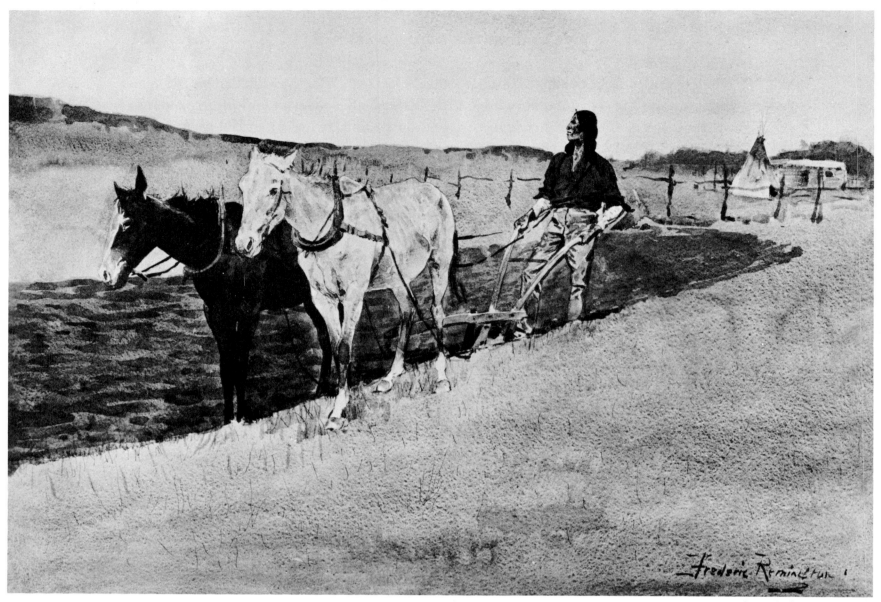

James Graham & Sons, N. Y.

355. TWILIGHT OF THE INDIAN

A GENERAL uprising among the Sioux followed the killing of Sitting Bull and the Wounded
Knee massacre. Nearly four thousand warriors in the vicinity of Pine Ridge attacked
the agency, burning buildings and destroying property. There was also trouble in other parts
of the Sioux country. The troops rallied quickly to put down the uprising and hundreds of
the Indians went back into the Badlands and were followed to forestall further trouble.
General Miles now had sufficient troops at his command to control the situation; the Indians
realized that the soldiers meant business; and wholesale bloodshed was fortunately avoided.

The pugnacious fighting spirit and tribal patriotism of the once proud Sioux had at last
been crushed under the irresistible power of the white man's conquest, whose civilization had
closed in around the Indian's shrunken world until there was no sanctuary into which
to take refuge. Their once wonderful wilderness world of freedom, fantasy, and tribal
insularity, which countless generations of their ancestors had left to them, was now gone
beyond recall—beyond the redemption of all their united power or their Ghost Dance
prayers for the coming of a beneficent Messiah. The time had come—the twilight and sun-
down of their race—henceforth to be in bondage, in the strange and inhospitable world of
their white conquerors.

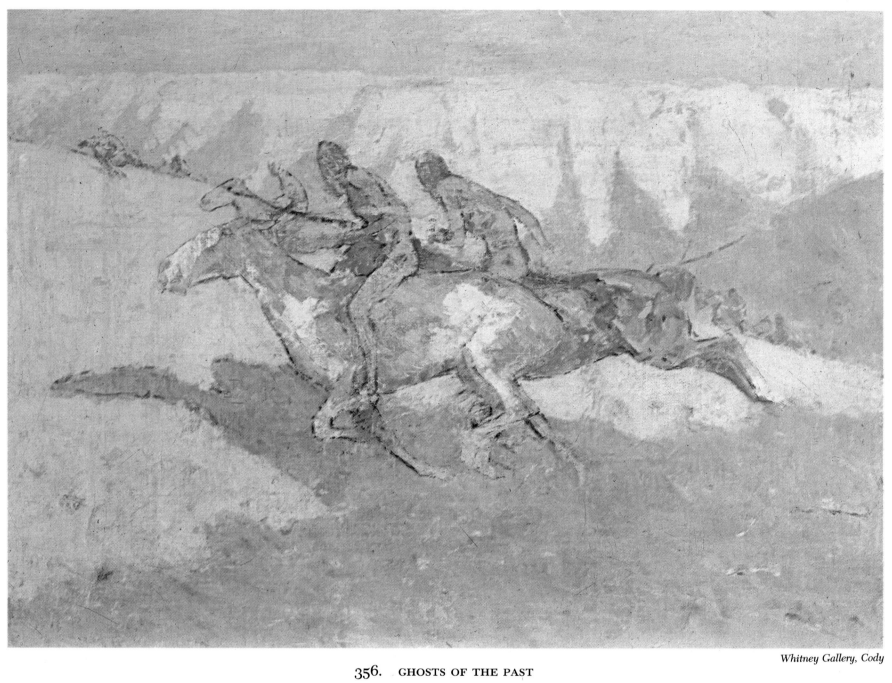

356. GHOSTS OF THE PAST

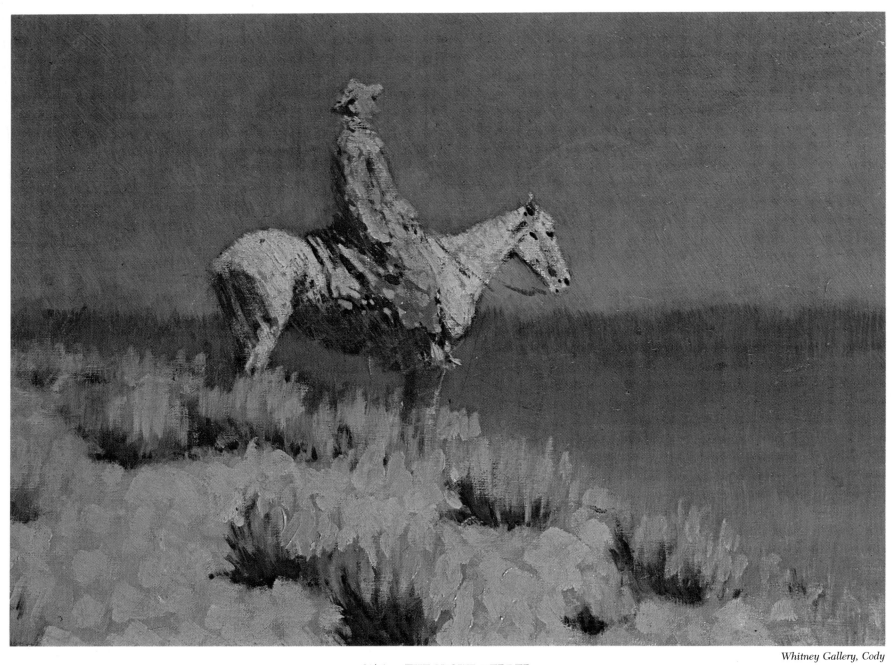

357. THE NIGHT HERDER

CHAPTER XV

Broncos in Bronze

FREDERIC REMINGTON entered the field of sculpture as another means of perpetuating the American West. The image of the old-time cowboy and Indian of the Plains will live longer because of his effort and ability. Self-taught in modeling clay as he had been in drawing and painting, his first attempt resulted in *The Bronco Buster*. "I always had a feeling for mud," he facetiously explained, "and I did that . . . I wanted to do something a burglar wouldn't have, moths eat, or time blacken." That first attempt at sculpture was acclaimed an outstanding success. Today it is the best known work of its kind by any American artist.

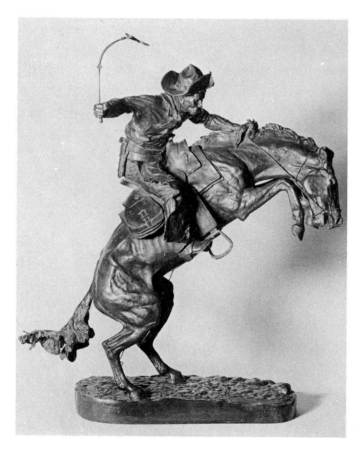

359. THE BRONCO BUSTER
(Henry-Bonnard)

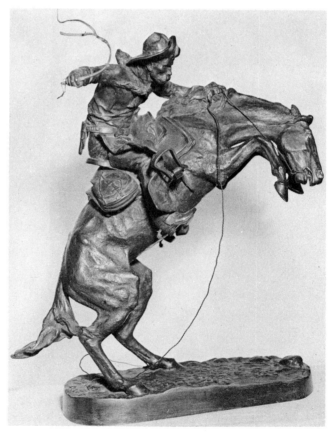

360. THE BRONCO BUSTER
(Roman Bronze Works)

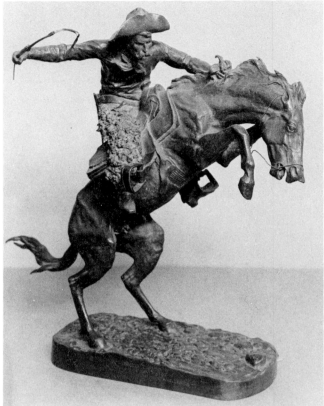

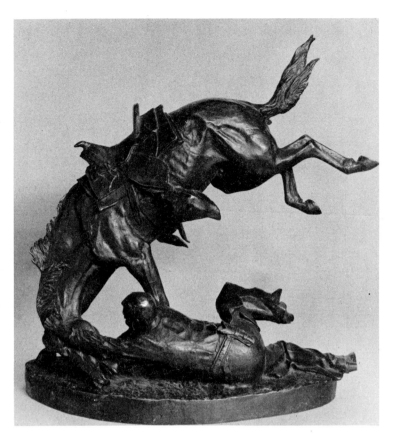

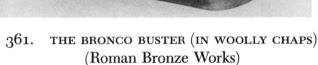

361. THE BRONCO BUSTER (IN WOOLLY CHAPS) 362. THE FALLEN RIDER
 (Roman Bronze Works) (Roman Bronze Works)

ALWAYS more concerned with factual realism than academic art, it was natural for Frederic Remington to undertake three-dimensional sculpture. He had worked with equal success in practically every other medium of art and always had a feeling for form. All it took to begin this new challenge was a bit of encouragement by a fellow artist. He began working alone on a hulk of clay, without interference with the large amount of pictorial work he was continually turning out. Within less than four months, however, the finished model was delivered to the art bronze foundry for casting. *The Bronco Buster* was copyrighted on October 1, 1895, on the artist's thirty-fourth birthday.

The first castings of *The Bronco Buster* and subsequent works up to 1901 were made by the "sand-cast" process in the foundry of Henry-Bonnard Company (Plate 359). There are considerably fewer of these than the later castings done by the Roman Bronze Works (Plate 360), which introduced the more delicate cire-perdue (lost-wax) process in this country. There is also a third variant, with woolly chaps added to the rider (Plate 361) of which only three or possibly four are known to have been made. The twenty-two-inch subject was a difficult one, in form and balance, for even a sculptor of long experience. However, its artistic merits received immediate praise by the critics. Its popular appeal is indicated by the fact that about three hundred castings were made and sold before the original mold was destroyed; and since then perhaps three times the number of recasts and spurious copies have been put on the market. The early illegitimates are crudely cast. More recent ones, made in Japan, are difficult to detect from the originals.

Physical variations between the Henry-Bonnard and Roman Bronze castings of *The Bronco Buster* are not great. In the former the right hand holds the quirt upright, while in the others it is parallel; there are also differences in the riders' hats and the horses' tails. Otherwise, their appearances are very much the same.

The Wounded Bunkie (Plate 363) was Remington's second work of sculpture—an ambitious undertaking, of two horses with cavalry riders at full gallop and the group supported only by one hind leg of one horse and a foreleg of the other. One trooper is wounded and is kept from falling by an arm of the rider alongside. It was copyrighted July 9, 1896, nine months after the first attempt. One critic acclaimed it as "Remington's complete mastery of the nature and anatomy of the horse . . . The action is superb . . . the whole group in the most natural manner possible." Originally cast by Henry-Bonnard and later by Roman Bronze, there were probably less than twenty castings made.

Next came *The Wicked Pony* (Plate 362), appropriately known as *The Fallen Rider*, copyrighted December 3, 1898. It is said to depict an actual incident in which the bronco killed the rider, hence the title. There were only about fifteen original castings.

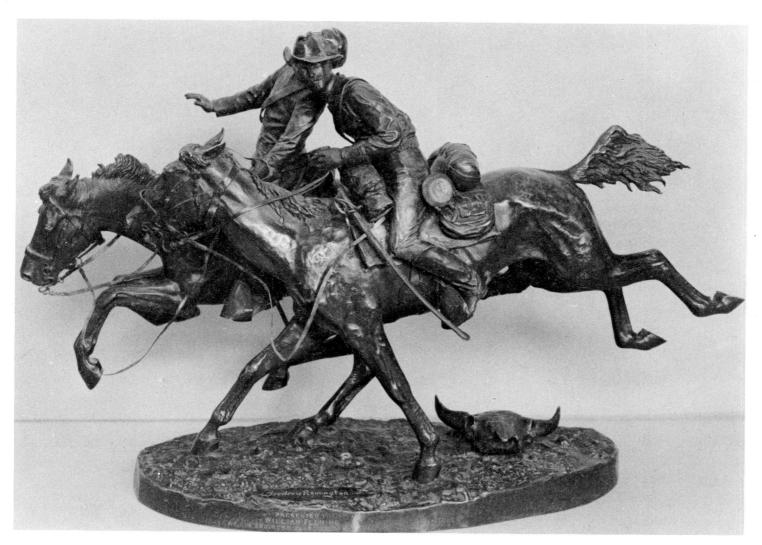

363. THE WOUNDED BUNKIE
(Roman Bronze Works)

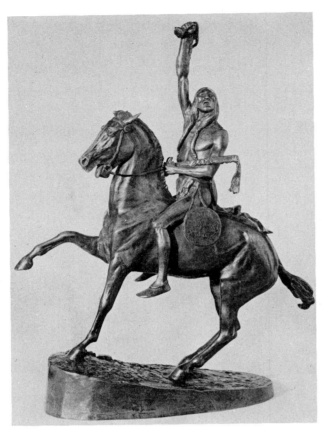

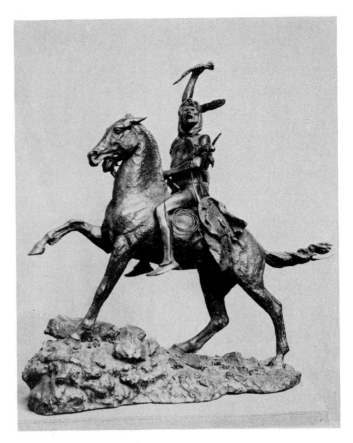

364. THE SCALP
(Henry-Bonnard)

365. THE SCALP
(Roman Bronze Works)

THE exact number of original castings made of the works of sculpture by Frederic Remington is extremely difficult to determine. All the records of Henry-Bonnard, Roman Bronze Works, and Tiffany & Company were destroyed more than twenty-five years ago, and no records are known to have been kept by the artist or others. For many years the present writer has gathered information on the highest numbers stamped on individual castings located, aided by similar efforts by Mr. Rudolf Wunderlich of Kennedy Galleries and Mr. James Graham of James Graham & Sons, two of the country's foremost dealers in Remington bronzes. These sources have provided the *estimates* given in this book. All titles of subjects, dates, descriptions, measurements, and other information put into quotes and not otherwise credited are taken from the artist's own applications for copyrights.

"*The Scalp*," sometimes called *The Triumph*, was Remington's first sculpture of an Indian. It depicts a mounted Plains warrior triumphantly holding high the fresh scalp of a vanquished enemy. It was copyrighted December 10, 1898, only a week after "*The Wicked Pony*." There may have been some difficulty completing one of these. The Henry-Bonnard castings (Plate 364) were changed when the Roman Bronze castings (Plate 365) were made. The entire base became different, also the position of the Indian's head, hair braids and feather, shield and war club, the position of horse's hind legs and tail. The explanation is that Remington began taking greater advantage of modifying the final wax model before each casting was poured and that wax model was destroyed in the process. This twenty-five-inch bronze was a popular one and fifty or more original castings were made.

THE lost-wax process permits making changes before each casting is poured. From the original clay model a plaster mold (like two "cooky tins") is made, is put together, and the cavity is filled with a soft wax to make a duplicate of the original model. The wax model can be touched up or modified before it is encased in a hulk of material and molten bronze poured in through a funnel at the top. The wax model is melted as the bronze fills the cavity. Each casting requires a new wax model, which is "lost" in the process. Remington frequently made changes in the wax models, such as changing the position of a horse's tail, a rider's hat or arm, or adding details and improvements. This explains the variations in many of the castings.

"*The Norther,*" shown below, represents "a cowboy on horseback in snow storm. Severe wind blowing from rear. Both man and horse almost frozen." In the opinion of many, this is one of Remington's finest works of sculpture, although strangely enough only three castings are known to have been made. It was copyrighted July 2, 1900.

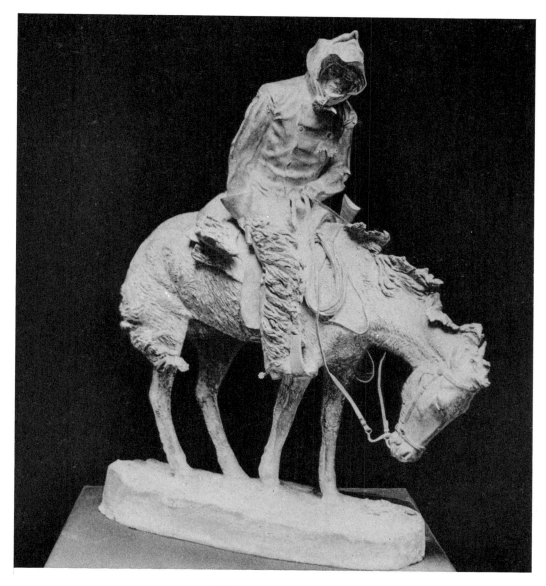

366. THE NORTHER
(plaster model)

Frederic Remington was a nonconformist and adventurous in nearly everything he did. The first American sculptor to use the cire-perdue process, he became a close friend of Riccardo Bertelli, who brought the technique here from Italy and established the Roman Bronze Works. In a conversation with the present writer a good many years ago, Mr. Bertelli commented: "He [Remington] always wanted to have his horses with all four feet *off* the ground. I sometimes had quite a time with him."

"*The Cheyenne*," shown below, was the first of Remington's bronzes originally cast by the Roman Bronze Works (copyrighted November 21, 1901) and it does have the Indian's horse with *all* four feet off the ground. The group is supported by a buffalo robe slid from underneath the rider and reaching to the ground. The center of balance had been carefully determined and the clay model was accompanied by a drawing and explanation. This twenty-one-inch-high subject resulted in some rather prominent variations in the individual castings. The position of the war shield varies from up between the Indian's shoulders to down on the horse's back; location of the scalping knife; contour of buffalo robe; and angle of the Indian's head. Possibly as many as a hundred casts were made.

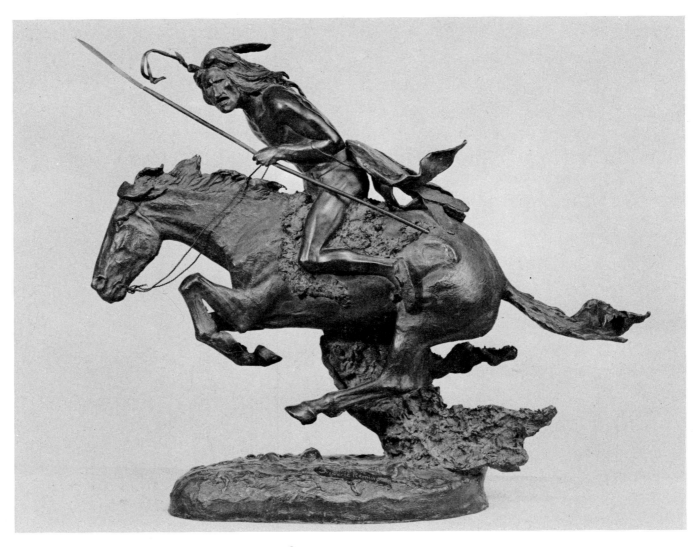

367. THE CHEYENNE
(Roman Bronze Works)

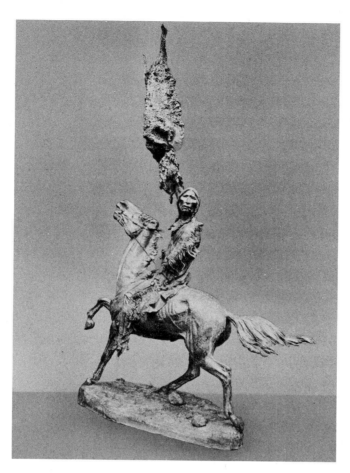

368. THE BUFFALO SIGNAL
(Roman Bronze Works)

REMINGTON spent a considerable amount of time with Bertelli at the Roman Bronze Works, and the latter was frequently a guest in the artist's New Rochelle home. Sculpture and art bronze casting were always a topic of conversation; and invariably when the clay model for a new subject was sent to the foundry it was accompanied by a sketch and memorandum as to just how Remington wanted the work done. He was always trying to get away from the conventional. Once he sent a Christmas card to Bertelli, consisting of a sketch showing a cowboy on a bucking horse precariously balanced on the tip of one toe, like a ballerina (see the sketch at the top of page 255). Underneath the artist wrote: "Can you cast him?"

Most sculptors today consider their work completed when the original clay model is delivered to the art foundry, but Remington insisted on personally cleaning up and putting the final touches on every wax model before it was cast, unless other circumstances prevented his doing so. This gave him the opportunity to make the little changes, in an effort to accomplish better results. In some instances he put forth more effort and added more details than on others, resulting in castings of finer quality.

The only Remington work of sculpture of which it is known there was only one bronze casting made is *"The Buffalo Signal,"* copyrighted December 17, 1901, and shown above. This, of course, is with the exception of the heroic size *"Cowboy"* in Fairmount Park, Philadelphia. In one of the artist's record books was found a notation stating that *"The Buffalo Signal"* was made on the special commission of a Chicago gentleman, with the understanding that only one casting would be made.

Coming Through the Rye" was the most ambitious work of sculpture Remington had undertaken. Copyrighted October 2, 1902, it is "a group of four cowboys on running horses. Men shooting pistols and shouting. Men represented as being on a carousal." One of his most popular bronzes, this twenty-eight-inch-high group realistically portrays the old-time cowboy of the Northern Plains. As with some of his other statuary, it was inspired by a picture previously done (see Plate 288). A heroic plaster replica was exhibited at the Louisiana Purchase Exposition in St. Louis in 1904. Forty or more of the original bronze castings were made and Tiffany & Company sold them for two thousand dollars each.

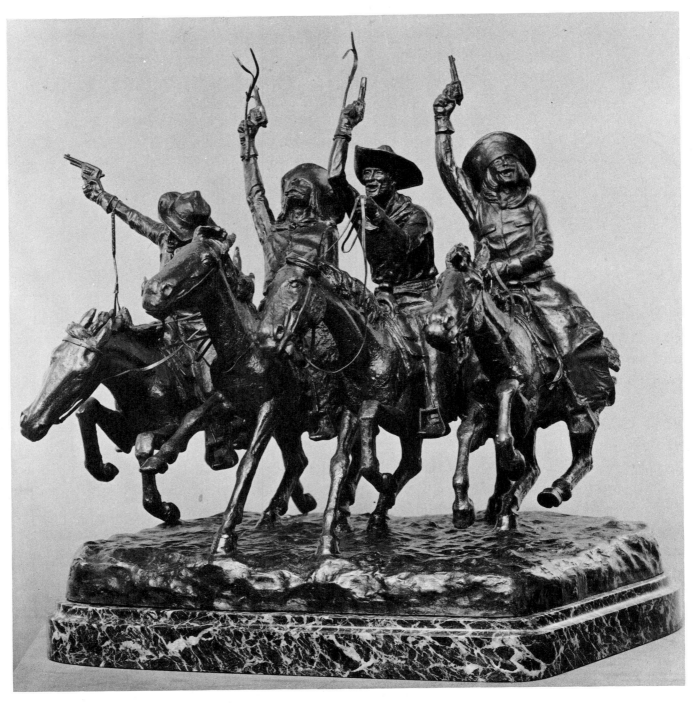

369. COMING THROUGH THE RYE
(Roman Bronze Works)

THE cowboy, mountain man, and cavalry trooper were three of the most colorful and characteristic types of Americans on the Western frontier; and what a triumvirate of hard-riding characters they were. Each Remington delineated in pictures and bronzes so comprehensively that future generations shall always know them. In his modeling of *"The Mountain Man"* (copyrighted July 10, 1903) he portrayed the lonely trapper riding down a steep mountain about as realistically as the sculptor's art permits. Always striving for better results, he made a number of changes in this subject as the castings progressed. In the first casting the rider's right hand clutches the tail strap as shown below, although the horse's right hind leg is raised and the gun lies across the rider's left arm. In later castings the hind leg is solidly on the ground as a skid and the rider's right hand is pressed on the horse's back. There were a hundred or more of this thirty-inch subject.

The eleven-inch *"Rough Rider Sergeant"* (copyrighted July 20, 1904) is the smallest of all the subjects. Four hundred or more of the original castings were made. Tiffany & Company sold them for fifty dollars each.

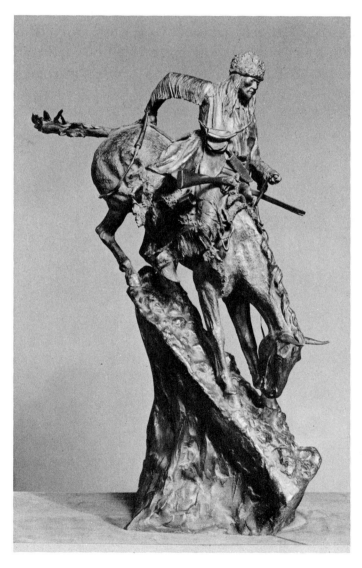

370. THE MOUNTAIN MAN
(Roman Bronze Works)

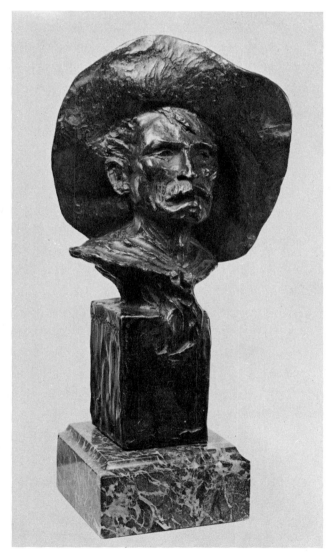

371. ROUGH RIDER SERGEANT
(Roman Bronze Works)

S CULPTURE proved to be a successful addition to Remington's busy career in the field of arts and letters. By 1904 he had broken away from the routine of illustrating, to devote himself almost completely to the more satisfying realm of fine art—something he had always aspired to do. His contract with *Collier's* permitted him to paint whatever he chose, for use as reproduction in color and subsequent release in art prints. This was rapidly enhancing his image as an artist. Demands for his canvases and bronzes was increasing. He was also writing well-received articles and stories about the West for the best magazines of the day; and eight of his own books had been published. One of these, *John Ermine of the Yellowstone*, was adapted for the stage and opened the new Globe Theatre, in Boston, later playing at the Manhattan Theatre, in New York. Along with these significant accomplishments he had made lengthy trips to old haunts in the West, to Europe and North Africa, and as a pictorial correspondent covering the Spanish-American War. He was also a popular *bon vivant* as guest or host to a distinguished list of friends. By all measures of evaluation Frederic Remington had become a substantial success.

His tenth work of sculpture in nine years was added on July 21, 1904. This was *"Polo"*, somewhat of a departure from the field of Western art, although the Indians and cavalry played polo as training for combat horsemanship. Another such departure was *"Paleolithic Man"* (copyrighted June 30, 1906) although primitive man was once a resident of our West. Each of the previous bronzes had been praised by the critics and the sales had been very good, although neither of the departures proved to be particularly successful and only a few casts were made.

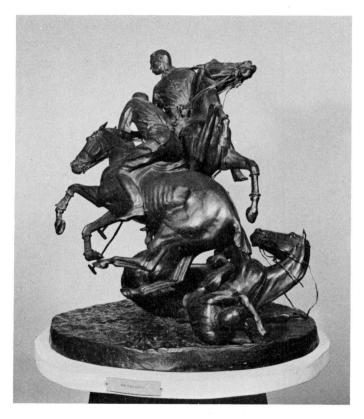

372. POLO
(Roman Bronze Works)

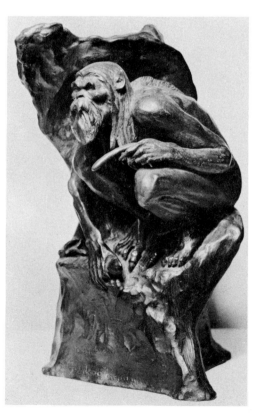

373. PALEOLITHIC MAN
(Roman Bronze Works)

The Rattlesnake" (copyrighted January 18, 1905), sometimes called *Snake in the Path*, was the artist's favorite of all his works of sculpture. "Fred was really pleased with it", recounted Riccardo Bertelli to the present writer. "He felt that it fulfilled his desire for faithful realism and fine artistic rendering. I completely agree." The sweeping circular symmetry of rearing horse and rider, caught at the instant of perfect balance on hind legs, is a creation of artistic beauty, without compromise to realistic portrayal.

There are two versions of this subject. The first one is "twenty inches high to top of rider's head" and the second is twenty-three inches. Not satisfied with the first, he made the larger model, improving both action and symmetry. The horse's neck is more acutely turned and the forelegs pulled up tighter, the cowboy's body is more gracefully curved and bent over, his left arm swung over to the right and his seat is well above the saddle. There are also minor variations in some of the individual castings, although, seen separately, none of the differences might be recognized by one unfamiliar with the statue. There are considerably more castings of the larger version and a total of probably well over a hundred in all.

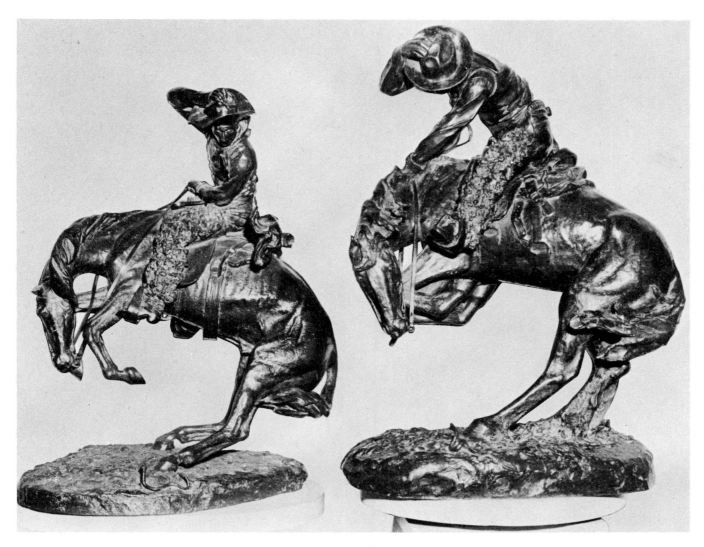

374. THE RATTLESNAKE (SMALL AND LARGE)
(Roman Bronze Works)

The Old Dragoons" (copyrighted December 6, 1905) was the largest and most complex
work of sculpture Remington had undertaken. The artist's own description is: "Two
Dragoons and two Indians on horses in running fight. One single horse without rider in lead.
Foremost soldier with raised sword in right hand ready to strike forward Indian who is pro-
tecting himself with spear and shield. Rear soldier with sword at Indian's throat and with
left hand protecting himself from Indian's battle axe. Both Indians wearing breech cloth.
Soldiers in uniform. Base 38 inches long by 13 inches wide. Group 26 inches high."

The old Dragoons were mounted infantry with short muskets and long swords. The First
Regiment of Mounted Dragoons was organized for early duty against the Indians west
of the Mississippi. They spearheaded many campaigns, including the U. S. Government's
first move toward acquisition of the Mexican-controlled region of the Southwest in 1834.

The detail pictures on the opposite page, showing reverse angles of the foremost
dragoon and his Indian adversary, indicate the fine detail Remington put into his works of
sculpture. These pictures were made of the first casting and it will be noted that the Indian
"is protecting himself with spear" as described by the artist in his application for copyright;
while the comprehensive photograph above shows the same Indian using a piece of buffalo
hide for the same purpose. This was a change made for a subsequent casting—although only
five or six castings are known to have been made.

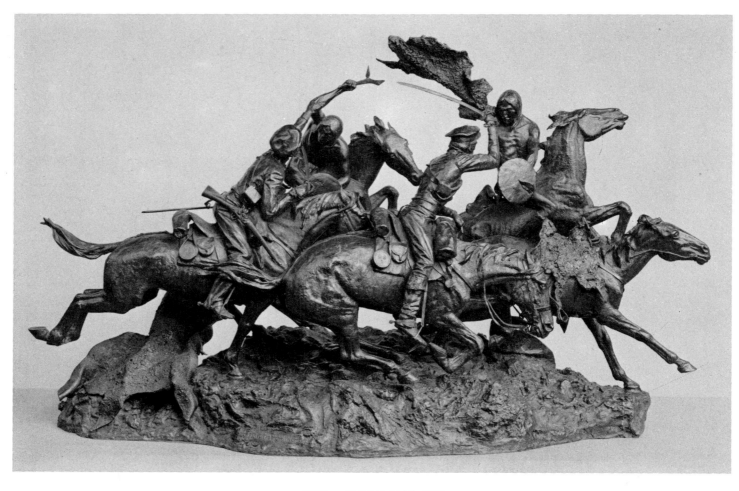

375. THE DRAGOONS
(Roman Bronze Works)

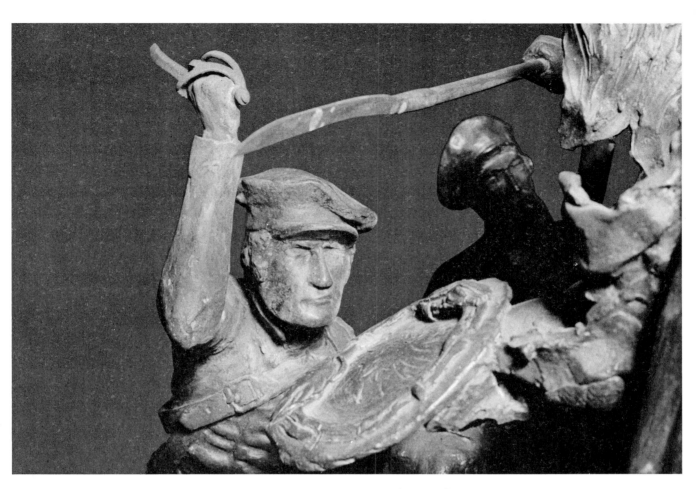

376. THE DRAGOONS (DETAIL)
(Roman Bronze Works)

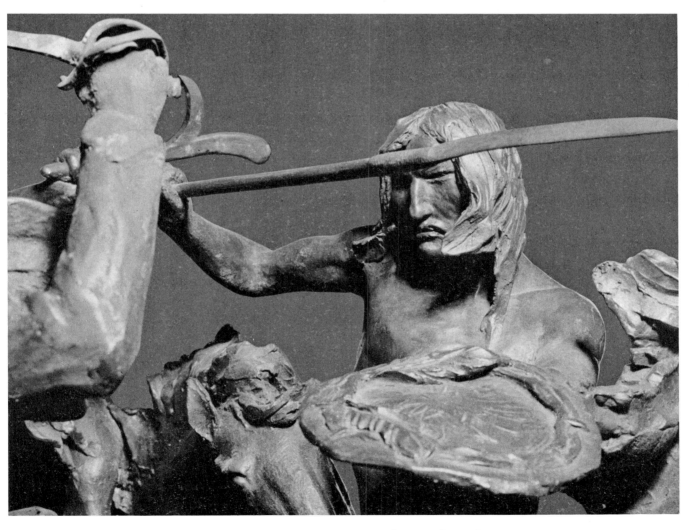

377. THE DRAGOONS (DETAIL)
(Roman Bronze Works)

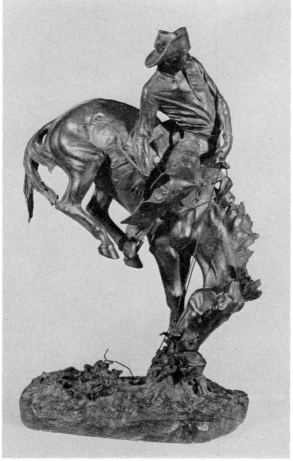

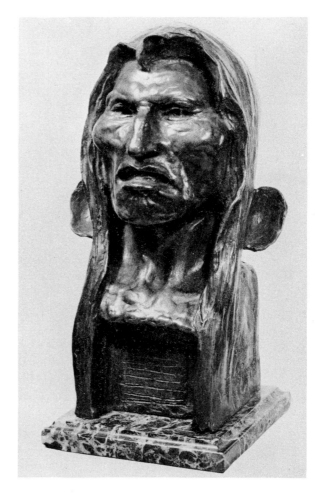

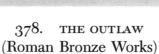

378. THE OUTLAW
(Roman Bronze Works)

379. THE SAVAGE
(Roman Bronze Works)

THE facetious remark Remington wrote under the Christmas-card sketch he sent to Bertelli, of the Roman Bronze Works, regarding the possibility of casting a cowboy on a bucking horse precariously balanced on one toe like a ballerina, was more serious than it may have appeared. On May 3, 1906, "*The Outlaw*" was copyrighted and the accompanying description reads: "A cowboy on a pitching bronco, same jumping in air, and balanced on 'off' fore foot only." A comparison of the above with the sketch on page 255 will show how closely the artist put the sketch into bronze. It is an excellent example of design and of balance for the sculptor's art, and about forty castings of this subject were made. In at least one of these the horse's tail is flared strongly upward, leading to the erroneous assumption that it is a separate work and titled *The Cowboy*.

It is not uncommon for artists to make small wax models of subjects for their paintings, to aid in accomplishing portrayal in the round. That is why human models are used. Remington had a different approach. He was rather unorthodox in most things he did. Although he sometimes used living models in his studio, he had the fortunate faculty of visualizing subjects in the round, and in his sculpture he made sketches in advance of working in the clay. This was an aid to accomplishing balance and design. As so many of his animals were rearing or running, with few or no feet touching the ground, balance in weight was an im-

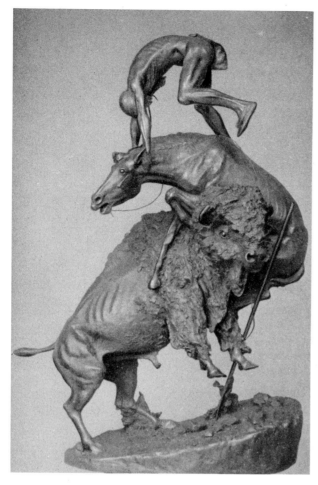

380. THE BUFFALO HORSE
(Roman Bronze Works)

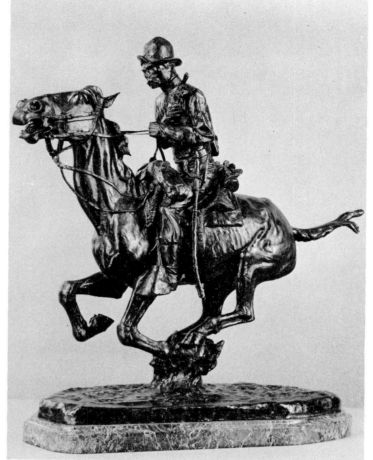

381. TROOPER OF THE PLAINS
(Roman Bronze Works)

portant factor. Good examples of this are shown in three of the subjects shown on these two facing pages.

"*The Savage*" (Plate 379) is a prototype of the red warrior of the western Plains, when the white man was rampaging on his conquest of empire. It is considerably more than an eleven-inch bronze portrait of an Indian, of which more than three hundred castings were made (copyrighted December 14, 1908). The expression on the face is one of defiance, determination, and bitterness, more eloquent than a writer's eulogy.

"*The Buffalo Horse*" (Plate 380) copyrighted December 12, 1907, became the inspiration for Remington's painting *The Buffalo Runner* (Plate 97) which appeared as a color plate in *Collier's* of July 1, 1911, a year and a half after the artist's death. So prolific was he that no less than seventeen of his important paintings appeared in *Collier's* after his death. Only a small number of this "thirty-six inch high" bronze were cast.

The "*Trooper of the Plains—1868*" (Plate 381) was the second Remington work of sculpture of a rider and horse with all four feet off the ground. This "twenty-seven inch high statue on a base twenty inches long" has the figures supported by a small bunch of sagebrush. It was copyrighted January 13, 1909, less than a year before the artist's death, and only about twenty-five castings were made.

The Horse Thief," shown below, portrays "a nude Indian on a horse, holding a buffalo skin with right arm as a protection. Buffalo robe flying in air. Horse running, with three legs in air. Total height 30 inches, length 27 inches." A tanned buffalo hide was sometimes used as a shield to protect rider and horse from the weapons of an enemy. Suspended in the air, the tough and flexible hide was impervious to arrows and effective even against the large caliber, slow-velocity bullets of a pioneer's musket when shot from a reasonable distance. Interesting as the subject is, it presented a problem in casting and resulted in a large and heavy work of art that had to be priced at considerably more than most of the other Remington bronzes. The result was that not more than four or five castings were made. Today, because of the rarity, it is much sought after by collectors and museums. It was copyrighted May 22, 1907.

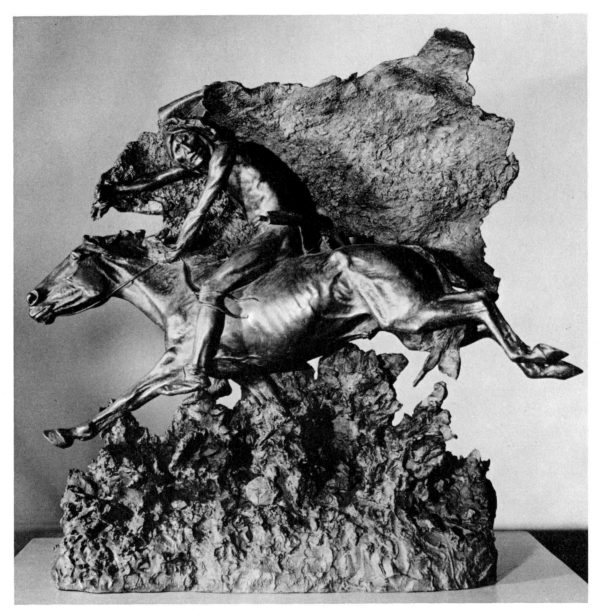

382. THE HORSE THIEF
(Roman Bronze Works)

*T*he Cowboy," a heroic bronze statue sixteen feet high and eighteen feet long, stands to Remington's and to all Western cowboys' memory in Philadelphia's Fairmount Park. One of the culminating accomplishments of the artist's career as a sculptor, the statue was unveiled a little more than a year before his untimely death. Rough and brusque as the pictures and sculptures he made, Remington was inwardly a quiet dreamer. One of his secret desires was to model a heroic statue of an American Indian, to be erected on Staten Island, in New York Harbor; a monument to this land's first inhabitants, so large it could be seen as a first welcome to travelers from across the sea. This dream was never realized, although *The Cowboy* unveiling was held on April 20, 1908, attended by a large throng including a group of mounted cowboys and Indians from a Wild West show in Philadelphia at the time. Another permanent reminder of those rugged riders of the western Plains and the heritage they gave us, it also represents the thesis of Remington's life.

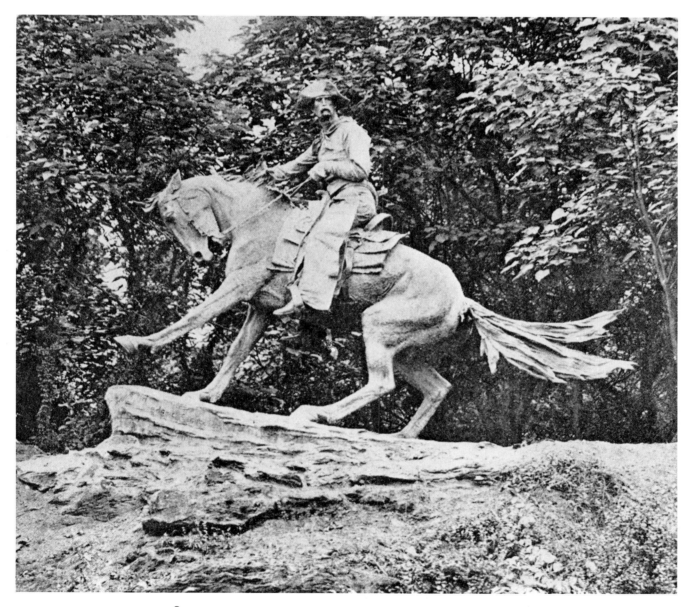

383. THE COWBOY—FAIRMOUNT PARK, PHILADELPHIA

FREDERIC REMINGTON's last work of sculpture was *"The Stampede"*—a group of plunging cattle with a mounted cowboy caught in the midst. The clay model for this subject, fifty inches long and twenty-three inches high, was completed shortly before the emergency operation for appendicitis which brought the sudden end on December 26, 1909. He had only passed his forty-eighth birthday and was just entering his finest period of accomplishment. It was his widow who sent the clay model to the foundry and obtained the copyright of April 13, 1910. Only four or five castings were made. So successful had Remington become that the old house in New Rochelle was sold and a fine new home designed and built on a beautiful estate near Ridgefield, Connecticut. Fred and Eva had hardly become settled, and the press of work had been carried on in the spacious studio in the midst of unpacked boxes. He had completed the large *"Bronco Buster"* (Plate 385), thirty-two inches high instead of the smaller one twenty-two inches high, done in 1895, and he sent the big one to the foundry. About twenty castings of this were made.

The least explainable of all the works of sculpture bearing Remington's name is *The Indian Dancer* (Plate 386). More than twenty years ago the present writer found a photograph of this work among the scores of photos the artist had personally made of his paintings and sculptures. But there was no copyright or record as to when or why it was made. This writer believes that it is genuine, although the modeling is strangely different from anything else he did. This may have been intended for the heroic monument to the American Indians, which he had quietly dreamed about and hoped to someday see erected in New York Harbor.

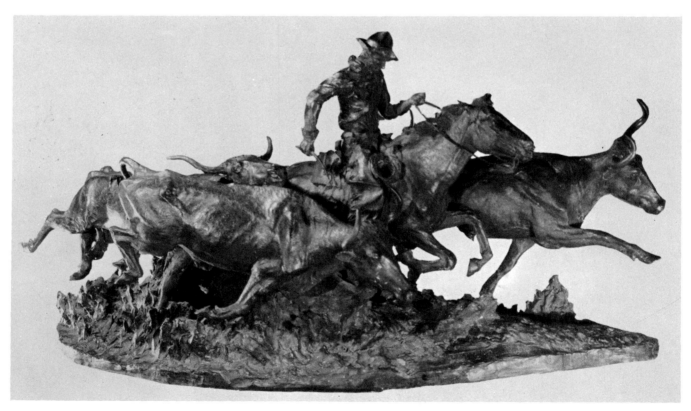

384. THE STAMPEDE
(Roman Bronze Works)

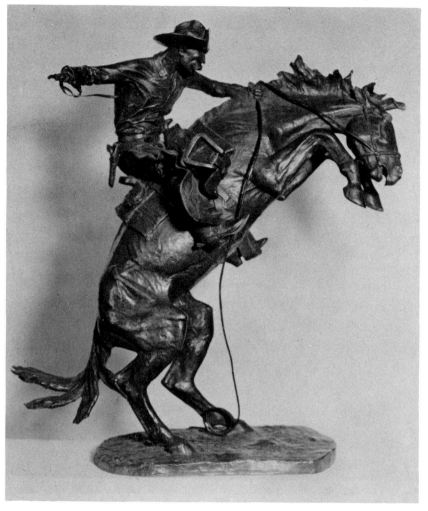

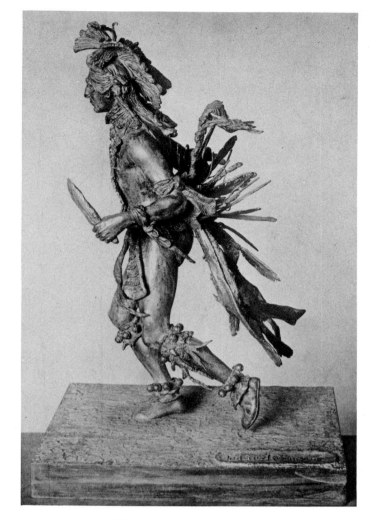

385. THE BRONCO BUSTER (LARGE)
(Roman Bronze Works)

386. THE INDIAN DANCER

IN THE summer of 1910, following Remington's death, a project was undertaken by
Theodore Roosevelt. In a printed brochure, written and signed by the artist's good friend,
recently retired from the presidency, the following eulogy and appeal were made:

"The Indian is civilized, the cowboy is passing, the range cattle are taming; even the
cayuse is passing into history. One man's work, however, will preserve them for all time in
pictures and in bronze . . . This man was Remington, the painter-sculptor, who saw the
plains and what was on them as they really were . . . He was a wonder-worker with his
pencil and brush, his facile fingers on the sculptor's clay . . . Now, you, men of the cattle
country, have an opportunity to do for him what he so marvelously did for you and for your
fathers . . . It is proposed and urged that there shall be subscribed a fund to be devoted to
the planning and erection of a monument to Remington . . . to be erected in Washington,
D. C., where, undoubtedly it should be placed, for Remington was national . . . It is high
time that Americans did something toward recognition of their native art, and that art
which most assuredly has earned the tribute is the art of Frederic Remington. (Signed:
Theodore Roosevelt.)"

The monument never became a reality.

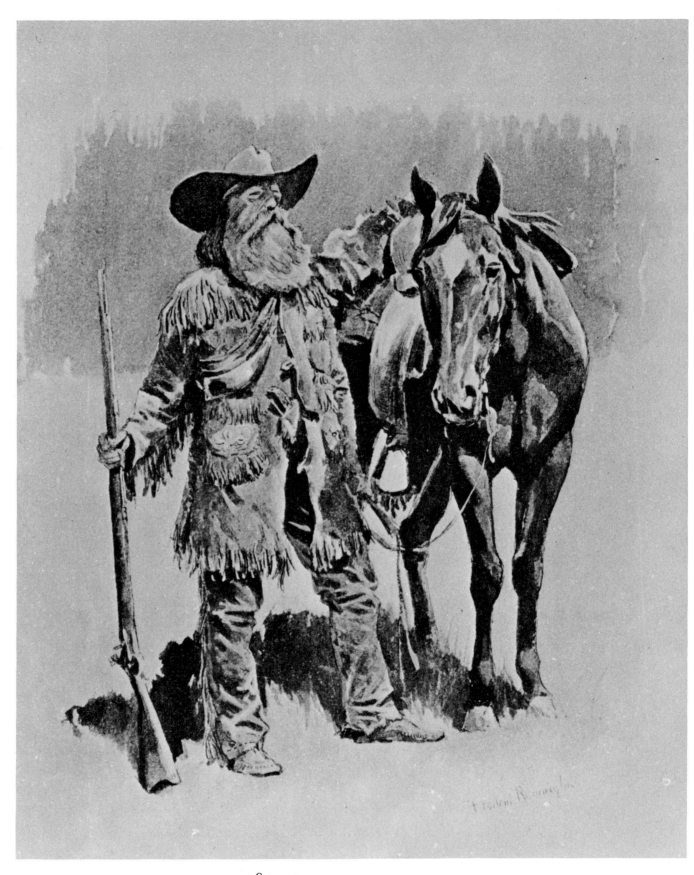

387. A TRAPPER AND HIS PONY

Index of Pictures

The pictures compiled in this book are intended as a comprehensive representation of the work of Frederick Remington as a pictorial historian of the American West. They have not been arranged in the order in which the artist did them, but in a semblance of historical chronology, collectively as well as in the various sections of the book. What is reproduced here is not all of the pictures done by this artist relating to the West, and he did a considerable number representing other areas, such as Cuba, during the Spanish-American War, Europe, North Africa, Eastern Asia and the Eastern United States. But the main theme of his life's work was the American West. The gathering of the pictures and data has been a pleasant task for this compiler, covering more than thirty years; and it is felt that the selection represents the majority of the best and most important of Remington's work relating to the West. A *Bibliographic Check List of Remingtoniana,* covering all the pictures that he did in the various fields, will be found in this writer's book *Frederic Remington—Artist of the Old West* (Lippincott, 1947). That list covers the first reproduction appearance of each of 2739 pictures, or about 97 per cent of everything he did. The following Index is intended as a reference as to where and when the pictures in this book were first reproduced. A good many of them appear here for the first time.

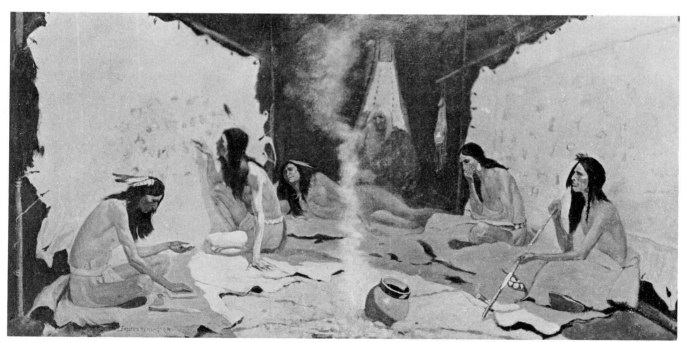

389. HISTORIANS OF THE TRIBE

James Graham & Sons, N. Y.

COLOR

BLACK AND WHITE

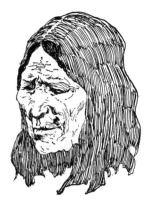

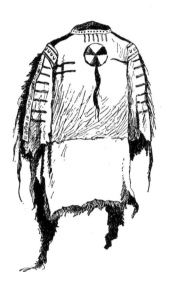

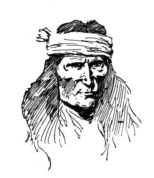

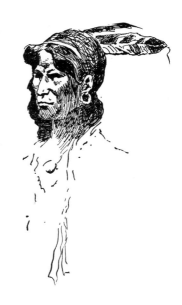

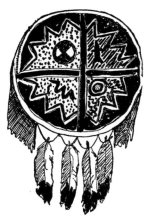

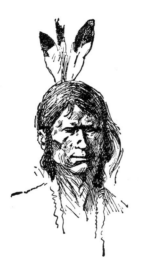

BRONZES

Just look at me and you will see
Why for a tail-piece Remington chose me.